AESTHETICS
and
THEORY
of
ART

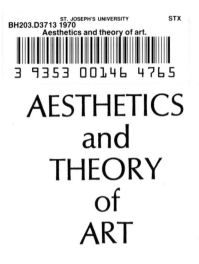

AESTHETICS
and
THEORY
of
ART

Ästhetik und Allgemeine Kunstwissenschaft

•

Max Dessoir

translated by
STEPHEN A. EMERY
with a Foreword by
THOMAS MUNRO

Detroit • Wayne State University Press • 1970

Published simultaneously in Canada by
The Copp Clark Publishing Company
517 Wellington Street, West
Toronto 2B, Canada.

Library of Congress Catalog Card Number: 68–22680

Standard Book Number: 8143-1383-3

Grateful acknowledgment is made to
The Journal of Aesthetics and Art Criticism for financial
assistance in publishing this volume.
This English translation has been authorized
by Ferdinand Enke Verlag, Stuttgart, publishers of the
original German editions of 1906 and 1923.

CONTENTS

5

IX. Spatial and Figurative Arts

X. The Functions of Art

Charts

N.B. The figures on pages 77, 83, 86, 87, 89, 132, 133, 134, 235, 390, and the musical notations on pages 92, 93, 94, 98, 99, 272, 273, 276, 294, were taken from the first German edition (1906). The 19 plates in that edition were not reproduced in the second German edition (1923) and in many cases references to them were dropped.

FOREWORD

The publication of Max Dessoir's masterwork *Ästhetik und allgemeine Kunstwissenschaft* is a second step in the plan of the American Society for Aesthetics to make available English translations of important foreign works in this field. The first work was *Vorlesungen über Ästhetik* by Friedrich Kainz of the University of Vienna, translated by Herbert M. Schueller and published by the Wayne State University Press in 1962 under the title *Aesthetics the Science*. This was selected as a broad, critical survey of ideas on aesthetics in Germany during the years immediately following World War II.

The Dessoir book, first issued in 1906 and revised in 1923, has the same relation to German aesthetics in the first three decades of the twentieth century and between the two world wars. That period, lasting until the Nazi regime, was highly productive in the arts and general philosophy, as well as in aesthetics, psychology of art, and art education. During the entire period Dessoir exerted a wide and stimulating influence through his writing, editing, teaching, and personal contacts. As professor at the University of Berlin and later at Frankfort, he lectured to large audiences and did much to advance the academic status of the subject.

In 1906 he published the first magazine on aesthetic theory, the *Zeitschrift für Ästhetik und allgemeine Kunstwissenschaft*, which he edited until 1937. He continued its publication until 1943. In 1908 he organized the Society for the Study of Aesthetics, which brought together scholars and artists in many fields related to theoretical studies of the arts. In 1913 the Society organized the

first world congress for aesthetics in Berlin, under Dessoir's leader-
ship. After World War II the congresses were resumed every four
years beginning in 1956. Societies and periodicals devoted to
aesthetics were started in the United States and several other
countries, somewhat after the model Dessoir had set. He died in
1947 at the age of eighty, but not before exchanging cordial letters
with some aestheticians in the United States, and expressing his
delight at the interest in his work among younger scholars in a
foreign country.

The American *Journal of Aesthetics and Art Criticism*,
founded in 1941, published several news notes with details about
Dessoir and his work, which readers may find as follows: Volume
v, Number 3 (March 1947), page 241; v/4 (June 1947), p. 330;
vi/1 (September 1947), p. 81. In December 1947 (vi/2), pp. 105–
107, a biographical note by one of his former students, the Finnish
scholar Kaarle S. Laurila, was published under the title "In Memory
of Max Dessoir." In the same issue the *Journal* published a transla-
tion of Dessoir's article "The Contemplation of Works of Art." A
list of his principal books and a biography of him in German are
also given in that issue on pages 196–197. Later, in the issue for
Summer 1961, pp. 463–469, another article by Dessoir was published
in translation under the title "Art History and Systematic Theories
of Art."

Many important articles remain untranslated, including
some from his later years, and it is hoped that the present volume
will encourage many students to examine them. He invents no
highly original system, but seeks and finds kernels of truth and
wisdom in many older systems. For that reason his flexible synthesis
contains much of value to the student and general reader. He avoids
the metaphysical emphasis which has made older German aesthetics
unpalatable to many English-reading students of the subject, but
he does not ignore the traditions or limit his approach to a survey
of purely empirical data. Therein lies the chief significance of what
some friendly critics have called the "double-barreled" title of this
book—"Aesthetics and the Science of Art" (*Aesthetics and Theory
of Art*). Neither was sufficient by itself, he believed: neither specu-
lations about the nature of beauty nor empirical studies of art and
aesthetic experience.

Whether the two approaches, the two realms of aesthetics,
should be kept as distinct as his title would indicate, is contro-
versial. The conception of a definite "science of art" has not found

great favor in the English-speaking world. Both realms, perhaps, can be included under the single name "aesthetics." In any case, those who favor the idea of a broad approach to aesthetics, with due consideration of its philosophical, practical, and critical aspects, will find much of value in Max Dessoir's reasonable teachings.

THOMAS MUNRO

AUTHOR'S PREFACE TO
THE SECOND EDITION

This book has long been out of print. External circumstances have kept both the publisher and me in doubt as to whether it was advisable to prepare a new edition. However, we finally decided to do so.

In the revision two points were kept in mind. The first one concerned the economic depression; the size and price of the book needed to be kept as small as possible. To accomplish this I have reduced the first edition, not only by omitting the appended plates of illustrations, but also by striking from the text itself everything in any way dispensable, including most of the source references. Additions have been made only where absolutely necessary. The second point does not concern the conditions under which German scholars now have to live and work. Since the appearance of this book in 1906 my views have been developing and have perhaps become more insightful. If I were to write a new book on aesthetics now, I would plan and execute it quite differently. It did not seem fitting, however, to replace a book of a certain definite character by a completely new one. I have, therefore, undertaken the task of shortening and improving my presentation without violating its earlier substance.

Let me restate the following passage from the preface to the first edition: "Rarely does an author achieve the books he wants to achieve. One conceives a book in a manic phase, so to speak, but later it becomes fixed and lives on a depressed level. The spirit of indirectness in our times bears the principal guilt for this, inasmuch as the relationship to life has shrivelled, and almost exclusively we

still read about what has been read, and write about what has been written, and speak about what has been said. Even though I feel myself strongly oppressed by this burden, I continue to hope that a personal view of the problems has left its traces and will be felt to be helpful."

<div align="right">

MAX DESSOIR

</div>

Berlin, March 1923

TRANSLATOR'S PREFACE

Every translator of an important work encounters a pervasive dilemma. Strict fidelity to the original text and easy felicity in another language are all too often incompatible. To secure one is to sacrifice the other. In aesthetics this general problem is aggravated by the breadth of vocabulary and the subtlety of thought. Here a comprehensive treatise uses language in its full scope and introduces terms which often defy sharp definition and accurate translation. Although these difficulties have not been adequately overcome in this English version of Dessoir's *Ästhetik*, it is presented in the hope that it will reduce the linguistic barrier for many who want to know his thought better.

Thomas Munro, a guiding and sustaining spirit for many years in the aesthetic life of America, has long advocated English translations of distinguished German works in the field. He proposed Dessoir's *Ästhetik*, obtained financial aid for the project from the American Society for Aesthetics, remained an encouraging and patient sponsor throughout its intermittent progress, and finally arranged for publication. To Dr. Munro and the Society we are all deeply indebted for this contribution, as for so many.

My brother, William T. Emery, turned over to me his written translation of several Dessoir chapters for comparative study. This manuscript threw light on various obscure points and saved me from countless careless errors. His generous assistance has greatly improved the present translation. My wife, Sarah Watson Emery, has read nearly all the chapters and made many helpful suggestions to clarify and smooth the style.

Charles H. Elam of the Wayne State University Press has edited the whole manuscript with the most scrupulous care, introducing more notational uniformity, applying his knowledge of art history to many technical passages, and relaxing the Germanic style throughout. His deft touch is evident on almost every page.

STEPHEN A. EMERY

This translation is based on the German edition of 1923. Since most notes are significantly germane to the author's arguments, all have been run into the text in parentheses or brackets. Zeitschrift für Ästhetik und allgemeine Kunstwissenschaft *is cited as* Z.f.A. *Certain terms have been translated variously, such as* spatial *and* visual, *or* mimetic *and* mimic, *or* plastic art *and* sculpture.

INTRODUCTION

In the development of our science from its birth to the present, one thought has always held good: that aesthetic enjoyment and creation, beauty and art, belong inseparably together. Though the subject matter of this science may have many forms, yet it is unitary. The function of art is to present the beauty which emerges from an aesthetic situation and is received in a similar attitude. The unitary science of both these mental states, as well as of the beautiful and its special forms, of art and its kinds, is covered by the one name *aesthetics*.

The present is beginning to doubt that the beautiful, the aesthetic, and art are united almost in essence. Even earlier the exclusive sovereignty of the beautiful was challenged. But art includes in its sphere also the tragic and the comic, the pretty and the sublime, indeed even the ugly, and to all these categories aesthetic satisfaction is relevant. So, clearly, the beautiful must be something more restricted than the artistically and aesthetically valuable. Yet beauty could be the ultimate goal and center of art, and the remaining categories could point the way to beauty. They could be, as it were, beauty in the making.

Even this view, which finds in beauty the proper goal of art and the center of the aesthetic processes, is open to serious question. Above all it confronts the fact that the beauty enjoyed in life and the beauty enjoyed in art are not the same. The artistic reproduction of natural beauty achieves a wholly new character. In painting spatial objects are relegated to one plane; in poetry being is changed into language, and thus always transformed. To be

17

sure, the subjective impression could remain the same, despite the objective diversity. But even that is not the case. The beauty of the living body—a recognized virtue for the possessor—speaks to all our senses. It often arouses sexual feelings, even though of almost imperceptible delicacy. It involuntarily influences our actions. But the marble statue of a human nude has that certain coolness which keeps us from considering whether we are looking at a man or a woman. Here even the most beautiful body is enjoyed as a sexless form, like a beautiful landscape or melody. Aesthetic experience of nature includes the aromatic scent of forests and the glowing heat of tropical vegetation, whereas the lower senses are banned from artistic enjoyment. As compensation, one might say, for what is lacking, artistic appreciation contains joy in the personality of the artist and in his power to overcome difficulties. Thus there are many other elements of pleasure never elicited by natural beauty. Hence both object and experience require a distinction between what we call beautiful in art and what is so called in life.

But our examples show something else. On the assumption that the pure and pleasant contemplation of any object whatsoever may be called aesthetic—and how could the customary use of words refute this?—it becomes clear that aesthetics exceeds art in scope. Our wondering and loving devotion to the phenomena of nature bears all the marks of the aesthetic attitude, and yet need not be concerned with art. Moreover, in all spiritual and social fields a part of the creative power is expended in aesthetic construction. These products, though not works of art, are aesthetically enjoyed. As countless facts of daily life show us that taste can develop and fulfill its function independently of art, we must assign to aesthetics a broader scope than to art.

This is not to say that the field of art is a narrow sector. On the contrary, the aesthetic does not exhaust the content and goal of that area of creative human activity we inclusively call *art*. Every genuine work of art is extraordinarily complex in both cause and effect. It springs not only from aesthetic joy in play and strives not only for aesthetic pleasure, to say nothing of the pure distillation of beauty. The needs and forces in which art has its existence are in no way limited to the tranquil satisfaction which traditionally marks the aesthetic experience as well as the aesthetic object. In spiritual and social life the arts have a function, uniting them with our whole cognitive and volitional activity.

It is the duty of a general science of art to do justice to the

great fact of art in all its bearings. Aesthetics cannot discharge this task if its content is definite, self-enclosed, and sharply bounded. We should no longer dishonestly conceal the differences between the two fields. Rather, through finer and finer distinctions, we must throw the two so sharply into relief as to show the connections actually present. The relation between the point of view previously adopted and the point of view now coming in is like the relation between materialism and positivism. While materialism ventured a very crude reduction of the spiritual to the corporeal, positivism set up a system of natural forces in which the relation of dependence determines order. Mechanism, physico-chemical facts, biological and historical-social groups are not reduced to one another in content, but are so joined that the higher systems appear as dependent on the lower. So also in the future is art to be linked methodologically with aesthetics. And perhaps still more closely, for even now aesthetics and the science of art are often working hand in hand, like tunnel laborers digging into a mountain from opposite points to meet in its center.

It occurs often, but not always. In many places investigations are going on without any concern for what has preceded elsewhere. The field is quite too large and the interests too diverse. Artists are telling us of their creative experiences and connoisseurs are teaching us about the techniques of the several arts. Sociologists are investigating the social efficacy of art; ethnologists, its origin. Partly through experiment and partly through conceptual analysis, psychologists are discovering the basis of the aesthetic experience; philosophers are discussing principles and modes of procedure. Historians of literature, music, and the spatial arts have heaped up enormous masses of material. And the sum-total of these scientific investigations forms the soundest, though not the greatest part of the public discussions which, issuing from various and sundry points of view, flourish in periodicals and newspapers. "There now remains for the thoughtful person no alternative but to resolve to place the center somewhere, and then to see and to seek as though he were treating the rest as peripheral" (Goethe).

Only through demarcation can cooperation arise from the bustling confusion. At the moment contradictions and hostilities are still quite numerous. Whosoever undertakes to establish a bland conceptual unity destroys the life expressed in encounters, cross-currents, and conflicts, and mutilates the full experience deployed in the various special investigations. For us systems and methods

mean to be free from *one* system and *one* method. But it is questionable whether a single person can come to have so broad a mastery of different methods as to apply them effectively. To be sure, the philosopher is commonly regarded as justified in studying aesthetics in the stricter sense, but his authority to talk about the general science of art could be challenged. The philosopher who wants to put in his word on each and every thing may look like a professional dilettante, like a prattling know-it-all, without correct ideas and basic knowledge of the things about which he spins fantasies. Should not scholars of art on the one hand, and creative artists on the other, be permitted to claim the subject exclusively for themselves?

The theory of the particular arts is usually covered in connection with the study of their history. In universities the art historian presents also the systematic science of the spatial arts, and the professional historian of literature is supposed to be a philologist as well. Both the history and the theory of music are likewise pursued by the same persons. Unquestionably the two dimensions of work can support each other and the historian, for example, without systematic knowledge would be powerless to advance. But, as experience shows, the purely theoretical treatment of the forms and laws of each art can be carried through fruitfully without a closer investigation of historical development. So the several systematic sciences arise which we usually call poetics, theory of music, and science of art. To examine their assumptions, methods, and goals epistemologically, to investigate the nature and value of art and the objectivity of its product, seem to me to be the task of a general science of art. Moreover, in the problems posed for reflection by artistic creation and the origin of art, in the classification and function of the arts, this science possesses fields which might otherwise be crowded out. And, at least provisionally, the philosopher is called to govern them.

But still another misgiving must be dispelled. Are not the creative artists perhaps the persons who should instruct us others concerning the nature of art? With what right can the philosopher who is not an artist pass judgment on art? Is he not exposed to the same criticisms as an economist who writes about stock exchange operation without ever having stood on the floor of an exchange?

Our science certainly owes much of value to artists, so far as they are theorists and authors. Reports of their own creative activity are quite indispensable, and they have said many pertinent

things about the techniques of their arts. But in principle their interest in theory has a different aspect from our concern. Through reflection artists try to foster their own creative activity, or at least to satisfy the natural need for insight into the preconditions of their art. Therefore their goal is either artistic achievement or personal education. Scientific investigation, on the other hand, cannot remain a means to one of these two intrinsically justified goals; it is itself a goal, and usually benefits little from dilettantish occupation with art. I will not mention the inadequacy of artists who feel disposed to discourse without being accustomed to abstract and systematic thinking, indeed without suspecting at all the questionable features of the apparently obvious. But I should like to see even the appreciation of art and the criticism of art excluded from the pure science. In teaching us to enter sympathetically into the peculiar life of particular works of art and to separate idea and form in specific creations, they contribute something to the cultivation of individuals and to their capacity for enjoyment. But here all the eternal values of philosophy serve the momentary. With Sainte-Beuve, connoisseurs and critics see it as their task "to confine themselves to knowing beautiful things intimately and to enjoying them as cultivated amateurs, as accomplished humanists." To be sure, description and explanation can contribute to this, and we have an obligation to justify and demarcate this sub-part epistemologically. But we are not concerned with the appreciation and enjoyment of a particular work.

Like every other science, our science springs from the need for clear insight and from the need to explain a group of facts. As the field of experience which this science has to make intelligible is the field of art, there arises the peculiarly troublesome task of transforming the freest, most subjective and synthetic activity of man in the direction of necessity, objectivity, and analysis. Unless this drastic change results, there is no science of art. Everything capricious, irrelevant, and irrational must be resolutely discarded. For, although often recognized as a bare fact, it is still not understood. In this transition, I admit, one often gets far from inwardly experienced reality and from the consciousness of the artist. Does a musician ever hear all that the science of music establishes? Does the reader (indeed, even the poet) know that the peculiar mood which a verse evokes is caused by the regularly muffled vowels? In speaking of such things our science antagonizes artists. Needing, as creators, to see almost nothing of all this clearly, they take it as

a strange distortion and finally retire completely into their feelings. Hence in every case the creative artist will recognize only another creative artist as a peer, even if as a rival he hates him most. Even the great poet will feel himself more akin to the uneducated author of a couplet than to the most learned thinkers. But precisely here lies *our* justification. We aim to understand the processes, and have no ambition to be able to produce them. Consequently, we are not trying to influence the artist. We cannot say concretely and effectively *how* one starts to create a work of art. Theoretical knowledge and practical ability are two different things, and the general science of art belongs to the broad field of theoretical knowledge.

Were I permitted to settle in the land of my desire, I might well sketch a portrait of the man to whom some day the crown of that realm is to fall. He would be born a king who could feel artistically and think scientifically in equal measure. Art in all its expressions would have to cultivate his passion; science with all its methods would have to train his intelligence. For him we wait.

I. THE TRENDS OF AESTHETICS

1. Content and Method

Aesthetics has never fared well. A late arrival in the world as a younger sister of logic, it has been treated with contempt from the start. Whether as the doctrine of an inferior knowledge or as the science of the sensuous veiling of the Absolute, it has always remained something subordinate and incidental. Perhaps on this account and perhaps because of an obscurity in the subject itself, aesthetics has never been able to claim either a sharply defined field or a reliable method.

Even the *history of aesthetics* in retrospect reveals an ambiguity. If the systematic treatments of the subject are serially arranged, a line of development appears, always paralleled by another, the line of taste and artistic judgment. But on the whole the history of aesthetic evaluations does not coincide with the history of scientific aesthetics any more than the development of morality coincides with the development of ethics, or progress in the understanding of the soul with the progress of scientific psychology. The countless insights provided in sketchy form, the artistic intuitions directly or indirectly expressed, are doubtless highly significant. It is important to discover wherein a generation glimpsed the pinnacle of art, and how far the dominant trends of taste and creative activity also influenced theory. But in a general history of aesthetics, nevertheless, the stress should lie on the systems.

Yet the other line takes on new value when one turns to the questions usually comprised in the meaning of *aesthetic culture*. Here we deal with the aesthetic fashioning of life. Our natural striving for pleasure can be refined, the will to enjoy can be puri-

fied, and the aesthetic realm is the proper place for this. Even Kant gave refuge in aesthetics to the pleasure banned from ethics. To be sure, this susceptibility to delicate joys remains fruitless unless united with the will to make existence more worthwhile through tasteful arrangement. But now both together yield beauty in speech and writing, bodily bearing and dress, house and garden. This has no immediate relevance to art. The aesthetic urge toward form induces the scholar to give balanced articulation to his book without its therefore becoming a work of belles lettres. Of such things we shall occasionally speak, while the *history* of our science will not be mentioned at all.

Now we pass from the peripheral regions to the heart of aesthetics. Here we find appalling conflicts of method. Three groups may be distinguished. They are speculative and empirical, normative and descriptive, and subjective-psychological and objective aesthetics. While speculative and normative aesthetics have a natural affinity, as do empirical and descriptive, the introduction of the third pair raises difficulties, as the field of the subjective is broader than that of the psychological. It seems better to place descriptive and normative aesthetics on the one side, and objective and situational aesthetics on the other, although even this grouping is distinguished more by its completeness than by its grasp of essentials. Descriptive aesthetics aims to present the facts of the field and to explain them analytically; normative aesthetics proceeds from the inherent validity of certain principles. Here we cut across the other division of definite things (or processes) in nature, culture, and art: those having *actual* features by which they are distinguished from extra-aesthetic objects, and those deriving their aesthetic significance solely from the way in which they are *regarded*. The central fact is that an experience of a definite kind, which we call aesthetic, can grow out of the contact of an ego with an object. As the subjective side of the process lies closest to us, the investigation of its content seems to fall to psychology. The correct aesthetic procedure would therefore be the psychological analysis of the experience, irrespective of the causes evoking it. The object of the pleasure counts for little; all-important is the inclination of the ego to produce an aesthetic state. But this view is obviously inadequate. Do not certain lines, planes, and colors excite in observers incomparably stronger aesthetic reactions than do others? Schiller was already seeking an "objective concept of the beautiful," and found it in "form appearing as free" in the constitution of an object to which aesthetic satisfaction is easily and

securely attached. Also, in such fundamental concepts as *noble* and *tragic,* above all in the structure of a drama or a sonata, objective elements are involved which give to those concepts and these works a lasting significance, independent of fluctuations in the meaning of the words. Hence, a philosophy of the aesthetic object stands beside the psychology of aesthetic experience. Without appealing to the cultural system of art we can show where the beauties of nature (including the human body) are to be found. Also, the distinction appearing here between the aesthetic and the artistic has been acknowledged by Renoir in the words, "Not in the presence of a beautiful landscape, but in the presence of a picture one resolves to become a painter." We can show further that beside aesthetic nature stands an aesthetic art, whose purity is at the same time a poverty, for by *aesthetic art* we mean all those works of tone and color in which the mere tones and colors as such are appraised in lingering contemplation. The way (shall we say) Ravel and Schönberg mix tones or Busoni plays, without the background of human-affective experience, the way contemporary painters let colors live themselves out and break up planes rhythmically—these show what aesthetic art can achieve.

But even apart from such an *aesthetic objectivism,* our science need not be treated as a part or branch of psychology. The example of epistemology shows that cognitive processes which run their courses in consciousness are, nevertheless, to be understood in a non-psychological way. Even the definition and description of the aesthetic state of mind presupposes a standard which psychology cannot supply. Here there are transcendental assumptions, categorial foundations. And when aesthetics tries to test the claims of mutually contradictory judgments of taste, it leaves the field of psychology and becomes a science of value. To be sure, as long as the diversity of judgments springs from differences in degree of understanding—which is usually the case—it can still be explained psychologically. But if two equally good observers differ and the trouble is, for example, that one has regarded the elements of content in the object as the chief factor, the other the elements of form, then the question becomes: which side will aesthetics take? So not only does aesthetic objectivism, that is, the reference to an objective status of the aesthetic, refute the complete psychologizing of our science, but even within aesthetic subjectivism there is an evaluative (or normative or critical) way of considering things, which is opposed to the psychologistic.

As we shall discuss both objectivism and subjectivism in

detail later on, we want now to fix our attention on the chief forms of *normative aesthetics* (metaphysical and critical) and of *psychological aesthetics* (descriptive and analytic). For they contain, in contrast to the divisions mentioned earlier, the really decisive points of view.

In being fitted into a philosophical system, aesthetics is assigned a definite place and a fixed connection with the other philosophical fields. The derivation of the beautiful from first principles grounds it deeply. But these advantages are outweighed by disadvantages. There is no one recognized philosophical system or metaphysics; hence the insecurity of an independent aesthetics is offset by another insecurity. Furthermore, only by hazardous leaps does the metaphysician reach the facts to be explained. This very circumstance, however, has provided friends and readers of the metaphysical aestheticians, for to connect remote things directly has a very great fascination. What is called ingenious in the good sense of the word consists chiefly in this. Startling similarities appear, with thoughts suddenly shining forth and shedding light. Even today discussions in which the individual is immediately united with the most universal are again popular. These accounts may be true; that is, the connections they assert may actually exist. Nevertheless, they contain no scientific truth, for which a progressive point-by-point demonstration of a constant connection is essential. All connecting links must be discovered and shown in their necessary coherence. Accordingly, we are unable to tell at the time whether or not such assertions are correct. These aesthetic reflections dazzle without warming; they startle without proving. They put the reader or hearer into a state of fruitless excitement, all too easily confused with scientific inquiry and reasoned conviction. Hegel has in general been excused for serious blunders because of his extraordinarily broad and thoroughly mastered learning and his peculiar genius for delicacy of feeling. (Contrast with this what Solger says in a letter about Michelangelo, "That also is an object which I really only construct for myself, although I would only too gladly know it from my own observation."—*Nachgelassene Schriften,* I, 494.) Hegel's more commonplace disciples have taken over only the principles and not the capacities of the master. So they very often make assertions with the ring of genius but clearly false, and they inflate the insignificant dialectically into the important. It is easy for him who masters the mode of expression of the school to raise the trivial to the extraordinary. If one looks closely, one notices behind these flights, in part lofty and in part

clever, simple truths, or undemonstrable analogies, or bold sallies of thought. And with the disciples of the master even the unity of the system is often only apparent. Many of them are like the tailor who sewed a large garment without any knots in the thread. When someone pulled at an end, he pulled everything out and the pieces of cloth fell apart.

As to the central idea of *aesthetics from above* there is general agreement. The beautiful is distinguished from the pleasant in revealing the essence and meaning of reality through appearance, in making an absolute value intuitive, in representing something infinite in the finite. To be sure, ideas are everywhere at work, but in conflict with other forces, hence invisible or even mutilated, while in natural beauty, and still more in artistic beauty, the ideas are made wholly sensuous. This doctrine has two sides: first, Platonism, which we need not consider here; secondly, the assertion that the aesthetic is merely the intuitive. This second aspect arouses misgivings, for there is another kind of intuitive imagination than the aesthetic; namely, the technical. The plan of a machine or a bridge, by which parts are fitted together for a definite purpose, is impossible without intuitive pictures, and deliberation during the further construction proceeds actually as a chain of images. An engineer has said that in this constructional activity "the concepts are represented not by words but by pictures of geometrical magnitudes, and in the last analysis even by geometrical symbols of technical building materials." Now this kind of intuitive knowledge certainly differs in important ways from the aesthetic, although they merge in architecture, but nevertheless its existence prevents us from regarding the immediacy of an idea as a prerogative of aesthetic experience and aesthetic objectivity. Moreover, for the art of the poet immediacy can be challenged. Recent psychological studies have shown how man grasps the sense and connection of thoughts without benefit of images, and it was a natural inference that in a corresponding way poetic language can be understood without sensuous form. Further investigation showed that the images which may appear differ individually, hence are not necessary, that the poetic description of a peaceful landscape, as well as of an excited action, evokes chiefly personal memory-images of experiences or literary impressions. In short, the poetic as a part of the aesthetic does not work essentially through immediacy in the usual sense of the word. At this point the metaphysics of the beautiful is inadequate.

Kant, to whose *critical aesthetics* we now turn, recognized

intuitive imagination only in cooperation with understanding. By contributing universally valid forms, sensibility and understanding make possible the construction of the objective world. Likewise the harmony between these faculties—a harmony on which the feeling of aesthetic pleasure rests—is entitled to universal validity. All beauty contains the free adjustment of those two rational functions, and hence an objective necessity. This holds not as a matter of psychological fact, but in the sense of the "questions of right." How do aesthetic evaluations follow from the essence of reason? How is this pleasure determined independently of experience? Aesthetics rests neither on personal taste nor on human nature in general, but on pervasive rational necessities which bring forth the values of beauty from the given. Selecting, forming, creating, the mind is active both in aesthetic feeling and in the *exemplary* imagination of the artist. The mind's activity provides the principle of contemplation, equally in accord with the empirical explanation of nature and with moral judgment. To the aesthetic consciousness, more strictly speaking, has fallen the task of achieving in the realm of feeling such a unity as thinkers strive for in the realms of thought and action. Beside *intelligible nature, beautiful nature* takes its place; beside the scientific, cognitive view of existence, the aesthetic, affective view. The self-sufficiency of the field is thus presupposed; it is independent of theoretical understanding and of morality. But Kant did not succeed in keeping the realm of aesthetic value free from influences emanating from the realm of moral freedom (as is evident in the doctrine of the sublime), and in raising the aesthetic from its intermediate position between the *is* and the *ought* to a real autonomy.

Is that in general possible? Does our field have its own unique laws? Can every individual aesthetic object be derived from these? As for the autonomy of the aesthetic, there has been a recent attempt to understand it through the relation holding here between subject and object. Whereas in the logical realm, according to many neo-Kantians, the subject—even in purely theoretical opposition to the realm of truths—has no meaning, to the aesthetic realm this pure ego with its immediate experience belongs unconditionally: it can be neither thought away nor treated as something incidental. That seems to me correct. If one attends to the essence of the aesthetic, it is obvious that here subjectivity is indispensable, whereas the construction of a proof or the connection of scientific propositions in no way points to a subject. But the situation is

different with the deduction of particular contents from this general characteristic of the field of aesthetic value. To be sure, we can make it clear negatively that the category of thinghood is irrelevant in lyric poetry, or that causality contributes nothing to the explanation of a piece of music. But still we cannot positively build up particular structures in detail from the basic level of the purely aesthetic. Even when we remind ourselves again and again that works of art do not use merely aesthetic means, when we therefore assign only a part of the artistically beautiful to aesthetic nature and culture, it is still difficult to establish a really continuous connection between the characteristic of value and the particular case.

But this connection is immediately given as soon as we make it clear to ourselves that aesthetic value is wholly confined to the appearance. A subordination of the particular under a universal, comprising many things, has no meaning here. When Croce calls an aesthetic form a "cosmic inspiration," he is expressing the wholeness of the object or—seen from the other side—the individualizing of the value. But it might be added that this coincidence of existence and meaning, which Lotze earlier extolled as a favor of fortune, assigns to the aesthetic object a noteworthy, intermediate position between the realm of nature and the realm of history. In nature there are phenomena which reveal at once to a clear eye the lawfulness prevailing in them. We need not even return to Goethe's "original phenomena," but only think of the color-spectrum, a series based on relationship and transition, in order to have a significant example at hand. It is obvious that usually many observations, based on deliberate assumptions and formulation of goals, must precede the discovery of the law, for this law is always similarly embodied in the cases falling under it. Since, however, it is contained even in a particular case, it can reveal itself to a single observation and a "penetrating inspection of essence" (to adopt the questionable term of the phenomenologists). Here the opposition of induction and deduction is overcome. Not even a combination of the two methods confronts us, but a result transcending them. The given is brought into an immediate relation to an abstract system; as we like to say nowadays, it is *evaluated* ("*beurteilt*"), whereas it is *adjudged* ("*geurteilt*") when a relationship between given elements is to be established. But the critical evaluation receives its full meaning only when the willing man takes an attitude toward the given. This is the situation in historical knowledge. The famous *individual law* of every historical event has the category of value

29

as presupposition and the concept of humanity as background. The first does not need to be explained, the second only to the extent of pointing out that mankind as the medium of historical events gives them their system and unity. This humanity, which articulates itself in peoples and times, runs through a development; that is, it is to become something (or nothing, if we may believe Eduard von Hartmann). Its law of development and life determines the value of the particular event.

Between the two ways of regarding things stands the aesthetic, as it were in the middle, almost as for Kant the faculty of judgment stands midway between theoretical and practical reason, or beauty and purposiveness between the sensuous and the moral world. An aesthetic object is grasped in a single intuition, but not as falling under an abstract and general rule, which becomes visible in the individual instance. Rather, beneath appearances lives a subject of value which we briefly call *the beautiful* and know as an organism of many members. It is to be recognized as a subject insofar as it is alive and develops itself. Its relation to the individual aesthetic object rests on the capacity to present itself fully in the individual without losing universal value. The same insight is involved in the old law of form, unity in variety, for diversity cannot stand beside unity, but must grow out of unity as an opposed development, out of a basic rhythm, so to speak. Within the mind, feeling shows a similar capacity, as it can combine all the criteria of universal validity with the strongest consciousness of uniqueness. This inseparability of the conceptual and the felt, this welding of a cognitive process and an alogical element has led Croce to say that the evaluation of a work of art is a mistake, that "the true and complete criticism is the account of what (in the intuitions of the artist) has occurred." But this inference must be rejected, as the intuitive value of the beautiful forbids a deduction of the individual object from a universal rule.

The course of aesthetics, as we have thus far seen it, begins with the basic assumption of objectivism, that aesthetic objects are more than merely agreeable occasions for a psychical process. As the relation to the ego is essential for these objects, their value must be termed an *experienced* one without consequent sacrifice of their peculiar nature. Aesthetic objects in space, for example, contain mostly that kind of variety called contrast, because contrast among all forms of variety has the strongest experienced value. Aesthetic processes in time favor intensification, because

the addition of something new to the given, while preserving this given element, evokes the most vigorous echo in the subject. All aesthetic objects stand there in their own right, for if they were as interdependent and intertwined as the things in nature or the events in history, they would not confine pure enjoyment to themselves. The theoretical understanding demands that its object fit into a whole; aesthetic feeling is satisfied with the detached object. The former comprehends only through endlessly progressive coordination; the latter enjoys the inner lawfulness of the individual. While the moral personality, for Kant, should free itself from every contingency in the life of impulse and refine itself into the universal, the work of art (which we may compare with a personality) is not required to make the same sacrifice. This insularity, therefore, provides a distinguishing feature of every aesthetic object. "But what is beautiful is blessed in itself," Mörike sings in a little poem. So, certainly more inner activity of the observer is demanded for the demarcation of a beautiful thing in nature than in art, which can use frames and pedestals. (The fact that the frame protects the picture against damage in itself excites no feeling of aesthetic pleasure during observation; this aid must appear in the refined form of isolation, etc. Moreover, the sharp border helps to accentuate the center of the picture.) Nevertheless one should not exaggerate the isolation of the aesthetic object. Gothic statues are to be viewed not for themselves but as parts of a building. A country house points beyond itself to the environs of the park. A chair extends a friendly invitation to sit down. It is not easy to bound the field of aesthetic influence. (A related difficulty lies in the application of the concept of identity to aesthetic objects. Is a piece of music, transposed into a very different key, still the same thing? For greater sensitivity to the identifying signs of the keys and for absolute musical pitch, certain transpositions mean so drastic an alteration that the work no longer remains the same.) One can say only this, that all such objects carry their centers in themselves and speak out from these centers to inner experience.

As an inner value, an experienced value is naturally not exempt from all categories of thought. Whatever exists is, as such, always subject to definite modes of connection, at least to the spatio-temporal. Hence also the thing of beauty in nature or art does not lie outside the synthetic principles which first make any object of experience possible. Only the unconditioned escapes this net. But it should not be concluded from this that aesthetic being

belongs to spatio-temporal empirical reality. (Marées said that perspective is nonsense, and Riegl refused to see an enrichment of painting in the discovery of the laws of perspective.) The aesthetic world stands indeed in the empirical world, but it does not live with it. Even without removing this aesthetic world, as the realm where the *Idea* breaks through, from the enslavement of the rest, we are entitled by the features just indicated to view it as a separate, sacred realm. Accordingly, within the sphere of the ego a special, *a pure, aesthetic attitude* is admitted. The characteristics of a completely and exclusively aesthetic attitude are, on the one hand, detachment from the fixed order of personal experiences and elimination of desire, and on the other, a wealth of uninhibited mental activity and a blending with the worldly unity of an object. Really something falls away from the whole of life, but it is so constituted that we feel its absence as an advantage. Perhaps *disinterest* is an unhappy term for this advantage. Lipps's descriptive psychology has explained the process better in saying that here the claim of the object to be apperceived coincides with the nature of the mind, thus inducing a lingering contemplation. This psychology is led on by its point of view to discover from the data of individual consciousness and its conditions the pure activities of thinking, evaluating, and willing. As the science of consciousness, it attempts a liberation from the contingent, like that which natural science achieves in its field. Such objectifying of the mental leads the aesthetician to the conclusion that the constitutionally vibrant mind, given the swelling fulness of strong inner experience, has the aesthetic state—a conclusion which can be reached also on philosophical grounds.

The situation is different with that form of psychological aesthetics which would analyze the aesthetic attitude into its ultimate elements to secure a body of testable facts. This form is not concerned with a universal characteristic, but with attaining elementary impressions, because these should be less exposed to individual variations than the higher aesthetic experiences built up from them. It seems, however, as though the crucial assumption were not entirely justified. Külpe, at least, says of such attempts that "the magnitude of the individual differences of judgment makes the calculation of averages illusory." Hamann raises other questions—whether such an element ever appears alone in the aesthetic experience, what effect is connected with its simplicity, what relationship it has in general to the aesthetic attitude—ques-

tions which in fact are still unanswerable. The uncertainty is further increased by the changes in aesthetic experience during its course. Hence in every case only the corresponding cross-sections of two experiences should be compared with each other. Finally, the uncertainty is increased also by the fact that with even the simplest aesthetic processes various mental attitudes are possible. It remains essential that a keen introspectionist make the experiments, or at least thoroughly sift the experimentally elicited reports instead of merely accumulating them. But the real advantage of collaborative introspection lies in the heightened responsibility of the individual who knows he is being checked by others, in the appearance of various kinds of content, and in the attainment of definite types.

Fechner's *Vorschule der Ästhetik* was the first work to present the idea that an aesthetic experience is produced by the mere combination of efficacious elements. Fechner's laws of combination are very numerous, badly arranged, and heterogeneous. One could reduce these principles to a much smaller number, or with equal right, add just as many more. In the effort to find definite empirical propositions in place of metaphysical generalities, Fechner obtained a multiplicity of laws, only a few of which have influenced the further development of aesthetics. The laws of agreement, of dulling, and so forth, have proved to be statements of mere collateral psychological conditions of the aesthetic life, not of its adequate criteria.

But the association principle, which Fechner often places beside these laws and investigates psychologically as well as aesthetically, has attracted everybody's attention. So also has his doctrine of the three experimental aesthetic methods: selection, production, and application. The first method is to collect the opinions of as many persons as possible about those forms which they have chosen as the most pleasing from a number of similar ones. The second is to let the subjects themselves produce the forms which appear most beautiful to them. And the third is to investigate the simple forms most used in daily life. This last method has the least value, for the style of letter paper, glove boxes, and such things is influenced not only by taste but fully as much by fashions derived from other sources. The other two modes of procedure, however, have been found valuable and developed. The series method has been worked out, according to which a series of objects, formed perhaps by the steady increase (say about

a millimeter) of one side of an otherwise constant object, is to be transformed into a correspondingly progressive series of aesthetic values. In this way it is shown that a growth of pleasantness does not correspond to the mathematical increase, but that a wholly different order arises from aesthetic points of view. Another method is the comparison of just two members of a series at a time, but the sequence of pairs produces complications. It is still more questionable to present only one object and let it be judged by one of several categories (for example: very beautiful, beautiful, indifferent, ugly, very ugly), for the choice, even with the same person, could be influenced by fluctuations of mood. The production method has been carried further, to the extent of seeking not merely the peak of pleasantness, but the members of the series which in aesthetic respects show a just noticeable difference from the other members.

This whole *aesthetics from below* reduces the aesthetic experience to a vortex of pleasure units. It remains as far from the essential problems as psychological hedonism does from the crucial questions of the moral life. In this it is like its adversary *aesthetics from above* which also brings alien concepts to aesthetics. Metaphysical systematics recalls the Dead Sea; every living being which falls into the apparently clear salt water swims on the surface and must die. In the Dead Sea of conceptual absolutism, living individual insights are poisoned and never gain depth. But in an investigation, explanation should start out as realistically as possible from the facts. Metaphysical and analytically psychological aesthetics together form an *aesthetics from without*. We choose an *aesthetics from within,* which in the spirit of criticism and of descriptive psychology strives to do justice to the peculiar value of the field. Its total content might be indicated somewhat as follows. Aesthetic objects (and categories) are indicated by special characteristics, and in the same way the aesthetic attitude possesses certain adequate criteria which show that the many individual processes contained in this attitude belong together and do not accidentally fall together. On the side of the object, the self-sufficient unity and equilibrium of the manifold in the individual form is decisive; on the side of the subject, the power of pure experience. Whereas in the realm of truth the subject has no place, and in the realm of morality the object is thought of only as something to be overcome, aesthetic subject and object are inseparable. Aesthetic value is therefore a subjective-objective value of experience.

Now that a standpoint has been found, the most important theories will be presented and examined.

2. Objectivism

The general principles which can give direction to a system of aesthetics show their greatest vitality when applied to the beautiful in art. At least this holds true of *aesthetic objectivism*. By this term we mean all those theories which find the distinguishing feature of our field in the constitution of the object, not in the attitude of the subject who enjoys it. But that constitution can be ascertained most easily by reference to the rest of reality. Hence those theories belong here which explain *the beautiful* and art on the basis of their relation to what is presented in nature. And, indeed, naturalism asserts that art is reality, while the various kinds of idealism declare it to be more than reality, and formalism, illusionism, and sensualism regard it as less.

Naturalism not only finds support in the testimony of artists—for they never weary of assuring us that they simply reproduce what they perceive—but it also falls in easily with a general trend of thought. It is positivism (in the broad sense of the word) which leads rather obviously to the view that art should hold strictly to the given. Even in ethics this principle has support. What optimist, who interprets the real world as the best of all possible worlds, can consistently approve a fanciful play of imagination? Finally, there is a connection—not necessary, to be sure, but intelligible—between optimism and naturalism on the one hand, and devout religious conviction on the other. That is to say, if the world is a reflection of God, then there can be no higher beauty than its beauty, no better art than that which faithfully copies it. To create naturalistically means, then, to honor the Creator in one's works. The order of the stars, the luxuriance of the organic world, the power of the great and the charm of the small—all this should turn the thoughts of the humbly creative artist to the Eternal.

Meanwhile, let us turn from its grounding in a world-view and look carefully at the theory itself. Then the following considerations count against naturalism. First, when we view an exact reproduction of a part of nature, feelings arise which are not

aesthetic and were not present on viewing the originals. A wax figure, if a deceptively perfect imitation, arouses fear, a non-aesthetic feeling which would not have arisen on perceiving the real person. Second, whatever can be called in any sense a work of art falls short of reality. The panorama lacks sunlight, noise, movement, and fresh air; the wax figure has no down on its cheeks and hands; in the plaster cast we miss the open eye and the continual bodily expansions and contractions connected with mental processes. The restlessness of the visible world cannot be reproduced in art. Third, similarity to nature and fidelity to nature are by no means the same. The caricatures and sketches of a clever artist may show a surprising similarity to the originals, but they are not true to nature. The caricature exaggerates certain peculiarities, and the sketch omits much that the completed drawing would have to give. We know pictures out of which faces, fully alive, come to meet us, as it were, although the artist has left out noses and ears, even eyes, and has put down only spots of color. Artists of all tendencies have asserted again and again that their art consists in "leaving out," in *savoir faire des sacrifices* (knowing how to sacrifice). Fourth and finally, in a perfect copy the decisive factor, the individuality of the artist, would have to be eliminated. But the attempt to blot out these personal peculiarities would take the life out of art, and furthermore, it would mean that aesthetic enjoyment springs from the satisfaction in similarity, hence from a cognitive pleasure.

But if naturalistic doctrines, when advanced, are proclaimed and apparently accepted, there must be reasons, partly theoretical and partly practical, which have not yet been discussed. Of the theoretical reasons we have to consider first the obvious confusion of apparent fidelity to nature and actual imitation. Even a sketch and a caricature can show clearly how different are the impression of naturalness and this actual imitation. Such unfinished or distorted works of art prove to be creations in the strongest sense of the word, and yet they give the most vivid impression of fidelity to nature. Naturalism is in error if it means that such an impression is to be achieved only through slavish imitation of the given. An impression of nature and a reproduction of nature are not equivalent. Hence, the negative view would be preferable to the positive. One would more correctly say that we must avoid those deviations from nature which are bound up with the disturbing sense of infidelity. A formulation of this sort, not as restrictive as the positive,

in any case leaves to art the free play which it needs. Perhaps
may say that the situation here is like what we find in the relat
of man to happiness. Most people want to be happy. Yet the attain-
ment of this goal would by no means assure them of the perfection
striven for. So art has often aimed at reality, and still does, but
the attainment of that reality would be the end of art.

Naturalism seeks support of another sort in the fact that
even the most deeply spiritual work of art is composed of elements
from life. When the component parts of the work of art have not
been drawn from reality, we feel it painfully. The elements of the
artistic are no different from the elements of the real. But this
cannot rescue naturalism. For the constituent parts are worked up
into something new, into a form permeated by feeling, and the
working up is precisely the point. To be sure, this synthesizing
seems also—at least as long as it is limited to choosing, strengthen-
ing, and weakening—to be bound to reality. No innovation, how-
ever vigorous, should create what would be impossible in experience.
But let us get this straight: such artistic creations need have no
counterparts in experience; they must only be such that, if they
existed, we could apprehend them. What is impossible in visual
sensation (that, say, distant objects have the same size as near ob-
jects of the same kind) should not occur in any painting that claims
truth. Furthermore, it profits naturalism nothing if every clarified
theory of art demands that the combination of elements show a
connection, leading the spectator, reader, or listener necessarily
from what precedes to what follows. On the contrary, it is not
empirical congruence that is decisive, but an inner consistency. We
call a work of art false whose parts fall apart. Imitation of nature
can probably serve for the purpose of artistic-systematic unification.
But unity of style, not this unity, is truth in the aesthetic sense of
the word.

It might thus seem as though art consisted only in a
peculiar combination of elements from life, as the winged horse or
the centaur is composed of real constituent parts. But this view,
denying any unique creative power to man, would not do justice
to the facts, for mere choosing and combining have never produced
art. The reality in a work of art can be so absorbed or changed as
to be still perceptible only to the finest sense. Even transcendental,
mystical, and symbolistical works of art finally rest on experiences
of some sort, but they have raised their heads so high that we no
longer notice their feet standing on solid ground.

Although so far a relation to outer reality has been ascribed to naturalism, yet now we must note, at least by way of supplement, that there is also a faithful description of mental processes which in principle belongs to the same stage. Emotional processes especially are eagerly described with realistic accuracy, and it is precisely the opponents of naturalistic art who enjoy the unrefined reproduction of feelings and moods. The lyric poet, who expresses his feeling as clearly and faithfully as possible, usually suspects as little as his admiring reader that he stands closer to naturalism than to idealism—to naturalism, that is, as a general conviction, in contrast to naturalism as an artistic tendency. This distinction is very important. The phenomenon in the history of art that we call *naturalistic style* is only loosely connected with theoretical considerations. Rather does naturalism, as a periodic practice, signify chiefly a revolt against moribund views and forms. Hence it is not a question of being true to nature in describing samples of reality, but principally a question of a new, up-to-date technique. The earlier forms, whose time has run out, appear as conventional, abstract, and untrue. The substitution of a new beauty for this old beauty naturally gives rise to the idea that an idealistic dream of beauty has been displaced by the truth. Just as men are historical beings and with the changing order of things alter their spheres of culture, and fashion for themselves new views of the worth and meaning of existence, so all the arts try to follow these changes. Every artist who can look at things with the eyes of the present and express what he sees in the form appropriate to his age regards himself as a naturalist. Naturalism in this sense is opposition to dead ideals. As antagonism to prevailing conditions in church and state readily finds release in materialistic and atheistic doctrines, so also the opposition party in art prefers to use naturalistic forms and modes of thought.

Thus in the order of historical development the break with custom comes first, and then from that the return to nature. In other words, the more anyone has emancipated himself from a tradition, the more surely he reaches back to nature; and inversely, one loses contact with nature more quickly, the more his feelings are confined to the usual forms. According to this law, those who are dissatisfied with the old art come to imitate nature almost passively. In this connection it is significant that as a rule the representatives of this movement belong to the younger generation. Youth has the prerogative of unhistorical feeling. It possesses also

38

that optimism which was shown earlier to go hand in hand so easily with naturalism. The youthful impulse to improve social and economic conditions is then combined with the consciousness of the ability to become a teacher and benefactor of mankind in the arts. But the older one grows, the less he warms to drastic changes. The rash venture of reliance wholly on oneself, disregarding all acquired wisdom, appears to older people a distortion of the progressive spirit. This holds for expressionism as much as for naturalism, however far apart they seem to lie. The present criticism of art fosters blind ranters, because the critics themselves are viewing the future with uncertainty and dread. Youthful insolence, carping, boastful, exhausts itself in polemics and sketches of programs. How many revolutionaries I have met in the course of my life, and how few of them really achieved anything! Such noisy fellows, unfortunately present even in our scientific after-growth, believe themselves exempt from the obligation to show talent or diligence. The truly great innovators have won their independence by their tireless and reverent study of the masters of the past. Many scarcely knew how revolutionary their treatments were. All were blessed with the modesty which makes even disagreement agreeable.

The historical view shows us further why the naturalist is so easily induced to choose ugly and shocking events. The real reason is that in the traditional and already set ways of art these elements were either no longer present or were embellished to the point of drastic change. The feeling of contrast and independence directs the attention precisely to the unusual and subtypical. Another reason is formal. The younger generation of artists wants to show its technical skill, and a newly developed technique can be applied with special virtuosity to remote and (as it were) recalcitrant materials. To justify this procedure we are reminded that content is irrelevant to artistic value. The representation of the abnormal is not an abnormal representation any more than the statement of an uncertainty is an uncertain statement. It will depend on whether the artist's individuality is strong enough to raise the natural feelings of displeasure, connected with the content, to artistic feelings of pleasure. Through her infinity and eternity Nature knows how to soften all discords. The work of art, which can give only an excerpt, must possess a similar cosmic breadth or depth to make tolerable what is repulsive in itself.

Here naturalism is very close to *essentialism* (Idealism), which in other respects is opposed to it. Essentialism aims to secure

for art a content and purpose transcending ordinary reality. The philosophical presupposition—contested by relativism and positivism—is the claim that behind things something supersensuous is enthroned. The world does not consist solely of appearances, but possesses an ideal content, an essence. Whoever wishes to establish the special standpoint of aesthetics under this general assumption may properly start with the distinction between the beautiful and the pleasant. The process of aesthetic experience includes an object, a recipient subject, and the resultant contact, chiefly sensuous, between the two. A particular object and a particular person meet; from this a feeling of pleasure arises. But obviously that is just as true of every sensuous pleasure. So something else must be contained in the beautiful beside the relation involving the senses and pleasure. And this something is precisely the essence of the object shining through. Art is not imitation of the particular thing, but the sensory presentation of its deeper meaning. Beauty is the Absolute in intuitive form, the Infinite in the finite, the Idea in definite appearance. While empirical objects point only imperfectly to the Idea underlying them, art shows the unveiled meaning of the actual. Insofar as *idea* means merely an objectified general concept, the theory amounts to seeing the task of the beautiful in the intuitive demonstration of the concept. This view is supported by the fact that concepts are not only general expressions or abbreviations of thought, but have in themselves something of the ideal. When Shakespeare says, "He was a man, take him for all in all," *man* is full of meaning, signifying perhaps what we would call a *true man*. But *true man* signifies not merely the logical universal, which unites all men; the term has also a prescriptive aspect. The true man is man as he should be, most actual men falling below this standard. If an object in nature or a work of art succeeds in expressing completely this fullness of the concept, it arouses a feeling of satisfaction. We sympathize with the particular object which is so perfectly adequate to the norms of its concept. This explains why the idea, appearing in sensory form, is pleasant. (Cf. Simmel, *Einleitung in die Moralwissenschaft*, II, 90 ff.) The explanation becomes even clearer when thought turns subjectivistic. Then the extra-human existence of the idea does not come into consideration, but it is valid as the higher spiritual life, which governs in superior persons. The joy in this is immediately intelligible.

We cannot go into the ramifications of essentialism in greater detail. In romanticism the living whole of nature, in A. W.

Schlegel's words, "this being complete in itself and continually creating itself," stands as the model of the artist. Art should reproduce this *inner* character of nature. The Idea, as the unity of universal and particular, "has its existence within us in a region which is inaccessible to the common understanding, a region of which only certain revelations appear in our temporal existence. Among these revelations is the beautiful." (Solger, *Vorlesungen über Ästhetik*, p. 55.) For Hegel, on the other hand, beauty is only a representation in determinate form of that *World-Reason* in whose development nature, man, and objective spirituality arise. Whenever a natural object expresses perfectly in visible form its proper place and significance in the whole realm of nature, it evokes our aesthetic appreciation. Eduard von Hartmann declares emphatically that beauty can be ascribed only to the sensuous appearance of the ideal value. Any additional element in this value, not fully expressed in the appearance, would diminish the beauty. The more concrete an object, the more beautiful it is. Hartmann always regards the hidden content as part of the absolute *World-Idea*, but Taine, who in a certain sense ends the movement, thinks merely of a generic essence, a *caractère dominant*. All the same, whether the one or the other, what counts is not only the fact that an idea is expressed, but also the content of the reality expressed. Thus one will always encounter difficulties as soon as he undertakes to indicate the supersensuous something, or the creative world-view, or the dominant generic character in the individual work of art. We hear, for example, that the idea of some novel or other consists in the thesis that every friendship between man and woman turns to love. But this thesis is in one sense too broad, being equally applicable to a hundred other novels, and in another sense too narrow, saying nothing of the vital richness of the work as literature. The differences in interpretation of works of art, especially works as perfect as *Hamlet* and *Faust,* are rooted in the difficulty of reducing the wealth of such works to a single formula, a single thought. And the theory cannot stop even at this. It must surely concede that Schiller's *Wallenstein* was intended to portray not only typical human striving, but also an historical figure with perfect accuracy. Delaroche even boasted that a single one of his historical pictures teaches more than ten volumes of historical research. Doubtless the artistic need is here understood as a special kind of the more general need for clear knowledge, and apparently explained by this release into a larger sphere. Philosophers enough have assigned

41

to art exclusively the task of portraying the typical in nature, as opposed to its accidental and irregular objects and events. They have demanded of art that, like a language of a peculiar kind, it convey ideas, that it destroy itself in order to disclose its inner treasures.

In the textbook of an idealistic aesthetician the following discussion of so-called *still life* occurs: "Let us suppose that a table with books, glasses, a little cigar box, etc., is represented. That is, if the book and the box are closed, if the glasses are empty, a lifeless picture . . . if the book has been opened, showing only the title of a chapter, the spectator will involuntarily read this title and will want to know what new information follows." This excellent suggestion shows what an idealistic theory can lead to. Such a theory becomes truly disastrous when adopted by creative artists. Finally the weaker among them no longer dare to fashion as they feel, but strive for a truth which robs their works of inner authenticity. Real artists, however, have always insisted that the significance of a work of art is not directly proportional to the number of theories it gives us concerning reality and its causal connections. When perplexed spectators asked Philipp Otto Runge what the pictures in his cycle *The Times of Day* were trying to say, he replied, "If I could say it, I would not need to paint it." Similarly Mendelssohn wrote in one of his letters that if music could be described in words, he would not put down another note.

Nevertheless aestheticians with literary training and interests have so far continued to regard art as an intellectual activity, applied to the conceptual realm. Even schoolteachers tend to see the value of a work of art in its rational and useful contents. Above all, the public readily receives such doctrines, for its chief aesthetic need is to preserve something conveyed in artistic form. Such an artistic need is a hankering for elusive knowledge, an intermediate stage of the cognitive drive, which is expressed in its lowest form as curiosity, in its highest as the joy of discovery. At certain times, therefore, the soul of a people has found full expression in letters, not in tones or pictorial forms. In national conflicts those works of art which captivated intelligence or curiosity were usually preserved from destruction, as were also, to be sure, those works which (like certain melodies) exerted a strong socializing influence, or (like certain buildings) met a practical need. As an attempt to interpret fully the whole aesthetic and artistic life, the theory of the Idea which appears phenomenally is at any rate inadequate. It does

justice to the aesthetic aspects of nature only by conferring on them a questionable metaphysical background; and even to art it does violence.

According to all the evidence, genuine works of art never arise from abstract thoughts. When they apparently do, the felt value of the thought, not its logical element, provides the incentive. In general, ideas are indispensable, but they are represented intuitively as figures, forms, colors, tones, and are communicated most effectively to one who grasps them, as it were, by sinking into them, not by thinking them. Essentialism also leads to an overvaluation of the material and the intellectually significant. Factual contents should be signified by conceptual words. But in addition every true work of art has something else which (as it is commonly put) we can only feel.

Aesthetic *formalism* has expressed such objections with justification. It claims that the artist speaks in and through forms, and that the observer enjoys an arrangement which gathers many elements into a unity. Aesthetic understanding never concerns *what*, but always merely *how*. According to Robert Zimmermann, it is a question of finding the agreeable and disagreeable forms and of investigating their application in the fields of nature and the mind. Whereas essentialism recognizes form only as a sign of content, especially of intellectual content, here every kind of content— bare sense-perception as well as the most sublime world-view—is excluded. Beauty has nothing to do with matter; it depends only on the balance or proportion among forms and sequences, and the harmony of colors and tones. The parts of an object remain forever aesthetically worthless. Only their combination, the relations among them, make possible a judgment of aesthetic value. If the combination of members, indifferent in isolation, is called their form, then it follows that aesthetics is the science of form, the morphology of the beautiful. Hence the subject matter of this science consists not of any material units, but of their relations, the quantitative or qualitative system which in principle has nothing to do with the nature of the content. All mental processes expressed in art also belong to this content. So Hanslick said that feelings can be neither the goal nor the content of music, that its essence consists rather in tonally aroused forms, comparable with the static forms of arabesques. In our time Wölfflin has given a new turn to formalism in teaching that the problems of the spatial arts have their necessary laws, that novel solutions are always possible, but precisely as

problems of painting and optics, and that the history of art should show the sequence of such solutions. A discussion of Wölfflin's *basic concepts* must be deferred to an examination of methodology in the history of art, which is not possible in this book. There would also be occasion then to assess the Riemann plan, which amounts to an interpretation of the history of music in its mutually exclusive stylistic periods as the result of a logically necessary development of the auditory faculty.

If one asks the formalists of the older trend about the justifying principle, which makes certain forms pleasant, others unpleasant, he usually receives the rationalistic answer that definite relations are clear and easily comprehended. The numerical ratios of harmonious sounds, the symmetry among parts of space, the effortless course of rhythmic patterns—all this pleases because of its adaptation to the knowing mind without reference to any content. Every clearly intelligible unity of a variety is aesthetically pleasing. And as it represents only a part of reality, the beautiful is accordingly less than reality.

What position should we take on this? As an abstractive science, aesthetics has the unquestionable right to restrict itself to formal relations. But, of course, the abrupt separation of form and matter entails the disadvantage that the continual reciprocity of influence between these two aspects is neglected in a strictly formal science. The fullness of formal relations is essentially dependent on the content represented in the work of art. It is questionable whether one can completely grasp the former without considering the latter. Meanwhile, even if one retreats to these formal relations, yet the central formula of unity in variety offers many points for attack. There are cases where variety is unified without aesthetic pleasure. We shall speak about this later. Moreover, we first need a clear explanation as to why the synthetic activity of consciousness, which has a thousand other functions, does not always evoke aesthetic pleasure. In any case, it remains true that we have an object of aesthetic and artistic value before us as soon as no part can be introduced without appreciable disturbance of the whole, and the parts refer to one another with intuitive validity.

The formalistic principle makes one element of reality, namely form, the whole of aesthetic value. In contrast to this, *illusionism* puts the world of art over against reality as a world of illusion. Art, we are told, offers us neither empirical data in a new version, nor hidden truth, nor pure form; rather, it is a world

of illusion and as such, free from necessity and compulsion—an eternal spring, independent of the inhuman laws of nature. The aesthetic object is to be enjoyed irrespective of personal affairs and possible consequences. Whereas in other contexts we regard objects in terms of their service to our interests and their role in the union of all things, this two-fold relevance is disregarded in the aesthetic life. We do not consider the effects of these things either on ourselves or on one another. Their reality vanishes and beautiful illusion comes into its own. Mental processes aroused by illusory objects lack elements which are otherwise present in consciousness. Especially relationships to acts of will drop out. The person experiencing aesthetic satisfaction must, therefore, feel as though he were dealing with something less than reality. This lower part of reality—if we may speak of the mental experience in this way— is very happily characterized also by reference to an illusory world. In any case we can understand that from the lower part, in our judgment, an upper part comes into being, and that we love the illusory world of retreat as a world of ideals superior to the given.

But perhaps the theory will become even clearer if the doctrine of illusion is carried over into an aesthetic sensualism. The representatives of this doctrine of illusion usually stress both the independence of the aesthetic attitude and the importance of perception. They demand not only that aesthetic activity be an end in itself, but also that the object by itself give pleasure, thus expressing its significance by being comprehensible through perception as such. Here we may start from a consideration which Descartes mentioned in his *Meditations*. Heat changes a piece of wax in form, color, and odor; yet it remains the same thing. Therefore its substance, the permanent element in it, cannot belong to what is grasped by the senses. Reality depends not on intuition but on thought, and indeed on a judgment made on the basis of sense impressions. Where we let mere sense perceptions have free play, we have no feeling of something independent, objective, and given. This is the case in the aesthetic attitude. There is yet another deduction, that man's outer world can be regarded as something indeterminate, from which the senses and the intellect select things of various sorts, or which they fashion in various ways under the guise of a selection. Now everyone knows that perceptions always remain uncertain, and that memory images are still more so, wavering unintelligibly. We fix both these kinds of intuition by transforming them into concepts. But this way—first pointed out

by Socrates—of advancing out of indeterminacy into determinacy has the disadvantage that everything intuitive is thereby lost. The concept is not to be found in the extension of intuition, but is a wholly different way of possessing reality. We win the certainty of the conceptual only by renouncing the intuitive. So the question is whether intuition itself cannot be raised to that clarity and calm which it lacks in life. Sensualism answers the question affirmatively with explicit reference to the arts. They make fast the ephemeral elements of intuition, hold the fleeting, preserve the perishing, and give permanence to everything pleasant that is connected with intuition. What does painting achieve? Having arisen from the demands of the eye, it has merely the task of helping indefinite impressions of form and color in reality to a complete and fixed existence. To use Fiedler's words, the plastic artist has "the ability, denied us, to guide the process of perception through the eye, on the side of its visible expression, to a free development." (*Schriften über Kunst*, 1896, p. 290.) When a sculptor copies a person in marble, he takes only the form from the model, and only what concerns the true development of the visual figure from the material.

With some variation this theory can be transferred to music as an unfolding of the auditory process. Difficulties result, of course, in its application to the very complicated art of poetry. So let us confine our examples rather to the field of spatial art. Here the free development of the visible world, achieved by the artist, should consist chiefly in furthering our perception of space. Every work of spatial art must represent a spatial unity, much as distant objects are perceived as spatial unities. The painter must, as it were, provide a frame and spatial center for a section of his field of vision, and furthermore he must view the colors in it not as separate spots but as harmonizing values. A synthesis of the spatial and colored impression, as it begins in the perception of distant objects and in memory imagination, distinguishes the painting and its aesthetic interpretation. As the conceptual thinker abstracts a form of thought from the constantly changing forms of existence in reality, so the artist derives from the incessantly changing phenomena of perception and memory the union of the intuitive and the universal as the form of art. He uses the devices of nature to emphasize activity, so far as they vigorously express merely the spatial essence of a form. On the other hand, he uses even the limitations of his materials, such as the superficial nature of canvas or the lifeless quality of marble, to conjure up images of space or of movement from the

definite peculiarities of his medium. Through the transformation of nature and through the apparent inadequacy of artistic technique, he imparts an immediate knowledge (otherwise denied us) of the visible.

If we examine the claim of this standpoint, we note first of all that it fits in readily with a fundamental epistemological conviction often acknowledged today. The problem of the relation of the ego to the outer world can be solved by asserting that we do not feel things as objects to which ideas correspond, that the heard tone, for example, is at once physical and psychical. Also the content of consciousness is never experienced as something primarily subjective, but equally as tangible reality. This original unity of outer and inner in perception indicates how important is the aesthetic role that falls to sense perception. A further advantage of this theory lies in its agreement with the views of artists themselves concerning their capacity and their task. Thus Théophile Gautier once said: "Friends and foes flatter and flatten me without catching the faintest glimpse of what I am. My whole value—they never speak of that—lies in my being a man for whom the visible world exists." Above all, painters declare that they merely see better than the rest of us and give back, in the form adequate to its essence, what they perceive with the eye. At the same time they confess how far even the highest achievement of art is excelled by the fullness of reality. They recognize the propriety of the objecttions raised against naturalism and yet take over from naturalism its vivid feeling for the value of the given.

Undoubtedly the artistic person strives passionately for reality. But on the other hand he also longs for the unreal. It seems logically impossible to comply with the demand that the artist be at the same time true and untrue to reality. He is to serve and govern, give himself and detach himself. But this logical contradiction is still the most accurate expression conceptually possible of the involved state of affairs. In personal life the two tendencies go hand in hand, to attach oneself to society and to free oneself from it. So also a naturalistic interpretation does not fully express the essence of art; one must recognize the overcoming of reality as a basic feature. But this overcoming moves in two directions; it makes art something more than nature, and at the same time something less. In aiming at the truly true and thus ignoring whatever is not apparent or perceptual, art gives us ideas whose nature fascinates and refreshes us quite aside from their other significance.

Art shows us the hidden essence of the world and life, and along with this the surface of things to be enjoyed, the purely mental pleasure-value of objects to be won from the senses. Art is both an elevation above nature and a cultivation and fulfillment of sensibility. Through imagery it frees us from the environment and at the same time ties us to the content of inner experience.

Accordingly, art is something qualitatively unique. However, as it is both more and less than reality, it can be viewed on this side as a phenomenon of intensity. On the one hand, of course, it means the creation of bare possibilities which fall short of given empirical reality; on the other hand, it contains an intuitive necessity which transcends all reality. It offers possibility and necessity in wonderful harmony. In the case of a landscape painting we do not ask whether it faithfully represents an original in nature. Indeed, we let ourselves be pleased by forms and colors which most certainly never occur in nature. Instead we demand that the picture express a necessity which does not appear so clearly in the contingent phenomena of the empirical world. Artistic idealization consists in descending to the possible as well as in ascending to the unconditional. Now, everything merely possible is intensively less than the existent; everything necessary is intensively more. Possibility is weaker than reality, necessity is stronger. Departing as it does from the merely existent in both directions of modality, the aesthetic can be regarded in terms of objectivism as a phenomenon of intensity.

3. Subjectivism

By *aesthetic subjectivism* we mean the whole group of principles used to solve the riddle of the beautiful by a general characteristic of the aesthetic attitude. Many of them are very closely related to objectivist theories; some are independent. They all have in common their view of aesthetics as a science of a certain kind of attitude, of inner experience, or the science of a psychic echo.

Suppose that the essence of the aesthetic is *illusion*. Then the question would be in order: Wherein lies the peculiarity of the conscious processes elicited by illusion? Obviously in the freedom

from all turbulent agitations of will. Hence some have spoken of disinterested pleasure and of will-less contemplation, thus indicating the relation of the aesthetic attitude to other states of mind. The term *disinterested pleasure* serves to distinguish aesthetic and sensuous enjoyment by means of a relationship. The objects of sensuous enjoyment—so the doctrine goes—arouse the desire to possess them, whereas aesthetic objects are contemplated without such a wish. That is correct on the whole, but perhaps the explanation is unusually simple. The reason might well be that merely pleasant things just cannot be enjoyed unless we take possession of them. In the frequent example of tasty food, everyone sees the point at once. But it applies also to clothing material that is kind to the skin, and to the amenities of a country house which I can actually relish to the full only as an occupant. Accordingly, disinterestedness would concern not the peculiarity of aesthetic enjoyment—the thing to be described—but the condition of its appearance, that even without our possession of the object it can be present in full strength.

In a different sense, *to have interest* is equivalent to *to be related to the will*. Then aesthetic feelings can be distinguished in this way, that they do not disturb the freedom of the self at all and they never influence its action, at least directly. As these feelings henceforth do without that connection with their objects which is present in the case of *real* pleasure, they are, as it were, restricted to themselves. This explanation, therefore, grants to aesthetic feelings a certain independence from the outer world. Dubos thus referred to the human need of activity and to the torment of ennui. And essentially Aristotle called the aesthetic processes of the mind the joy in function itself when he spoke of the exercise of a faculty and demanded that tragedy let the emotions run their courses and die out without bad effects. For freedom from volitional processes on the one hand, and from attachment to reality on the other, would indeed yield this as a common result: in aesthetic enjoyment the mind rejoices in the fulfillment of its processes. The world of illusion serves only to induce mental activity and to prevent the discomfort of idleness or frustration. Indeed, the joy of inner activity in aesthetic experience is unmistakably prominent, but how this joy is produced is not a matter of indifference. The description of the mental state, to be complete, must add that it meets a demand of the object.

A good many theories are grouped together in what we

have just discussed. The doctrine of illusional feelings, which now follows, we owe chiefly to J. H. von Kirchmann and Eduard von Hartmann. Starting with the fact that aesthetic impressions can be supplanted very quickly, these investigators have inferred that the feelings they contain are less intense than real feelings. The instability of the ideal feelings makes them seem weaker than the corresponding real feelings. Thus the difference between aesthetic and other feelings would be chiefly quantitative. Other thinkers have doubted this. They would concede the merely negligible strength of aesthetic stimuli, which most deeply move the whole person, only if every other possible explanation of the resulting fact should fail. It is convenient, of course, to pass off a not easily definable difference of quality as a difference of strength. Indeed, this has been done with perceptions and memory images in the assumption that the images are very much weaker revivals of the perceptions. But the cause of the undeniable inconstancy of aesthetic feelings may lie also in the fact that they are essentially bound to impressions of the higher senses and have approximated their mobility. Further, the underlying ideas may be partly responsible for the fact that those feelings perish so quickly and can be revived so easily. These ideas are indeed a unity in themselves, and are thus exposed to prompt dissolution when new vital impressions rush in. *Real* feelings arise from events which occur in the whole context of life, while *ideal* feelings form a world for themselves. Accordingly, the difference in stability is explained not by a particular quality of the feelings, but by the coercion of vital conditions, by accompanying circumstances. It is certainly strange how after the last words of a tragedy or the last tones of a symphony the people all crowd to the exit, chatting and disputing with one another. Still we see no ground in this for the assumption of illusional feelings, but only the evidence that those feelings have sprung from a particular occasion and are detached from the context of our experience.

A further customary characterization of the subjective processes which correspond to objective illusion is expressed in the statement that every illusional feeling is the counterpart of a genuine feeling. Earlier aestheticians thought that two series run parallel in the mind, comparable to the primary and secondary series on which Fichte's *Wissenschaftslehre* bases experience. In our time a similar view has arisen again; Meinong has argued for it in detail. According to Witasek, it starts from the fact that the

totality of mental content falls into two halves. Each occurrence in the one half has its reflected image in the other. To perception corresponds imagination; to judgment, supposition; to real feeling, ideal feeling; to serious desire, fanciful desire. Of all these secondary mental states, imagination is best known. Now it is asserted that supposition is also to be understood in like manner as something opposite to judgment, which can have the same content as judgment. "Supposition is a psychical fact which in all essentials is equivalent to judgment, except that it leaves the conviction of the subject quite untouched and lies outside the realm of all belief and knowledge. Hence it can present no actual judgment, but only (as it were) an imagined judgment." (Witasek, *Allgemeine Ästhetik*, pp. 111–12.) The aesthetic feelings connected with suppositions, that is, illusional feelings, are scarcely distinguishable, as feelings, from other feelings—at best, perhaps, through their weakness. The chief difference lies rather in what they presuppose, and this is just a supposition. Only insofar as feeling takes over the distinction between primary and secondary from its presupposition, can one speak of real and illusional or genuine and fanciful feelings.

But the representatives of this special kind of illusion theory are not entirely agreed. Some let illusional feelings become such only through a kind of supposition; others believe that they may assume a diversity also in the feelings themselves. I would prefer the latter view if I could make up my mind in general to accept the whole construction. For certainly fanciful feelings follow also from judgments and not only from suppositions. So if there is a distinct group of fanciful feelings which repeat the real feelings with a soft echo, they are surely something distinct in themselves already, not merely through the ideational fact that precedes them. Moreover, suppositions are often followed by real feelings of the greatest intensity. The pleasure or pain based on a mere fiction can sweep away the whole person, and need not remain in the sphere of the fanciful, ephemeral, and fleeting. In a certain total situation we create an opposed fanciful feeling only with difficulty, whereas in the case of a judgment we very easily make an opposed supposition. This pertinent fact from another quarter indicates that there are distinctions within the realm of pure feeling. A fanciful feeling is still a genuine feeling to the extent that it does not tolerate another opposed feeling as coexistent or right after it. But is the foundation of the whole theory firm? Introspection does not reveal

as clear a difference between judgment and supposition, as between perceptual and imaginative ideas. From a certain epistemological point of view one can speak of judgments and suppositions as opposed, but hardly when one remains within the bounds of inner experience. The judgment, "This object is green," and the supposition, "Suppose that this object is green," offer no demonstrable difference for psychological report. For the relation of thought to the outer world the first is, of course, different from the second, but for the nature of the conscious process there is no sharp boundary here.

Starting with sensations, it seems to me, one can establish the illusion theory more firmly because it accords with the inner facts. Let us remember that works of art are intended almost always for only one sense, seldom for more. In contrast, that which acts is called actual, and the acting concerns the whole susceptibility of man. The rose is actual because it is accessible to many senses; because it can be seen, touched, smelled, and tasted. But a painted rose exists only for sight. Precisely for this reason it loses the character of actuality. We call everything illusion which cannot be checked by other senses. The suddenly emerging form of a spectre is an illusion, for we merely see it and do not feel it, we glimpse its gliding step and do not hear it, we view the movement and do not catch the slightest breeze. Hence it makes psychological sense to call music an art of illusion, for it is there only for hearing and perhaps for the associated emotion. In a word, the limitation of every kind of art to a single sense guarantees its illusory character. As the operation of a single sense is related to the cooperation of several senses, as illusion stands to reality, as the reflective image resembles the reflected object, just so the imaginary object is related to its corresponding perceptual object. The latter has a fullness which the imaginary object lacks. When I think of a person, I see perhaps a portion of his face, or in the next instant, a characteristic bodily movement. But in my mind I catch no sight of his surroundings, which in reality are nevertheless always perceived along with him, and I do not hear the sound of his voice. Moreover, an imaginary object of unmistakable sharpness remains still much more onesided, limited, and thin than a comparatively cloudy perceptual object. Suppose I intend to lay something down. Then I represent to myself only the arm movement, but not the little supporting movements which in the actual execution occur in the whole body. One often imagines early in a doze that he has looked

at his watch. Now if he actually does it on awaking, he notes that he had previously supposed he saw the hands without hearing the ticking of the watch, that he believed he had reached for the watch without raising the upper part of his body. In a word, the mere image was certainly more incomplete than the percept, if not weaker. Hence fanciful forms are often more charming and seductive, for they shed all the discomforts of reality. This peculiar quality of pleasure largely explains the agreeableness of the illusory.

Finally we still have to mention that variety of the illusion theory, worked out by Konrad Lange, which is called *aesthetics of illusion.* (A cautious and excellent account is contained in Lorenz Kjerbüll-Petersen's commemorative remarks on Lange in Z.f.A., xvi, 210–15.) According to it, everything depends on the state of mind when the impression is received, and this state consists of a conscious self-deception, of a continued and deliberate confusion of reality and illusion. Aesthetic pleasure is said to be the free and conscious hovering between reality and unreality, or in other words, the ever futile attempt to blend original and copy. The enjoyment of a good graphic representation of a ball would rest on the observer's belief at times that he was seeing an actual ball and his clear recognition at other times that he was looking at only a two-dimensional drawing. Hence the oscillation goes on between judgments, between two equally genuine convictions, not between a judgment and a mere supposition. In every work of art there are those constituent parts which promote deception and those which hinder it. The former are connected with the content and the latter with the form. But this division is neither clear nor exhaustive; where, for example, should rhythm and rhyme be placed? And as for the continual interchange of ideas, it seems to me that the person who is experiencing aesthetic enjoyment does not notice any such oscillation, and that where it can really be demonstrated in consciousness—as in indecision—it usually is not pleasant. As a matter of fact, the person who looks at a portrait does not believe for an instant that he is seeing the living man before him. Nevertheless, if we could speak of an illusion, it would be simply the frequent instance in which we take something unreal as real. If it has been said that a picture really consists only of oil spots, this reality being changed through conscious self-deception into the illusion of a landscape, yet one can also assert with equal justification that the reader now sees only printed letters, but indulges in

the illusion of perceiving words and thoughts. The chief proponent of this theory thinks that in the theater we well know the actor is speaking on a stage, but we intentionally forget his identity in order to substitute a fictional figure. Is not the situation similar when the student forgets that a certain professor is speaking to him and receives the thoughts purely as such? We can escape from the aesthetic illusion, as well as from illusions in general. In the fatigue of normal reading we finally recognize only words; in the fatigue of proofreading, indeed, only letters. The question therefore arises whether the relation of the real to the unreal, which can appear everywhere, is not here falsely made the essence of the aesthetic state. There is the further question whether the separation of being and seeming is not quite unjustified by our subject. The aesthetic life may run its course in a realm which knows nothing of this dualism. The opposition of yes and no, of truth and untruth, of reality and unreality, belongs in the sphere of judgment, but not in the context of aesthetic experience. According to this view, precisely the beautiful can produce a harmony of mental powers among themselves and with the outer world. Only when one has tasted of the tree of knowledge, does the rift enter between inner and outer. But the artistic genius is, like a child, still in the state of innocence. He leads us back to the unity we have lost, and lets us confess with Goethe:

> Nothing is within, nothing is without;
> For what is within is without.
> —Epirrhema in *God and World*

The same view, differing merely in mode of expression, confronts us in the so-called *aesthetics of feeling*. One must, of course, take account of the following facts. Whenever feelings are made the center of the aesthetic life, we are concerned not with the contrast of pleasure and pain, but with the appearance of feeling as the fruitful disposition from which the other expressions of the mind spring. There is no mental capacity which cannot radiate out into the area of feeling, and none which cannot issue from this area. Central feeling stands at the point of control between centripetal perception and centrifugal volition. Therefore the whole essence of mind is to be grasped in feeling, hence also—for this view—in the aesthetic. The vast opposition between aesthetic existence on one hand, and scientific and practical existence on the other, is expressed in the attempt to base the totality of aes-

thetic processes on feelings. Just as judgment—for traditional doctrine an intermediary between concept and reason, and also a *vis aestimativa* (evaluative faculty)—forms the heart of logic, so feeling—traditionally an intermediary between understanding and will, and also a *vis aestimativa*—forms the heart of aesthetics.

Yet all this would scarcely suffice to justify an aesthetics of feeling, if feeling were merely a subjective state. But primarily it reaches out beyond the individual subject, in that it unites this subjectivity and a universal validity through which it first becomes accessible to scientific treatment in general. Furthermore, feeling has its object within itself, though not, of course, as perception has its object before itself. For immediate experience feeling is authentic not as the inner perception of a merely personal content. Rather, it is so vividly and certainly related to objects that in an unsophisticated philosophy, affective qualities are regularly attributed to objects, indeed to things-in-themselves. So it was even with the Greek skeptics. In our experience feeling is bound up with the consciousness that here the mind is blending itself fully with something external; precisely the same blending we discovered earlier as a sign of the aesthetic state. If we assume that artistic life is rooted in unification, then it is also immersed in feeling, as feeling implies a unification of all mental phenomena, otherwise separated in cognition, as well as of the self with the outer world.

From here it is only one more step to the *principle of empathy*. With the help of concepts already mentioned, let us try to take this step. The primary fact of our nature, a fact which will ever remain a riddle, is self-consciousness. In observing ourselves we split our unity into a subject and an object. As Fichte says, we establish two series within us, one of which constitutes the content of our consciousness, the other the knowing of this content. If we assume with German Idealism that the world is in essence spirit, then even empirical things, indeed even things-in-themselves, can be regarded as belonging to the first series. Everything that we call an object has sprung from the original divisibility of the self; it has been split off from spirit by that primal capacity of the self. Now as far as the mind remains conscious of the subjective origin even of objects, knows them as animated by spirit, and finds itself again in them, the feeling of the beautiful arises. Fichte's thesis now becomes clear: "Art makes the transcendental standpoint the ordinary one." In art everyone becomes aware that even the objects are creations of spirit, which the self knows because it is at once

subject and object. If we now slip over from metaphysical into psychological categories—a transition which can easily occur, and in fact has—then we can say that the world becomes truly intelligible to us as we interpret it in terms of ourselves, that its beauty and works of art are then the fullest expression of this meaning of the world. Just as Narcissus sees his reflection in the fountain pool and falls in love with himself, so anthropomorphic thought sees its reflection in nature as a whole. This Narcissus is the prototype and symbol of the artist; for where human personality achieves self-perception in the external world, there it passes into the aesthetic state. Beauty issues from within more than it enters from without. Our grasp of the beautiful comes from the patterns of our souls, their life, growth, and decline.

With the aid of descriptive psychology the theory of empathy has been further developed during the last decade, but the basic thought has remained the same. Throughout this period aesthetic enjoyment is found in the harmony of inner and outer. Whenever a given object affords us the possibility of expressing ourselves spontaneously in it, we feel at once a peculiar joy. But how can an object offer us this opportunity? Earlier aestheticians answered with suggestive and interesting descriptions. Robert Vischer, for example, described how the glance slips forward with deliberate sinuosity, now dreamily lingering, now hastily darting on. "The tendency, connected with the observed form, and the time of this movement thus acquire the character of human intentions and agitations." (*Das optische Formgefühl*, p. 24.) "The symbolic power of phantasy does not even need to have the external form of the objects suggest the human figure; through mere tones and colors they often convey a mood to us." "The poet's delicacy of feeling ensouls an object even when it only remotely suggests anything human." (Carl du Prel, *Psychologie der Lyrik*, p. 88.) Hermann Lotze advanced to a more detailed explanation, at least in respect to music, and correctly noted that the transfer of mental processes to patterns of sound is facilitated by various peculiarities of this medium. Our own organic growth and decline are repeated in the countless gradations of intensity which are possible with tones. All the modes of transition from one state of consciousness to another, all the nuances from gradual modulation to sudden transition are found again in musical forms. The temporal character of the mental is present also in tones. Finally, both contain events. So, if details of the self can easily appear as details of musical reality, satisfac-

tion is to be found in this very similarity and congeniality. Music pleases because it is a kind of mental movement.

Theodor Lipps, the most important of the recent advocates of the empathy principle, actually believes that the empathic pleasure in rhythm can be traced back to association through similarity. As the similarity of elements and of groups in rhythm carries the listener forward, the objective course corresponds to the tendency of every mental occurrence to continue in like manner. This tendency, the law of association through similarity, is broadened to a law of the psychical resonance of the similar. Every particular rhythm of a mental movement seeks to dominate the whole system of conscious processes. The character of rhythm lies in a general freedom or lightness, heaviness or constraint, so that mental processes of any content whatever, indeed all possible contents, can be brought into sympathetic vibration. As an inclusive personal mood arises in this way, it is also attributed to the object, since it is determined by the rhythm heard, and directly joined to it. This hypothesis accords with Lipps's belief that the task of psychology is "to make the *contents* of consciousness intelligible by proceeding from them to disclose the (unconscious) mental *processes* and their interaction." (*Zeitschrift für Psychologie*, xxii, 448.) A further hypothesis lies in the field of metaphysics. What Fichte demands of thinking man (in considering the world to replace the category of thinghood by the category of action), Lipps requires of the person who experiences aesthetic enjoyment. Violent actions come from static forms. Empathy transmutes every *being* into *living*, hence into ceaseless *becoming*. To be sure, the simple forms, to which Lipps is partial, *originate* in some such way. A line is produced by the movement of the drawing hand through abrupt starts and stops or continuous gliding. But do we experience the *finished* line in just the same way? If it were a question of entering sympathetically into the inner history of forms, crooked and curved lines, sinuosities and interlaceries would necessarily be preferred to stiff, straight lines reflecting one another at right angles. Then in architecture the Portuguese Manuelian style would be the most beautiful. That is obviously wrong. Generally in aesthetic enjoyment, not every single rest becomes motion; not everything spatial, something temporal. Where a figure is predominantly horizontal, it is subject to the law of rest; where closed forms are encompassed at a glance, introspection reveals no endowment of the object with life.

But our most detailed investigations directly concern the relation of empathy to spatial forms. Taking the erect and compact Doric column as an example for contemplation, Lipps has tried to show how spatial forms are first interpreted dynamically, then anthropomorphically. We read into the geometric pattern not only the development of power, but also free purposive activity. Viewing it in the light of our own action and thus sympathizing with it, we find it beautiful. And, more precisely, definite possibilities of action unfold in definite spatial forms for a sympathetic appreciation. As soon as these possibilities of action are called ideas, it once more becomes evident that the theory of empathy is not very far from the explanatory techniques of metaphysical aesthetics. The chief difference is, finally, that the empirical origin and objective character of such ideas are asserted. But now whether the ideas (which in architecture, for example, concern the conflict of force and weight, of pressure and counter-pressure) are treated by Schopenhauer as Platonically conceived stages in the objectification of the Will, or appear in contemporary aesthetics as experiences common to everyone, through which the forms appear meaningful to him, still an unmistakable kinship in fundamental features remains. In this the view is similar to the doctrine of functional pleasure.

Sympathetic empathy, so we are told, pleases us as an act of freedom, as a meeting of subject and object, as a melting of the inner act into the appropriate thing. In the given forms of architecture I feel myself as nimbly playing or powerfully overcoming obstacles, and in this way I am made happy. Hence, in the last analysis, this feeling of happiness consists of the joy in an inner activity as such. The encounter with the aesthetic object only facilitates for me an inner life, freed and raised into a larger realm. To avoid such subjectification, Volkelt asserts very emphatically that on the objective side something definite, namely, the unity of content and form, must correspond to the empathy, which is to consist of the blend of feeling and intuition. Lipps often calls the relation of the self to the aesthetic object a *dialogue*, meaning that object and person are detached from the rest of the world and have to do only with each other. But as the aesthetic life of the object is the aesthetic life of the empathic self, and the aesthetic enjoyment is just the self-development of the object, at bottom person and object merge, *object* in this case signifying the whole outer world.

In some such way the enjoyment of the beautiful can be made intelligible as "enjoyment of the inner self objectified, enriched and broadened in the contemplation of the object, raised above and beyond the ordinary or real self." But our justification in taking negative empathy in the presence of the ugly as signifying aesthetic value is not made clear. For, according to this view, negative empathy is merely aesthetic dislike or antipathy. Lipps takes as an example the portrayal of a stupid pride, and says: "It claims a place in me, but I resist, or the man in me resists. He opposes the presumption that he feels himself such a man." Then how do I enjoy the portrayal of such a character in (let us say) Molière's comedies? In this conflict of objective demand and inner need, how is empathy as such still possible? With the addition of the abstract word *negative* a term is created, of course, but the difficulty is not removed.

So let us remain with the beautiful and investigate its nature more closely. If beauty rests on the agreement of an object with the nature of a self that judges it aesthetically, then it must be proved with perfect precision and cogency that the life of the object is our inner life, and hence aesthetic enjoyment is self-enjoyment. Actually it has been established thus far merely that one can interpret spatial and tonal forms as a play of forces, and as such describe them in detail. As an example let us take the Doric abacus. "It is broader than the column, and seems accordingly to spread in yielding to the pressure of the entablature. But in yielding it draws itself together forcefully at the same time, thus maintaining itself against the further effect of the pressure. In this way it constitutes the absolutely resistant intermedium between the upward force of the column and the weight of the entablature concentrated in the architrave." It seems to me that this description is immediately applicable to structures of other forms, or at least of other sizes. Why does the abacus lose its beauty if its contour is displaced just a trifle? The aesthetician advocating empathy could simply reply that then it no longer yields, no longer draws itself powerfully together, and so on. However, for anyone who has appropriated the language of this aesthetics, it will probably not be very difficult to interpret in the same way even the casual linear strokes of a gliding pencil as the effect of hidden life. We receive no explanation at all, but a linguistic reproduction of the object. (Johannes Volkelt, the most thoughtful adherent of the empathy doctrine, does not go into this aspect of the problem, but

he throws light on the problem most effectively from many other sides. Cf. *Das ästhetisches Bewusstsein,* 1920, pp. 43 ff. In his *"Kritik der Einfühlungstheorie"* Theodor A. Meyer stresses the fact that in the greater works of art (e.g. Leonardo's *Last Supper*) several types of feeling are present at the same time and for comprehension of the whole must also come simultaneously into consciousness. How should that occur in the case of genuine empathy? "Complete empathy is an exceptional state."—*Z.f.A.,* vii, 529–67.) Thus the actual process of aesthetic evaluation seems to have been found, as the strange has been transferred into the circle of the familiar. This mode of treatment works all the more corruption, the more extensive and finely discriminating the vocabulary covering the mobile, dynamic, living, and organic. The recent literature on empathy has flooded us with a wealth of variant expressions, and with them has unmistakably characterized states of mind as they are obscurely felt and instinctively experienced in *some* cases. But the theory threatens to develop into a stereotyped mode of linguistic expression, for the ingenious as well as luxuriant use of words does not always spring, as it does in Lipps, from an intellectual activity, pointedly penetrating, incessantly stirred, never complacent.

Since it has been assumed thus far that actual feelings are transferred to objects, we should recognize that other investigators allow only intuitive ideas of feelings to achieve this absorption into the object. The content of an intuitive idea is just as rich in determinations as the feeling itself, which it copies, but the act of feeling is lost. If, for example, the grief absorbed into the aesthetically pleasing object is not actual grief, but only the intuitive idea of grief, then aesthetic sympathy is distinguished from ordinary sympathy as intuitive is distinguished from non-intuitive representation. On the assumption that the aesthetic attitude consists in an actual feeling, it follows, of course, that empathy—as mere representation of feelings—cannot constitute the essence of the aesthetic attitude. This consequence also results from other critical considerations, as we shall soon see. The argument just paraphrased is subject, however, to the doubt whether or not intuitive ideas of feelings exist at all. In attempts to observe or even to produce such ideas, the result—for me, at least—has been either that an actual feeling enters again, or indeed something that I should not know how to refer to in any other way, or that we are concerned with ideas of the forms in which the feelings are

expressed, or finally with bare verbal representations. As I see it, one can speak of ideas of feelings only as intuitive ideas of all sorts of expressions of feeling or as conceptual transcriptions of the feelings themselves. In both cases it would be misleading to speak of an idea of a feeling, as the essential content of feeling, and not only its act, remains far from consciousness. All the common feelings, in particular even the feelings of tension which appear in empathy, are very real and not merely represented.

Now for the final objections. Without doubt empathy plays a decisive role in broad fields of aesthetics, and artistic interest can always be united with anthropomorphizing contemplation. But the question is whether every aesthetic satisfaction consists in the gratifying feeling of sympathy. In experimental investigation "so many cases of clearly aesthetic experience without sympathetic empathy have appeared, that to base all aesthetic experience on this empathy is to fall into open contradiction with the facts." (Emma von Ritoók in Z.f.A., v, 544.) Daily experience teaches the same thing. Simple patterns and decorations please without any need to refer the pleasant regularity to an animistic interpretation of ours. Among architectural forms, quasi-organic ligaments are objects of aesthetic joy, surely for the most part through personification. Yet the peculiarly architectural feature, the rigid conformity of the monumental forms, stands over against our appreciation as something quite foreign. What such structures and the experiences of the self have in common is most happily signified by the word *mood*. Gothic cathedrals, rococo salons, and the like have a pervasive mood because a certain total state of the inner life is expressed in them. In such work all particular elements are gathered up into one harmonious whole, just as our minds often unite all particular elements into one continuous movement. In such cases we ascribe mood to the self and to the object. But mood coincides with the broad concept of the aesthetic no more than (let us say) the picturesque does. Indeed, one might hazard the assertion that the figurative language of the beautiful gets its inexhaustible charm from the fact that it speaks like ourselves and yet differently. The endless conflict between its unity with us and its opposition to us gives to art its vitality and power.

II. THE AESTHETIC OBJECT

1. Its Extent

To speak of aesthetic objects would have no meaning if the aesthetic consisted merely of mental processes. Of course even an aesthetic thing is fashioned subject to conditions imposed by the evaluating person and according to a cognitive rule. But these presuppose objectivity and not subjectivity. So, as has been said repeatedly, we start out from the assumption that aesthetic objects with their characteristic qualities make demands on the subject. On this assumption we investigate the extent of their occurrence.

First, it is a fact that a certain sphere of objects, whose contents can be indicated with a fair approach to certainty, constitutes the scope of the *beautiful*. As to what is called beautiful outside of art and often uninfluenced by it, opinions do not differ considerably, as there the individual person is generally a fair sample of the race throughout the range of his pleasure feelings. After all, human beings agree in placing the beauty of their fellows higher than the beauty of other living beings, and even within this realm of value there is pretty general agreement as to gradations. One bodily form is regarded as ugly, a second as indifferent, and a third as beautiful. If we transfer this very familiar idea to reality as a whole, a scale of levels arises. On the lowest level is the ugly, then comes the broad region of the indifferent, and finally the field of the beautiful. To have a short term at hand let us call such a view, which is akin to theocracy, *callicracy* [from κάλλος]. For callicracy art would have a delightfully simple task; namely, through repetition to make the beautiful in general, or the intrin-

sically pleasant, more important and more accessible. Naïve souls are apt to look at art in this way. In life they have encountered things which (chiefly through visual and auditory impressions) produce a tranquil enjoyment, and now they demand of art that it offer such pleasures collected and refined. As in life, so also in art they seek the beautiful and flee from everything ugly. "Beauty is the highest ultimate goal and the heart of art," says Winckelmann.

This way of looking at things has two unmistakable advantages. It is distinguished by its admission of inequalities, superordination and subordination, and its unification of natural and artistic beauty facilitates the guidance of theory. But the disadvantages outweigh the advantages. How the scope and significance of art would shrivel if we tried to restrict them to a higher pleasure! In general, art should not be identified with a definite content. Indeed, one of the first steps to the appreciation of art consists in learning to enjoy the indifferent because it is artistically portrayed, and to let oneself be neither seduced by the actual beauties contained in the work of art, nor repelled by the ugly elements. Aesthetics and the science of art are not catalogs of all beautiful objects, but sciences of the outer and inner conditions for certain events in which value occurs. As for the second advantage, the steady advance from corporeal beauty to art seems really to succeed only for an idealistic metaphysics. The continuum which leads from the aesthetic stratification of the world to art gets its greatest support from the assumption that ideas are the causes which produce both the things of nature and the works of art. Whenever an object of the real world is filled by an idea in such a manner that it pleases merely as a symbol or sensory expression of this idea, then, to be sure, the beauty of this object is essentially the same as what we commonly mean by beauty in art also.

Let us venture the following speculation deriving from Plotinus. The essence of God is manifested most clearly in the beauties of nature. As the distance from the Unconditioned increases, the beauty decreases. At the ultimate, obscure limit dwells the Demon of the Ugly. The privileged points of the cosmos show a beauty which no art achieves. Plotinus, to be sure, does not stop there. His philosophy is just as much a dynamic pantheism as a doctrine of emanations. Besides the inaccessibility of the divine One, the permeation of the whole world by supreme intellect is also declared. If we follow this tendency of Neo-Platonism, things take on a different appearance. Earlier we sketched a picture of the

world, presenting a scale of aesthetic values. But there are strong inducements to a general point of view somewhat like pantheism and panlogism. Just as there is nothing wholly detached from God, nothing wholly independent of spirit, so we can point to nothing wholly devoid of aesthetic significance. In these three spheres the mind can rise to the thought that value, which seems to appear only sporadically, really belongs to all things. Hence the receptive mind can discover in the lowliest and shabbiest thing at least as much beauty as in those splendid phenomena provided with the label *beauty*. The observer must only search carefully and immerse himself in the object devotedly. The function of art is to express this character of the world as clearly as the *logos* of reality has been revealed through purified religion and speculative philosophy. The standpoint thus reached we will also signify by a special term; let us call it *panaestheticism*.

Panaestheticism possesses the seductive power of pantheism. Yet it tends toward the depreciation of art. Every selection by the artist appears as bold presumption, every idealization as blasphemy. To improve on nature here and there is on a par with that wretched mode of painting which inserts colored angels' wings into the photographs of dead children. Ruskin calls beauty a reflection of divine perfection, holding that thing to be beautiful which has preserved a similarity with an attribute of God, and hence has the power to attract the divine part of our nature. Thus unity is a symbol of God's all-embracing nature; repose, of His steadfastness and eternity. Symmetry is a symbol of His righteousness; purity, of His will. Whoever can clearly apprehend these divine perfections in reality and reproduce them is the great artist. "Idolize a peacock," says Ruskin, "and you will paint it as no one can who sees in it merely a bird." And the same Ruskin declares, "No Greek goddess has ever been half so beautiful as a young English woman of pure blood." In fact, for persons who can observe and have an innate affinity of soul with nature, natural beauty is no longer a pre-stage of art, but its adequate substitute, perhaps even surpassing art. Wilhelm Heinse describes the falls of the Rhine and adds: "In the presence of nature all the Titians, Rubenses, and Vernets must turn into little children and comical monkeys. . . . Come and let nature present a different opera for you, with other architecture and fairy painting, other harmony and melody than those which charm you by pitiful pruning with a little knife. (*Werke*, ed. Laube, 1838, ix, 43.) The inspired author of an aes-

thetics of forests has declared that "in beauty alone the treasures of nature which our forests conceal immeasurably surpass all art collections, and in the former we are the museum directors." (Heinrich von Salisch, *Forstästhetik*, 2nd ed., 1902, p. 38.) For this way of thinking it necessarily follows, of course, that in aesthetic value colors and forms of the outer world eclipse every artistic attempt. This seems to be felt by the Japanese who celebrate blossom festivals and make pilgrimages to beautiful places to wonder there in silence. They judge nature, then, as a work of art, but not from a work of art. As evidence of this, queerly formed roots of trees are highly valued, and anyone who can find them and cut them out well is well paid. In general the Japanese force plants into definite lines and value this control. The heart of the German clings to his woods, to the dark solemnity of the conifers, and to the bright friendliness of the young birches and beeches. In the woods the colors blend, combine, and separate with an inimitable delicacy. The incessant movement continually creates new and enchanting harmonies. The light playing on the objects and the air between them and the spectator make their contribution. The whole appears as unlimited, or as limitable at any instant one chooses. Yet it is not only spatially larger, but also richer in content than any creation from an artist's hand, for its warmth and fragrance appeal to the lower senses. In this way it perhaps achieves something significant. (A landscape is also the largest form there is in spatial depth. Even a relatively near object stays far enough away to hold the spectator at a distance. Cf. Hugo Marcus in *Z.f.A.*, XI, 46–60; XVI, 201–9.) At least an earlier aesthetician of odor asserts that it conveys, "as it were, out of the inmost heart of the plant, a simpler, quicker, clearer knowledge of its kind than do its forms and all attempts at an artistic description." (Schelver's *Lebens- und Formgeschichte der Pflanze*, as quoted by Franz Thomas Bratranek, *Beiträge zu einer Ästhetik der Pflanzenwelt*, 1853, p. 154.)

But even one who approves the shift of emphasis from art to nature can scarcely find in panaestheticism the absolute certainty and rest which are the goals of explanation. From this point of view the world and art equally assume an aspect of deliquescence and of evanescence. If all things are equivalent, then no possibility of a fixed order remains and all articulation drops out of the world-picture. We come to the point where we extol the beauty of a blade of grass just as loudly as the beauty of a woman. And that is not all; no, we must finally renounce all objective proof and

abandon everything to subjective preference. Nowhere does a reliable boundary appear between what is objectively beautiful and what interests me personally. When I am in a susceptible mood, I discover everywhere the most exquisite charms, and it is due to my dullness that I usually notice only this or that striking beauty.

The choice between callicracy and panaestheticism is not a question of yes or no. Only we must preserve the distinction between the aesthetic view of the world on one hand, and the relation of nature and art on the other. Moreover, on both sides the analysis must be carried through ruthlessly to the end. Within the aesthetic view of the world we distinguish the beautiful and the aesthetic, the former as an important special case of the latter. The stimulative power of every single phenomenon—even those apparently indifferent, indeed ugly—is undeniable, as is also the peculiar status of beautiful forms and events. A view of aesthetic value aims to set up an order of rank in terms of fixed standards, and to establish in its field a *highest good* determinate in content, the beautiful. But this should not be regarded as involving the narrow-minded demand that art, a creation of the human spirit, draw its sustenance only from the beautiful. In general the comparison of the beautiful and the artistically valuable is illegitimate, as they lie, so to speak, on different levels. In their ultimate basis, of course, all things are coherent, par excellence those which in the development of culture and of thought have always been regarded as unitary. For the purposes of analytic and discriminative knowledge, however, and for the progress dependent on this knowledge, it will now be necessary to throw the difference into relief with all the force at our command. And, indeed, this can be done in a two-fold way: first through the insight that imitation of the beautiful is neither the source of art nor the sole determinant of its achievements and effects, then through the proof that there are aesthetic objects and impressions which have absolutely nothing to do with art. The second point calls for consideration here, where we are speaking of the scope of aesthetic objects.

Let us again turn our attention briefly to the *beautiful in nature*, the crux of aestheticians. As important an aesthetician as Hegel coolly opposed this form of beauty. He said of the Grindelwald glaciers: "Their appearance offers nothing more of interest. One can call it merely a new mode of seeing, but a mode which gives the mind no further employment whatsoever." (Rosenkranz, *Hegels Leben,* Documents, p. 475. Moreover, Hegel thought just

as contemptuously of "applied art" and its pleasant play. Even great art was for him only "a stage of liberation, not the highest liberation itself."—*Enzyklopaedia*, § 562.)

Even now there are many who feel no natural joy in living beauty and have no knowledge of its peculiar quality. If they enjoy nature nevertheless, that is because they catch from it an echo of art. They delight in color moods which they know from paintings; they admire the proportions which sculptors have taken from the wealth of actual forms—in a word, they owe to artists their joy in nature. Their sympathies and antipathies have been instilled in them by painters and poets; their retinas and eardrums have been trained by sculptors and musicians for aesthetic activity. Others, however, have an innate affinity with nature, a kinship not affected by art. Generally they find beauty in its natural forms more glorious than beauty forced into a frame or pressed between the covers of a book. Among the significant events of their lives are their free encounters with nature, those hours, days, weeks in which the pleasure came not from the need of recreation, but from the stored up psychical energy. (Concerning the relation of the enjoyment of nature to the enjoyment of art, cf. Emil Utitz, *Grundlegung der allgemeinen Kunstwissenschaft*, 1914, I, 133–79.)

Both of these attitudes toward nature are very easily fused with a view of life in general, and subjected to moral judgment. One of the Goncourts remarks incidentally, "If hay wagons brush the walls in the morning while you are still lying in a doze, it sounds as though a woman sitting at the foot of your bed were drawing on silk stockings." In such associations culture, and not merely artistic culture, issues the death certificate of natural feeling. Lamentations over this are as old as they are futile. As early as 1770 Garve wrote the words which in our time Tolstoy could have uttered: "From childhood on, first by our education, then by our mode of life and occupations we are kept from viewing nature . . . Only occasionally, only for a moment are our people taken out into the open country . . . Many things occur daily before our eyes, or only a few steps away, which we nevertheless scarcely notice until we have found them in books. The poets must first tell us what a beautiful region is and how the sun rises and sets." Even this kind of perception is clouded, for we dispense with the whole view, without which neither a great achievement nor a great experience is possible. As lovers of the anecdote, not of the heroic epic, we waver and incline to the ephemeral. In the midst of the most

enchanting view the interest of the average person clings to some striking characteristics of his neighbor, just as visitors at an artist's studio are usually not attracted by the pictures adorning the walls, but pounce eagerly upon the photograph album.

Aesthetic objects contained in the real world can be interpreted in various ways. When they are enjoyed with pure naïveté, there is usually an inner aversion to the scientific explanation of nature. To a person who feels this way it seems as though the roving botanist destroys the flower's charm in picking it to pieces. Science not only says nothing of all the consolations and promises whispered to us by the colors of a sunset; it even kills what for man and his life is of utmost importance. Or does it perhaps signify nothing when someone driven far away remembers German forests, their recollection strengthening ever anew his attachment to the fatherland? They are aesthetic impressions to which the love of native soil is joined. No scientific thought should intrude into this purely human feeling. Just as the beauty of a movement or a linguistic sound is grasped more surely and enjoyed more fully as long as its meaning remains hidden, so the charms of nature and life are felt most deeply by the ignorant.

We now pass almost imperceptibly to a view deviating from this. Whereas the former standpoint represents in its way the principle *l'art pour l'art* (art for art's sake), another aesthetic interpretation of natural phenomena appears, mingled with considerations of utility. The feeling for nature should not be playful and a luxury of the privileged; rather the springs of the beautiful in nature must flow to everyone, hence be made accessible and kept pure. If an inalienable human right to the enjoyment of nature is asserted, yet this right itself is reinterpreted. Here social movements of many kinds originate, in which the aesthetic approaches art. Moreover, the attitude of the critic seems to be the same—as the old expressions put it, a contemplative and disinterested pleasure. All the more earnestly are we to be warned against equating the natural and the artistic conditions of aesthetic enjoyment. I call attention again to the restlessness and boundlessness of the real, as well as to the cooperation of the lower senses. In these three respects art is poorer. But in this very restriction lies its strength. From first to last poetry offers only words, and painting only pictures; that constitutes their meaning.

Having spoken of the intrusion of artistic, moral, and scientific views into the experience of the beautiful in nature, we

turn now to the principal topics. The question has surely been settled as to whether plants and animals give the impression of wholeness (even in the context of their natural setting). Mere *purposiveness* is never an adequate term. In this the descriptions of the naturalists agree. In other respects these descriptions usually stop short of the essential problems. In some cases they have advanced the study of aesthetics and have often been focussed upon correct aesthetic investigations. For example, we possess several treatises by the zoologist Möbius on the beauty of animals. The beauty of mammals is to be determined by the bodily structure. This, however, conforms neither to a mathematical law nor to the requirements for survival, but signifies the triumph of force over the weight of the body. Moreover, the zoologist stresses the influence involuntarily exerted by the familiar appearance of the human form and domestic animals, an influence which makes the mandrill look like a caricature of a man, the giraffe like a misconceived horse. In the case of birds their aesthetic and social characteristics depend upon form, color, and manner of movement. The composition and luster of their colors especially produce strong and regular aesthetic feelings. Although he was not familiar with the distinction between flat and surface colors, Möbius called attention to an essential difference: "The gay coloring, luster, and iridescence of birds and insects is even surpassed by the beauty of translucent aquatic animals. If one compares, for example, a jellyfish in the water and a butterfly, he feels that the butterfly's colors lie hard and cold on the surface of a rigid body, whereas the colors of the jellyfish softly and warmly permeate the whole supple body." In his *Kunstformen der Natur* and in the eighth section of his *Lebenswunder*, Häckel made several *aesthetic* observations: linear (repetition of simple forms), actinal (radiate order), and bilateral (symmetry). These formal conditions are supplemented by associative or symbolic ones concerning the agreement of an organism with its vital activities, concerning comparison with man, and concerning difference of kind. The size and richness of a landscape, Häckel finally asserts, require a certain irregularity, to which strong feelings are attached.

When the intimate relation to the landscape is thoroughly intelligent and scientifically applied, it leads to activities which, in spite of their connection with the aesthetic life, are not properly classed as artistic creation. Topography reproduces inanimate nature with the implements of the draftsman: paper, pencil, ink,

and colors. The mechanical part of the work can be disregarded here. But after the cottages are placed, every object to be found between the precise points must be carefully viewed in its spatial relations and drawn in with correct shape and size. The whole map should finally be not only easily legible and reliable, but clear and attractive. Moltke called such topography "overhearing the secret of the earth's scenic art." Hence this activity requires first a familiarity with all the details of the terrain—field, forest, stream, mountain—and then the technique of the draftsman must be mastered in a certain sphere. Still no one calls topography an art in the same sense as painting and sculpture.

If one asks for the reason, then almost certainly it is to be sought in the lack of free construction. The first commandment of topography, precision, excludes the exercise of that creative imagination which is inseparably fused with our concept of art and the artist. The case is different in the second example which we are about to consider. Flower gardening gives free play to the creative impulse. The Japanese, so we are told, *compose* their gardens, constructing a representation of a landscape out of the constituent parts of nature (thus, moreover, enabling these parts to have symbolic meaning; certain stones under a tree perhaps signify the seat of Buddha). Even our gardeners of higher rank are no mere manual laborers or imitators; so other considerations have been adduced to ban their work from the sacred sphere of the arts. Some have contended that the horticulturist does not have to overcome such obstacles as the plastic artist does. Yet that hardly proves to be the case. The difficulty of fashioning from a desert tract or a tangled wood an integrated whole, where every color and form is at the right spot for every position of the observer and every season, where the survey of the whole and the joy in its details do not interfere with each other—this difficulty is indeed of another sort, but is no less weighty than the average of what an artist has to overcome. Perhaps the restriction to the materials of nature is incompatible with the unworldly character of pure art. Perhaps we feel instinctively that the detached and exotic quality of the artistic is impossible in horticulture. If so, we might well have a reason for striking horticulture from the list of the arts. It is an aesthetic skill, if you will, but then not yet art. The instinctive feeling expressed in linguistic usage has guided us more surely than the theories of aestheticians.

Moreover, in all such situations where boundaries are

70

marked off and titles conferred, the standards are set by social conditions not sufficiently considered in pure theory. How high the artist is placed in the social scale, which arts are most in demand in an age, to which field the greatest number of distinguished talents is applied—such conditions determine quite fundamentally the evaluation of a particular field of activity as an art. The boundaries between craft and art are fluid and subject to historical change. As no conceptual definition can do justice to the variety of content and of application, even theory must concede the mobility of the boundary. Clearly we are now again entering a period in which architects will not disdain to devote their powers to the laying out of parks, and in which artists will be as vitally interested in the floral decoration of balconies as they are now in the restoration of tapestries. We can observe that the change of taste from the spatially static to the temporally dynamic has already made its way into the art of horticulture. Plants like yew hedges were formerly cut according to fixed types, and flowers in bouquets were pressed together into definite patterns. Now the gardener treats all plants, whether the garden be large or small, as temporal creatures, as living and growing individual beings. Once the landscape architect fashioned water terraces which had the effect of spatial forms; now he seeks grace in the movement of the water.

If we pass on from the aesthetic objects of nature to the region of what man himself fashions—apart from art—we find the aesthetic need so powerful that it spreads out to nearly all human activities. We not only strive for a maximum *intensity* of aesthetic pleasure wherever obtainable, but we also apply aesthetic considerations much more *extensively* to the conduct of practical affairs. Throughout intellectual and technological fields the vital energy partially takes on an aesthetic form. Whenever a machine, the solution of a mathematical problem, or the structure of a social group is called beautiful, the judgment is more than a mode of speech. For we find the similarity in the inherent purposiveness of the whole and the harmony of the constituent parts as revealed by the whole. The self-sufficiency of the aesthetic form and its prevailing unification of the manifold become a model for the arrangement of things and events. In so permeating our creation spiritually that its happy arrangement of parts sets it off from the incalculable diversity of natural existence, we make our product for the first time wholly satisfying. Hence Dugald Stewart could sketch the outlines of an aesthetics, while showing scarcely any concern about art. To our

scientific habits of mind that seems absurd. We fully believe we have lost our bearings when we read in Alexander Bain that the joy in our nation's position of power, the consciousness of class, and family pride are aesthetic feelings. But on second thought we recognize a certain propriety in this paradoxical view. For the consciousness of activity which the creative artist and the appreciative beholder have in common can be freely expressed also in those feelings. Moreover, the claim of superiority for the nation, the class, and the family to which the thinker belongs facilitates a synoptic view which affords intellectual satisfaction. Since in this case the ego stands at the center, the pleasant regularity obviously depends also on the content. Under such conditions more justice is generally done to the content of the parts and their nature as parts. Also, increases of value and displacements enter which can finally destroy the unity and lead to asymmetry. In the development of nations and of individuals there are times when this liberation from a constraint lends a great charm to the asymmetric forms thus achieved.

Social affairs and modes of life doubtless belong within the scope of aesthetic objects. No regulation of social relations, no mores or customs should violate good taste; indeed, they should evoke aesthetic feelings. Unfortunately, the aesthetic aspect of our life is at an alarmingly low level. In social intercourse there is a prevalent lack of form, which we euphemize with the expressive term *geniality*. We are continually shouting instead of speaking, and no social gathering is arranged without the table set for a meal or the definite purpose of some club. We think that etiquette requires us to introduce ourselves to one another in the drawing room, and to use the third person, with titles, in address. In our newspapers we put notices of engagements and broken engagements, that is, announcements and nullifications of intimate pledges. To understand very clearly how sadly the sense of form has degenerated, even among intellectuals of high standing, one should listen to the speeches or conversations of famous men. He will then have to admit that in these fields aesthetic perfection is not even attempted, still less attained.

Now that we have found our way to some extent in the broad field of aesthetic objects, it will no longer sound too bold to say that someone could set up a complete system of aesthetics without knowing of the existence of poetry, music, or painting. He could then describe and analyze the aesthetic experience, since this is evoked in full strength by the objects of our environment. He

could also adequately interpret the beautiful and the sublime, the lovely and the ugly according to external conditions and in terms of the things and events of daily life. And that is not all. In skills and organizations of all sorts he would have the most instructive examples of the aesthetic transformation and fashioning of nature. Hence the proposition may pass as established, that *taste* can develop and operate independently of art.

At this point we shall put aside the relation of the beautiful and the aesthetic to the artistic, and return to the question which has now become simpler: With what right does science, in clear opposition to linguistic usage, treat the objective side of the aesthetic experience as something separate? Aesthetic experience bears within itself a two-fold necessity; an inner necessity, the self-certainty of the cannot-be-otherwise, and a necessity directed outward, the control by the object, the consciousness that an objective reality is completely taken up into the experience. This consciousness proves to be dependent on the constitution of the thing, and hence leads to an independent investigation of it. Indeed, it seems as though in every perception the thing were wholly conveyed to the self. But closer consideration, as Theodor Lipps has indicated, reveals that something is lacking. In such cases the parts or characteristics have a merely de facto coexistence. When I distinguish color, form, weight, and tartness in a lemon given as one whole, I feel that each of these qualities could be different without disturbing the connection with the others. Were the lemon perchance a red fruit, it would likewise be perceived completely and readily. In the aesthetic object, on the other hand, the parts and the qualities demand and support one another. Hence the mental contents implanted by the object show an unusually high correlation with the whole state of consciousness. On the assumption that pleasure in general is grounded in an ease of vigorous mental activity, we understand that a thing whose constituent parts and properties obviously refer to one another in spite of diversity must evoke an intense functional pleasure. For this necessary affinity of different elements gives impetus to the mental activity, and in its further progress creates the feeling that the mind is wholly aware of the object.

Theoretically viewed, the aesthetic experience is the necessary result of an objective situation. On the basis of a decisive characteristic we shall call this situation *intuitively felt necessity*. A figure whose details support one another and a chord whose

tones meet one another from an inner affinity possess intuitive necessity. When children and uneducated people, who know nothing of prosody, catch the meter correctly and thoroughly enjoy it, this is because not a single foot can be added to or taken from the verse at will. Why are we pleased by the roundness of a full tree top or the silhouette of a resting cow? Because they are *bien enveloppé*—by the regularity of the enclosure they indicate a sure direction to the psychical energy which has been thrown into flux. An aesthetic creation arises from a succession of sounds only when they are immediately taken as belonging necessarily to one another. In unusual kinds of sequences we at first hear no melody, but only tones; the intrusiveness of the elements or undue attention to them prevents the appearance of unity. We do not see the forest for the trees. The dramatist Wilhelm von Scholz asserts that the basic feature of all human activity is a "striving for coercion, for felt necessity," and thus—by a road we do not propose to follow—it attains artistic necessity, which in the last analysis is "the organic relation and interaction of the whole and its parts." (*Gedanken über das Drama,* new ed., 1915, esp. pp. 59, 82.)

Hence all aesthetic objects show in common attractive features, in virtue of which intuitive necessity (to be discussed again later) is ascribed to them. But we should not go beyond this concession to tradition. It would surely be questionable to require of every object a clearly visible structure. An artistic whole must, of course, have a beginning, middle, and end. The beautiful in nature, however, can occasionally lack even a focal point. Likewise we should be judging prematurely if we labeled the condition mentioned as the only one. It is merely a presupposition for every aesthetic effect of an object on mental life. No *one* formula is the key to the aesthetic, not even the apparently most comprehensive. For if it is so broad that it covers everything, it evaporates into the meaningless.

The task is to describe the object and then the experience in their chief aspects. This is possible through analysis. Although the aesthetic object par excellence is a whole which is more than a sum or a collection, yet only through analysis can it be scientifically presented. In the animal organism digestion, movement, circulation, respiration, and sense perception occur in the closest connection with one another, but the physiologist must treat these functions one at a time. Such is our procedure also. At our disposal are aesthetic experiences on one hand; on the other, as objective

data, the qualities of the objects and the crystallized designations of language. Since the modes and validity of aesthetic judgment are to be investigated, the wisdom contained in the gradually fashioned linguistic categories and in the adjectives of praise and censure should certainly not be ignored. Our terms of comparison indicate which qualities, from the simple to the complex, and which degrees, from the weakest to the strongest, play a role in aesthetic life. That very low and very high degrees are excluded we note at once in the terms for such conceptual pairs as icy-ardent, imperceptible-deafening, dull-caustic. With equal clarity we see in the usage of words how sense experiences are transposed into other sense departments—a color, for example, may be warm —and statements of fact merge with evaluations. In all these processes the spirit of the language exerts a control which we have considered in connection with the problem of empathy and shall continually be recalling. But as soon as we have in principle overcome the naïve certainty of the person who fancies that in words he possesses a perfect copy of the inner or even of the outer facts, the help of language can also be gratefully received.

In the aesthetic object we distinguish merely the most important and general features. The several arts are to be analyzed in much greater detail. The particular sciences of art have adequate opportunity for this, as their aim is to make intelligible the construction of the works they study and thus to facilitate historical investigation. The origin and growth of a group of musical forms can be presented with proper accuracy only when the elements of this group have been separated from one another and then examined in their development, in part independent and in part cooperative. Thus the history of the ballad has not been written yet, because historians of literature trace back the form as a unity, and hence do not push on to the roots. But aesthetics and the general science of art can stop much earlier.

2. Harmony and Proportion

Aesthetic forms include relations which may be treated separately, as they have a certain independence. With the exception of the relations between colors, they are such that they can

remain constant despite fluctuation of the contents they articulate. Although the relations between colors depend on the qualities of the individual colors, differences of brightness and of spatial and temporal distance are free from control by the content.

An intuitively necessary and pleasant relation between colors is called harmony. Later on more will be said about tonal harmony, which pertains only to music and the parts of poetry dependent on music. There is an essential difference between tonal harmony and color harmony; the former is very seldom found in nature, but the latter quite often is. Hence aesthetic judgment of color combinations is subject to two influences, dulling and association. In the realm of tonal harmony we are sovereign, but when considering the relations of colors we must always keep in mind that combinations existing in nature, although they originated without regard to aesthetic sensibility, nevertheless do not pass away without exerting some influence upon it. Hence combinations unpleasant in themselves can become indifferent or even pleasant if they often appear in nature. Secondly, the associated idea of the object in which that combination is regularly observed can enter into the impression generally. Supposing that the red of dark roses and the green of leaves did not go well together, still the frequent repetition of this combination would deaden the feeling of unpleasantness. Moreover, where both colors appear in a quite different context, remembrance of the most familiar bearer of the combination involuntarily exerts an influence. If I see the whole matter correctly, the second danger is more imagined than actually present in experience. The difference between the objects almost always prevents the appearance of association and even its emotional aftereffect. And we yield to the power of custom also in the mere artistic representation of objects with which we have been familiar in reality, hence perhaps in the portrayal of roses surrounded by leaves.

Even such cases are not immediately comparable, for the colors given in nature and the colors used in art differ considerably from each other. The difference is due in part to the fact that in nature there is a great deal of light shining through translucent objects (dew drops, for example), there is the finest gradation in the intensities of light, and a wealth of modulations between colors. Then the quality of the individual color has great importance. From psychological investigations we know that saturated colors have a different effect from colors strongly tempered with neutral

76

gray, that modest, delicate colors are preferred to brilliant, lumi-
nous colors, and these to dull, dirty ones. The last point, which is
generally neglected, seems important to me. Very strong colors are
decidedly vulgar. Flamboyance is barbarous, not harmonious, espe-
cially when it changes at random as in the iridescence of flashing
diamonds. Or more cautiously put, the plumage of a pheasant, the
glaze of enamel, the sparkle of iridescent ornamental glass, and
the splendor of fireworks appeal only to the light thirsty eye and
not to the sense of harmony. To be sure, all this dazzling confusion
may be counted as aesthetic, but it must be sharply distinguished
from harmony. From its undeniable efficacy we conclude that the
more brilliant the colors, the more arbitrary and shifting their
combination can be, for the observer gives himself up to the charm
of the gorgeous splendor and demands little harmony. These are
impressions which can be fully enjoyed even by children and
primitive men, impressions of unbridled, reckless vitality.

The harmony of colors can best be judged when the pig-
ments are not too brilliant and the areas they cover are not too
small. Also, to be sure, the spatial extent should not be too large,
for uniformly colored areas of considerable size tire the eye and
tend to give the complementary color to adjacent areas. But colored
dots produce no feeling of harmony. The requirements set in the
usual technique of painting (a certain flatness of the colors, gen-
erally obtained by mixture, and a certain spatial extent of each of
the colors) are therefore the most favorable for evoking feelings
of harmony. But pictures cannot be judged in a place flooded by
bright, unobstructed daylight. Thanks to some well known artifices,
however, a picture may be freed from these disturbing influences
and restricted without seeming too remote from sparkling reality
bathed in light. The first such device is the use of contrast in
brightness. The simple experiment which is always chosen to make

Fig. 1.

the contrast clear consists in pasting a small white paper square to
a larger paper square three times: first to paper of the same white
color, next to gray paper, and finally to black. It is immediately

clear how the brightness of the paper grows through contrast with the border. Hence, for the representation of widely separated intensities of light, painters will be permitted to use frames or at least border lines, regardless of their knowledge that in nature there are no outlines. Where it appears that an actual contrast in brightness would be ineffective, by means of color the painter can simulate differences in the intensity of light like those in nature.

Out in the open, but also under certain conditions in confined spaces, streaming light acts as an aesthetic quality of things. By creating the so-called *tone* as a unit, great painters have understood how to reproduce this light through differences between the relations of brightness in color qualities. But their technique of values (*valeurs*) suffers from the defect that the impression of light disappears at once if the colors are marred and dull, or if the observer is at a greater distance. As one can see in the paintings of Claude Lorrain, this is serious because the requisite (but undue) closeness of the eye to the plane of the picture makes the correctly drawn perspective appear distorted. If the observer steps farther back, the spatial relationships fall nicely into place, but the light goes dead. Hence another method has long been used, which conjures forth the fullness of light precisely at the greater distance. The colors are analyzed, as it were, on the canvas, and the eye is left to blend them into a unity. With certain modifications Jan van Eyck and Constable, Watteau and Turner, and finally the Impressionists have worked in this way, achieving striking impressions of brightness. Nevertheless the result depends largely on choosing pigments that are not neutral but as vivid, brilliant, and pure as possible, rivaling the colors of the spectrum. We must consider this again in the chapter on painting. Yet even the present discussion of elementary questions permits an instructive application to the general problem. This technique can reproduce the real world of color no more faithfully than that other technique can. What we attain is a new transformation of nature into a system of color laws. In certain schools, such as the Flemish primitives and Böcklin's circle, the individual colors and the harmonies in smaller regions of the canvas have claimed the powers of the artist to such a degree that he does not achieve the highest unification. But where a whole is attained—whether in Rembrandt or in Monet— the color must somehow be stylized. A higher degree of luminosity is secured, even for the individual color, not in the natural way, but only through a number of gradations. Luster and vitality are artificially won.

For all these reasons it is utterly impossible to say whether two colors—red and green, yellow and blue, red and blue—do or do not go well together. Also the customary limitation to a pair of colors is an oversimplification of the problem, since the triad is usually basic in nature and art. So the experiments which have recently been undertaken in psychological laboratories can provide only a provisional standpoint for further investigation. In any case, it seems to be established that true complementary colors are seldom pleasant in juxtaposition. We prefer pairs of colors that are qualitatively closer. When complementary colors are placed together, they easily—though not always, as a glance at our environment and at good pictures shows—become uninteresting and glaring, for effects in the form of imitation and contrast can set in harmfully. The deeper reason for the dissatisfaction so often felt is, indeed, that the complementary color on one hand is not sufficiently independent of the original color, and on the other hand, is not bound to it by any unifying relationship. Therefore a given color harmonizes with a remote but not complementary color as an independent quantity, and with neighboring colors because they seem to be tints or shades of itself, hence fundamentally at one with it. Ordinary red, bright red, and dark red are agreeable as values of the same color. Ordinary red and dark blue owe their moderate pleasantness in spatial contact to the circumstance that their opposition is not physiologically necessitated, as it is in the case where the eye, fatigued by one color, covers the surrounding region with the complementary color. Let me say incidentally that in the first relationship the knowledge of the color quality of the values is included; dark red beside normal red usually acts as a shaded part of it.

We turn now to the theory of proportion. By *proportion* I mean an intuitively necessary and pleasant relation of measure between a whole and its parts, or between the parts. We speak of proportion in spatial forms as well as in temporal intervals, in visible as well as in audible objects. In both fields we are concerned with relations within an objective whole. With spatial forms these relations appear either in the structure or in the boundary.

If, following old usage, we call *symmetry* the simplest structure, we must add that the equality of the two parts with respect to a vertical axis is to be understood. In the strictest sense a form is called symmetric if it is vertically divided into two halves which, when placed one on the other, exactly coincide; the parts

on both sides of the axis are the same in number, position, shape, and size. But the pleasantness of the figure depends on the presence of these parts since, for example, a circle symmetrically divided by a vertical diameter is so poor in content as to make almost no impression whatever. In general, the effect of symmetry as such is rather weak; hence one usually reads not of its beauty, but merely of its pleasantness. The aesthetic value of a congruence attaches to the large number of parts, and so it is not primarily a question of formal perfection and real significance. If I write my monogram in ink on the dividing line of a sheet of paper and then fold the halves together, the monogram blots and yields a corresponding impression on the other side. A symmetric pattern appears in which the flourishes form the skeleton, as it were. If one views it so that the flourish or its reflected image is above, he remains indifferent, whereas looking in the other direction evokes a slight feeling of pleasure. This feeling can have various tones, for associations are very easily infused. (Many specimens of handwriting produce forms which are as regular and at the same time as grotesque as the comical verbal distortions occasionally created by the baby-talk of our children.) However, the feeling is always an aesthetic pleasure which the half by itself will never evoke. Accordingly, a two-fold enigma remains to be explained. Why does congruence please only in a horizontal arrangement, and furthermore, what value does duplication add to an aesthetically ineffectual object?

The first question is partially answered by the fact that most natural structures concerning us aesthetically show lateral symmetry. As we are thus accustomed to this symmetry, its transfer to works of art affords the pleasure of rediscovering a familiar regularity. Yet the bilaterally symmetric form of men and lower animals would not suffice to explain the obvious preference for this symmetry in the creation and enjoyment of works of art. A second circumstance lends support. There are technical necessities which lead to the placement of two congruent parts more often in a horizontal than in a vertical direction. With simple structures and useful objects the logic of the thing compels this practice. Where a material manifests its nature and a work of art in application shows its purpose, geometrical symmetry naturally appears. A spear may be thrown well, although fashioned with only right-and-left symmetry, but in this very way it acquires part of its formal beauty. Finally, there is a reason derived from psychology. We know that an optical illusion prevents the equality of two vertically

measured parts from being seen correctly as equality. If we divide a vertical line into two apparently equal parts, we regularly make the upper "half" somewhat too small, since we overestimate the section above the dividing point. An 'S' and an '8' appear to us almost symmetric although, as inversion (S 8) shows, their lower parts are much larger. If we try to draw a square or right-angled cross, judging lengths by eye, we almost always make the corresponding mistake. Accordingly, an actual congruence, which is sensed as such in the horizontal direction, can here evoke no feeling of pleasure.

This acknowledgment provides a transition to our second problem, for it follows from our last conclusion that we should not identify symmetry and mathematically exact coincidence. So the reason for the pleasantness cannot be sought in congruence. Our question was expressed too narrowly when we spoke of a duplication of the half. Also, it would be unintelligible how asymmetric forms can so often evoke aesthetic satisfaction, but agreement in all relations of measure and form is in fact unnecessary to give the impression of a symmetrical pattern. Rather, the aesthetic equivalence of two halves can be obtained in still another way. A painting with two persons on the left side and only one on the right, or with a figure advancing from the left rather close to the center, while one at the right stays farther away, may have the effect of a symmetric composition. Or to put it better, in such a picture a proper balance of the two halves prevails. In the theory of the aesthetic experience we shall have to justify this use of the term. Therefore, we must either use the concept of aesthetic symmetry in a broader sense than before or if we intend to use it only for complete congruence, speak of isodynamia. Symmetry is the simplest, but by no means the only way to produce aesthetic isodynamia. Of the positions of the human body as they are found in life and art, those that show actual symmetry and were preferred by primitive artists are not the only ones having aesthetic value. We are pleased at least as much by those positions in which more on one side is balanced by less on the other. The pleasant balance is achieved when tensions of certain groups of muscles are counter balanced by relaxations of corresponding groups.

The isodynamia present here also appears clearly in two other connections. A posture that forces the right and left sides of the body into very different movements tends either to let the body return to the initial position (in which slight flexions predominate)

or to pass over into the opposite posture, as usually happens in calisthenics and dancing. Hence, in this second case the alternation of the movement produces a new balance which, of course, can make itself felt in the mere lapse of time. Another adjustment often occurs, it seems to me, between the bodily attitude represented in the work of art and the one faintly suggested by the spectator. If I have observed myself correctly, pleasure is heightened in many cases by a contrast between the thing and the self. If we ourselves are standing or sitting lazily, we feel a very vigorous posture in a picture with peculiar intensity, and we straighten up instinctively on seeing the statue of a bent man. Naturally it is a matter of very delicate motor adjustments, and so an error is not out of the question. Yet I believe I have noticed that sympathy is occasionally caused not by imitation, but by an involuntary act of compensation.

We turn now to the ratios which lend aesthetic value to vertical arrangement. Various investigations show that the division of a vertical line which makes one part less than a tenth of the whole can at best acquire any pleasantness at all only through associative influences. Bisection, even if our optical illusion is allowed for by shortening the upper part, produces no favorable effect as long as the dividing mark serves only to make us aware of the vertical arrangement. On the other hand, the ratio 1:2 in the simple straight line proves to be pleasant for almost all investigators. Yet opinions differ even here, some preferring the longer part above, others below. Finally, the *golden section* $a : b : : b : (a + b)$ is said to be unconditionally beautiful.

Here we must tarry somewhat longer. Since Giotto's time artists have sought for a key to proportion. Their incessant efforts are quite understandable. It would be wonderful if one could put a standard into the hands of draftsmen, painters, sculptors, and architects and say to them, "Arrange everything according to this geometrical proportion and you may at least be sure that no form you fashion will offend the eye." Even more intoxicating is the thought that all beauty of form in nature and the arts, in poetry and music, rests on the same numerical harmony, that the radial distances of the planets, the ratios of the atomic weights, the vibration frequencies of the major chord, and the normal forms of the human body are all special cases of the same great law. Even very cautious investigators believe that they possess in the golden section the principal proportion for men, animals, and plants on the

82

one hand, and for useful objects, buildings, and works of art on the other. They declare every form to be beautiful which is articulated in such a way that the ratio of the smaller to the larger part equals the ratio of the larger to the whole; in the simplest proportion 3 : 5 :: 5 :8. The accompanying figure shows how from a base line

Fig. 2.

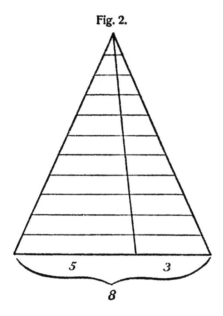

so divided, other lines divided in the same ratio can easily be constructed. To be sure, many years ago Fechner believed he had found that this proportion in a form is by no means always pleasant to everyone. He let the transverse bar of a cross slide back and forth until the most agreeable position was obtained. This was not always the position in accord with the golden section. He constructed two rectangles, the smaller snugly fitted into an end of the larger in such a way that this proportion was exemplified by each rectangle and also by the relation between them. Instead of constituting the acme of formal beauty, they were indifferent for most persons tested, and actually unpleasant for others. In measuring crosses on graves, ornamental crosses, coffers, and so forth, to which, of course, the manufacturer necessarily gives the most acceptable form, Fechner discovered many deviations from the golden section. But more recent investigations, which were under-

taken with a complete series of proportions (that is, a series as nearly continuous as possible), do not wholly agree with Fechner's results. They prove that a proportion deviating slightly from the golden section evokes pleasure. But the calculation of such mean values shows merely that aesthetically valuable forms lie within certain numerical limits. (Witmer, *Analytical Psychology*, 1902, p. 74. The painter Curt Hermann said, "The thought of the golden section has guided me for many years" (*Der Kampf um den Stil*, 1911, p. 57), but even here we need not take the expression as referring to the exact mathematical proportion.) Were the mathematical proportion the ground of our pleasure in the forms, it would have to hold with perfect precision; the structures exactly conforming to it would have to be the most pleasant, and other structures would be so much the more lacking in beauty, the farther removed they were from the equation in question. In fact, some proportions which deviate considerably from the standard of the golden section are regarded with approval. One of the best experts on these questions, the American psychologist Witmer, finally reached the rather indefinite view that the preference for such forms rests not on mathematical proportion, but on the desire for a certain distinctness of the parts, and that "the maximum inequality or variety which pleases will depend on the general character of the object and on the degree of personal intelligence and taste." With this we have relapsed hopelessly into that uncertainty out of which we aimed to raise ourselves by means of the golden section.

Of the other misgivings which have recently been expressed, two especially call for consideration. Our view of the proportion varies accordingly as the form is divided in the same fixed dimension, or as the smaller part lies in another dimension from the larger part. In the former case, hence with a horizontal line, the left section can easily be compared with the right, and in the same sense the right (larger) section with the whole line. But with a rectangle only the two sides can be immediately perceived in their quantitative difference, while the sum of the sides does not present a given magnitude in this way. Where there are component members of some systematic whole, a second difficulty grows out of the problem of applying the measuring scale, starting from a definite point. If it is said that on the human head the major part extends from the center of the neck to the eyebrows, and the minor one from there to the crown, yet the question must be raised: What rational justification is there for beginning to measure at the center of the neck? And what about bearded faces?

All these objections are avoided by Johannes Bochenek's system (*Das Gesetz der Formenschönheit*, 1903). From a specially constructed rectangle, its four sides divided in the golden section and these points of division joined by lines, he tries to fashion a linear net which, so to speak, lets the outlines of the figure arise spontaneously. Besides the golden section bisection, duplication and quadratic arrangement are copiously used. And the differences between the male and female figure, between rest and movement, between the skeleton and the full body, between the forms of the child and the adult—to mention only a few examples—receive full consideration. (I quote as the simplest example the "construction of the front view of the male figure." "The length of the figure we indicate by the number 89. If this is divided according to the golden section, the minor section is 34. If 34 is divided in the same way, the minor section is 13. Thirteen, taken twice, gives the breadth of the rectangle of the front view, which consists of two equal halves. (The body is bilaterally symmetric.) If one divides all the sides of the rectangle in the same way, starting from the corners of the enclosure, 34 and 55 result. If one joins these lengths by lines, the lines intersect one another at those points of the figure where the divisions, the projections, and the indentations of the members are found.") The regulative constructions achieved in this way may be useful for the artist and instructive for the natural scientist, but they do not solve the aesthetic problem, for no one can show what connection there is between these extraordinarily variant and complex ratios and our pleasure in form. No one can really explain this pleasure from the ratios.

Finally, we must mention a characteristic of the aesthetic object, namely repetition, which can determine its structure in both spatial dimensions. (The Japanese do not like it. "The tearoom expresses the constant fear of repetition. The various ornamental objects are so chosen that not a single color or pattern recurs. When a living flower is present, pictures of flowers are banned. . . . When one places a vase in the incense basin of a tokonoma, he must be careful not to put it exactly in the middle, lest it divide the space into two equal parts."—Okakura Kakuzo, *Das Buch vom Tee*, Leipzig, Inselverlag, n.d., p. 51.) Later on we shall inquire as to what part repetition has in the construction of works of art of all kinds. At the moment the question concerns the elementary conditions to be met by spatial forms. We have already encountered the principle of repetition in symmetry. But in its effect it transcends the multiplication of an identical unit, for it evokes pleasure by a

regularly graduated repetition of only similar elements. The accompanying Figure 3, which also lends itself to consideration in a horizontal position, makes the law clear in a simple example. The constant process of expansion or contraction, the increase or decrease in the sizes of the parts determined by the lines of the angle,

Fig. 3 Fig. 4

leads to what cannot be called repetition in any literal sense. As soon as an elemental form of the object recurs in a freer manner of this sort, a structure of aesthetic value arises. I call your attention to spinal columns and ribs (Figs. 4 and 5), to wings and fir cones, to the structure of arboreal leaves, and to the countless applica-

tions in plastic art. On the whole, something still further is achieved here; namely, a pleasing boundary line. Even if the content is removed, the outline of every figure formed according to our principle will never be displeasing, and will often be pleasing. The recurring parts also enhance the value of the boundary.

Fig. 5.

Boundary lines insure aesthetic value, as they give firm support to a well articulated form. A contour wins coherence and pleasantness through what it encloses, through the regularity proceeding from point to point and determined by the articulation of the contents. The inner organization produces the outer form. Thus the line of enclosure, determined from within, proves to be a special case of the general dependence of form on function. A short digression into other fields will make the idea intelligible. When the extremities of animals evolve in the three forms, fin, foot, or wing, accordingly as the animals live in water, on land, or

in the air, these forms are products of function. Now, since many parts of the human body perform exactly the same tasks as certain mechanical contrivances, they must agree with these in the form demanded by the function. To meet the chief demand made upon it, namely, the pressures and stresses in standing and walking, the thigh bone, the longest and strongest hollow bone of the human skeleton, has the structure of a supporting arm like that of a crane. The little bony ridges in its spongy substance have precisely the same direction as the lines of tension and pressure in the loaded crane. The same law holds true here as in engineering constructions, in the dome of St. Peter's in Rome (according to the calculation of an eighteenth-century French mathematician), for example, and in the instruments of physics and measurement (first constructed consciously in this way by Georg von Reichenbach). That is, the structure of the bone gives the most appropriate shape with the least expenditure of material. And since even the last little ridge, the boundary of the whole system of ridges (that is, the outer shape of the bone), serves this function, the bone has a functional shape. (This account follows more or less closely the basic work of Julius Wolff, *Über die Wechselbeziehungen zwischen der Form und der Funktion der einzelnen Gebilde des Organismus*, 1901.) Similarly all aesthetically proper lines of enclosure depend on what is enclosed, and indeed on its construction, whether it be mechanically conditioned or merely governed by other laws of form.

The importance of the enclosed space for the linear boundary is shown by the following little experiment. Draw on paper two outlines of the same human form and carefully cut out one of them. The shape of the hole is not grasped. Its outline is the same as the other, but where we have a hole before us, we do not recognize the shape. Only when the hole is filled with black paper, which changes it into a silhouette and provides an object for sight, does aesthetic apperception reappear. Bright colors do not serve the same purpose, for here the content affects us emotionally, but in the case of a silhouette our attention must be concentrated on the pure form. Hence we choose the most abstract dull color, black, thus excluding at the same time all inner articulation. In this way the dark, outlined mass presents a unitary appearance. The upshot seems to be that the spatial content must confront us as stuff of some nature or other to make the boundary lines effective. (Far Eastern taste, however, values empty space; for

example, the equally useful and beautiful vacuum in a water pitcher or a room enclosed by ceiling and walls.) For the same reason half an octagon makes an unpleasant impression of incompleteness, although the lines stand in correct relationships to one another. Central vision is developed in proportion as we replace the outlines (say, of eye, nose, and mouth) by unreal, highly stylized center lines, and can thus achieve the most vivid impression. Consider the three figures of Humbert de Superville which express repose, sadness, and joy.

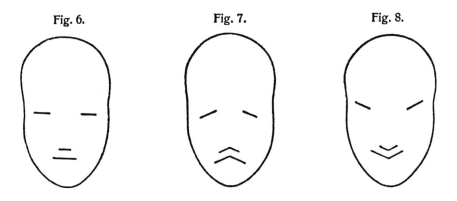

Fig. 6. **Fig. 7.** **Fig. 8.**

We shall now draw the consequences of what we have learned. Since the boundary lines are objectively determined by the content, function, and structure of what is enclosed, and since every form is viewed in relation to a center, the aesthetic value of the outline cannot be deduced exclusively from this outline itself. The usual theory, which nevertheless attempts this, seems to be not only incomplete but also vulnerable when judged by what it does say. It starts out from the measurement of a distance between two points, not connected by any line, and carries on the proof as follows. Whenever the eye is to traverse the interval between two points, it does not choose the shortest path, that of the straight line, but describes a slightly curved line. Accordingly, such curved lines, wherever they appear in art and nature, are the pleasantest, as they correspond to the natural, free movement of the eye. For the same reason we see long lines, especially horizontal lines, as not perfectly straight. A horizontal line, for example, which lies above the level of the eyes appears to be slightly bent down at the ends; if it lies below eye level, its ends seem to rise a little. One

notices this most clearly when the lines on the façades of houses are brought out sharply by illumination. Here the optical impression of curvature becomes so strong that even the knowledge of their rectilinearity and parallelism cannot counteract it.

Granted that all these statements are true. On the assumption that they determine, or at least concern, aesthetic value, straight lines would have to be avoided in large objects and used only in small ones. But the fact is that architecture prefers to use long straight lines, and ceramic art uses curves. Hence those optical illusions can have no influence on the pleasantness. The natural movement of the eye does not explain the formal beauty of outlines. Rectangular relationships, which are supposed to block so effectively the spontaneous wandering of the glance, can free aesthetic pleasure on a large scale as well as on a small. In brief, this theory is not only to be supplemented by the considerations previously worked out, but on the whole to be rejected.

3. Rhythm and Meter

Rhythm and meter are two objective characteristics of an aesthetic event. It is as such, and only as such that they are treated in this section. Rhythm, being the more comprehensive notion, is properly considered first. (Schmarsow has given a brief but very penetrating account of the theory of rhythm in Z.f.A., XVI, 109–18.) Indeed, we shall begin with the question (which only seems to suggest indirection): Under what condition is the feeling of rhythm certain *not* to arise?

A sound that persists with perfect constancy does not produce any consciousness of rhythm. There are two possible reasons for this. Either we miss the division of time or we lack the difference of accent, for both of these characteristics are brought to our consciousness by rhythmic forms. Indeed, an invariant sound no more forces us to an idea of time than does the paper that we see before us. The sound must be broken into fragments, its line must be resolved into points, so that empty moments, pauses, arise. Then awareness of time develops, and also rhythm. Although the particular fragments of the sound show no difference of stress whatever, the hearer provides them with accents. The experiment is always available to show that equally strong impressions of sound,

if repeated, are not heard as such, but changed into a regular series of stronger and weaker sounds, provided merely that the pauses have a certain fixed and invariable length. If they are too long, we cannot hold the sounds together; if they are too short, the regular series of subjective accents becomes impossible. So temporal relations in the object seem to be an indispensable precondition for rhythm.

We can vary the strength of a continuing sound in two ways. One way yields no result. An alternation of increases and decreases in which each period is a long time-interval leads to no rhythmic organization. The fluctuation considerably alters the sound, of course objectively and also in its aesthetic significance, but by no means gives it a rhythmic form. So let us proceed in another way; let the differences of strength follow one another with abrupt discontinuity, as violinists are accustomed to do in a precise preparatory exercise for staccato. Rhythm arises through the opposition of these sharply contrasted differences in accent of the same sound. In other words, although the sound goes on continuously, we nevertheless believe that we hear pauses—how often and where is irrelevant. It is enough that we make subjective incisions and thus attain rhythmic articulation. So dynamic relationships seem to constitute a necessary basis for rhythm.

According to the experiences of the first group, rhythm would be defined as a series of temporal segments which, for psychological reasons, becomes a pattern of accent. According to the other observations, rhythm is a series of contrasts in stress, which produces from itself the consciousness of a temporal movement of mutually supplementary phases. In our relation to music there are moments when this opposition attains more than theoretical significance. The organist cannot graduate the intensity of tones (as by touch), but he can simulate such gradation merely by the change of tone quality and tone color. Yet even here we add the accents to the temporal order. On the other hand, Palestrina's harmonically polyphonic choral compositions are—at least for me—so timeless, so free from all control by measure and meter, that these features are disclosed only by the accents, especially by the entrance of new voices. In general, however, time-rhythm and accent-rhythm are closely connected. Which of the two is to be viewed as the original cannot be determined with absolute certainty by a systematic consideration. If the theorists usually decide in favor of the time-element, they do so involuntarily, because the relative durations, at least in the notation, can be determined exactly, whereas the

relations of strength cannot be established with corresponding precision either in music or in poetry. It seems more appropriate to treat temporal arrangement and accent as equal in importance.

Definite intervals of time with various degrees of stress are comparable in our present field with that element of aesthetic objects in space which we have called the line of enclosure. The rhythmic line of enclosure consists of simple noises; it achieves a bodily, and in the higher sense, articulate form only when filled by tones or words, musical or linguistic elements. We call this frame, into which the two-fold material can be fitted, the meter.

Meter is variable in two directions. Suppose it is given to us through beats. Clearly, then, the alternation of strong and weak beats produces diversity. Of course the mere repetition of beats of the same strength may be regarded as an extensive diversification in the broader sense of the word. And since we know that mere repetition can become aesthetically effective, it must be definitely excluded here. There is another possible direction whenever the degrees of strength are stepped up from the weakest to the strongest in equal gradations or conversely stepped down. But even this regular ascent and descent over a specified number of discernible intervals (symbolized by the series a b c d e f) does not meet the demands of metric-dynamic variability. Rather, we are concerned only with the following regularity: strong and weak beats alternate and this alternation is repeated (*ababab* . . . or *abbabbabb* . . . or *aabaabaab* . . . up to a limit of combinations still unknown to us). The simplest forms of this dynamic regularity are doubtless ♪ ♪ and ♪ ♪ or, in another notation, ⌡ ⌣ and ⌣ ⌡. If we may trust our observations of children, human beings are sensitive earliest and with the greatest certainty to the first form, the trochee. (In the use of these terms, the distinction in ancient meter between short and long syllables is ignored.) But even before tones or words are introduced to provide content, the two opposed metrical lines, trochee and iambus, have an affective quality which can be fully utilized for the purposes of art. The falling meter, which passes from accent to non-accent, strikes us as stiff, while the rising meter has something exciting about it. Doubling the unstressed beats (♪♪♪ or ♪♪♪) intensifies this quality. Especially the anapaest ⌣ ⌣ ⌡)) has a pronounced effect, almost like an attack. When in Old German verses even more than two unstressed syllables precede the accent, it is as though someone were making a running

approach before the final spring, or as though out of muttering weather came a thunder clap. But even in the three-beat meter of sound, the third beat, if accented, affects us like the completion of a beginning or the resolution of an uncertainty.

The other dimension of metrical variation is the temporal. If we suppose the elements of a meter to be indicated by tones of the same strength and quality, then their various durations distinguish them. Such a change in quantity may occur without any accent. More natural, however, is the union of the two, so that differences of stress and of length appear together. Thus

$2/4$ ♩♪ | ♩♪ | ♩ | easily becomes $3/4$ ♩♪ | ♩♪ | ♩. | . In this example, to be sure, the time is shifted, but the accents remain. We gather from this that the change of time (from 2/4 to 3/4) makes little difference, so long as the metrical accents are not altered. A third possible case consists in the opposition of duration and stress, as perhaps in ♩♩ or ♩♩· In none of the three cases is it a question at all of the absolute duration of the metrical form. The notations employed may be imagined in as slow or as fast a tempo as one likes, just so long as the ratios stay fixed. But the question must be raised as to how many of such ratios are aesthetically pleasant. In musical notation we have the answer for the time values. As to the relations of accent, however, neither music nor poetry provides us with any information clearly expressed in fixed symbols. According to the usual theory, the available relations of accent-strength are far fewer than the time relations—so far as these latter may be equated with all the divisions of a whole note that occur in music—for the former are supposed to permit as gradations only unaccented, weakly accented, rather strongly, and very strongly accented values. It is further assumed that the theory of meter permits at most two unstressed beats between two stresses, never more. Hence the highest attainable limit in this pattern is

♪♪♪ ♪♪♪ ♪♪♪ ♪♪♪. But both statements seem to disagree with actual music. In the simple sequence

ppp *fff*

more than the usual four degrees of strength are employed, the second quarter-note of each measure remaining clearly weaker than the first, and the whole phrase being grasped as a unity. Likewise, it contradicts the practical experience of musical and poetical composition to claim that only two weak elements can stand between two strong ones. In the anacrusis of Old German verses one finds, as was mentioned, many unstressed syllables in succession, and in the musical figure

one plays and hears the sixteenth-notes as equally unstressed or as weakly stressed values.

The rhythmical line of enclosure, that is, the meter (a number of definite and variously accented intervals of time) is represented in our musical notation by measures. This representation (which in one earlier passage was slightly qualified) is not entirely reliable, for in our current practice the whole measure always begins with the strongest accent. So it would look as though there were only descending meters, to which at times up-beats are prefixed. But in fact, whoever starts from the audible process, not from the conventional form of notation, must declare without hesitation that quite genuine ascending meters also are to be found in music. Indeed, there is no question that the metrical group rising from

the light to the heavy beat (♪♪ or in measure form ⅜ ♪ ♪ ♪ ♪)

is far more effective, for the movement quickly reaches its climax and ends there. This form has more unity than the other. If the notation in terms of measures recognizes only descending meters, the reason is that with every lengthening of the time intervals (eighth-notes becoming quarter-notes, for example, or a second, slower part being inserted) the change must occur on the strong accent. But, after all, measures are only a helpful device for writing notations, although they are important for musical education and ensemble playing. Yet we regard the measures as existing not merely on paper. We hear the first and third quarter-notes in three-quarter time. We feel a certain uneasiness whenever an unfamiliar piece of music fails to disclose its time-scheme immediately, whether the

failure occurs because it is written in an unusual kind of time or because rhythmical complications at the start conceal the time. But if we catch the time, it soon becomes automatic and no longer an object of conscious attention. A mechanical foot movement and silent counting are the usual devices, not scorned even by musicians. Conductors who describe the rhythmical curve with one hand often beat time simultaneously with the other hand or a foot.

Versification uses no bars and does not restrict the meter to the descending type by accent signs. Then does it always have at least some kind of meter? For German verse there has been an attempt to introduce a distinction. Such verses—so it is said— as are combined with music, especially sung or trilled nursery rhymes, share the metrical precision of the sister art; they are scanned. But literary poetry differs from these common little products. It has no elements of numerically determinable duration and almost calculable weight. Its verses are recited, not scanned; it contains spoken verses in place of sung verses. Of course there are quantitative differences, but they are so elusive that they can be indicated only by the following two symbols: ♩ quarter-note increased a little, ♩ quarter-note decreased a little. The opposing theory regards the distinction between scanning and reciting as a matter of execution, which as such has nothing to do with the objective metrical form. There are a thousand possibilities, ranging from the simple sing-song of the school child to the perfectly free declamation of the modern actor. But they persist everywhere, in contrast to the little counted-off verses of children, as well as to the "Wanderer's Night Song." These varieties of execution do not alter anything in the actual constitution of the poetic form; they are rather its subjective interpretations. I can render a poem so that every length and every stress is sharply brought out, or so that these values wholly disappear. But surely the poem does not, therefore, belong simultaneously to the verse of song and the verse of speech!

There are indeed cogent reasons for the view that every poetic work, in contrast to prose, has its meter. How otherwise should rhymeless poetry be distinguishable from prose? Moreover, was not all poetry originally a strictly metrical choral song of a horde of primitive men? Even before the times of the oldest Germanic poetry preserved to us, had all memory of the nourishing

root of poetry disappeared? Even if we confine ourselves to our own experience, we confront the convincing fact that precisely the best speakers, with all their free flexibility of diction in conformity with the meaning, let the metrical structure of the verses come through. And even from a quite spontaneous declamation we hear the objectively present meter emerging, just as a trained ear can detect the time of a musical work, although the performer now increases and now decreases the tempo, now brings out and now represses the accents. This very conflict between the fixed rhythmic line of enclosure and the independently fluctuating movement of execution gives to musical and poetical verse the charm of supreme vitality. Every shift of tempo alters the time values, but it leaves the metrical scheme intact. It makes four-quarter time as fast as two-quarter time without confusing the two; it allows one verse to be spoken twice as rapidly as another without changing anapaests into iambuses or rising into falling meters.

If we follow carefully the investigations of Rutz and Sievers, we advance a step further. For they reject the view that one can read verse just as he pleases, sing a melodic phrase of Wagner's exactly like one of Bellini's, or understand a picture intuitively in various ways at pleasure. They assert (and rightly) that the work demands a definite treatment—the one most appropriate to it, we must add. Now it is also meaningful to say that a work of art is complete only in enjoyment, since this enjoyment stands as the legitimate fulfillment of the artistic purpose embodied in the work. Without going into the details of the doctrine, we may agree with it that although the mechanical separation of sung and spoken verse is indeed absurd, somehow as it were, a work of art expresses the wish to be presented in a certain way. That personality of the author which cannot be constructed from the facts of his life—in other words, the inner life of the work itself—makes demands on us which, if we are sensitive enough and not restrained by prejudices, we instinctively meet.

Now at last we are entitled to examine the question as to what happens when musical tones or words are set out in metrical form. In both cases a manifold of sounds, differing in intensity and quality, enters into temporal and dynamic relations. The sound quality, which adds so much to the sensuous beauty of the aesthetic object, as a rule has no importance for rhythm. Exceptionally, a change of sound quality can act as so noticeable a deviation from the state of indifference that rhythmic articulation results. Pitch

is very important for rhythmic structure, on a small scale as well as on a large, though only in music. For the philological trick of speaking continually of principal accent and secondary accent should not mislead us into the view that in our present versification the shifting pitch of the voice has a regular part in the rhythmic impression. Its significance lies rather in the expression of the emotions. But we have not yet touched upon the chief difference between musical and linguistic material: the fact that tones readily fit into any metrical use, whereas monosyllabic words by their vowel length and polysyllabic words by their accent already contain in themselves the elements of a rhythmic pattern. So the poet faces the problem of combining word-rhythm and verse-rhythm most pleasantly. A repetition of exactly equal word-feet is monotonous and restricts the poet uselessly in the choice of words. But the history of literature and the theory of poetry aim to show how one proceeds in detail to avoid these dangers, doing no violence to language and leaving sufficient influence to meter. A final difficulty arises from the conceptual kinship of several words, which proscribes any dismemberment, demands inclusion within a unit of breath and marked separation from the adjacent complex of fact and of sentence. The problem is solved by the caesura. Where the metrical scheme has definite places for caesurae, the poet must adjust his sentences and parts of sentences to these. In most verses, fortunately, the choice of places remains open. The full effect of the poem comes from the blending of all the syntheses—small and great, outer and inner—into a comprehensive unity.

We call these temporal and accentual relations of words and sentences linguistic rhythm (in the narrower sense). Hence this rhythm must be distinguished from the metrical scheme. In other words, the metrical frame is complemented by materials which have already undergone rhythmical ordering. Or, in the language applied to spatial forms, but in reverse order, proportioned contents enter into the circumscribed area.

Then is it perhaps also true that the tone-sequences which music has to fit into meter are already rhythmically arranged? Is there at least a rhythm independent of meter? The answer is certain. Every melody, moving in syncopated and similar forms, replies in vigorous affirmation, for it shows its own immanent rhythm, which as such has nothing at all to do with meter. The essence of a musical idea is a rhythmical motif. This motif, to which naturally various tonal steps at once impart the character of a *Gestalt,* has

a beginning, middle, and end without any regard to metrical unities. In our musical notation this is very inadequately indicated, as the composer takes it for granted that the inner logic of the motif will impress itself upon the performer and the listener. The smallest rhythmic motif corresponds to the rhythm of a word; for example, possibly ♪♪♩ ♩ to the word *metaphysics* (*Metaphysik*). A larger musical phrase has a coherence comparable to that of a spoken sentence. In Liszt's symphonic poem, "Battle of the Huns" (*Hunnenschlacht*), the following passage, sharply molded in rhythmic terms, portrays the Huns advancing on horse to the attack and then in a flash charging into the mass of the foe:

This rhythm is spontaneous, free of time and meter, just as the continuity of lyrical feeling is never subservient to the metrical line.

The factors hitherto discussed individually are joined in tune and song. The meter of music and speech, the rhythm of motif and sentence, enter into the most complex combinations. This complexity is least in the roundelay and in the nursery rhyme stemming from it, in the singing of primitive men and in the folk song. Here we encounter the regular metrical music of song. Furthermore, we readily see that whenever metrical lines coincide with the unitary content of a poem, they find their natural expression in a rhythmic motif which, however, deviates from time and meter. Such is the case, for example, with the two songs, "No Rest by Day and Night" (*Keine Ruh' bei Tag und Nacht*) and "Within These Hallowed Halls" (*In diesen heil'gen Hallen*). If one were to phrase them by metrical bars, the text would appear as follows:

Keine / Ruh' bei Tag und /
Nacht, nichts was / mir Vergnügen
Macht, schmale / Kost und wenig
Geld, das er / trage, wem's gefällt.

In diesen heil'gen Hallen kennt
Man die Rache nicht, und
Ist der Mensch gefallen, führt
Tugend ihn zur Pflicht.

A further example:

u. s. w.

Wir win- den dir den Jung- fern- kranz

The rhythmic motif does not coincide with the meter; the prosody shows two iambic dipodies. Heinrich Rietsch observed: "Word feet and metrical feet occur as follows: *Wir win—den dir—den Jung —fernkranz.* So, in any case, the dipody synchronizes with the rhythmic motif, and on the whole the word foot does also." (*Die deutsche Liedweise*, 1904.) Moreover, the very fact that the syllables in *winden* and *Jungfern* are each assigned to two notes indicates a wealth of possible arrangements. Thus the so-called unequal stanzas in the "Song of Ludwig" and in the lays are easily explained: perhaps the first line of the shorter stanza was sung twice, thus equalizing the stanzas in the musical performance.

The more extended rhythmical forms get their effectiveness from the interrelation and steady recollection of all their distinguishable elements. The same holds for meters. Meters, like rhythms, if they are not yet familiar, become intelligible only through repetition in their entirety. They do not arise through synthesis, but they yield to analysis; they are not formed by the grouping of particles, but they unfold into particular elements. If we would seriously push the once prevailing doctrine to its limit, the poet's activity would resemble that of a mason placing stone on stone. The poet would begin his work with the elements (phonetic groups), which are immediately felt as units (syllables). Out of syllables he would compose metrical feet (and words). The unification would then proceed, the feet becoming verses, the verses stanzas, the stanzas a poem. But by and large this building up corresponds neither to the procedure of the artist nor to the feeling of the person who enjoys the product. Justice is not done to the individuality or indivisibility of the whole. The aesthetic object, for purposes of systematic study, is form. Of course, we must dissect it, but we

should not lose sight of the fact that in the analysis we move further and further from the concrete into the abstract, from the actual into the inferred. Epistemology has long seen that the qualities of a thing are not the realities of which it is composed, but that we must start with the thing. Elementary logic no longer begins with concepts, but with judgment. Accordingly, a well developed theory of rhythm could begin with the period (stanza or musical phrase), then move on to the more subordinate line (verse or musical sentence), and end with the *foot*. By this means we are in a better position than heretofore to take account of the fact that we are never clear about a metrical construction until it is complete. At the beginning of an iambic verse we cannot tell whether it will turn out to be three-footed or four-footed, senary or octonary. Premature truncation of a longer line, provided it is the first one, causes no mutilation, but only a shorter form. If the remainder does not appear, the line is unified in another way. Hence, the rhyme has its place at the end, for it stresses most effectively the conclusive force of this position.

But it seems unnecessary to pursue these matters in detail, since only the general rhythmical constitution of the aesthetic object concerns us here. Yet we must still note briefly in passing that rhythm even penetrates into the spatial arts and helps to establish an aesthetic community of all the arts. Quite properly we speak of a rhythmic division of a surface, of a rhythm of lines, and of a rhythm in the movement of figurative groups. Indeed, we can represent graphically the pattern of a metric-rhythmic construction by following (as if directing) the temporal process of arsis and thesis and the rhythmic vibrations in general with our hand movements, and letting them stiffen into a plane figure. (For a good example, cf. Z.f.A., xvi, 499.)

4. Size and Degree

Like all reality, aesthetic reality is an indissoluble union of determinate qualities and quantities. In a work of art no quality appears without an extensive and intensive magnitude, and these in turn are always tied to qualities. Yet scientific abstraction may distinguish inseparable aspects. Hence formalism has long studied

the relations of size and degree within works of art. Seen from this standpoint, beauty lies in the relationships of parts or elements of form. If all beauty consists in form and form is a variety somehow gathered into unity, then it is merely a question of having the elements in quantitative relations to one another. But the absolute magnitudes of the parts and of the whole have no aesthetic importance. From this point of view, in short, 10:20 is the same as 1:2. And as we are taught also by psychology that in mental life ratios play a decisive role, absolute sizes a minor one, we are predisposed to accept the corresponding view in aesthetics.

The theory of beauty as appearance forces us to the same conclusion. Suppose that in art we deal with mere appearance. Then it is clearly a matter of indifference how far the measurements of reality are preserved or altered, whether a man is portrayed life size or smaller at our pleasure, whether a dramatic event occurs in the actual time or in a shortened time. In that exalted state of mind in which art moves, it seems finally to be no longer a question of quantitative precision at all, but merely of quality and value.

Actually this is not the case. Even the natural objects which we take to be beautiful are judged so on the basis of their absolute size and power. And in life, of course, what accords with the species stands as the norm. Whatever deviates too sharply upward or downward from this norm is usually unpleasant. If less sensitive spectators find a certain delight in giants and dwarfs, it may be more a pleasure in the unusual than in the large or small.

More important and more difficult, it seems to me, is the question: What relevance do the size and intensity chosen by the artist have in the artistic transformation of reality? The average of our personal experiences, which serves as a standard for natural beauty, fails us here, for the picture of a man can be x centimeters or x meters in size. Nevertheless, the significance of the absolute size of a picture is demonstrated by the fact that the increase or decrease of its dimensions, without any change of form, can make a different aesthetic impression. Compare a cartoon and its much smaller photograph; the disparity is astonishing. Its actual dimensions give the original picture a certain nuance of value which the smaller reproduction—even though perfect—lacks. There are paintings aplenty which can be enlarged or reduced as we like without changing their aesthetic effect. But a picture of imposing size cannot be shrunk and a miniature cannot be enlarged without their losing the essential elements of their charm. In famous cathedrals

models are often displayed to aid closer study of the details. The observer senses at once that Cologne Cathedral itself, for example, affects him very differently from its model.

On considering the significance of such familiar experiences, we also notice that the spatial relation of a work of art to its surroundings derives its aesthetic value not only from this relation itself, but also from the absolute size of the work. A church between large buildings, it is true, does not appear to be as stately as it does between low houses. But even with the most favorable conditions it cannot fall below a certain minimal size and still be impressive; on the other hand, it cannot—and this is nothing against surrounding influence—transcend an upper limit and still be apperceivable as an artistic unit. A change of surroundings can have a favorable effect with a very large picture when it is moved from a small living room into a museum gallery. Nevertheless, the objective spatial extent, which of course has not changed, is the basis for the part quantity plays in the aesthetic effect.

The case is similar with an objection which very soon demands consideration, namely, that quite often we know nothing of the absolute size of the work of art. Naturally, I do not mean that the definite numerical values remain unknown to us, but only that in general we do not consciously grasp the magnitude of the whole and its parts. Even in these cases the magnitude may be effective, since it can be approximately reproduced in recollection, although not considered in perception. If now even the spatial size varies from the usual mean values, it produces a plainly noticeable effect. So with pictures a much too small size is usually an obstacle to depth, especially when many pictures of this sort hang side by side. Even before we have viewed the picture itself, its dimensions give us the impression that it is not worth looking at. We see a large number before us and at once lose courage. This preconception then influences our enjoyment, whether as confirmation or as a pleasant contradiction, whereby we ascribe more value to the work than its subject and execution warrant. A different disposition arises from our perception of a picture of considerable size, which tends to precede our perception of its content. Such a size is like an alerting signal: the painting must match it by significant subject and technique on a grand scale, by the avoidance of the petty, and by firm lines and heavy colors. (Cf. Thomas Couture, *Entretiens d'atelier*, 1867, i, 271: "A large frame demands great feelings expressed in large noble forms and heroic coloring.")

It has been pointed out by connoisseurs of art that mistakes in choosing the absolute quantity show different directions within the various arts. Painters tend to choose a size rather too small than too large when they do not strike the correct one. The reason for this may be that the painter trusts the imagination of the spectator to extend the constituent parts of the picture even beyond the given dimensions, whereas in the opposite case he fears that the correct interval will be missed and hence the unity of the work not grasped. At least, such a consideration would be adequately grounded in the typical attitude of the public. On the other hand, poets and musicians tend to err rather through over-extension. Their work seldom falls short of the requisite length; often enough it exceeds it and thus becomes tiring.

This observation leads us to the second kind of extensive magnitude, the temporal. Here also we must first consider briefly the relevant aesthetic facts, although only in a few essential features. Now again I am speaking not of the *ratios* of temporal magnitudes, but only of measurable time-intervals. First of all, we should recall the importance of objective time for human relations. In Fontane's *Effi Briest* the Baron Instetten, after more than six years, discovers his wife's infidelity. He confesses to himself that he feels neither hate nor thirst for revenge. "And if I ask myself why not, I can find almost nothing but the years. We are always speaking of inexpiable guilt. Before God it is certainly false, and even before men. I should never have thought that time, merely as time, could have such an effect." (9th ed., 1900, p. 411.) After a duel he says: "If guilt really exists, it is not tied to place and time, and cannot disappear between today and tomorrow. Guilt requires atonement— that makes sense. But forgiveness is something half-way, something feeble, at least something prosaic" (p. 425). I would say that at first it is repugnant to us for moral qualities to be altered by mere temporal intervals. That has something "prosaic" about it, indeed something crude. It should be wholly irrelevant to the worth of an act whether it occurred ten minutes or ten years ago. But does not repetition, which is essentially nothing but numerical increase, produce a similar effect? Of course the purely aesthetic result usually stays within rather narrow limits. Repetitions stand midway between what we have hitherto discussed and another kind of extensive quantity, the temporal. Spatial works of art can contain this element. Simple repetition is found in all ornamental patterns and most decorative structures, in house façades and buildings with columns.

Here the purpose is augmentation. The mere numerical plurality of identical elements, as such, would be just as intolerable for one's developed taste as the clumsy devices used in writing and printing for underscoring, spacing, or the bracketing of exclamation marks at the ends of quotations. But because a new aesthetic quality is indicated by the "often," that is, the frequent repetition, the practice becomes tolerable. The forest of columns is not distinguished from the single column merely as x is from 1. In its uniform multiplicity it has something overpowering, which is lacking in the column standing alone. If the artist aims to show clearly the general nature of structure, he can choose no simpler means.

The same instructive purpose becomes still clearer in the temporal use of repetition. In rhetoric this practice is very familiar to all of us. For the most part a speaker should choose different forms in order to afford his audience several avenues of comprehension. But for his passages of unusually happy phraseology, he cannot dispense with plain repetition. The one-dimensional nature of time gives us no better means of emphasis. Midway between spatial and temporal art, as it were, stands the ballet with its rows of identical movements. Inasmuch as many persons are doing the same thing, it loses in individual charm of course, but its main features are better impressed on the eye and the memory. Poetry has developed a technique of repetition with the annular poem (in which the final words repeat the beginning), with the refrain, and the like. The older music depends very largely on the pleasures of repetition in regular performances as well as in variations.

Furthermore, there has long been general agreement that quantitative determinations can be used to distinguish art forms. Within the smallest musical compositions, motif and theme are differentiated chiefly by length. And among the kinds of theme, the fugue-theme is from two to four measures long, the sonata-theme as a rule has an eight measure period. The sonatina is shorter than the sonata as a whole, and hence in its parts. In poetry, the lyric is generally restricted to short forms, and tradition allows the romance to have greater elaboration of detail than the ballad. The short novel is distinguished from the full novel in various ways, among others by its stricter limitations. The brevity of the epigram and aphorism, the sketch and fragment, gives them that individuality which would disappear with further extension and completion.

We turn now to intensive quantity. Every musician knows from experience that for certain effects maximal power is neces-

sary, whether in the instrument or in its use. Think of Liszt's *E-Major Polonaise* when played on the spinet! Even with the most careful shading in the performance, no fortissimo comes out, as the nature of the piece demands. The maximal volume possible on a spinet is simply not enough. We do not judge merely in relative terms. There are pianists whose touch is incapable of a resonant pianissimo. Even if they plan their rendition of a piece so that everything is carefully shaded down to the least volume possible for them, this may still be too great. Distinguished singers are limited in the choice of their songs because they lack certain accents. If one could play Berlioz's *Requiem* on an harmonica, even preserving the whole musical structure, the impression would still be utterly different. In the fourth movement of this *Grande Messe des Morts*, four small orchestras of wind instruments are specified in addition to the main orchestra. For this the composer requires twelve kettle-drums, many kinds of other percussion instruments, and one hundred and eight stringed instruments. For the chorus he requires seventy sopranos, sixty tenors, and seventy basses. This whole display is not in vain; for a proportionate reduction of the ensemble to one-tenth of its original size would, to be sure, leave the ratios constant, but would so reduce the absolute intensity that the work would become unrecognizable.

We observe something similar in the field of the spatial arts. Objections have recently been raised against the appearance-theory that in architecture and the skilled handicrafts the actual properties of the materials used are important. Hard, bulky oak would be suitable for heavy objects. A palace must be built of massive materials, not of cardboard. Here too, it is a question of aesthetic quantities, for weight and firmness are surely intensive characteristics. Accordingly, the facts cited not only constitute an objection to aesthetic phenomenalism, but at the same time confirm the view advocated here. Moreover, the phenomenon of grace is pertinent at this point. Spencer has reduced it to the law of least energy; movements are said to be graceful when they reach their goals with the least expenditure of energy. This definition, however, is subject to some doubts. The telegrapher discharges his task with such movements, although they need not on this account be graceful. Obviously his little, quick, easy movements still fail to meet all the requirements for grace. On the other hand, many unquestionably graceful movements are laborious, as professional dancers and acrobats bear witness. The *impression* of spontaneity is what counts,

not the *actual* facility and economy of energy. The effort must not become visible or audible. We are fascinated by the play of sunbeams on water because the movement occurs silently, without visible exertion, and as if with perfect freedom. Its rhythm is irregular and unpredictable. A freely falling stone, exemplifying the principle of least energy as it gravitates to the earth, lacks grace. How different the leaf, moving fitfully here and there, carried by the wind, until it reaches the ground! (These views were taken in part from Paul Souriau's *L'Esthétique du mouvement,* 1889.)

Of course, advocates of a relativistic world-view can insist that our examples are all finally reducible to mutual relationships or are at least relative to the limits of perception. Whoever refuses in general to acknowledge that anything absolute can be experienced will analyze into mere relationships even what we call an absolute quantity. But this fundamental view is not under discussion. We are speaking of an absolute quantity and its aesthetic importance only on the assumption that the usual distinction is preserved.

In passing on from our survey of the facts to their explanation, we first examine a point of view which Fechner's *Vorschule der Ästhetik* introduced: the aesthetics of content, which ranks a work of art chiefly according to the significance of what it expresses. We should certainly concede to this view that the nature of the subject conveyed by a work of art is relevant to the form of the work. Then the demand can be made that the "outer magnitude" of the work must correspond to its "inner magnitude," in the sense in which something external can correspond with something internal. As Fechner says, we have no absolute standard, but a very confident general feeling that certain events, facts, and acts have more weight and substance than others. And on this basis, in works of art which treat important subjects we expect different spatial and temporal magnitudes from those in works filled with inferior and incidental ones.

So we judge it fitting for the painter to select a large area for a Resurrection or Entombment, but a small one for a genre scene. It is as though we felt a necessary proportionality between factual significance and sensory form. This creates a difficult problem for religious painting. How can the Christ Child be represented as the Savior; how can a little figure be the spiritual center of the painting? Many pictures of the first rank fail here. For example, in the Adoration of the Shepherds by Hugo van der Goes (Portinari

Altarpiece in the Uffizi Gallery, Florence), this problem was not solved. In the *Sistine Madonna,* on the other hand, it was solved brilliantly. The composition of the picture and its distribution of forces, the posture and glance of the child, whose disheveled hair suggests a prophet, his tranquil pose, a prince—all elements contribute to the effect. But the decisive feature is the enlargement of the child beyond real to heroic dimensions. Raphael could undertake an unrealistic enlargement because it gives no offense whatsoever to the natural wish of the spectator to see the Redeemer, despite his childish form, appropriately embodied.

In general, ecclesiastical art should be imposing. Ignoring particular cases, a small size is simply not seemly for world-shaking events. On the other hand, it would be in infinitely bad taste to give equal space to a still life. A lemon as large as a bulky beer cask is absurd, not because a real lemon is smaller, but because its insignificance does not permit such magnification. In fashioning sculptural works of considerable size, inanimate accessories must be treated very cautiously, especially if there is danger that the size actually seen may be further exaggerated in the spectator's interpretation of the work.

But Fechner has limited the parallelism of outer and inner magnitude. Indeed, we must grant that the external magnitude of a work of art grows more slowly than the internal—insofar as the two are to be compared in respect to progressive alteration. That is, if one contrasts a religious-historical event of supreme importance with a tavern scene, the discrepancy is infinite, but the two pictures do not differ infinitely in size. One may be very much greater than the other, but in no case is its spatial superiority proportional to its superiority of inner significance. One reason for the disparity is the fact that the import of the theme presented is not expressed merely through spatial extent. Since the artist has other means at his disposal to reveal the inner greatness, change of outer magnitude need not keep pace with change of content. The principle of least energy provides a second reason; within every work of art no more energy is to be used than just the amount necessary to reach the set goal. The least magnitudes that still suffice are the best, even though they fall below the work's level of significance.

Now here the theory of empathy helps us further. If readily and with pleasure I perform a movement which reaches its goal with the least expenditure of energy, I also judge an artistically represented movement as beautiful, insofar as it satisfies the same

conditions. This already implies that the dimensions of the work of art must not make my imitation impossible. Suppose that I try to feel myself empathically into a statue. Then I can imagine figures so gigantic that I am no longer able to merge myself with them in fancy. I recall the *Statue of Liberty,* which one sees as his ship enters New York harbor. In this case one can observe at which instant the possibility of empathy begins. At first the statue seems small and indistinct. As one approaches, there comes an instant when he shares the feeling of the upraised arm and the proud, erect stance—and a few minutes later the feeling vanishes. Then, with the further approach of the ship, the statue grows so colossal that no empathy remains. On the other hand, there are puppets so small that they exclude empathy and all pure artistic enjoyment. With too great and with too small magnitudes, inner imitation (as it has been called) can fail to occur. Our mode of organization confines the humanizing interpretation within certain quantitative limits. Although these limits cannot be fixed by principles, they have nevertheless been established with tolerable accuracy for particular peoples and periods. They are also present in music and poetry, although as temporal magnitudes, naturally. While Bach's variations often seem to us too long, we endure Wagner's operas and Mahler's symphonies. Our fathers and grandfathers read the novels of Gutzkow and Sue in many volumes; now we have telegraphic lyrics. The confluence of many elements yields an historically shifting range within which empathy flourishes most securely. Hence aesthetics must leave more precise limitation and explanation to the history of art.

In summary, extensive and intensive quantities are artistically significant. A principal reason for this is that aesthetic enjoyment requires a proportion between inner and outer magnitude. The limits are actually (even if not logically) fixed by the restrictions of empathy to a certain range of size.

But now we must add that even artistic technique involves a relation to size. For example, the grade of line chosen by the draftsman is not something accidental. When we laymen try to draw a head on an octavo sheet of paper, we test various strengths of stroke until we end with two or three. These degrees of strength naturally depend on the paper, on the crayon we draw with, on the angle formed by the hand, and so on. But still they are determined chiefly by the size of the sheet and by the artist's problem. Large subjects and large surfaces call for special techniques. And indeed,

the relation is so intimate that we can start from each of the three factors. The surfaces may be given, if the project is (let us say) to cover walls with mural paintings; the subject may determine the artist; or finally, a technical problem can lead to the choice of theme and dimensions. But this reciprocity is not necessarily limited to its simplest form, the one hitherto assumed. There is also the strange relation in which intentional diminution produces the effect of enlargement. A notice in small print and in the middle of an otherwise entirely empty page has a more striking effect than if filling the whole page. One has the sense of something particularly important and valuable. The same result occurs as soon as a small drawing is pasted on a large sheet of white paper or separated from a frame by an exceedingly wide border. The impression of size which we get from the little picture is deliberately weakened, and by this very means its significance for our feeling is heightened. The reason is, obviously, that we instinctively take the spatial extent of the whole to measure the value of the middle, the only artistic part. A parallel to this aesthetic procedure is provided in the field of logic by the so-called hypothetical (better, consecutive) judgment. By depressing the potential assertion of the antecedent into the merely possible it raises itself, in the connection of antecedent and consequent, to a necessity of the strictest kind. The renunciation of the reality of what the if-proposition asserts is compensated by winning a necessary implication.

The field of aesthetic objects shows a necessity which one can characterize as having sprung from the *objectifying consciousness*. These objects are mental constructs whose value is wholly contained in the phenomenon, but also points to the immediate experience of a subject in general (not the individual man). We must see clearly the kind of necessity obtaining here to avoid two false inferences: (1) that we are making empathy (which is the most important means for comprehending form) the feeling which fashions the object; (2) that we are counting muscular sensations (which are a precondition for the realization of certain aesthetic objects) as these objects themselves. If we now pass on to aesthetic experience, we reach the other side of the situation, hitherto considered onesidedly.

III. THE AESTHETIC EXPERIENCE

1. Its Temporal Course and Character as a Whole

The aesthetic world prescribes to itself its own unique laws, while art, being used in the service of life, of the church, and of instruction, recognizes also the norms of the moral will and the command of truth (though in a certain manner and mixture). And the aesthetic world annuls all mere existence, whereas art at most subordinates it. This intrinsic value, concrete and yet released from existence, is stifled in knowledge, repressed in action, and kept pure only in simple aesthetic reception. As our earlier discussion showed, such reception consists in surrender to the peculiar significance of the aesthetic object and of inner experience. This should be beyond question if we hold fast to the special position of art, that works of art are more than means to elicit such an attitude and that they produce more than merely aesthetic moods.

Our science has been inclined to dwell on the simplest conditions of aesthetic experience. It also makes use of exact observation and experiment, where at all relevant, and with good reason, since satisfaction and dissatisfaction accompany elementary aesthetic processes far more certainly than they do any other events affecting the feelings. It has been said, quite properly, that in our workrooms and laboratories, we cannot be glad or sad to order, but we can produce the calm, delicate pleasure in proportion and rhythm at will, and in terms of the laws involved, show its perceptible changes as the effects of fatigue, attention, exercise, and similar conditions. Yet beyond the simplest aesthetic processes this highly esteemed experimental investigation is really inapplicable. It does not achieve for us what it does for the physicist. He can transfer the

results of his investigations with weak electrical discharges to thunderstorms; he can study ocean movements through undulations in a wash basin. But we do not get the aesthetic effects of a thunderstorm and of a heavy sea at all from an induction machine and a "storm in a glass of water." There we have a difference merely of magnitude, here a difference of kind. Hence, the nearer we come to the actual aesthetic processes, the more cautiously we must apply experimental results. We should not treat pure introspection and the comparison of many introspections as unimportant.

Aesthetic experience must be regarded in two ways. One, used for centuries, seeks to indicate the constituent parts contained in it; the other is connected with the fact that every fairly significant experience unfolds through a temporal interval. When the aesthetic object is itself a temporal process, its reception is determined by the objective occurrence on the one hand, and on the other hand a broad field is opened to free selection, recollection, and expectation in general to relating activity. Indeed, we do not follow the details with perfect fidelity, but fashion for ourselves a subjective course of time on the basis of the objective. Similarly, the more complex spatial structures of aesthetic value are grasped part by part, in the succession of which regularities may be discovered. So we face the task of clarifying for ourselves the temporal sequence of conscious activities in these various cases. I have tried to approximate an answer of the question through special investigations. The procedure consisted chiefly in presenting the same objects to the experimental subjects for different periods of time, and when works of temporal art were concerned, in using various devices to facilitate temporal introspection. The shortest time used was ten seconds. The other arrangements need not be mentioned here.

Hence one does well to explore the lapse of time in enjoying a piece of sculpture or an impressive object in nature by interrupting the inspection at various instants and ascertaining what is present in consciousness after ten or twenty or thirty seconds. He finds that even at the very start there is a certain total impression, that the stimulus immediately evokes a definitely tinged pleasure or displeasure. Without any hesitation we adopt some attitude toward what is offered. No matter how much the preparation of the experimental subject and the constitution of the object may alter the content of the inner experience, this experience always shows form and definiteness. In its aesthetic aspect, as in every other, the first impression has a peculiar value. It signifies something quite unique

and unrepeatable, something irretrievable which occurs only once, something which can subsequently be assimilated or deepened, corrected or supplemented, but never replaced. Although aesthetic pleasure may seem to be exempt from temporal coercion—for such pleasure fades but slowly and can often be renewed by the same objects—yet it too is really subject to the ruthless cruelty of time, restlessly hastening only onward. Every repetition of the pleasure, every later moment in the development lacks the exquisite freshness of the first. We have all learned from experience what it means to meet a person for the first time. We are all acquainted with places, at the first glimpse of which we said to ourselves, "Here I will return when I need peace."—Gone! Never again do we feel the magic of that very first meeting, never do we find the Promised Land.

The particular event which indicates the beginning of pleasure in the statically beautiful is an immediate emotional reaction. Without reflecting we say yes or no, as in the case of persons who at once do or do not please us. If we now examine, by deliberate reductions of the time span, what in this instant is received from the data and what lies in purely subjective states, it turns out that the sensuous qualities of the thing and the organic sensations in the observer are decisive factors. This also explains the instinctive certainty and strength of the first impression. At the start, that is, the unbiased observer sees and enjoys what is spatial and colored. The impression of the significance of the dark and light spots— something for many persons connected with empathy—as a rule comes later. Whether the forms or the colors enter consciousness earlier depends on the object, but a relatively large number of natural objects and works of art evoke feelings of harmony at once. These feelings seem to be connected with the mood, which sets in surprisingly fast, but is usually transferred to the object without any reflection. (The mood at the beginning of the empathic attitude is "represented neither in the form of the emotional character of the object, nor as the effect of the object on me. Rather is it grasped as my mood and yet also as belonging to the object. The landscape does not seem really animated, as a strange person is animated, but nevertheless I take my mood as conforming with and participating in the mood of the landscape."—Moritz Geiger in Z.f.A., vi, 42.)

From here on, observation turns to matters of fact, where the questions arise as to whether the content is easy or hard to understand, and whether it expresses an interesting idea. Associations from individual experience tend to reattach themselves to the

object later. Yet this sequence, which was ascertained for many experimental subjects and for quite different objects as the average course, presumably holds good only for specially prepared—or if you will, influenced—observers and for colored objects. But the principal result may certainly stand. Before one sees clearly everything that is present, indeed before knowledge is possible at all, mood and judgment are formed on the basis of perceived sense qualities. I might almost call this fact an aesthetic reflex. A nearly physiological reaction takes place, whose higher intensities are quite distinctly expressed in organic sensations: in the acceleration or interruption of breathing, in a chill running up and down the spine, or in the feeling of flushing and blanching. As a maximal effect, the first glance at a beautiful object can produce spasm or faintness. When a voice begins to sing we feel ourselves deeply moved long before we catch the words or melody. There are tone colors which excite or soothe immediately, which whip us into a fury or caress us like a gentle breeze. Perhaps they act in this way for only a few seconds, as a sensuous stimulus to vital feeling. But this initial effect is precisely what concerns us here.

Their differences in kind prevent much generalization about the aesthetic effect of poetic works. Heinzel's *Beschreibung des geistlichen Schauspiels im deutschen Mittelalter* considers the passage of time and starts from the assumption that "the first aesthetic enjoyment, which consists essentially in the satisfaction of the desire to see and hear, is followed by another enjoyment, which presupposes full appreciation, especially of interconnections." Judging from my own experience and extensive inquiries, I would say that the stage business operates in this way (like a painting) for not more than the first five minutes. We must therefore try to decide in our theory of the arts whether or not the satisfaction of the desire to see and hear is to be attributed to the drama. For in its other forms, poetry is taken on the whole in such a way that at the start intellectual feelings arise; the enjoyment of form and the imaging of what is read or heard (so far as this imaging occurs at all) come as a rule at the end. I have about a hundred notations on the first impressions made by short poems. They agree that the starting point is the effort to understand the content. Perhaps it would be different if here also the flower of inner understanding necessarily grew from the root of sensuous emotion. The fact that usually the treatment is different should not shock us. Beyond this point we are left to conjectures, as the statements concerning

113

further reactions vary greatly. And we can foresee that artistic enjoyment is precisely what leaves no trace behind; that even with a description, as faithful as possible, to prepare for the explanation of inner experience and to serve as a basis for scientific work, there will almost inevitably be a breaking up of the continuity, an arbitrary preference for the climactic points of the experience, and so on. The longer an aesthetic experience lasts, the harder it is to grasp. When one has observed himself for a minute, he thinks that he sees clearly; after two minutes he wavers; after three he is lost. What goes on within is like a flame, never constant, incessantly renewing itself, and yet ever the same. The whole incoherence of reality as we live through it seems to concentrate itself at this one point. And everyone feels the hopeless isolation in which he finds himself as soon as he lets the drops of water, darting up from the inner stream, strike the ear of another person.

In connection with the greater poetical works, and occasionally with pieces of music, so-called suspense appears during the temporal course of the impression. There are a few points to be noted concerning this suspense. Together with relaxation, it indicates one of the temporally conditioned tendencies of feeling. Physiologists say that suspense corresponds to a shortening, relaxation to a lengthening of the pulse rate, in addition to which still other opposed changes appear in dicrotism. This highest degree of expectation is connected with the relations which insure vital richness and logical consistency to the aesthetic process. There is also a dormant expectation, of which we become conscious only on its subsequent satisfaction. (Karl Büchler sums up his conclusion thus: "We recognized the enlivening of the aesthetic object as the chief significance of suspense. In particular, the various kinds of suspense, corresponding to the kinds of art and poetry, take on various aesthetic values. Nevertheless, the suspense which accompanies inner conflict is everywhere the cohesive element, in the subject as unitary expectation, in the object as the constitutive form for all perceptions." —"Die ästhetische Bedeutung der Spannung," Z.f.A., III, 253.) Over poetical and musical works a net of relations is spread out, in which suspense leads us further. We look forward with uncertainty and misgiving to what is coming, and press on after it, thus unifying the individual self most firmly. Our expectation can mount in such a way that we hasten greedily to the end, as in lower kinds of pleasure, although we know that it is the end. When the composer carries his theme through various keys or involves it in apparently

irresolvable chords, he delights and torments us at the same time. Often we renounce the tranquil pleasure in the course of events and rush forward, ever forward; we confuse aesthetic and actual existence; we skip whole chapters or close the book, the excitement having grown intolerable. Nevertheless, this intensity is intoxicating. The literary author takes account of it whenever he begins with the description of obscure circumstances or skilfully delays the removal of a difficulty. This is especially true where the predisposition to sympathy is to be raised to the utmost. Participation in the fate of a character in a novel develops into a human interest. The longing for release induces the reader to shorten intentionally the duration of the reading or to anticipate the conclusion, thus ending the pain caused by the still unknown and the new. Over them hover countless hopes and fears, wishes and suspicions. But all this lies essentially beyond the aesthetic sphere.

Apart from suspense, only a few regularities appear in the temporal course of the experience. What strikes us first is the unsteadiness, which should be called not a wavering of attention but a surging back and forth of the total consciousness. Some see the characteristic feature of aesthetic experience in the feeling of activity, in the enhancement of psychic powers, in what the object gives us as soon as we grasp it consciously. Others regard as essential that dreamy state in which we indulge in ideas of every sort, and occasionally feel a shudder, as though the object were tearing off a piece of us. No matter which of the two moods is the principal one, the mind wavers between them. I personally, by the way, find the play of imagination most closely akin to what is properly of aesthetic value, for both productive and reproductive imagination bring with them the joy in the significance of the inner life. (There is a similar distinction (partner and spectator), though it comes closer to the concepts of empathy and contemplation, in Richard Müller-Freienfels, *Psychologie der Kunst*, 2nd ed., 1922, I, 66.) Secondly, it seems certain that ideas and courses of feeling tend to rise to the peak of intensity. An unforeseen obstacle increases their energy insofar as they succeed in overcoming it. Otherwise, the attention is turned to the inner self and feelings arise which destroy the unity of the work of art and diverge from aesthetic pleasure. If the peak is reached, the feeling easily shifts into an opposed feeling. To the first general regularity we may add, as a significant bit of experience, that between the active and the passive state of mind a pause often intervenes—the mind's catching

breath, as it were—an actual, though short interruption. If the dreamy state has preceded, the attention pulls itself together with a jerk, so to speak, and images begin again with greater strength. If the active stage has run its course, either fatigue or a kind of restrained freedom appears. Then the mental movement usually passes over into reflection. In the second regularity the intrusion of individuality is concerned, and it has been said that this disintegrates rather than deepens the impression. But such is the case only when the personal ideas have a pleasant or unpleasant tone and persist beyond the region of individually colored sympathy. If, on the other hand, it is merely that a person's recollective imagination is aroused to revive his earlier experiences, his consciousness can remain in aesthetic contemplation. (Heinrich Wirtz describes not only the general activity involved in awareness of all stimuli, but also the aesthetically directed participation in the object: "In the course of the aesthetic reaction actual feelings develop which take on the value of beauty and insure its effects. This activity has many stages and degrees of intensification. The creative urge is one of the highest."—Z.f.A., vIII, 554.)

The chief features of the experience in its temporal course are not identical with the rules set up for the sequence of parts in poetical and musical works. This is true not only because these rules vary with the various kinds of poetry and music (and even then each variation is riddled by exceptions), but also because the course of time within us differs considerably from the order in the products of the so-called temporal arts. The relation of the inner movement to the objectively given is very different from the relation of the reflected image to the object. Nevertheless there are corresponding elements. We saw that activity and strained attention cannot remain continuously at the same pitch. The technique of the poet and composer for meeting this is to include in elaborate works many passages of slighter importance or of appeal to the free play of imagination. After accounts of action or after forms of musical expression that stir us through and through, that (as it were) cultivate the aesthetic field deeply, others follow that evoke a sabbatical calm of spirit, that broaden the aesthetic field, and even let the soul wander forth beyond its borders. The climax corresponds to the striving for maximal intensity; the obstruction to the dramatic action corresponds to the happily overcome obstacle. But, to repeat, agreements of this sort should not mislead us into the belief that the subjective and the objective course always precisely coincide.

If one examines typical experiences without regard to their temporal course, he almost always finds three groups of causes. Karl von Rumohr distinguishes first, "the causes of a merely sensuous pleasure in looking"; second, "the definite relations and arrangements of forms and lines"; third, a class of events which he describes in the following way: "But the most significant beauty rests on that symbolism of forms which is given in nature and not grounded in the human will. Through this symbolism these forms in definite combinations become signs, at the sight of which we necessarily recall certain images and concepts and also become aware of certain feelings dormant within us." (*Italienische Forschungen*, 1827, I, 138 ff.) If this classification is somewhat broadened and modified, it corresponds to what we find within. Actually, with and in aesthetic enjoyment we have sensory feelings which are interfused with general sensations as well as with the sensations of each special sense. Beside these we notice feelings of form which are connected with spatial and temporal relations and are determined by similarities and contiguities within each of these intuitional media. Finally, in line with all these ideas and the feelings immediately given with them, we have a vast swarm of interpretations, associated ideas, and relational judgments. Not by chance, but because they are half sensuous and half logical-affective, the (usually called primary) feelings of aesthetic form stand at the center. More precisely, these are the feelings induced by the affinity or the arrangement of the contents, and naturally also by the combination of internal and external mutual relations. The qualitative relations among sounds and colors produce feelings of harmony; order in space and time arouses feelings of proportion; blends of these two tendencies yield feelings of aesthetic complication. We call the feelings in the final main class feelings of content.

Deferring more detailed explanation of these statements to the next sections, we add for comparison Max Deri's results, in which the causes of feeling fall into three groups: the vehicles of sensory feeling, the content, and the objective form resulting from the limitations of the content. (*Kunstpsychologischen Untersuchungen*, which first appeared in *Z.f.A.*, VI.) With these three groups an absolutely authentic naturalistic work of art can be produced as a pure copy of the beautiful in nature. But the artist can also deviate from nature. He contrives new combinations of color and sound; he thinks up absurd material; he alters the forms and outlines of things and events to give them expressive value and make them symbols of feeling. Again, the work of art far removed from nature

can elaborate the human types (Michelangelo) or "serve to express the finest shadings of personal modification" (Dürer). But these matters are not pertinent here, only the threefold division which is close to the one proposed above. A different result has been obtained in experimental analysis, mainly because the purpose of the investigation and the attitude of the investigator were different. Emma von Ritook stressed, on the one hand, the division of the effective factors into the direct and the relative; on the other, the clarification of the problem of empathy. ("Zur Analyse der ästhetischen Wirkung auf Grund der Methode der Zeitvariation," Z.f.A., v, 356–407, 512–44. Oswald Külpe's points of view, made use of here, are now expounded in his *Grundlagen der Ästhetik,* Siegfried Behn, 1921.) She finds that division justified and the appraisal often determined merely by direct sense perceptions (covering, of course, by this term the recognition of the form, such as a triangle or circle). When we grasp intellectually the meaning of form, attitude, and expressive movement (that is, content), we come to the relative factor and close to objective empathy. With subjective empathy, intuition and association take on major importance. To these are added "reactive feelings as reaction to empathy" (sympathy, fear, affection), as associative emotional reaction or emotional transference (moods), and as reactions of normative feeling (admiration, scorn). Here also the elements distinguished can obviously be classified as feelings of sense, of form, or of content. Meanwhile we will drop this point and pose the question: What arises from the confluence of all these sources of aesthetic enjoyment?

A stream is formed, only the variety of its colorings revealing to the keener eye its derivation from many springs. Often all those psychic processes blend into perfect homogeneity. Here, as has long been noted, the total effect is not to be explained qualitatively and quantitatively by the mere composition of particular parts. The enumeration of the component processes and the establishment of logical relations among them fulfills the scientific purpose only if more is introduced into the particular mental contents than it is psychologically possible for them to possess. That is to say, if a surplus of efficacy is tacitly attributed to the components mentioned, a surplus which otherwise does not properly belong to them, then indeed their combination seems to make the vital feeling of aesthetic reception transparently clear. If, however, one avoids this unwarranted overrating of the constituent parts, then the whole does not emerge. A general difficulty of constructive psychology

is involved here. Yet justice demands that we look also at the other side of the case. The inability to present the living whole as a mere resultant of the several members concerns all humanistic studies. That is painfully evident in our field, and in dealing with this particular problem it should not be held against our treatment of aesthetic experience. And in any case, the investigation of groups of conditioning factors retains a special value.

Since the issue here concerns the total character of aesthetic enjoyment, we must ask next whether or not it is to be called a pleasure, as it has been traditionally. The pleasantness of the ugly and the tragic has often been questioned, for they seem to produce more pain than joy. This is a verbal dispute. Certainly any attempt to equate tragic emotion and the trifling pleasure in a bit of sweet food would be perfectly absurd. Even the satisfaction in simple symmetry and the ecstatic enjoyment of the *Tristan* overture are worlds apart. So we may, if we like, restrict the use of the word *pleasure* to the more trivial impressions, but speak elsewhere of experiencing a felt value, as was suggested above. Yet after all, the other terminology is also permissible. If, that is, we so broaden the concept of pleasure that it comprises degrees and kinds, then the affective state which interests us may likewise be included within it. The lived experience of an inner enrichment through devotion to a value we have derived intuitively, and the heightened consciousness of inner being—these, although not sharply defined and labeled as pleasure, remain in the higher sense pleasant. Both the more passive and the more active enjoyment, which we distinguished in discussing the lapse of time, merit this predicate. Naturally we do not justify it by the hopeless attempt to add up in opposite columns the existent units of pleasure and displeasure. Rather we seek through reasoned reflection to win clarity. We must remember that pleasure and displeasure are interfused. Even the psychognosticators of very ancient times and later the scientific psychologists noticed how trouble and sorrow contain a drop of pleasure. Who does not know the ecstasy of pain, whether bodily or mental? A vital feeling of the most rudimentary sort tends to arise when pain is inflicted on another person, but merely because the pain is felt sympathetically; that is, it is felt. Undoubtedly in many cases and for most persons the sorrow witnessed in another has pleasure-value, for it imparts the joy of superiority. Man first becomes aware of his existence, one might almost say, only by reviling, insulting, and injuring. And so he turns against even his

own body and soul. Whoever fears bodily insensitivity, sticks a pin into his own flesh; whoever suffers from emptiness of spirit, torments himself with anxieties and reproaches. Nothing else evokes the life-force as strongly as displeasure. We are now permitted by linguistic usage and psychology to call the result, the vital inner activity, a pleasure since, indeed, nothing prevents us from assuming different degrees and qualities of pleasure.

If we want to deepen further this preliminary result, that the concrete mental state of aesthetic enjoyment may equally well be called pleasure or enhanced vital feeling, two ways are open. The one is the way of composition out of ideas or sensations. Most aestheticians have gone this way, and we have already spoken of it. The other leads to the point of view in which the mind is no longer regarded as a bundle of ideas, not even as an arena for independent faculties, but as an activity of force or, more precisely, as a sumtotal of dispositions to activity. The moving force is called the self. This self is like the heart; greater and smaller cycles flow from it. One animates the whole field of consciousness; the other stays close to the center. Dropping the simile, the activity of the self, which this psychology identifies with the mental life, extends in one direction to relations with the outer world, which begin at the periphery; in the other direction, to inner relations. The latter have the distinguishing characteristic that the interconnections holding among them are given for direct introspection. In what relations do the solution of a riddle and the resulting joy, or anxiety and the deed issuing from it, stand to one another? This question need not be left to interpretation, for the answer is there. In such necessary connections the spontaneity of the self is shown. (Hegel has spoken of necessity *and* freedom as determinations of concrete spirit.) Surely psychology stays closer to its subject matter in dealing with immediate experience, and does more justice to what we experience or how we experience it when it starts with a creative subject than when it builds with ideas. But this alone would not be decisive. Rather, the question is whether the spontaneous author of ideas can make intelligible every kind of inner experience of value (like every other group of mental states) as its particular mode of determination. But aesthetics cannot pass judgment on this.

The aesthetic experience can therefore be regarded in a twofold perspective: either as a mental state whose constituent parts, separable through abstraction, are seen from below; or as an activity of the self which must be viewed from above and

followed in its individual tendencies. The second method is without question the more correct, but it is so difficult to apply that we cannot dispense with the first.

2. The Sensory Feelings

Imagine a brightly lighted concert hall in which most members of the audience are indifferent, bored, or diverted by silly tricks of some sort—a disagreeable sight. But in the audience there are also persons with all the signs of fervor and ecstasy. They close their eyes or stare into space, let their muscles play tensely or relax. From time to time this nervous state shifts to the other people. It is as though an electric shock convulsed soul and body.

The aesthetic reflex consists of general sensations. The term *general sensations* does not here indicate movement, but has been chosen to bring out the role of general bodily feelings. Here and there, to be sure, there are reflex movements. When we see a hurrying pedestrian suddenly fall, we respond to the visual impression with reflex laughter. In general, we readily react to the immediately comic with laughter or other sudden movements. Human stupidity and conformity with instinct are all rooted in these most primitive responses. Everything else gradually rises from these depths. What we experience aesthetically extends from our animal to our divine nature. (So artistic creation is rooted in bodily states, premonitions, emotions, obscure voices and forms; slowly it rises from the subsoil to purity and clarity.) What does this physical resonance signify for aesthetic enjoyment? First of all, it does not enter into the feeling of activity in the person who enjoys. The chill that runs down the back, the impulse to laugh, the filling of the eyes, the need to swallow, the contraction or expansion of the chest, the growing cold or hot—we sense all these as occurrences in our bodies. The conscious self is not the author. But also it seems that we do not let sensations of this sort pass beyond the limits of our bodies; that is, we do not immediately count them as qualities of external things. In short, we experience them as psychophysical events, having their place in the borderland between the self and the world. (The sensory, kinetic, associative, intellectual, and emotional factors of artistic enjoyment

121

are discussed in detail by Richard Müller-Freienfels in his *Psychologie der Kunst*, 2nd ed., 1922.)

But psychological aesthetics has brought the organic sensations nearer to both the subject and the object. The first change results from a much discussed view of emotion. Organic sensations had been formerly regarded as phenomena *accompanying* emotions. The idea of what gives a person joy or fear stood as the chief factor, and the change in pulse, respiration, bodily temperature, and so forth, as a collateral result. Then some time ago the view gained prevalence that the emotions consist of these general sensations. The most plausible proof of the view lies in an abstractive method like the one which the English and Scottish philosophers once used to destroy the concept of substance. If, that is, we think away all organic sensations from an affective state, only a neutral idea remains. The emotion vanishes without the sensations of bodily states. That is true, and yet the proof is faulty. No feeling comes from organic sensations alone, to say nothing of aesthetic feeling. As will be shown more clearly later, many other elements must be added. To be sure, a physiological pressure, for example, may develop into an anxiety, but then the developed complex is not composed entirely of this pressure. In short, aesthetic enjoyment is so far above the mere passivity of general sensations that this theory is untenable.

Other investigators have, so to speak, externalized the general bodily sensations by undertaking to show that they do not form the basis of the aesthetic judgment, but are precisely identical with it. When we thoroughly enjoy a spatial form, respiratory changes and a feeling of balance are supposed to be especially perceptible. A symmetrical jug arouses the comforting sense of sure balance, the dome-form causes muscular contractions in the head, and so forth. I will not give a complete list, since in my experience such sensations are indeed present, but quite irregular. The regular effect of perceiving definite forms cannot be explained by bodily states that vary capriciously with time and person. If only they were permanent and always the same! Then we could well understand that they are objectified because of their great frequency, while the organic sensations, active in other emotions, remain subjective, because they appear so rarely. But they are *not* the same. Finally, the theory is completely wrong in forcing a biological basis upon art and in asserting that the work of art, since it brings our most primitive sensations into a salutary unity, thereby

enhances our vital feeling and proves itself useful for biological development. It seems to me that this amounts to putting art on a par with food and medicine.

Our view will therefore have to be the one we previously discussed. A new point of view appears when we test the specific kinaesthetic sensations for their aesthetic value. The enjoyment of actual movements in nature and represented movements in art is doubtless strengthened by such sensations. The following observations will serve for comparison. As soon as we close our eyes and think of a flying bird, our bodies slowly and unconsciously turn toward the imagined direction of flight. When we stand by a rushing stream, we immediately feel the barely conscious impulse to move in the direction of its course. Yet with aesthetic experiences something else comes up for consideration. A good many people accompany *all* aesthetic experiences with suggestions of movement. Tendencies to muscular adjustments and imitative movements are frequent and important. The chief reason for them—a reason seldom noted—is their representative power. A clenching of the fist is an adequate substitute for countless bodily and mental activities in which a condensation or tension of some content is expressed. Hence, when enjoyment seems to be connected with the appearance or imagination of such a mental state, many persons will find in that simple bodily gesture an effective device to evoke this enjoyment. It is astonishing beyond all measure what vicarious value the smallest movements of the larynx can acquire, but just as incalculably useless to describe them at length.

The muscular sense is more allied to the so-called higher senses than to the lower. These lower senses are important for natural beauty, but it would be downright absurd to say that on seeing a picture which portrays a tropical landscape, or on hearing a "warm" melody, an increase of temperature is felt. If a literary description of new-mown hay gives me a very vivid impression, still I am not aware of any olfactory hallucination. In spite of their strong emotional stress, these sensations have no place in art. From what, indeed, does the superiority of the higher senses come? Sight and hearing are the most solid supports of the aesthetic life, because they are able to fashion unitary structures of greater extent. Neither smell nor taste in their various modes creates such independent and permanent wholes in the mind as melody and form. In themselves alone they never yield objective qualities having aesthetic value; they merely cooperate with other factors toward

the aesthetic significance of natural objects. The irreplaceability of tones and colors is the ultimate reason why there is no art of touch in the same sense and to the same extent as there is an art of tone and an art of color. Certainly colors cannot be represented by anything else, tones only by way of suggestion through vibrations perceptible to the skin. But the distinctions of fluidity and rigidity, which govern the sense of touch, can perhaps be directly presented in colors and tones. When we just now assigned a vicarious value to the most delicate kinaesthetic sensations, and when we shall later treat the vicarious value of language, we do not hold that the original and the substitute even produce experiences which are just alike, but that in spite of diversity the one can pass for the other. Visual and auditory images have the further advantage that they can be more easily reproduced. They are distinguished finally by their ability to stay free from the immediate exigencies of life and the relations to personal welfare. Their qualities of pleasure and displeasure are less obtrusive than those of smell and taste. But on the whole these emotional colorings have only a limited significance. Even though, when anyone is not fully sensitive to them, his aesthetic experience is thereby impaired, yet the whole by no means arises simply from them. The joy in a regular figure is by no means to be derived by analysis from the pleasure values of the particular sensations of light, nor the joy in rhythm from the particular sounds.

The sensory feelings attached to colors and sounds are strongly affected by differences of personality. Discriminating and undiscriminating persons in matters of color and sound naturally differ also in aesthetic susceptibility. For sensitive natures each individual color has its particular character; indeed, not only as warm or cold, but also as rich or thin, and charming or brash. For two or more colors, selected most naturally by an optical rummaging about among colored bodies, the resulting combinations can be very characteristic of the person concerned. Colors have been freed from their basis in things about as much as conformity to law has been separated from definite phenomena (such as astral movements) in the development of human thought. Like artificial rhythms, colors by themselves produce moods. Their waxing and waning or their violent conflicts serve to express mental life. If in art they are used to portray reality, this can be done freely, either in such a way that different colors are attributed to different forms of reality, or so that several associations are introduced; perhaps

for red: blood—fire—revolution. With sounds it is still harder to decide whether their aesthetic qualities belong to the sensations or arise from accompanying ideas. For the most part, the latter seems to be the case, since otherwise it would be almost impossible to understand the variety of judgments, not only among different nations and periods but even in our society among persons of different ages. It is perhaps a matter of general experience that in music the seventh interval has a sharp and irritating quality, but its rejection on this score cannot be explained merely in terms of sensation. An empty fifth can be felt as hollow or as mild, and so on. The individual tone has an absolute felt value at most in timbre, but never in pitch, intensity, or duration.

A problem connected with sensory feeling, and just now touched upon lightly, deserves some special discussion. To what extent are clear images in the various sense departments aroused by words and especially by literary descriptions? Considering how Zola revels in the description of smells, or how Hauff tells of the poor gourmet who seasons his meager meal with Clauren's descriptions of banquets, one might assume that olfactory and gustatory images arise in this way. On closer inspection, however, one finds only muscular adjustments of mouth and nose, and word-images flitting about in consciousness. I offer for the reader's own experiment the description in Jacobsen's *Niels Lyhne* of the front house of an estate—a description which would necessarily evoke olfactory images, were the feat ever possible—"In a dark corner was the rear door to the shop which, with the peasants' room, the office, and the servants' room, formed an obscure little world apart, where a confused odor of cheap tobacco, mouldy floors, groceries, acrid dried fish, and damp frieze made the air almost thick enough to taste. But after getting through the office, with its penetrating fumes of sealing wax, and into the corridor, which formed the boundary between business and family, one was prepared by the prevailing fragrance of ladies' new finery for the soft, flower-scented air of the chambers. It was not the fragrance of a bouquet or of any actual flower. It was the mysterious, reminiscent atmosphere which pervades every home, no one being able to say exactly whence it comes. Every home has its own, recalling a thousand things, the odor of old gloves, new playing cards, or open pianos; but each is always unique. It can be concealed by incense, perfume, and cigars, but it cannot be destroyed. It always returns, and is there again just as it was. Here it prevailed like flowers—not stocks,

125

roses, or any other existent blossom, but as we imagine the fragrance of those fanciful, dull blue lily tendrils that creep along old porcelain vases." Even in the first stage of so powerful a description, sensory imagination fails us. Such imagination works better in the field of sound. Creaking, hissing, rustling, and rattling can appear faintly before the mind's ear. To some persons, at least, words intuitively present tones with pitch, intensity, and timbre.

With respect to sight, we must distinguish between descriptions of stationary objects and those of temporal events. A clear and comprehensive picture of things regarded as fixed (landscapes, interiors, the appearances of people) is almost never obtained by hearing the description only once. Even with simple things, adequate visual images seldom arise—involuntarily. For a clear image of what is described in all details, we must struggle, and occasionally we reach the goal, as far as ideas of free imagination can ever be called clear. On the other hand, hovering, fragmentary, and ephemeral forms often appear. Frequently the images called forth by particular contexts are surprisingly clear. Recently I read: "Outside, a wonderful field of snow stretched before our eyes. Everything was white, dazzling, grand, and sublime." The impression of color—probably supported by the optical stimulus from the page of the book—was so strong that, almost as though blinded, I raised my head a little more from the white paper. In *Effi Briest* Fontane says that the giraffes looked like noble old maids. One misses the deadly aim and the humor of this remark, I believe, unless a fleeting visual image of the giraffe appears, with the long, aristocratically extended neck and the blank look of the stupid eyes. But there are many apparently intuitive descriptions which, in fact, resist sensualization. When I read in Jean Paul about the cavalry captain, "whose face was an etched plate of pain," I certainly do not imagine any etched plate. Rather I mentally say to myself that pain is deeply and indelibly engraved on the surface of the face, just as it is engraved with a caustic fluid on a hard metal plate. Hence I paraphrase and enjoy the terseness of Jean Paul's expression. The whole process runs its course in terms of language. I do not pass from images to images, but from words to words, and in this way am emotionally stirred. So, for the effective expression of moods, writers even employ sentences which cannot possibly possess any intuitive value.

The situation is somewhat similar when immediacy is sacrificed for the sake of a universal insight without depriving the

words of their aesthetic significance. The best examples of the way in which a concrete core is covered by various abstract wrappings, indeed is mixed with deliberations, again come from Jean Paul. His descriptions tend to begin and end with generalities. For example, in the sixth chapter of *Unsichtbare Loge* a final remark is made about Gustav's beauty. "But all beautiful things are gentle; hence the most beautiful nations are the most tranquil; hence also strenuous work deforms poor children and poor nations." Yet also, as it proceeds description passes over easily into reflection. A passage of this sort occurs in the same place. "His eyes were the unclouded sky which you meet in a thousand five-year-old eyes, and in only ten fifty years old." Whoever reads these few words with sensitivity has his heart enlarged, just as though a melody in unison were to spread out into harmony, as though the detached individual were released from his isolation and led to his place in the scheme of things. But he has hardly been given an adequate intuition.

Now we come to the second point, the description of a visible occurrence. It is an old doctrine that the description of a temporal sequence corresponds to the course of conscious processes better than the description of a coexistence. The reason for this does not lie in the temporal nature of speaking, writing, and reading, but in the fluidity of consciousness as such, and in the necessity of apperceiving fairly large structures by bringing one part after another into visual focus, since the whole cannot be taken in all at once. But if the peculiar feature of poetry is to be found in language—something to be shown later—then the peculiarity of consciousness on the whole, the temporal unfolding of total mental processes, cannot be regarded as decisive. When my glance wanders over the details of a large painting, I turn the coexistent into the successive, just as I do when I describe the painting in words. But now to the point. Visual images tend to be called up less frequently by the literary description of events than by the literary description of static objects. The urge to follow the events quickly seems to be too strong to allow the introduction of many intuitive elements. This becomes particularly clear when the author or his character speaks to us in great excitement. Especially in gripping passages at the moments of greatest tension, we devour the words without giving ourselves time for visual images. Yet the whole mental and bodily reaction is as strong as though we saw everything most clearly. We read on through this verbal profusion, get the right impression, and take the right emotional attitude. So with music.

All possibilities lie in the total score, but we hear only one of them, and in general are concerned with it.

Most persons declare that descriptions of visible actions lead to kinaesthetic sensations and images far more often than they lead to visual forms. Both an actual (even though insignificant) movement and its mere representation can either imitate the action described or correspond to its effect upon the self. When we read an impressive description of violently onrushing waves, we actually or imaginatively either move with them or recoil, as though the waves were breaking in upon us. In none of these four cases do we need the previous appearance of a visual form. And still the field of effects spreads out with its adjustments and adaptations, as we saw earlier. Nevertheless, one should not assert that full artistic enjoyment arises only through the mediation of kinaesthetic sensations. When I read about the expressive movements of a feeling, no imitative movements need to stir in me, not even the slightest incipience. From varied experience I know the mental significance of the muscular movements described and hence can sympathize vividly enough with the state of mind. Without any such middle term the general knowledge of these matters joins the words and the state of mind indicated. It is therefore no inexorable law that an action described by an author needs the help of our kinaesthesia.

3. The Feelings of Form

We have already become acquainted with various properties of aesthetic objects. Some of these properties consist in relations of harmony, proportion, or rhythm, others in an absolute quantity of space, time, or intensity. If we may call all of these phenomena form, then the feelings induced by them should be called feelings of form. At any rate, by *feelings of form* we mean such feelings and also their combinations, so far as they can be regarded as unaffected by content.

With regard to feelings of harmony, the individual facts have been accurately investigated. The chief question for us now is whether feelings of harmony result from the combination of particular sensory feelings or independently of them. Since on the

average the perception of a dirty color tends to be unpleasant, the perception of a bright color pleasant, the coexistence of the two feelings could produce a third, the feeling of their conflict. Or the feeling of harmony might arise through a combination of the pleasure values of two bright colors. Our examples have shown that it cannot work this way. For not just any two colors, even though they are ever so saturated and radiant, but only certain colors induce the feeling of harmony when juxtaposed. Hence the feeling of harmony is attached to a relation—let us say a kinship—of the separate colors which is grasped along with them, even at the same time, but is clearly distinguished from them. And only because this is so, do we have the right to separate feelings of harmony from sensory feelings in theory. Otherwise they would be complicated sensory feelings. The same holds for sounds. We have here a very general question which we have already mentioned several times.

The tones in a melody, the lines in a figure, in short, the parts of an aesthetic object, so far as it is merely form, stand in certain relations to one another. The tone just heard is higher than the preceding tone and lower than the following one; the upper section of a vertical line is equal to its lower section (not in measurement, but in our impression), and so on. Now, are the relations to the accompanying contents already given in the particular ideas themselves, or is a comparative judgment needed to grasp them? Experience and epistemological necessity, it seems to me, equally force us to the second position. In a heard tone A there is great variety, but not the fact that it is higher than A *flat*. No one can *see in* the color green that it is not red (like its neighboring color), but it is and remains exclusively green, and the diversity is established in the mind by an act of thought. The *parity* or *disparity* of extensive or intensive magnitudes is disclosed only in a *comparison*. From unrelated contents relations are built up as facts distinct from these contents, facts of another order. Acts of perception and of comparison, often very faint and fluctuating, permeate all parts of aesthetic experience. Often they are lived through; often, to be sure, they are only inferred. In any case, these intellectual processes are indispensable for feelings of form.

With respect to feelings of proportion, we note especially that the halves of a spatial form can be sensed as symmetric in spite of a very heterogeneous content. The problem has been translated into the language of psychological experiment with the fol-

lowing questions. If there is a line of a certain length on one side of the center of a square and at any chosen distance from the center, where must a line twice as long be placed on the other side to make the arrangement satisfying? If one line is at the left, where should two or more lines come at the right? How are lines best disposed when they have different directions? How are colors best arranged according to luminosity, quite aside from agreement in hue? These questions can be multiplied endlessly. The answers depend on what we demand of the aesthetic object. If we want it to arouse easy ocular movements, we shall judge in one way; if we want it to have the power of lasting attraction, we shall judge in another. For this reason let it be noted expressly and emphatically that at the moment we are concerned only with the psychological aspect of *isodynamia,* which was described earlier. That is, we assume that the right and left halves of a form, although they are unequal, are sensed as being equivalent, and we ask for the explanation. (Whether the form would retain its beauty even without this sensed equivalence of the halves is irrelevant here.) The most detailed theory that we possess refers to the eye movements needed for observation, movements whose magnitude we are said to transfer involuntarily to lines and two-dimensional figures as a measure of their importance. For example, near the center on which our eyes are focused we see a long line, and so make a rather sweeping ocular movement. Thereby this line balances another one, distant but shorter, since an equally sweeping movement of the eyes is requisite for the glance to reach it, and merely the magnitudes, not the directions, of the eye movements are compared. Accordingly, the arrangement is agreeable because equal amounts of movement are induced on the two sides.

In this way, then, all contents in general are supposed to maintain balance, since other sensations of strain also, especially those connected with attention, are to be taken into account. The farther a color is from the center, the brighter it must be to arrest attention, thus opposing the forms and colors of other areas with something equivalent. Even the actual participation incited by the portrayal of an action can balance the color, for every feature of the content that attracts attention has its physiological basis in kinaesthetic processes. We must regard the surface of a picture as a target on which every spot has a scoring value, determined, however, not only by its distance from the center, but also by its intensity. This idea agrees very well with a theory to be developed

later, according to which the pleasantness of a picture is connected with a formally beautiful model which serves as its basis. It is only unfortunate that no fixed rules have been established for the scoring procedure. One can assign the greater value to the central parts as well as to the outer parts of the surface. For, in order to have the picture apparently flow out from a focus into the boundless, the artist must concentrate at the center all strong lines, bright colors, and everything important in reality, while the colors grow fainter and the forms less important as he approaches the borders. On the other hand, as a stimulus to attract the eye equally to every point, the bright colors and important forms must be placed in the outer parts of the sharply bounded surface. Actually, among the masterpieces of painting there are examples of both procedures. Hence, to decide the question, so far as a decision is possible at all, still other points of view are needed than the ones at our disposal here.

In any case we should distinguish between the ease of the eye movements and the balance of the composition. A spatial arrangement (whether accidentally present or artistically produced) in which the eye easily and surely finds its way has aesthetic value. But this orientational work of the eye is not perfectly correlated with the degree of comfort in eye movements. Otherwise every vertical line would have to be more offensive than every horizontal line; the direction of movement from left to right (which writing has made usual for us) would have to be more agreeable than the reverse direction; a rectangular zigzag would have to have considerably less aesthetic value than a wavy line. This is not the case, and so Lotze seems to be right in asserting that of course we regard the effort of the eye movements as aesthetically irrelevant. A further reason, already generally established, is that the observer's eye seldom follows a line, point by point. Consequently, at most the tendency to such groping eye movements should be introduced into the calculations of elementary aesthetics, and that would shift the question from physiology to psychology. In that case, of course, we are dealing not with completed eye movements, but with directions of attention or, more generally, of cognitive activity. And in the last analysis the issue really turns on this.

As we have already seen, an unavoidable optical illusion makes the symmetric division of vertical lines unpleasant. Now we add, by way of supplement, that even in the case of an inexact mathematical ratio, which nevertheless seems to us to be the ratio

1:1, a pronounced impression does not occur. The ratio 1:2 and the golden section are much preferred. We can convince ourselves of this with the four lines of Figure 9 in which *a* is divided at the mathematical and *b* at the optically apparent center, *c* shows the golden section, and *d* the ratio 1:2.

Fig. 9.

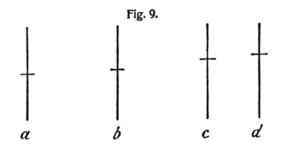

Why does the subjectively correct bisection here not suit us? With simple lines it is monotonous; with fuller aesthetic objects it is actually offensive. In line with earlier analysis we may suspect the explanation is that the parts in a vertical direction never assume the state of equilibrium. We learn empirically that only forces acting *beside* one another maintain balance, and the effect of this experience is seen in our aesthetic judgment of elements in a vertical column. Why do the other ratios please? Not in virtue of equilibrium, but of a division which separates the two parts clearly and by means of the larger part determines the basic nature of the whole. The analyses by Lipps suggest the view that in a rectangle constructed according to the golden section, when the horizontal sides are the longer, the impression of a resting form arises, the

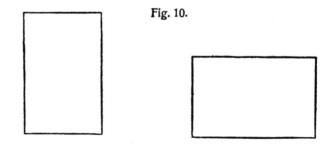

Fig. 10.

other sides, however, appearing as counterparts with a certain independence. If we further shorten these, we get a slimness which seems to displease many observers, but to me personally is not

without formal attraction. The rectangle whose longer sides are vertical raises or stretches itself; it does not merely stand there as thin and forlorn as a poor double line (which also, by the way, has its aesthetic value), but acquires a certain fullness or corporeality through the unmistakable power of the horizontal sides.

Fig. 11.

After all this, science will have to be very cautious in its theoretical conclusions. Indeed, there is no more to say than has been said. If rectangles are to comply with the twofold aesthetic demand, to embody both a definite type and a variety, then they cannot avoid approximating the golden section. This means, to repeat, that a more general aesthetic law—not the mathematical proportion—determines the pattern. But since, as we saw earlier, the sum of two unequal sides of a rectangle is not apprehended as directly as each of them separately, the total formal impression approaches what is called a combined form. The simplest and most familiar example to show the influence of combinations is a composition of circle and square. When the circle is inscribed in

Fig. 12.

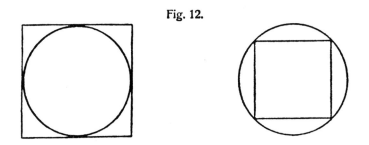

the square, the figure is very much more pleasing than when the square is inscribed in the circle. The inscribed square looks stiff because its straight lines stand out obtrusively and because the

133

enclosing circle is felt as too unstable. But in the other case the sharp corners of the square are seen almost as though blunted. In all situations the two parts influence each other and evoke an aesthetic feeling that varies with the spatial arrangement. This holds also for the combinations of circle and triangle in the diagram.

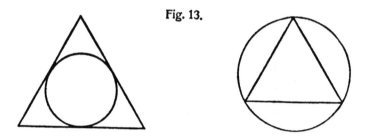

Fig. 13.

We must now learn about the feelings of form aroused by rhythm and meter. They are usually connected with the joy in movement.

Movements in the sense organs, as in the rest of the body, can easily acquire a pleasure value. Yet this has nothing to do with aesthetic value. After long rest every movement is pleasant. Strenuous bodily movements prove to be a useful remedy for physical and mental pain. On the death of his mother Byron assuaged his grief by boxing. (How English, and yet at the same time how human!) Movements that lead quickly and surely to a goal, and indeed even the passive state of being carried along in a rushing vehicle, are keenly enjoyed. Feeling ourselves freed from the law of inertia and triumphing over gravity, we rejoice in such movements, and also in dreams where we practice the art of flying. But none of these feelings is a feeling of aesthetic form. The feeling of form is related exclusively to *rhythmic* movement. There are plenty of rhythmic movements outside art, especially in working and speaking. Their rhythm is enjoyed as a formative process, articulating the subject matter and facilitating mental activity. Such rhythm can be carried over into art. Then do we have the original rhythm here? I am not asking about those periodically recurrent movements of the animal body from which earlier theorists tried to derive rhythm. For the natural man knows so little of the periodicity in breathing and heartbeat that he can hardly make them a basis for his rhythmic creations. But how does the case stand with the involuntarily rhythmical and consciously

apprehended movements in work and play? Does the source of auditory rhythm lie in them? Is the proper locus of rhythm to be sought within the sense of movement? We have theories on this point, to be sure, but no really decisive investigations. Hence we do not know whether rhythm of movement is the cause and rhythm of sound is its effect. Only one thing is certain, that the two lines of development at times run parallel, at times merge. And it is equally certain that it would be useless to start with the rhythm of movement, as this is fully sensed only in one's own bodily movement. So we shall discuss first and chiefly the rhythm of sound.

The question has been raised as to whether we catch this rhythm most clearly in the elementary forms of psychological experiment or in the creations of art. The rhythm would necessarily lose in impressiveness, it seems, as soon as new elements were added, such as simultaneous and sequent harmony in music. Actually it is precisely in musical and poetic forms that we enjoy rhythm longest and most certainly, for attention and enjoyment lapse very soon when we are exposed to a series of mere sound-impressions. Let us therefore test ourselves in listening to music and poetry.

A temporal sequence of alternating tension and relaxation has been pointed out as the essential feature of a rhythmical impression produced in this way. Yet to me this statement seems correct only with qualification. As a rule we do not await the next accent with full consciousness and sense it as a relaxation of the tension, but detect in ourselves only a general swelling and subsiding activity. This inner activity has high points and low points—that is all. With further analysis into two processes of quite different kinds, the whole would disintegrate into disconnected parts. The actually present up-and-down in rhythm led psychological aestheticians of the more obscure processes to compare this up-and-down with the undulatory course of many emotions. From the formal similarity of rhythm and emotion in their temporal course, this comparison enables us to understand easily the aesthetic value of rhythmic forms for arousing emotions. Nevertheless it must be opposed, in the first place because rhythm can be enjoyed without any stronger emotion, and in the second place because the strict order of rhythm is scarcely consistent with the concept of emotion.

We give cursory attention to a further controversial problem in asking what importance the speed of the rhythmic pattern may have for the nature of the aesthetic impression. Everyone knows there is a natural tendency to accelerate the tempo in

performing musical and poetic works. Both primitive and civilized men tend to speed up more and more when dancing. Musical composers take account of this need for acceleration, almost always ending a composition of several movements with a rapid, lively movement. Such changes of tempo have an exceedingly strong effect on the aesthetic character of the work, stronger than any change of tonal intensity. If a piece of music is played, first soft and then loud, the difference is considerable, but is increased far more as soon as the tempo is changed. The piece cannot be recognized when it is played over again very much faster or slower The same thing is true of speech. On the stage the tempo of diction is always of crucial importance. Every actor, whether of the earlier school or the most recent, should understand why a hundred years ago theatrical directors conducted performances of metrical dramas with baton in hand. Now, it is true, for music there is still a connection between tempo and tonal strength to consider. Celebrated theorists have the view that "acceleration and the progressive shortening of tone values are associated with the heightening of tonal intensity and the positive development of the dynamics, a sudden restraint marks the culmination of the dynamics, and the return from the climax to the normal quantity of tone values goes with the decline of the dynamics." (Hugo Riemann, *Die Elemente der musikalischen Ästhetik*, 1900, p. 76.) Yet it should be pointed out emphatically that both the prescribing composer and the executing artist very often break away from this monotonous correlation.

Now we return again to the essentials of rhythm. Its unifying power, already considered above, makes it a device for gathering up a number of impressions into a whole and correctly perceiving the temporal sequence, but without attaching equal importance, that is, giving equal attention to each individual beat. It is doubtless very essential for rhythmical feeling that the order be grasped with certainty, despite unequal distribution of attention. The unstressed tones or syllables require no effort of us, and yet the coherence within and among groups remains perfectly clear. In daily experience also, to be sure, we gather up what is objectively quite heterogeneous and held together only by the unity of the conscious act. With rhythmic patterns we feel free from the contingency of random occurrences, as the course of events corresponds to our natural expectations.

Most of what I have to say about the special feelings connected with absolute quantity has already been said in the section

dealing with the aesthetic object. Spatial occupation, temporal extension, and degree of intensity evoke special feelings which can finally develop into permanent aesthetic moods. The larger the object, as a rule the more strenuously we work to comprehend it, since only with effort can we see the parts as a whole. Yet even short, sketchy little things or events can divert the mind in certain enjoyable ways if they serve somehow as freshly bubbling fountains of aesthetic joy. But now we are to investigate further (as far as we can do so here in an elementary fashion) what experience results when feelings of harmony and feelings of shape are combined. Harmony of tones unites with rhythm, harmony of colors with proportion. We call this connective process a complication and the feeling arising from it a *feeling of complication*. When these two parts exist together, the qualitative component usually furnishes the variety, whereas rhythm and shape contribute the unity. While the tones change, the rhythm remains the same, and in the multiplicity of colors the spatial order is the connective element. Besides the connections familiar from music and painting, there is the connection between rhythm and proportion, which gives us the experience of beautiful movement. Whenever postures occur in a clearly rhythmical sequence, they take on a pronounced aesthetic value, much like the value of ornament and of the more abstract forms of music. A dance of this sort pleases us even without expressing mental processes, especially emotions. In the three complications just mentioned the constituent parts generally maintain their independent efficacy, acquiring by their union the surplus of aesthetic value already so often referred to. The result is meager, yet at any rate certain. Of course, we have more pretentious theories, but they hold good only if we presuppose a certain psychology of feeling. So, for example, it is assumed that feeling operates in three dimensions of contrariety: pleasure–displeasure, excitement–composure, tension–relaxation. Then the gradations of pleasure and displeasure are supposed to be produced by tonal harmonies and disharmonies, whereas the degrees of excitement and composure come from rhythm, those of tension and relaxation from both rhythm and harmony, in the case of harmony from the resolution of dissonances. Ingenious though this analysis is, it becomes a hampering schema when carried through, and it does violence to the facts of music. But the principal point is that the variety of distinguishable feelings will not submit to this tripartite yoke.

Looking back, we see that the magnetic field of the feelings

of form stretches far and wide. In the special arts it can gain the power to carry away reflective artists and philosophical aestheticians with transports of enthusiasm. Flaubert once wrote: "I recall having felt a pounding heart and violent pleasure while contemplating a bare wall of the Acropolis—the one on the left on the way up to the Propylaea. Well, I ask myself, can a book not produce the same effect, quite apart from what it says? In the precision of the composition, the rareness of the component parts, the polish of the surface, and the harmony of the whole, is there not an intrinsic value, a kind of divine power, something eternal like a principle?" (*Lettres à George Sand,* p. 274.)

4. The Feelings of Content

In his 1785 essay on Spinoza, Goethe speaks incidentally and contemptuously of measuring bodily proportions. He claims that the spatial and externally derived standard lets the relation of the head to the whole body degenerate into a simple numerical ratio. Friedrich Theodor Vischer raises a similar objection to the application of the golden section, that for the head to fall into the minor part is absurd. I cite these examples to show how feeling for the purpose and meaning of constructed forms rebels against the most precise, mathematical kind of formal consideration.

Let us have a cursory look at the parts of the human body. A small hand pleases us, but not as a long, slender form. It is pleasing because it seems refined, incapable of violent acts, perfected by a mind familiar with the higher life. It grasps nothing coarse and carries no heavy burdens. The light, delicately fashioned foot is pleasing because it is merely a point of support, more fit for hovering than for tramping. Large, protruding ears are ugly, for they claim (so to speak) a significance which they do not have; they invite us to take hold of the head like a jug by the handles. Since the nose is a bridge from the forehead to the mouth, if it thrusts itself forward like a cocky boor, it not only pushes itself out of alignment, but seems to demand a position it does not merit. We find forms attractive in the male body which are unattractive in the female, and vice versa. The reason may be that our view of masculinity allows certain angular, hard, strongly accented forms

which do not accord with our idea of the feminine character. Such feelings of content lead us to speak of the boldly tilted nose, the proud forehead, the melancholy eye ("the mirror of the soul"), many actual experiences having been compressed into a uniformity, applicable in the particular case. This instinctive judgment of forms, like the feeling for a language, always refers to the meaning of the forms, and occurs very quickly and surely. But as soon as it is retarded and filled with conscious reflection, the form ceases to be a natural sign of mental content and becomes symbolic (as some philosophers say) or allegorical (as others express themselves), the second term probably more appropriate than the first. All personifications of concepts (such as Apelles for slander) imply the intended concept. But this is shown still more clearly by the consideration of a case in which we find artistic allegory along with natural symbolism. Moritz Carriere once analyzed the characteristics which Lysippos gave to the *Kairos*, the representation of the favorable moment. The statue has wings and portrays a hurrying figure. At the forehead the hair is thick; behind it is cut short. That fortune hastens by and must be taken by the forelock may perhaps have been in the minds of the Greek spectators, and hence may have seemed to be something that the work of art was saying— although this is quite doubtful. But most certainly even Hellenic connoisseurs had to ponder the meaning of the razor and the scales in the youth's hand, for surely they were not supposed to mark him as a barber or shopkeeper, but to recall the proverb that fortune rests on a knife-edge and its scales are seldom in perfect balance.

In aesthetic experience, therefore, factual ideas and feelings of content are active either in perfect fusion with the form of the object or in loose connection. But just to be sure, let me point out once more that with this knowledge the sensory feelings and feelings of form are not to be dismissed. The color of hair charms us without our seeing it as a sign of health or youth. Regardless of size, ear and nose are well or ill formed, nor is any mental content thereby carried over into them. Which point of view predominates in the aesthetic consciousness depends partly on the personality of the recipient; a few persons prefer the feelings of form, most prefer the feelings of content. But as long as the feelings are tied to definite qualities of the aesthetic object, personality does not become a prominent factor. Inner experience is objectified.

A rectangle with relatively long horizontal sides seems to be lying down. If we look at a rectangle beside it which has relatively long vertical sides, it is as though a recumbent figure had raised itself. A broad angle, open downward, is viewed aesthetically not only in respect to its size and the length of its sides, but also as having its lines press together or maintain balance like two posts. As a line is generated by movement, so also it continues to be movement and the unfolding of forces. But the extensional need, implicit in it, has soon been satisfied, whether by transition into other linear courses or by the counter-tendency to limitation. In both cases, and on all occasions when we regard lines, surfaces, and spaces not mechanically, but dynamically, we have the forms of the will's activities. In spite of ourselves we turn Schopenhauerian. Even with Fichte we agree in feeling that whatever has balance shows both an *expansive* activity, producing space, and a *contractive* activity, setting limits. This whole play of forces remains, as it were, abstract, offering nothing but the striving and restraining of the will in various forms, no concrete events. Such directions of force do not need contact with any contingent plant or animal form, for they have within themselves the essential characteristics of life.

The activities of which we are speaking are infused into the figures, and in no sense are present as ideas beside them. The evidence for them is not sufficient to enable us to distinguish the aesthetically pleasant forms from the unpleasant and the neutral, but it does enable us to capture an event in words and give it conceptual expression. We must note that beside the organic and muscular sensations, beside the activity of attention and apperception there is something else, the mental work involved in the use of metaphor. The feelings occasioned in this way are weak and very indefinite. In the case of rhythm they may have the quality of driving forward in excitement or of coming to rest. But they are capable of much finer distinctions, becoming—let us say—the feeling of hostile and angry attack or of bold and triumphant attack. Likewise with linear forms. If I erect a perpendicular in the middle of a horizontal line, this simple mathematical figure takes on the affective quality of unwavering stability. The inverted figure (the T-shape) was used by the ancient Egyptians to suggest power of life and death. Here the straight line seems to soar upward, only to be cut off suddenly with a calm, irresistible certainty. (I cannot convince myself that Paul Klopfer is right in maintaining in

Z.f.A. (xiii, 135–49) that spatial rest is expressed by the vertical line, motion by the horizontal. Although the glance certainly tends to wander along horizontal lines into depth, still this movement, which must always occur, does not make the line an expression of motion.) Even in such cases, where form and content are separated more sharply, the feeling of content does not mean that along with the perception of the rhythmical or linear form the factual idea of a wild cavalry attack or of a court room suddenly appears in consciousness, any more than in regarding the rectangle as raising itself we inwardly glimpse the form of a man or dog getting up. Rather, there is only the same stimulation of conscious process and the preference (which the nature of language makes intelligible) for the animistic words used above. I can be affected by the vertical line at the middle of the base as I am by a tree standing alone in a broad field; the line growing up out of the ground is felt as an individual being, proudly raising itself aloft. In each case we have the same relation between an underlying ground and something raised in relief from it. As soon as one case of the relation is given, the other is faintly suggested. We do not remember the other, but we possess it with and in the given one. Now, since language likes to name and explain everything in terms of the experiences of our psycho-physical selves, since language must humanize a thing to vitalize it, language expresses the outer through the inner. Goethe says that man does not realize how anthropomorphic he is. Or, to put it more correctly, how anthropomorphically he speaks. We do not give the most accurate scientific description of our inner experience by representing it as actual empathy. That vertical line does not grow, does not raise itself proudly aloft. From first to last it is a linear form. But its relation to the horizontal line under it corresponds to other relations with which we are familiar. So, when this relation is perceived, it gathers to itself, so to speak, everything similar to it from the whole reservoir of experiences, or it fades out into ideas akin to it. In the struggle for existence, which even the conscious processes carry on, each process seeks aid; it supplements and confirms itself by what is like it. And nothing secures a definite mental process more effectively or accents it more vigorously than a word signifying the innermost recesses of life.

If spatial forms were aesthetically viewed as actually striving for certain goals, lying down, arising, and pulling themselves together, instead of enjoying them we should be duped by illusions. That cannot be the meaning of empathy or the view of

the empathy theorists. We change no resting thing into a moving thing and we make no mechanical motion into a purposive event. Nevertheless, the aesthetic attitude as a whole has an aspect which lends support to that mode of description. I mean the affective aspect in general and the relation of feeling to an object. In Schleiermacher there is a passage much like this: "To surrender oneself and at the same time find oneself is the essence of piety, in which the person, sacrificing himself to the Whole, likewise enjoys this sacrifice. Hence, religion is neither a knowing nor a doing, but a feeling, the feeling of the common life of the whole and myself." In this sense public worship and purest emotion can also be called the aesthetic attitude; herein lies a large part of its dignity. As in all higher spiritual endeavors, so also in the service of beauty and art, surrender to the object means at the same time an exaltation of the self. The miracle of love is realized here also; whoever attaches himself to what is worthy of love, wins himself again twofold. In this sense we may speak of empathy when dealing with the highest aesthetic and artistic values.

But now let us stop to consider particular facts. To grasp the significance of empathy more clearly, some have compared it with the processes known as *meaning* and *expression.* Concerning the first concept, at least in a certain use, a few words will suffice. The perspective drawing of a house *means* a much larger and three-dimensional house, but it does not *express* the building and the building is not empathically injected into the drawing. The distinction is clear. The drawing is the visible reproduction of a visible object; expression and empathy, on the other hand, involve the fusion of something visible and something invisible. The situation is more complicated when something mental is expressed in *words.* I have already spoken of this and shall have more to say later.

Now we turn to expression. We have the best example in the familiar movements expressing astonishment, anger, joy, and so forth. Let us suppose them to be so ephemeral as to lead to no practical goal and to convey no suggestion of purpose. As involuntary eruptions of an emotion they can strengthen this emotion as well as weaken it. If, overcome by rage, I spring at my opponent's throat or tear a letter into a thousand pieces, these acts are performed to punish an enemy or to destroy an impersonal cause of anger. Such expressive moments do not concern us. But if I thrash about in a raging fury, smashing to bits everything near me, if I cry aloud without anyone able or supposed to hear me, such

indulgence whips up the emotion to maximal intensity or may just as easily weaken and wipe it out. We understand both psychognostically from inner experience and psychologically through analysis. Still these outer signs have no aesthetic value. They get such value only when the expression is sought and provided for its own sake. The external aspect should not remain merely incidental, but must become the chief fact. The sensuous nature of the aesthetic requires it. The expression must be separable from the inner process, just as the word is from the thought; we must be aware that the two sides of the event belong to two different regions or ordered series. A raging person is thoroughly unified, and as such is contemptible, formidable, comical—depending on circumstances. But aesthetic enjoyment is connected with the distinction between what we see and what we know to be behind it. If we confuse the two, we make a naturalistic misinterpretation of aesthetic expression: from the symbol comes crude reality (or even magic substitution).

Now let us examine more closely just what we do in actively interpreting expressive movements, but without analyzing one by one the sub-varieties discovered by other aestheticians. (Volkelt wrote in his *System der Ästhetik*, I, 282: "Aesthetic empathy can . . . not be reduced to the same basic formula. The goal is always the same: fusion of sense perception and mood, striving, emotion, passion. But the ways to the goal are of various kinds. The mental life of man offers several essentially different possibilities for the achievement of this fusion. These various ways I have called bodily mediated empathy, associative empathy, and direct empathy. Also in the *Ästhetik* by Lipps (I, 150 ff.) I find this threefold division, even though expressed in other terms.") Suppose we sympathize with a grief expressed in movements. The inner process involved is described as follows: "I see the person's manner and thereby feel a tendency or impulse to a certain kind of inner attitude or psychic adjustment, the one which everyone calls grief." The familiar, trivial, and yet instructive example of contagious yawning is described in the same inquiry: "With me the bodily process of yawning occurs because I have the mental inactivity, the mood, disposition, and general attitude from which this bodily process, the outwardly visible yawning movement, naturally results. This inner state of mine is produced by seeing the yawning of another person. I do not represent this inner state to myself, but I live through it." (Theodor Lipps in *Archiv für*

Psychologie, IV, 1905, 467, 482–83.) That is hardly so. The most careful introspection reveals no inner experience of boredom or fatigue when we imitate the yawning of someone sitting opposite us. We yawn reflexively and say later, if at all, "How desperately boring it is." The reflex and words can be verified, but not the inner states which we are said to experience. If this situation has become clear to the reader through his own verification, he will question the first example also. I see the facial expressions and movements of deepest grief. If I am stupefied, or if I intentionally maintain a state of passively receptive objectivity, those forms of expression are only forms. Just so, the thing standing before me, if regarded dreamily or merely as a visible object, is something bright, partly yellow and partly green—the lamp on the writing table. But with vital and natural apprehension, imitations of the gestures are suggested in very slight efforts, often not yet of a bodily nature; intrasomatic processes are added to these, and a host of ideas whirls through consciousness. Is it a fortunate turn of expression that this sympathetic experience, which does not really affect the whole personality or even its present state, is called empathy? The sympathetic mutuality among human beings is ultimately rooted in merely organic activity—a reflex connection among animals of the same species. When one of them sees another become excited, cry out, laugh, or yawn, it does the same thing and, mark you, without the intervention of the assumed emotional states. Moreover, there is the same immediacy in aesthetic enjoyment; hence I spoke of the aesthetic reflex.

In any case, *knowing* about the outwardly manifested state of mind can become a sympathetic experience, usually beginning later than the reflex. For all knowledge has the natural tendency to become a complete inner experience. Our primitive mentality is predisposed to believe every statement and obey every command; its very nature makes every mere idea tend to unfold into an adequate reproduction of the sensuous and especially of the mental content given in the idea. But this vital urge of consciousness achieves its goal only in children, primitive men, and abnormal conditions of civilized men. Usually the obstacles in the way are so many and so strong that the idea remains just an idea. Empathy, in the sense of unrestrained sympathetic experience of the passion expressed by the actor or the statue, occurs only when we ourselves are in a highly emotional mood. Whether this mood is regarded as the goal or the vulgarization of the aesthetic attitude depends on one's general view. In any case, aesthetic empathy must preserve the

fine boundary line which runs between loss of personality and the personal enrichment through surrender.

Whereas in *empathy* we are drawn into the inner life of an object or person, the *associations* evoked by the aesthetic object function, as it were, beside it. The duality which has met us throughout becomes patent here: everyone perceives that we draw associated supplements out of our own inner life. For this reason reference has been made so often since the eighteenth century to *relative* or *adherent* beauty. Fechner, let us remember, distinguishes a direct and an associative factor. The direct factor includes the pleasant relations of form, the sensuously agreeable impressions, and the feelings of pleasure which spring from the content, so far as they presuppose only an instinctive appreciation. The associative factor is based on observation and experience. All sensations, thoughts, and feelings, whether aroused by a constituent material part or by a beautiful object as a meaningful whole, revive feelings in us which help to determine aesthetic experience. This psychological distinction has incurred the justified objection that the two factors are far too closely interconnected for their theoretical separation to seem fruitful. According to Fechner, the impression made by music, for example, should be attributed essentially to the direct factor. Without any associations, sad music makes us sad and gay music makes us gay. But since many ages and nations have battle or dance songs that seem sad to us, so indeed even here we are dealing with associations which custom and tradition have made especially strong. At any rate, here—and in general—it would probably be very hard to distinguish between the share of the associative and the share of the direct factor. But, aside from these methodological misgivings, two other objections have been raised. On Fechner's assumptions, all feelings attached to memory ideas, particularly feelings of pleasure, would have to be aesthetic in nature. Yet the associative connection of significant ideas can be instructive or even enjoyable without taking on the slightest aesthetic tinge. At the sight of an important letter after a long interval, a thousand memories spring up, but they give the letter no aesthetic value. Then in aesthetic enjoyment events like the one just mentioned would have to be more akin to similar events than the aesthetic excitements of various sorts are to one another. This unavoidable inference does not fit the facts. For aesthetic experiences are actually more similar to one another than are significant memory ideas in general and the associative factor within aesthetic experiences.

The other problems, usually treated in the aesthetics of

association, are purely psychological, and hence need not be considered. For our purposes the matter of chief importance is to be aware of the distinction between fixed empathy and free association. The distinction becomes dubious only when the so-called inevitable associations are taken into consideration. The color green, so it seems, necessarily awakens thoughts of spring and incipient life. Yet such is not the case. No idea whatever from this field needs to be revived. But if something of the sort is added in thought, the associated feeling can also be the opposite one. According to Oscar Wilde, green is a sign of decadence for those who love the color. Red is taken as the color for blood and the ardent joy of life; whoever considers the red leaves in the autumn woods must feel otherwise. When we view a picture of a landscape spread out in the dead of night, ideas of death and terror may loom up, pervaded by oppressive feeling, or the comfortable ideas of peaceful rest. In short, it would probably be difficult to point out any unequivocal and necessary associations within the aesthetic experience. At least we know of no principle in terms of which the associations indispensable for aesthetic purposes could be selected from the whole group of possible associations. To pass adequate judgment on the climactic scene of a stage play we must, of course, supplement the scene with associations from the earlier course of the drama. Only we cannot say which of the many appropriate ideas should be revived. Music is the most striking case. If music were expression in the sense in which mimic art is expression, it would imitate the cries of human beings and the natural sounds of animals. Its expressive power is therefore of another kind. For many reasons music lends wings to our powers of imagination, evoking that strange and wonderful state in which the motliest flock of associations flutter through consciousness.

Nevertheless, we do not deny that associations mean a great deal for aesthetic enjoyment. Precisely the most personal associations —those which we feel belong to us exclusively—are the very ones that enhance the charm of the aesthetic experience. Such associations function like the serenade settings in Venice, where it is not the trivial music that affects us, but the enchantment of the surroundings. The free, imaginative activity of the self, and not the aesthetic object, operates this way in cases of individual aesthetic awareness (and whatever else comes alive from the store of inner experiences and artistic impressions). Accordingly, associations are essential for the experience and enjoyment, not for the object and

factual judgment. Being able, with a little cultivation of taste, to distinguish between what is in the object and what we ourselves contribute, we have a judgment as to what is objectively present, beside our report as to what is subjectively felt. In its general affective character aesthetic experience is indeed unitary and, I grant, unitary in itself and in its intimate connection with the object. But in its chief components it harbors a duality, and even the possibility of distinguishing between object and subject, which culminates in the distinction between the critics' evaluation of the object and one's own reply.

Beside associations there is something else not melted down into the object, a feeling of connection, which is clearly present, to be sure, only in relation to living beings, especially characters in novels, stage plays, or films. We pity them, fear for them, love or loathe them—in short, we accompany them on their artistically presented way with feelings which are never projected empathically into the characters themselves. Certainly anyone who arouses our pity can also have pity for himself, but as a rule our participatory feelings do not repeat anything in the other person's state of mind. Of such feelings we may say that, although they belong to the aesthetic experience, they do not determine it decisively. The same holds for the states of pleasure and displeasure in cases of simple pleasing and displeasing, so far as they appear as expressions of the individual and of the moment. The unpredictably fluctuating capacity for enjoyment should not be confused with the aesthetic value of lived experience; otherwise we should surrender every standard. Only the feelings we discussed before we concerned ourselves with associations do justice to the significance of aesthetic forms; only they can pass over into judgments which wholly determine the object and its value, into theoretical statements about a non-theoretical value. Konrad Fiedler's famous renunciation of aesthetics was based on the assumption that the aesthetic consists wholly in feelings of pleasure and displeasure, hence in subjective states, which cannot explain art's conformity to objective law and which are of little worth in comparison with the struggle for truth. In his words: "Whoever still holds the view that he should apply the standard of pleasure to works of art does not yet know their meaning. . . . A work of art can displease and nevertheless be good." (Ninth aphorism in *Schriften über Kunst,* ed. Hermann Konnerth, II, 1914.) Here a correct insight is grossly exaggerated, and the distinction between objective feelings and feelings which re-

main subjective is overlooked. (A similar extravagance is becoming customary again nowadays. Walter Strich declares: "An aesthetics that, in accord with the laws of beauty, looks for or actually tries to prove what is pleasing in art—or as it is put still more inanely, 'arouses pleasure'—can only stand against history onesidedly, subjectively, dogmatically, and disembogues into the misleading triviality that taste changes. But this aesthetics is itself to be understood only historically, and indeed as the expression of a very frivolous age, which demanded of art merely pleasure, consolation, amusement, and the illusion of something noble to lure it away from its own inner misery. Of the ridiculous psychological theory that man strives for pleasure and the work of art arouses pleasure I say nothing here."—"Die Dioskuren," *Jahrbuch für Geisteswissenschaften,* Munich, I, 1922, 16 f. To what aesthetics now vigorously active is that supposed to apply?)

Although things are found pleasant in a purely personal way, irrespective of their real value, we ought not to ban feeling in general, ignore the sensory feelings, feelings of form, and feelings of content, and declare a theoretical knowledge (albeit of a peculiar kind) as the artistically valid knowledge. Whatever we enjoy aesthetically is an actual value of the object. Even though pleasure may be the first feeling, the cause of this activity lies in the object itself.

IV. THE PRIMARY AESTHETIC FORMS

1. The Beautiful

Not only can we distinguish in an aesthetic object aspects like proportion or rhythm; we can also consider what character special modifications of these aspects give to the whole. So, for example, we may consider harmony in a pervasive harmony of colors, rhythm in a quick change of beat, or absolute quantity in large dimensions. In this way distinct, individual aesthetic characteristics are formed. In the same way, the whole fabric of aesthetic feelings can—so to speak—take on various tints. We take these emotional attitudes to be the possible forms of the aesthetic consciousness in general; we regard those basic characteristics as the most comprehensive predicates to be asserted of an aesthetic object. These forms of the aesthetic consciousness are available to inner experience as characteristic mental attitudes, whose appearance the object causes or directs. Moreover, they are also caused by the artistic technique which gives the advantage of unusual energy to certain kinds of apprehension.

To classify and arrange the primary aesthetic forms we can start (like Dilthey's theory of poetry) with the definition of the beautiful as that which, in perfect conformity with our inner activity, wholly satisfies the soul. Then on one side we can add groups of feelings "which derive their character from the overwhelming size of the object, whereas in the mental states of the other side, the subject feels itself above the object." The two halves of the line, whose center marks the ideally beautiful, show an admixture of the unpleasant. (This comes out clearly in an investigation by Paul Hofmann in Z.f.A., IX, 468. While the beautiful object is appre-

hended in an easy, regular, and free movement, the dominant aspect in the tragic is an emotional resistance (to the destruction of a value), and in the comic it is the surprise at an unwarranted claim to esteem.)

The earlier aesthetics usually placed the beautiful and the sublime at the pinnacle, deriving the comic from the sublime by inversion. (Incidentally, note an application of the dialectical method even now in modern theories. These follow the classic Hegelian inversion of pure being into nothing in their thesis that it is only a step from the sublime to the ridiculous.) One may just as well take the sublime and the comic as the primary categories, regarding the beautiful as the transition from one to the other. It might be most useful to arrange the primary forms in such a way that the transition from each to the two adjacent ones occurs with conceptual ease, and those opposed in content are opposite in position. The following diagram meets these requirements:

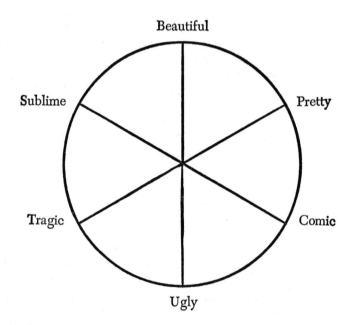

Chart I. From the Beautiful to the Ugly

The beautiful has always been very closely connected with classical art; so also has aesthetics, which regards beauty as the most

comprehensive concept, or indeed the only one. But we should not charge against aesthetics in general, as recently some have, that through its preference for the concept of beauty it has thwarted the appreciation of other artistic forms, like the Gothic. For in the most important systems there is the insight that the beautiful is a special kind of aesthetic object, hence restricted. But in all idealistic systems the beautiful does form the center. Lotze wrote: "Wherever in certain favored phenomena there is an agreement (which need not generally occur) between what the phenomena ought to be to accord with the Idea, and what mechanistic necessity makes them, there we find beauty." The Idea (the world of values) must pervade reality (the world of forms). This occurs when three conditions are met, corresponding to three standards within us. First, the object must please the senses—the physiological condition. Next, the object must conform to the laws of our mental life—the psychological condition. Finally, however, the object must also satisfy our ideas concerning the import and systematic unity of the world—the metaphysical condition. Here the point is well brought out that the question concerns the harmony of the object and the nature of the aesthetically appreciative self—a three fold nature, Lotze thinks. Even in Ruskin's high-flown doctrine we find a trace of this insight. He calls everything beautiful which has preserved in its nature a likeness to a divine attribute and consequently can draw to itself the divine part of our nature. So unity is a symbol of God's all-encompassing essence, rest a symbol of His constancy and eternity; symmetry is a symbol of God's justice, purity a symbol of His will. Whoever can clearly see and reproduce these divine perfections is the great artist.

Perhaps it can be put more simply in this way. Ideal beauty is the immediately apparent formal unity which coincides not only with the natural course of inner activities, but also with the harmonious coexistence of inner states. Thus beauty requires the clear gradation of the important, the subordinate, the incidental, and the indifferent, which accords with the nature of consciousness and assures smooth reception. Mammals and birds, with articulate bodily organization, are more beautiful than whales and fishes, whose heads, trunks, and tails run into one another. Unusually large heads and snouts or beaks, as with the hippopotamus or pepper-bird, are displeasing, because they divert the glance unduly from the principal mass, the trunk. If the parts accord visibly—or audibly—with one another and with the whole, and if this accord has a clarity,

achieved without drastic means (such as sharp contrasts), we like-wise speak of beauty. Think of a tree as the unity of trunk, branches, and leaves. Finally, the beautiful has fullness and depth, which create an enduring interest. Here already is an indication of what the object does for the experiencing person.

Although our joy in examples of perfect beauty is intimately connected with the nature of the object, nevertheless, before the unique experience of pure beauty had occurred even once, we would not know that any particular objective quality evokes it. I repeat, it is a unique experience, its distinctive feature being that the appreciative self enjoys without disturbance or discomfort. "Beautiful forms seem to caress one," an Englishman once said. If the inspired description of pure contemplation which Aristotle gives in the *Metaphysics* were applied to the life of feeling, a tolerably adequate picture of this inner process would result. Opposition to all practical activities, freedom from all painful burdens and wishes, escape from the fetters of an inconsistent reality—all these features, stressed by Aristotle, characterize the enjoyment of beauty. The concept of the beautiful expands almost irresistibly into the concept of the aesthetic, since beauty, of all the categories, is least con-cerned with the existential import of things. With equal vigor the concept of the beautiful strives eagerly toward unity with art, beauty possessing supremely the necessity immediately given in feeling, the richly and symmetrically clothed form. This feeling breathes joyful self-assurance, inner solidarity, a freely floating, rest-ful harmony with oneself. An older aesthetician portrays admirably the calm intelligibility and vitalizing attractiveness of the beautiful: "Whatever is to satisfy us fully and give us unqualified pleasure must, first, not disturb our faculties and powers, and second, put them into vital activity." (Karl Köstlin, *Ästhetik*, 1869, pp. 69, 75. What Hermann Cohen calls, too inclusively, the original action in the world of art fits the beautiful, "an affectionate conversation takes place between the soul of the beholder and the soul of the work of art." Cf. *Ästhetik des reinen Gefühls*, 1912, I, 394 ff.) Börne means the same thing when, in the memorial address on Jean Paul, he exclaims exultingly of poetry (what is actually true only of the perfectly beautiful) that it offers "a golden age which never cor-rodes, a spring which never fades—cloudless happiness and eternal youth."

Unfortunately, we do not use the word *beautiful* exclusively for this quite definite type of feeling and the corresponding nature

of the object. We call a portrait beautiful, although we would not use this term for the person portrayed. Here we are evidently referring to artistic value. But even in the judgment of artistic value, which we are inclined to include in the one word *beautiful*, several shades of difference can be detected. Amazingly often this eulogistic predicate refers to only a part or a tendency of the work, but is involuntarily extended to the whole. This exemplifies one of the generous traits of human nature, that we—as they say in rhetoric— take the part for the whole, forgetting the defects of drawing because of the splendor of the colors, forgetting the poverty of the instrumentation because of the swing of the melody, or remembering a brilliantly successful episode and attributing it to the entire work. Strong individual impressions help their contexts, just as a few fulfilled prophecies, despite all his false predictions, crown the prophet with glory. If too many particular beauties are collected, the whole loses repose and unity, and so its effect is generally impaired.

Secondly, beautiful signifies that a work is the best of its kind. If this comparative judgment is based on historical knowledge, it concerns also such works as are indifferent or even disagreeable to present taste. We witness daily examples to support the proposition that historians of every art, or even collectors of works of visual art, enthusiastically extol as beautiful the poorest and most indifferent productions. Technical skills work in the same direction, making us acquainted with the limits of a particular art. Certain tone qualities of the violin are beautiful, whereas they would not be if produced by the human voice. Certain effects are admired in lithographs, disapproved in etchings. In short, beautiful is here a compressed comparative judgment. And finally, the basic meaning of the word *beautiful* can involve the idea of a norm, an absolute value, which has never been realized. Beautiful would then mean a close approximation to the ideal, at best its achievement. Since, therefore, beautiful serves as a nebulous and confusing term for various kinds of aesthetic value, it is no wonder that this suggestive word is also used for other evaluations. In customary usage we transfer it to what we taste, smell, and touch, although its extension to ethical qualities is no longer as natural to our speech as it formerly was.

If we ask now whether the word *beautiful* is reserved for definite objects in nature and their reproductions, and whether an inventory of beauty can be drawn up, we must answer the question affirmatively—with slight qualifications due to historical change.

Gerard de Lairesse expressed himself frankly on this; he disclosed (as did also Helvétius, the ethical egoist, according to the witty Mme du Deffand) "everybody's secret (*le secret de toute le monde*)." What is beautiful? "A landscape with straight trees, lovely vistas, azure sky, ornamental fountains, stately palaces in formal architectural style, with well-formed people and well-fed cattle and sheep." What is ugly? "Misshapen trees with old, twisted, split trunks; rough ground without roads; sharp knolls and too high mountains; crude or dilapidated buildings, their ruins lying in a heap; marshy ponds; a sky full of oppressive clouds; lean cattle and awkward tramps on the plain—that cannot possibly pass for a beautiful landscape." (Adapted from Lairesse's *Grosses Mahler-Buch*, Nuremberg, 1728, pp. 183 ff.) For the average taste Lairesse is doubtless right, since features like those first enumerated usually evoke a calm aesthetic enjoyment.

If we pass over from mere description to analysis, we find everywhere constituent parts which have no discord either within themselves or in their combinations. A luminous color, a rich tone, and an attractive curve arouse pleasure without conflict. Harmonious spatial and tonal forms possess within themselves an intrinsic intelligibility properly called beautiful—a natural flux, which knows no restraints, no struggles, no rude interruptions, no uncertainty. Empathy introduces only pleasant interpretations; association calls up only agreeable ideas. Just because of this lack of any disturbance, the value of mere beauty always remains a superficial value. Moreover—though it is not a defect—this value is confined to the beautiful object, while the values of truth and goodness point beyond themselves to a unity of knowledge and moral action.

In Platonism, nevertheless, the beautiful belongs with the true and the good. And in the form of Platonic thought which has become (as it were) popular, the auxiliary concept of type serves to characterize the beautiful. Just as truth unveils itself in the conceptual assimilation of universal ideas, so beauty becomes apparent in perception as the meaning of a phenomenon. Everything beautiful must therefore be typical, for we call an object typical in which the class and the purpose of the class are clearly evident. According to this view, we have a class concept of everything, the perfect agreement of the perceived thing and this concept yielding aesthetic satisfaction. Hence the typical thing would be something conforming to and characteristic of the class. This view encounters some difficulties. Nature contains phenomena which, despite their

full endowment of generic features, remain ugly—indeed, offer resistance to the aesthetic enjoyment which is possible even with the ugly. Furthermore, the theory entails almost an extinction of individuality: the less there is of personality and the more generic the character, the greater the value. Is the average really that exalted thing we call beauty?

These misgivings are certainly not to be dismissed. The case is different with an objection which can be compressed into the question as to whether the concepts of kind and class and the trite idea of the mean can make strong aesthetic impressions. Such a question is based on a misunderstanding. Aesthetic types are by no means empty generic forms; rather, they are the result of the broadest experience and filled to the brim. In the eighteenth century the beautiful was occasionally defined as an external event which affords the greatest number of ideas in the shortest time. In fact, every form which is both the effect and the cause of unusually many ideas of the same kind is a type. To be sure, the correlated particulars must all belong to a definite group of characteristics. They are either visible, audible, or linguistic characteristics which consolidate themselves into an imaginative whole. But these very particulars keep the aesthetic type distinct from the logical concept. When we judge that a certain feature in a statue of a wrestler is not typical, we are not comparing what we see and the generic concept of the wrestler; we are taking offense at the contradiction between this feature and all the other details of the figure. Violence is done to the typical connection of visible forms or to the striving of the visual images for unity.

The normative is very closely connected with the purposive. The particulars just mentioned are always selected to attain the goal of the impression. Let us think again of logic. Ordinary language and science could fashion thousands of logically incontestable class concepts, if only they did not have the disadvantage of being without sense or purpose. To extract the essentials from the play of possibilities is to stress the purposive. This statement is true also of the aesthetic type. From the point of view just established we understand why in the philosophy of beauty (especially since Kant) the concept of purpose has been assigned a leading role. The coupling of the two concepts, beauty and purposiveness, becomes intelligible on the assumption that the consideration of purpose permits us to join the ought-to-be and the is, the ideal and the real, and then either to show these two worlds (which would be meaningless

without each other) as in lasting connection or to explain the one as a development toward the goals contained in the other. Purpose becomes essentially aesthetic as soon as—without even obtruding itself—it imparts an organic unity to the members of the whole it governs. Just as one loves without being able to point to any justifying reason in the person loved, one admires the harmony of the beautiful without knowing the cause—control by a purpose. Perhaps that is Kant's *Zweckmässigkeit ohne Zweck* (purposiveness without purpose).

In the theory of art we shall become more closely acquainted with the relation of the beautiful to the useful. Here I make only the preliminary remark that in many cases the beautiful has sprung from the useful. Perhaps the reverse has also often occurred. As the bustle of life consists in a constant expansion of needs—a fact which surely contradicts the paltry moral ideal of freedom from want—the transformation from aesthetic to practical drives can occur as an aspect of this development. If we want something new for the first time, it appears to us as beautiful, as an ideal. After repeated satisfactions of the desire, the thing becomes one of the vital necessities. Insofar as something is an unattained goal, it is beautiful; but as soon as we lose interest in it, because it has passed into the system of practical needs, it also loses its sportive, free, festive, subjective, and fanciful qualities—those which common opinion regards as properly aesthetic. No matter whether in the majority of cases it happens in this way or whether, conversely, the beautiful has come from the useful; in any case the finished product embodies the notion of purpose, whether as the past of the present or as the future of the present or as both together. That is clearly true of all artistically fashioned utensils. In their production the artist must be guided by the demands of the norm—the purpose. So far as we see at the first glance that an object serves a purpose, we feel it to be beautiful. A wine glass is supposed to show at once that we can drink out of it. Unquestionably, personal experience, education, and environment exert a decisive influence on such judgments. In regions where the inhabitants are threatened by creeping reptiles, ravening beasts, and especially earthquakes, easily mobile houses and lake-dwellings are seen to be effective; but with us the feeling of pointlessness would prevent any impression of beauty from arising. Furthermore, it is very probable that in the useful arts practical necessities led to certain forms which seem beautiful, now that their lowly origin has long been forgotten. Finally, it ap-

pears possible that the beauty of the human form has something to do with the preservation of the species. At all events, purpose and use have an influence of some kind or other on the beautiful.

It is therefore advisable to use a separate word for the cases of the beautiful in which utility and superficiality are absent and the very frequent danger of cheap ostentation is avoided. It almost seems to me that we could introduce *gentility* into aesthetics as a special category. It is closely related to the beautiful, indeed is in essence only the unobtrusiveness of that harmony which prevails in the beautiful. In other words, it is the self-sufficiency of the aesthetic life, suggested as restraint or unconcern. The word has always been used in this way for modes of disposition and action or for lineage and family membership; now we are applying it also to works of art. The beautiful becomes genteel when, to guard its character, it renounces the meanings and forms which have grown intertwined with it historically.

There is a superficial beauty for the whole world, and it does not lack a single characteristic of beauty. But this beauty, recognized and established by the favor of the times and the masses, prostitutes itself: with the delight of the *nouveau riche* it calls to us, boasting how flawless its colors and forms are, its tones and rhymes. Still more do we like effective technique and rejoice in the quiet necessity with which an artist draws a line in a very unusual way without depriving it of its pleasing form. Indeed, we even call such artistic style "apart"; yet we distinguish it from the intentionally bizarre with that instinctive certainty which operates more delicately than conceptual evaluation. Modesty conceals genuine power; silence often takes more courage and determination than striking out. Gentility arises wherever restraint and certainty are united. Its seriousness is opposed to everything loud and ostentatious; it gets its effects through soft tones and colors, through calmness and delicacy. As soon as gentility is confined to small dimensions and weak intensities, it approaches the ornamental. Japanese art offers choice examples. And from the ornamental a short road then leads to the concept of *prettiness* in our schema.

In Edmund Burke's investigations of the beautiful and the sublime there is a section entitled "Beautiful Objects Small" (3:13). The argument is this: What at first strikes us in an object is its size. In the case of beautiful things, we can learn from the usual expressions for them which sizes are normal. Now, in most languages diminutive terms are used not only for those we love, but also for

beautiful objects. There is a difference between admiration and love. "The Sublime, which is the cause of the former, always dwells on great objects, and terrible; the latter on small ones and pleasing; we submit to what we admire, but we love what submits to us; in one case we are forced, in the other we are flattered, into compliance." This sentence reveals to us the one reason for the striking title of the chapter. As Burke on the whole recognizes only two aesthetic categories, beauty and sublimity, and as sublimity is doubtless connected with unusual magnitude, so through contrast he reaches the conclusion that beautiful objects are comparatively small. Secondly, he had formerly attempted to prove that our sense of the beautiful consists in a pleasure connected with our social impulses and ultimately with sexual love. Accordingly, the use of diminutives to express tender affection can be simply transferred to beautiful objects. (In *The Sense of Beauty*, 1896, George Santayana investigated the connection between aesthetic susceptibility and sexual development.)

To recognize that the situation is more complex we need only to recall how often diminutive words express another feeling— ridicule and contempt. Small size is pleasing, on the one hand, in virtue of its unpretentiousness and the comfortable feeling of superiority which it imparts to the beholder; on the other hand, it also gives the impression that the object need not be taken seriously. Therefore, two quite different shades of our feeling of superiority come from the same quantitative constitution of the object. This shows why the smallness of a work of art allows it to be called pretty as well as comical. Something of aesthetic value, but restricted to small dimensions, is pretty; a small object has a comic effect when we necessarily expected a large object in its place. The ornamental and the pretty have this in common with the merely beautiful: they all lack unusual depth. If a playful, saucy disposition is added, grace appears, in the sense in which the country lasses and shepherd girls of the Rococo Period show it most exquisitely.

Here let us recall once more the opposition of callicracy and panaestheticism. Now we see the whole contrast better than before. We know that beauty is inseparably bound up with the essence of the aesthetic. We are familiar with the distinguishing features of beauty and with its aesthetic neighbors. It will now be shown that a certain effluence from the realm of the aesthetic can join with the other basic forms, and later it will become clear that

art is not a collection of aesthetic pleasures, but a comprehensive reworking of the very stuff of experience.

2. The Sublime and the Tragic

In the case of things we take to be sublime, their magnitude especially strikes us. Pyramids and Gothic cathedrals, thunderstorms and wild revolutions of the masses, contempt for death and heroic passion appear sublime in virtue of their size or strength. This emotion in the face of power and struggle is unmistakably different from the blissful transports of the beautiful. Now the question arises as to the source of its peculiar psychological nature. Surely this nature springs from the fact that a certain boundlessness and inexhaustibility broaden our souls. Externally regarded, works of art are naturally confined to narrow limits. Even the sight of the starry heavens and the sound of the rumbling thunder storm quickly end. But in the uniformity and magnitude of such aesthetic objects there is something that carries them beyond themselves, and us beyond ourselves. The quantitative aspects are always essential. If we confine our reflection to them, we find within the field of art an established fact which has engaged philosophical thought since ancient times. It is the fact that through mere increase a new quality can arise; that a single grain of wheat, added to five others, gives them the quality of a heap, which they did not have before. Even here, to be sure, other circumstances come into consideration—the things must lie close together and without arrangement—but nevertheless the principal point is still the number which, through the addition of a single grain, can become a number no longer immediately intelligible. The centimeter which I add to ninety-nine others is worth no more than the centimeter which is added to twenty others, and yet it creates the new concept of the meter. From similar examples Hegel has abstracted a "nodal line of measure relations." Speaking of the solid, liquid, and gaseous states of water, he remarks: "These different states do not appear gradually, but the merely gradual continuation of temperature change is suddenly interrupted and checked by these points, and the appearance of a different state is an abrupt transition." (*Wissenschaft der Logik,* I, 313.) In our line

of thought, the comparison of a drop of water with the ocean would be more appropriate. The drop is the same as the ocean, and yet unable to raise a storm. Or we could think with Hegel of the moral example: "With merely a quantitative increase the limits of levity are overstepped and something quite different, crime, appears—right passing over into wrong and virtue into vice" (314). Thus, at a certain point which cannot be indicated more accurately, an object or event of aesthetic value becomes sublime.

In the eighteenth century the beautiful and the sublime were given coordinate status as concepts of equal importance. The best known writings in the literature on the sublime are the anonymous Greek treatise *On the Sublime* ($\pi\epsilon\rho\iota$ $\H{\upsilon}\psi o\upsilon s$) and Burke's *Inquiry*. The anonymous book is concerned with what we should call the pathetic mode of writing and speaking, and opposes the authors who demand scrupulous stylistic precision. The general considerations are of no particular value. To Burke, on the other hand, we owe the very important insight that the feeling of sublimity always contains astonishment and fear, hence pain, and that these emotions can be ennobling. Sublimity signifies such overpowering might in the object that petty feelings of personal fear vanish from the soul. Clearly this self-forgetfulness, produced by the power of the object, can occur most easily and certainly in the presence of artistic sublimity. For the negative condition, necessary for self-forgetfulness, is still the more or less unconscious feeling of security when one is confronting superior might. The cleverness with which we guard ourselves against the dangers of life, great and small, would avail nothing here. The essential mood is, therefore, not only one of subjection to overwhelming power, but also one of confidence and, as was said, it must appear more easily with works of art than with objects of nature. This can also be expressed in such a way as to show, with Friedrich Theodor Vischer, that the feeling of the sublime contains conflict within itself, whereas the feeling of the beautiful is devoid of all discord and disturbance. This may be pointed out as a fact of inner experience, but Vischer's metaphysical explanation of it tells us nothing. The Idea, so he asserts, tears itself loose from the calm unity in which it was fused with the form, reaches out beyond the form, and holds up to that finite form its own infinitude. This statement is instructive in showing how a correct feeling is translated into metaphysical metaphor and thus robbed of its general scientific utility.

Originally the physical strength of a person may have been

the only object of aesthetic admiration. Gradually this limited feeling has broadened into a feeling for sublimity in all fields. It is not worth while to enumerate the forms of the subjectively and objectively sublime after the model of Vischer's aesthetics. All kinds of physical and mental magnitudes which are imposing in life produce in artistic form an enjoyable exaltation of the person who is aware of them. But the dimensions or strength need a certain absolute magnitude for sublimity. To make an object sublime it is not enough that it be much greater than the surrounding objects; it must be so great that it borders on the infinite, and this is possible only above a certain minimal quantity. No poet can confer sublimity on the life of a three-year-old child, although in comparison with the life of a fly it covers a vast time span. But with proper artistic presentation an old man of a hundred years, whose age seems to reach back into eternity, inspires unqualified respect. Of course, these magnitudes hold good only for human awareness, and to this extent are relative. Yet with considerations such as these the anthropocentric standpoint is obviously assumed. This relativity must be even more restricted in the sense that it fluctuates historically. In our age, when relatively many persons become familiar with the sea and the Alps, and are early accustomed to the broadest dimensions, the qualities of the sublime must meet a particularly large standard. Earlier generations, to be sure, could get the same inner excitement from smaller impressions, but we need vast vistas. It seems as though henceforth the sublime in art will more and more renounce formal beauty. So we feel at once the sublimity of a formless colossus, because in forms—even the largest—we too clearly detect the purposiveness. The training of the eye has so advanced that the unexpressed feelings of anxiety, which creep very gently into the beginning of an uplifting experience, are absent when we are viewing a building of iron construction, even one of the mightiest. Greater massiveness is necessary for us than for the artistic taste of the past. Finally—now as always—the values of sublimity are only perceptual, not conceptual. Logically viewed, they signify an inability of the self to draw sharp boundaries, a defeat of thought, which grows giddy in the face of superior power. Yet, where impotence threatens thought, enjoyment beckons to perception. This enjoyment takes on a physiologically conditioned tinge through articular sensations of relaxation and epidermal sensations of shivering. But more important is the purely spiritual aspect of the process. We called it exaltation. One can cravenly comply with a superior power or flippantly ignore it.

In neither of these two cases does the impression of sublimity appear; for such an appearance man must transcend himself without forgetting himself. Whoever has a real sense of sublimity cannot feel himself as an harmonious being in an harmonious world. Rather he must grasp the extraordinary he encounters as the essentially human in himself. That man as man is an infinite being we learn through the powerful experience of the sublime and the similar experience of the tragic. And they show how onesidedly the lovers of beauty with their friendly optimism present the meaning of the universe by gliding over the riddles and seeing nothing but blessed peace. The tragic consciousness is the knowledge of the inescapable suffering destined for all that is good, that knowledge united with the power to win from this discord an ultimate state of exaltation.

The efforts to discover the essence of the tragic are blocked at the very start by two obstacles. The first lies in the question as to what forms of reality and art embody tragedy, which certainly is primarily something going on subjectively. This is connected with the other question as to whether there is a general or only a dramatic tragedy. Both questions widen into a thorough discussion of the mutual bearings of aesthetics and ethics. Aristotle builds on a psychological and realistic basis. For the characteristic feature of tragedy, alleviation through catharsis, is a mental process, and to explain its occurrence Aristotle assumes that the usual non-aesthetic state of mind is constantly controlled by a tension of fear and compassion. Our psychology, of course, does not admit that fear and compassion, as permanent emotional moods, form the shadowy background of the soul. Still, the statement is not sheer fabrication. Many persons, especially children and artists, are chronically oppressed by a primitive dread, apparently without any justification. What others know only from the terrible hours of sleepless nights, the fear of the unrecognizable and inexpressible, pulsates incessantly in the souls of such persons. And a gentle, overflowing mood, a tender urge to caress human beings and animals, plants and stones, fills some persons in such measure that we could say they were ruled by compassion. But no transition can be found from these generally very rare temperaments to the aesthetic. For in the enjoyment of tragedy such moods do not come to any real purgation that actually releases the spirit. A dissonance of noises in the real environment cannot be resolved by any musical harmony. Those tensions of fear and compassion are freed, to be sure, when we read

in the newspaper about the horrible suffering in a shipwreck, but they are not aroused and purged when we live through Tristan's fate with him. Fear and compassion are like care; they bind man to the earthly and check his higher self instead of liberating it, as the theory demands and must demand.

If anyone sought to console us with the claim that a mitigating effect would appear later, then—in harmony, by the way, with earlier aestheticians—we should have to call his attention to the fact that enjoyment is indeed experienced simultaneously with the occurrence of the most painful feelings. The power of tragedy to stir us cannot get its significance from what will perhaps take place later on. But we need only recall an earlier remark to make it clear that this power of tragedy does not hinder aesthetic joy. The basic psychological fact is the pleasure with which we give our imagination free play throughout the breadth and depth of life. The soul strives to live itself out untrammelled in the world of imagination it has fashioned. It does not shrink back from the most frightful things; indeed, it looks for them in order that it may be able to enjoy great excitement. As certain kinds of death, certain illnesses and other misfortunes are in fact less painful than we imagine, so conversely the most painful thing becomes tolerable or even pleasant when it passes into the world of fancy. Let us not be misled by the use of words. What is called tragic in ordinary life is indeed sad, but not tragic in the artistic sense. Artistic tragedy has splendor and grandeur. Tragic it is, when the author lets a strong and full life end at its peak. But it evokes our compassion only if we unjustifiably introduce conventional concepts into the aesthetic world. In obituary notices someone is said to have died at the "honorable age" of eighty. From the same point of view one may pity the hero of the tragedy, because he is called away prematurely. But the hero and the author do not intend to evoke any pity at all. They find it as natural as it is ennobling that a burning candle consumes itself. Candles which do not become bright flames can, of course, last for countless years. Should we, perhaps, call this a complete life ($\beta\iota o\varsigma$ $\tau\epsilon\lambda\epsilon\iota o\varsigma$)? Aristotle meant by the term not a great age, but an undisturbed self-development. Yet the tragic hero's completion of life is shown also in the manner of his downfall. When we ask now for the feelings which stem from personal sympathy with the hero, envy and admiration are mentioned rather than fear and compassion. This is not supposed in any way to deny the significance of suffering. Later on, when considering the artistic man, we shall be

163

shown most impressively that suffering is the very state which heightens the value of personality. I might almost say that suffering really creates this value for the first time. Through the mode of his suffering man becomes really what he is called to be, and no guilt which leads to suffering can rob him of his humanity. But, of course, it depends on the cause of the suffering. If it is trivialities, we smile at his despair; if it is the rules of an etiquette which has grown unintelligible to us—as often in the Spanish drama—we shake our heads; if, on the other hand, it concerns the things that make life worth living, we sympathize.

The purgation theory becomes even more confused, as soon as the standards of bourgeois ethics are boldly applied. If we explain our joyous mood by the fact that here in its supreme degree we are living through the evil we fear in life, but without harm, because it is in the soul of another person; still this is really no better than "Thank God it isn't I." This is the way old women read detective novels. The same aesthetician says, "In tragedy the general welfare, the welfare of society, should be preserved." Here the majesty of the Universal Mind, before which every finite magnitude vanishes, is deliberately transferred to civil society. The social order, as a miniature of the eternal world-order, allows us a glimpse of its greatness and affords us awesome joy! No. If we enter upon such a line of thought, then we should say that with the deepest shock we experience the annihilation of a value, and thus become most poignantly aware of its authenticity. Or let us recognize the danger of destruction which necessarily dwells in all our possibilities. ("We feel a tragic shock, when we see a line of succession broken off, a line we also feel as lying within our range of possibility, so its utter destruction frightens us as our own possible fate."—Christoph Schwantke, "Vom Tragischen," Z.f.A. x, 25.)

Now we come to the objective side of tragedy. The usual account restricts this particular form of the aesthetic to a definite kind of poetry. Furthermore, it requires that there be a hero and his guilt, an unbalanced devotion to something good which leads to suffering and ruin.

Undoubtedly the favorite place for the category of tragedy is a certain form of drama. But we can also transfer this concept with some justification to other fields of art, such as music. Overtures and symphonies have repeatedly been called tragic. Whether there is anything similar in architecture is questionable, but there are many paintings and works of plastic art which portray tragic

themes. We need not waste words on the obvious truth that every art expresses the tragic in its own fashion and in conformity with its media. The spatial arts can only with difficulty reveal the gradual approach of the tragic event; the novel does this with supreme clarity. In the drama, again, the aspect of combat comes to full expression. The more sharply the equal justification and strength of the opposing forces stand out, the greater is this combat in human value and artistic effect. The opposition, thus pointed up, arouses our interest most vitally. A hero seems not to be absolutely necessary, for concentration of attention can be achieved even without a central figure, as many tragic works show (Gerhart Hauptmann's *Die Weber,* for example). Furthermore, it should be said categorically that to call partisan action and passionate devotion wicked and punish them by downfall has never been the meaning of a genuine tragedy. The expressions, tragic guilt, inner purification, and poetic justice, all aim to make tragedy an outcome of fictional morality. But when we examine the greatest authors without preconceptions, we do not find them handing down moral decisions. *King Lear* contains no more morality than a Bach fugue; before his destiny is fulfilled, Macbeth is rather more excused than condemned. Shakespeare's sensitivity to all the relevant facts, especially the facts of passion and will, is far too strong to enable him to take a moral position. Above all, the heroes in the plays of his youth follow their desires so impulsively, are such natural outgrowths of selfishness, and change their feelings and views so quickly, that a fixed norm, perhaps even Christian charity, strikes no root in them. They have no sense of wrong and no conscience. Their creator never condemns them. I could not say how the ethical scheme of the usual theory of tragedy would be applicable to his *Henry VI.* Nevertheless, even though we may not let the whole play pass as tragedy in the academic sense, its trend is tragic.

The demand that every tragedy lead to reconciliation also rests on a misunderstanding. Dynamic equilibrium as a moral ideal and the exemplary status of perfect beauty have given occasion for the view that even in tragedy the discords must be resolved. This may be true for the serious stage play, but genuine tragedy leaves the conflict unresolved. Such tragedy proves that in the world and in life there are oppositions which nothing can remove—no greatness of character, no heroism in battle, no guilt or innocence, indeed not even death. Precisely in the highest values of man lie the seeds of sorrow and ruin. Above deity and its forgiving generosity

165

stands inexorable fate. In this world there is something powerful and harsh, a cruel justice. It forms the dark core of tragedy, which could therefore be called in general the tragedy of fate. As we become aware of fate only when it thwarts us, so tragedy, which reveals the rule of fate, is based on misfortune. We detect it as soon as human limitations appear in coping with great problems. Is there anything more terrible than the fantastic idea of the human mind enclosed in an animal body? And yet we are all in a similar situation. We feel our weakness, and fate never allows us to overstep the boundary. We human beings are granted neither the outer circumstances nor the inner constitution fate permitted for the evolving organism at lower levels to work itself out fully. This mutual struggle of self and world, or even of elements within the self—a struggle recognized as interminable and marvelled at as the mighty dissonance underlying the world—this constitutes the objective content of the tragic. Tragedy is intelligible only if we concede that man and the world are discordant. Whoever would live a life in pure beauty, taking refuge in the peaceful ideas of pervasive harmony, must abolish the tragic in principle. Tragedy, it seems, cannot be united with the ideals of culture and of humanity that float before the most refined souls. To be sure, alarm and the clash of swords, murder and the smell of blood concern only the historical development of tragedy in the past, and not the changeless essence of its meaning. But nevertheless, all intrinsic tragedy is forever bound to severity, cruelty, and discord, if it is to be worthy of its name. Georg Simmel has taken up this thought and pursued it in a posthumous "Fragment about Love": "The tragedy of Romeo and Juliet is measured by their love. The empirical world has no room for this one of its dimensions. But, since love has nonetheless come from this world, and must involve its real development in the contingencies of this world, so from the first it is afflicted with fatal contradiction. If tragedy means not simply the collision of opposed ideas, purposes, or demands, but rather that what destroys life has grown from an ultimate necessity of this very life, that the tragic contradiction of the world by the self is, in the last analysis, a self-contradiction—then it afflicts all who live on the level of the Idea. What is above the world or against the world gets its tragic aspect not from the fact that the world cannot tolerate it, combats and perhaps annihilates it—this would be only sad or shocking. Its tragic aspect comes from the fact that it—as Idea and bearer of the Idea—has drawn the strength for its origin

and sustenance from this very world in which it finds no room."
("Fragment über die Liebe," *Logos*, x, 1921, 1 ff.)

Against this well-supported view stands another one, which
has been referred to more than once. Adalbert Stifter has expressed
it in the following words: "As it is in external Nature, so is it also
in internal, human nature. A whole life of justice, simplicity, and
self-control, of reasonableness, of effectiveness in one's group, of
admiration for the beautiful, and of calm, radiant aspiration—this
I regard as great. Mighty turmoil of the spirit, terribly thundering
rage, the yearning for revenge, the inflamed mind that strives for
activity which changes, tears down, destroys, and in the excitement
often throws away its own life—these I regard not as greater but
as meaner, for they are just as much the mere products of de-
tached and unbalanced forces as are storms, volcanoes, and earth-
quakes. We seek the gentle law by which human life is guided."
(Preface to *Bunte Steine*.) Applied to tragedy, this would be to
say that not the conflict, culminating in dramatic form, and not the
crushing destruction, inflicted by fate, but the transcendence of
such fatal oppositions is the very heart of the tragic. So far as this
attack is directed against the crude and antiquated forms of
tragedy, it seems to me thoroughly justified. But it falls into a grave
error in attenuating the mood of enjoyment to that of a gentle,
ironic smile. Recent investigators of the problem compare tragedy
with the epigram and the witty paradox in the form of their
appeal. There is much truth in this. But the tragic contradiction is
not resolved, and the laughter evoked by this antithetical play is
the laughter of despair.

The distinction just mentioned can be made still clearer.
The artistically interpreted discords of human life are humorous
when slight, tragic only when much sharper. Moreover, the charac-
ter of the discord changes with the degree. Often, when confront-
ing the same fact, the Heraclitus in us wants to weep, the
Democritus to laugh. We can imagine the incidents in Strindberg's
Dance of Death (Totentanz) as furnishing also the subject of a
humorous novel. Only for the heightened sensitivity of such
"modern" men do these events portray the fate that threatens life.
There is a threshold, so to speak, between humor and tragedy.
Only by surpassing a certain degree is the conflict sure to achieve
a tragic effect. This effect is further fostered when the conflict
does not come gradually, but breaks in suddenly. With good reason
dramatic practice in ancient times preferred catastrophes—sudden,

violent events. If we dissect them into their smallest elements and spread them out into long temporal series, they find it harder to cross the threshold of tragedy.

3. The Ugly and the Comic

Like tragedy, ugliness rests on discord. We need only recall what was said apropos of naturalism about the value of ugliness to see clearly that the ugly should not be equated with the unaesthetic. On the one hand, the ugly can even be enjoyed aesthetically and used artistically, as the facts show most impressively; on the other hand, the non-aesthetic need not by any means be ugly. (In the past, to be sure, it has been firmly held that the arts do not grant a place to the ugly with equal ease. Adam Smith thought that "the picture of a very ugly and deformed man such as Aesop or Scarron might not make a disagreeable piece of furniture. The statue certainly would. Even a vulgar ordinary man or woman, engaged in a vulgar ordinary action, like what we see with so much pleasure in the pictures of Rembrandt, would be too mean a subject for statuary."—*Works*, 1811, v, 250.) Obscene pictures display the most beautiful figures and yet fall outside the aesthetic sphere. Moreover, in daily life there are thousands of objects and incidents which, though not ugly, scarcely ever give us occasion to regard them aesthetically. The ugly is only the contrary opposite of the beautiful, something positive in any case, whether one takes it to be a value or a disvalue. In this respect it is like the bad, but superior to the bad by virtue of its greater worth. Although akin to the tragic and to the comic, it is distinguished from the beautiful by its instability and inconsistency. In a word, the ugly is a primary aesthetic concept, one among the others, and the main question is where to place it. Elsewhere our aesthetics does not take up problems in terms of placement, but with these primary forms the place becomes almost as important, on the whole, as the form itself.

The figurative arts and drama very often show that the addition of ugliness gives an overpowering character to the sublime and the tragic. Ugliness of this sort is distinguished by its intensity. There are things which we cannot like, and yet they keep

drawing the eye to themselves. This ugliness has the attractive power of the abyss. Even in common life the distortion of the ugly, the revolting, can actually fascinate us, not only as a stroke of the lash for our aroused sensitivity, but also as a painful stimulation of our life as a whole. The sick never weary of regarding their deformities in the mirror; indeed, they can take a certain pride in the fact that their repulsive appearance exerts a fatal power of attraction over others. The masters of art are justified in embodying such stimuli in their works for merely artistic use. None of those phenomena of life is incapable of sustaining a form of art. Think of the incest in Sophocles' *Oedipus* or of the *Philoctetes*. Look at the leprous cripples covered with sores in Holbein's painting of St. Elizabeth.

Something independently ugly may be achieved by a small variation from the pleasant or the ideally beautiful. The slight distortion of a square or a circle, or the combination of incompatible colors, produces an ugly effect. So far as such effects are due to the artist's lack of skill, we need not consider them; the senseless interference with a natural outcome is never justifiable. But it can be artistically intended and permitted as a foil to the beautiful: as the dark from which the radiant light is set off, as the marshy ground in which wonderfully bright and fragrant flowers flourish, or as the sinister power with which the good struggles. Still more important is the ability of the ugly to extract aesthetic values from itself. When eye and ear enjoy customary forms or contents, the spiritual core hidden within them can only with difficulty be freed from the outer covering. When dealing with these things our awareness moves smoothly along without feeling the flaming fire within. But as soon as the usual and harmonious are abandoned and an unusual choice of form attracts our attention very strongly, we comprehend the sensuous as expressing a spiritual life of worth, hidden within it. The conventionally beautiful becomes meaningless all too quickly; the unexpected ugly is generally meaningful. Hence artists turn away most definitely from what is sensuously satisfying and aesthetically pleasant when they are consciously aiming to enhance the expressiveness. Especially when they would reveal that realm which is not of this world, beauty must be shunned and may be replaced by the mute and meager forms of ugliness. All kinds of beauty—the strict beauty of forms, the jubilant beauty of colors, the euphonious beauty of musical harmonies—spend, as it were, so much energy for their showy exteriors that none is left over

for their interiors. They are acknowledged as children of this world. That is their right and their proper purpose. But when the artist would express the deepest yearning of his heart, revealing the most intimate and spiritual things, then ugliness offers itself along with gentility as an adequate means of expression.

The textbooks on aesthetics take peculiar pleasure in expounding the thesis that the beauty of the human body is its transparent revelation of health, that the power and suppleness of the limbs assure them a dynamic beauty superior to the purely formal. Now clearly that does not hold true on the positive side, for there are plenty of persons about with red cheeks, tonic muscles, and thoroughly sound health, on the whole, without thereby becoming beautiful. A little snub nose over a broad manly mouth, small eyes beside large ears, a short neck and a square hand are not made aesthetically pleasing even by the most robust health. Nevertheless, health could form an indispensable condition. Thus under all circumstances a sick body would be ugly, a healthy body being the indispensable presupposition of a pleasing outward appearance, although other elements would still be needed for beauty. But even in this version the thesis is still inadequate. Among diseases there are some which might be called disfiguring and have been used in the arts as examples of extreme ugliness (the plague in Hermann Lingg's *Schwarzer Tod* and dropsy in Zola's *Joie de vivre*). There are other maladies which for long periods of time, and perhaps always, remain invisible, physiological disturbances which bring sudden death. Finally, however, there are also diseases which, as the unprejudiced observer will grant, often beautify the patient. Even in the case of consumptives we can see this transfigured beauty—slender form, luminous eyes, and transparent, uniformly pale skin. That is a beauty apart from nature, a beauty revealing the soul, and higher than the celebration of form and color in a body parading its plenty. Whoever holds that bodily health is aesthetically indispensable will perhaps show maternal happiness by portraying a Rubens-like mother with broad hips and milk-swollen breasts as she nurses her child. On the other hand, more sensitive artists look down with a touch of disgust or pity on this happiness of the healthy mother animal—a happiness they hold to be bestial and not necessarily connected with spiritual development. "When I am painting a mother," said Jean François Millet, "I try to make her beautiful merely by the way she looks at her child."

The ugly ultimately passes into the comic. When the ugly

is a deviant, under certain conditions it can shift into the comic. Aristotle pointed to this in defining the comic as the innocuously ugly. Rousseau rejected comedy because it claims our sympathy for base deeds and characters—for the cheap (ψαῦλον), as Aristotle calls it in a similar context. Refined natures are hence unable to greet with good grace much that seems funny to the majority. They cannot laugh when they read in the illustrated comic papers of the practical jokes played on this or that person. Are all the pranks of Renard the Fox really fit sources of diversion for the reader? Can one really laugh at Molière's *George Dandin* and *Le Misanthrope?* In *L'Invalide imaginaire* Doctor Diaphoirus praises his stupid son Thomas: "He never had a very active imagination or that spirit which we see in others. When he was small, he was never, as we say, lively and mischievous. He always seemed gentle, serene, and taciturn. He never said a word and never took part in the so-called boys' games. It was hard to teach him to read, and at nine he still did not know his letters. 'Good,' I said to myself, 'the late trees bear the best fruit. Digging in marble is harder than digging in sand.'" This description usually arouses uproarious laughter. I am touched, not amused, by such paternal love, and the inhuman delight of the author, sneering forth scornfully from this distortion of the human, creates for me an impression of sorrow and ugliness rather than of entertaining drollery. Much of what passes as funny remains on just as low a level as the brutally tragic, which forms the opposite pole. Princes once kept idiots, dwarfs, and monsters to laugh at. On the one hand, to be sure, they enjoyed these poor creatures' flashes of insight, free from all court restraint. But on the other hand, the grotesque show was good sport for them. Even now children and crude adults laugh at drunks, hunchbacks, and cripples. The Punch and Judy show, in which the jester deals out and takes blows, relies on the primitive mind's prevailing pleasure in violence. At this point also the covert and sinister kinship between the tragic and the comic crops out. Implicit in both categories is something that glaringly lights up our essential turbulence. Even the comic, I must repeat, is intelligible in its whole extent only when we keep in mind the immoderation of man. The sublime and the ugly, the tragic and the comic can in like manner contain grotesque features in which the monstrous comes to expression.

But let us see man as he really is. The most important thing for him is the satisfaction of his desires. If we omit mention of hunger and love, curiosity and the striving for power come first

of all. The urge to be present on all occasions makes respectable old men impatient children and transforms the gentlest women into brutes. They simply cannot endure being absent when something is going on. No effort is too great and no danger frightens them when required for their presence at a festive procession or a riot. The same curiosity drives them to the theaters and art galleries. And the feeling of a power they have exercised consoles them for all the shortcomings of existence. This feeling makes the invalid worry those about him; it spurs the man of superior station to abuse his dependents. The outer as well as the inner life of man is full of the yearning for influence. But an ultimate and universal human desire for absurdity can break out. There is an active pleasure in kicking over the traces and a passive pleasure in nonsense. This is what assures the strongest response to the comic. A whole host of concocters of farcical comedies—authors, theatrical directors, and actors—lives on this pleasure in nonsense. In a comic paper I read a fairy tale which begins like this: "There was once a prince, named Agnes, who went to the churchyard at midnight to reign there and grow a beard. Here he met a man who pretended to be the justly deceased Cromwell and cried out 'Oh turn back! Turn back!' But the prince understood him to say 'Oh dear me! Dear me!' and wept and turned into a carnation. In the calyx of the carnation there presently formed a dewdrop which one could take for a flamingo, and when this basilisk regarded itself in the mirror, it was actually frightened at being so similar." That is sheer nonsense without any trace of wit; yet this supreme contempt for logic amuses most people. And in its freedom from the restraint of reality there lies something that links nonsense with wit, with play, and with art—especially with the comic, which can, indeed, yield very intense pleasure, but no deep, inner joy. In Christian Morgenstern there are poems born of the sheer delight in rhyme or sound without any conceptual meaning. Take "Gruselett" (*Gingganz* 16):

> Der Flügelflogel gaustert durchs Wiruwaruwolz,
> Die rote Fingur plaustert und grausig putzt der Golz.

Theorists have long tried to explain the comic on the basis of laughter. That will never succeed, for laughter, on the one hand, is evoked also by other bodily and mental events and, on the other hand, often fails to occur with funny experiences. It is more promising to describe the inner experience and its outer occasion. Like each of the other categories, the comic can be regarded as a

peculiar mood, determined by a quality of the object. Hence, it has a subjective and an objective aspect. The subjective process is interpreted variously in accordance with one's basic psychological view. One theory, long accepted, described the experience of the comic as a contest of feelings. But, since modern psychology will not acknowledge a coexistence of several feelings, it reduces this experience to a distinction of several aspects in a unitary feeling of self. More definitely, the event is supposed to consist in the observer's expecting something great or important and being amused by the arrival of something small or trifling. Lipps explains the comic as something small that behaves like something large, and then suddenly evaporates into the nothing that it really is. Our impression is composed of confusion and subsequent enlightenment, this movement of ideas being repeated until it finally fades away. The special feeling of the comic would accordingly be viewed as the disappointment occurring when the mind prepares for a strong impression and a weak impression appears. The pleasant character of the feeling would be explained by the fact that the surplus of mental power, like every preponderance of inner strength, feels pleasant. Somewhat differently expressed, the pleasure in the comic would be a pleasure springing from the hypertension of attention. From other psychological points of view one could say with equal justification that there is a momentary hypertension of consciousness. But it is questionable whether the shift of the important into the trivial evokes a to-and-fro movement of ideas and a so-called damming up of psychic pressures. (According to Baerwald's investigations, the oscillation does indeed occur, but only as a peculiarity of many persons; so it offers no further support to the dam-theory—Z.f.A., II, 224 ff.)

What can be observed has been interpreted otherwise as a fluctuation of the whole comic pattern in intensity, as a decrease and increase of strength, like what occurs also in meditation or in listening to music. In these cases only the temporal interval and not the qualitative peculiarity of the process would be concerned. The second theory would seem to fit impartial observation better than the first. In any case, since the description and explanation of what goes on in the mind depend throughout on one's whole psychological outlook, the question can hardly be decided within an aesthetics that is striving for independence.

It is also more important for aesthetics first to ascertain the objective conditions which, within and outside art, lead to the

impression of the comic, and then to gain an insight into the deeper meaning of the comic in general. The first task is made the more difficult by the fact that individual and historical differences are indeed never more evident than in this very field. We have already discussed why the sphere of the comic must be narrowed for the refined, cultivated man. Now we would recall how extraordinarily fast the funny grows stale. The charm of the intellectually comic (witticisms and puns) fades in a few years, and even the comic drawing is relegated astonishingly fast from the field of the funny to that of indifference and insipidity. Yet there are a few permanent types. By the perceptually funny we mean any thing or event which evokes a comical feeling through mere sense perception. Two cases are to be distinguished. First, we laugh on perceiving a harmless and unwarranted violation of a familiar regularity, or when something trivial crowds out an important expected object. On the vaudeville stage one sometimes sees the following bit of fun. Someone is trying to pull a horse in the wing on stage. His efforts are futile. So he calls to his aid a second person, then a third, until finally six men are stretched out, puffing and sweating as they tug at a strong rope. The neighing of the horse and the pounding of his hoofs are heard off stage. At last, after the sixth man, a veritable Hercules, has added his strength, the rope moves and a tiny wooden horse appears. This is funny because the regular relation between force expended and result obtained is disturbed, and something relatively small is directly perceived to replace something relatively large. The precondition of all this is that the feelings of displeasure involved in perceiving the false or frivolous remain weak, and that the worthless thing come into view with apparent justification, and quickly and surely call up its associated contrary, the appropriate thing.

Such cases can be explained, as French philosophers have done, by the fact that the destruction of a barrier leads to a feeling of one's superiority and freedom. Yet even the opposite occurrence can seem funny. Whenever a man makes machine-like movements, he strikes us as comical. If we meet someone of whom we have just spoken, believing him far away, we say: How funny! Here it is probably the mechanization of what is otherwise incalculable, or the substitution of the automatic for the living, which in its worthlessness and futility seems comical to the observer. For both kinds the immediacy of the perception is always a chief precondition. Hence the perceptually comical can only with difficulty be de-

174

scribed and conveyed in words. We must feel it for ourselves or get it as portrayed by the draftsman's pen.

For the witticism, to which we turn as the second kind of the comic, the rule again holds: as intensely as it can amuse us at the moment, yet so quickly is it forgotten. With each repetition it loses in charm, except for the person who recounts it, and with the resultant laughter celebrates a triumph of his vanity. The witty expressions induce the formation of meaning-images which are suddenly annulled. Over the bed in a country inn I once found the following friendly advice in large letters:

"And if you climb into this bed,/Put the other leg also under the spread." (Und steigst du in dies Bett hinein,/So zieh auch nach das andere Bein.)

This quip, which serves as a transition from the perceptually to the verbally comic, requires the formation of an image which loses its physical importance as soon as it is completed. The idea that anyone could forget to take his second leg along to bed is— particularly if it comes as a picture—immediately funny through its contradiction of all that is usual. Now for an example of pure wit. Long ago an academician classified university teachers as ordinarians, extraordinarians, and dinarians, the last class comprising the wealthy, unsalaried lecturers who can give sumptuous banquets. Were the word *dinarian* in existence, even if only in the sense of "host in general," its use in this instance would perhaps be striking, but not comical. The word formation, free and yet governed by phonetic patterns, along with the mischievous secondary meaning, makes the sentence funny. Thus the talents of wit involve a linguistic mastery, indeed a creative power, akin to the gifts of the poet. And the effect is enhanced by the ulterior purpose, which is usually a more or less covert "dig" (even in the case of indecent jokes). But let us dwell upon the technique of wit.

The playful production of an unexpected connection is shown especially in the use of mere phonetic similarities. This was so when Hans von Bülow called the two leading singers on his stage—women conspicuous for obesity—the two *Primatonnen* (first tubs) and spoke of the stage manager and his composer-wife as *Kulisses* and *Mausikaa*. [Plays on stage wing (*Kulisse*) for allusion to Ulysses, and on music for Nausicaa.] In other plays on words the use of double meaning may be mentioned. A school girl who has written an essay on the Maid of Orleans, describing her

175

ecstasies and visions, closes with the words: "From this we see that the Maid is in an *übernatürlicher* (supernatural or strange) state." The double meaning lies in the word *übernatürlich*.

Of another sort are the witticisms which do not play with words and sounds but with the things and arrangements of this world. A wag lets a child describe the impression he got at a concert: "A lady screamed, because she had forgotten to wear her sleeves, and a waiter played for her on the piano." The first part of the sentence contains a false causal interpretation, and the second part a false analogical inference, based on seeing the dress coat. This disruption of natural and social relations arouses a feeling of our superiority, which makes the anomalies pleasant, as caught by thought in a flash. When the teacher ends his description of the rattlesnake (*Klapperschlange*) with the question "Who knows a similar animal that we should not trust?" and the pupil replies, "The stork" (*Klapperstorch*), not only is the phonetic similarity the almost intuitive cause of the laughter; the free play of imagination also has a large share. We call persons witty who can see unexpected similarities everywhere and convey them to us in language that is terse, even phonetically obvious. Hence it was not so absurd for the eighteenth century to assign a separate mental faculty to wit. For there is a transition of steady ascent from the flexibility of a witty mind in the field of familiar verbal meanings to the ability to advance science, or art, by discovering surprising similarities and establishing connections between the most remote things.

The value of wit for life, it seems to me, consists in the fact that it lifts us, at least momentarily, out of the uniform order of reality. Wit transforms this reality, which is just as much inferior to wit in some respects as it is superior in others. Therefore good jokes are not contemptible, but a kind of artistic performance for the person who makes them, and for the recipient a kind of aesthetic enjoyment. The mysterious was once regarded as an essential part of art. Moreover, Baumgarten has expressed himself amply on the subject under the title, "Aesthetic Thaumaturgy." Not much more remains for us than an artistic evaluation of the surprising, and in the comic we have the most certain and familiar means for doing this. Whoever derives art from the play instinct can regard the comical aspect of action as a resting place on the way to the highest art, especially when such art deals with perceptual objects. This is obviously true for drawing and also for music, since the sudden reversion of a melody or rhythm, the

entrance of an unexpected timbre, all this is surely present only
for the ear. But even in the linguistically comical a great deal
depends on the choice of words and sounds.

If we follow the line of transition to its end, we encounter
a concept opposing the concept of fate (which is the basis of
tragedy) and yet, quite like it, foreign to philosophical discussion.
I mean chance. One might say that everything comical—combining
dissimilar elements, as it does, and playfully confusing the serious
and the absurd—is a concentrated and striking portrayal of the
rule of chance. Three acrobats in dress coats and with high hats
in hand are intertwined by Thomas Theodor Heine into an effec-
tive ornament as they introduce themselves to their worthy spec-
tators.* Thus the impossible is realized through the caprice of fate
and its artistic agent. But now, even as every case of chance must
ultimately be lawful in some hidden way, every funny situation
and every joke must also have a causal basis and explanation. Of
the countless arbitrary combinations which we could contrast with
those actually existent, only a few are funny; precisely those which
in the last analysis point again to some coherence. Hence even its
severest critic will not want to deny to wit all right to survive.
Like superstition it merits and retains such a right. Superstitious
practices, at whose altars even the most enlightened people are
wont to burn secret incense—I am thinking of the little expression
"knock on wood"—rest on the half-conscious conviction that on
the one hand, man can influence the course of events apparently
independent of him, and on the other hand, even things most
remote from one another have an occult connection. Like wit,
superstition constructs a world in which human subjectivity unfolds
without trammel, and in which there are no distinctions of distance,
the most remote objects coming together just as easily as adjacent
ones. All this is closely connected with the play of fancy in the
fairy tale. Hence the fairy tale tolerates the dullest "funny" inci-
dents and the most atrocious twists of language, as when the
princess says to the jester "Don't disturb (*störe*) me in my medita-
tions" and he replies "I am no sturgeon (*Stör*), I am the court
courier (*Reisemarschall*)." In one of Brentano's fairy tales the
ancestors (*Altvordern*) are contrasted with the young followers
(*Junghintern*)!

There is scarcely a better collection of passages to ex-
emplify the control chance and the spirit of the language exercise

* *See* Fig. 16, p. 390.

in the world of the comic than the work of Christian Morgenstern. When a four-quarter hog and an up-beat owl are found dancing together, the most alien objects are combined. When we read in the poem on the fountain pen, "Carry a fountain pen around! (you know:/ That's the way always upright to go)" (Trag einem Füll drum! [du verstehst:/ Damit du immer aufrecht gehst]), the things are stood on their heads (to continue the figure of speech). For the existent, Morgenstern contrives something corresponding or opposite: *Nähe* (proximity) he enlarges to *Näherin* (seamstress); *Sitzfleish* (assiduity) he contrasts with *Sitzgeist* (sedentary spirit); to the *Weste* (west, vest) belongs the *Oste* (east), which will be worn some day by all fastidious gentlemen. He distorts grammatical rules, sentence structure, and word order with the gayest abandon, often falling into Dadaism by discarding the meaning of words. So at the close of the familiar "Song of the Gallows Brotherhood" (*Bundeslied der Galgenbrüder*):

> O Greule, Greule, wüste Greule!
> Hört ihr den Rufe der Silbergäule?
> Es schreit der Kauz: pardauz! pardauz!
> Da taut's, da graut's, da braut's, da blaut's!

Value and sense being, on the whole, hard to find in human beings, inanimate things are brought to life—a bell tone tries to bring in another—and new beings are created: a hobgoblin (*Klabautermann*) gets a letter from his wife (*Klabauterfrau*); from *tout le mond* (everyone) comes a creature *Toulemond* who, along with *Mondamin*, has experiences in the moon which are strange even to the *Mondkalb* (moon calf). How whimsically and wonderfully reality and language are intertwined when the werewolf wants to be declined by the schoolmaster or the warring punctuation marks set up an anti-semicolon alliance! The most impossible events are described in a serious manner, objectively and yet sympathetically, often with melancholy mien. Morgenstern leads us through all sorts of fancifully playful drollery to the two forms which our science especially likes to study, caricature and humor.

Grotesque distortion is most effective where there are susceptible objects. The painter and the author should caricature only what already has a slight touch of the comic. The hollow mirror in which the caricaturist catches a pronounced form invariably produces a comical effect by its distortions when a trace

of the comic is already present. This is seen most clearly in the cartoons which change the human head into the head of an animal. A special technique has been developed in political cartoons. Such cartoonists represent events and projects—abstract concepts in general—either by following the model of great art, or by working with their own symbols, derived mostly from figures of speech. For example, we express dependence by the phrase "hanging onto someone's coattails," and the cartoonist draws it in this way. Even familiar animal fables and parables are made to serve his purposes. The genuinely artistic relationships within the picture—spatial values and proportions of form—are sacrificed to its factual content and didactic aim. If the point is, let us say, to make clear the magnitude of one political state and the smallness of another, the cartoonist does not shy at drawing the ruler of the first state three times as large as the ruler of the second. We speak of parody or travesty when the form (in parody) or the content (in travesty) is ridiculed by its retention in a similar but altered situation. Mahler's *First Symphony* contains a frolicsome funeral march in which both possibilities are musically exploited. Whereas in its freely creative fantasy the grotesque renounces every standard, in the recognized forms of the burlesque we have either the ordinary raised to sublime heights or the heroic reduced to the plain bourgeois. Naturally every device is added which can evoke a laugh. A verse like "Italy!" Achates is the first to cry./Italy his comrades greet with a shout of joy. (Italiam primus conclamat Achates,/Italiam laeto socii clamore salutant.—*Aeneid*, III, 523 f.) goes like this in Blumauer's *Äneis*:

Suddenly from his bunk	Auf einmal schrie: Italien!
Achates cried, "Italy!"	Achat aus der Kajüte.
"Italy!" resounded in the bow,	Italien! scholl's im Vorderteil,
"Italy!" resounded in the stern,	Italien! scholl's im Hinterteil,
"Italy!" amidship.	Italien! in der Mitte.

Humor is a frame of mind in which a person is aware of his significance and, at the same time, of his insignificance. The consciousness of one's eternal worth and the feeling, interwoven with it, of one's worthlessness, have been pointed out as the two aspects of religious feeling. The same blend of superiority and limitation marks out the humorist and his works. As an author he describes characters and situations whose importance is not de-

stroyed by an admixture of the ridiculous, but indirectly enhanced by it. In a strange combination of self-annulment and self-confirmation the two aspects of life constitute a *reductio ad absurdum* and arouse that painfully peaceful feeling which the person must experience who confronts the ultimately valid conquest of existence. Similar mixtures are familiar in visual art. When the artist draws a pug-faced man with a sausage so that the lines combine to form wonderful arabesques, or when the fairy king strides in with the highest pomp, his nose dripping, the humor consists in the fact that even the most vulgar intrudes into the pure sphere of the fine arts, and the most sublime in life can lapse at any instant into the ridiculous. One of Clemens Brentano's fairy tales ends very gaily: "King Pumpan took a big knife and cut his kingdom into two parts and asked Schoolmaster Klopfstock 'Back or edge?' He said 'Edge.' And Pumpan gave him the half which lay at the edge of the knife." Humor likes best of all to dwell in fairyland. If banished to lands of lesser freedom, it still fixes its gaze ever upon that realm. In *Sartor Resartus* Carlyle imagines that at a ceremonial court function the clothes of all the participants are suddenly carried off. The king is no longer distinguishable from the footman; all bonds of decent restraint are broken. Real humor lies in this fabulous picture, which glorifies and derides the power of clothing. For even in Carlyle, behind all the derision, a great love for mankind shines forth. Humor never treats of misfortune—which is not always spared by wit. Whoever portrays the pettiness of the great without disparaging their greatness, whoever presents the illogical character of life without denying its rationality, this very juggler is a humorous artist. In times when the mystery of existence has no compensation whatsoever, there is also no humor; for without joy in life and the world, humor cannot breathe. And conversely, the ages and peoples which consumed themselves in a mad lust for life lacked humorous art.

Humor sees fate behind the accidental. It joins the finite and the infinite, and it teaches us how we can conquer fate with a smile. True humor is therefore an indispensable rainy-day coin for the peculiar housekeeping which we carry on between heaven and earth.

V. THE CREATIVE ACTIVITY
OF THE ARTIST

1. Its Temporal Course and Character
as a Whole

In the general science of art the two basic questions, which have already confronted us in aesthetics, concern the relation of art to reality and to aesthetic existence. We can regard it as an established truth that art never merely repeats what is given. But when Georg Simmel goes so far as to refuse to consider the relation between the two fields in general, since "each field is wholly autonomous and the two are equally authentic," we should object to this exaggeration of an essentially tenable doctrine. If the values which seem to us crucial in our struggle with nature and man were not also vital in art, art could form only a remote realm of detached experiences. If works of art did not in some sense belong to the universal Reality, and if facts were not somehow assimilated into art, we should never, as we actually do, emerge from both regions into the deepest levels, which even Simmel acknowledges, where being and becoming, death and destiny dwell.

There is likewise a relation between works of art and aesthetic objects in their general nature. In certain circumstances things of daily use can yield aesthetic pleasure, and yet they remain intact in their own significance when they evoke no such feeling. Works of art, on the other hand, call for aesthetic judgment. Hence aesthetics and the systematic theory of art cannot be wholly separated. Even Kant did not succeed in freeing epistemology completely from metaphysics. But, in some such way as he fashioned a general theory of knowledge, which was to stand above the oppositions of the metaphysical systems, we are seeking a general theory of art which will transcend aesthetic problems.

181

The close alliance must be loosened and ties broken to provide free movement for the theory of art. For art is not primarily the pure cultivation of the beautiful. Natural beauty, however tasteful and pleasant, remains, like natural ugliness, outside the portals of art. Art does not arise through any condensation of the aesthetic. This innocuous truth, unfortunately denied by the most upright and sensitive souls, is now to be justified by reference to the nature of the artist and the origin, character, and effect of art. We begin with the investigation of the artist's creative activity, because the existence of such activity not only makes art possible, but also in itself, as distinguished from the aesthetic life, first attracts attention. No one can deny that (besides sense of form and good taste) intellect, feeling, scrupulousness, and—above all—formative power have a share in producing works of art. Mere aesthetic taste is no measure of artistic capacity. Whereas amateurs and art critics can develop the most cultivated taste, artists as great as Grabbe and Böcklin have occasionally revealed a grotesque lack of taste. And we who enjoy a work of art are pleased by the individuality of the artist, by his visible triumph over the recalcitrancy of the material, by the sure aim with which he penetrates to the heart of realities, by the fullness and vitality of the content—in a word, by features which could be ignored in an examination of the aesthetic. (I strongly recommend the important and helpful work by Emil Utitz, *Grundlegung der allgemeinen Kunstwissenschaft*, 2 vols., 1914 and 1920, especially II, 160–284, the section most relevant here concerning the artist.)

In the main, three theories of artistic creation have been proposed. We may call them the theory of illumination, the theory of intensification, and the theory of good technical judgment. According to the first, the artist creates in a state of mystical vision, which is ultimately inexplicable, interrupting as it does the ordinary course of consciousness. So the ancient poets invoked the assistance of the Muses and believed, as Ovid put it, "a god rules within us." According to the second theory, the artist is a man of heightened faculties, with livelier ideas, a stronger power of empathy, a more inclusive imagination, and his creative activity is a "manic mood," to repeat an expression from the *Westöstlichen Divan*. For the third view artistic ability consists in technical skills—a dexterous hand, absolute pitch, and so on—in diligence, patience, discretion, and the gift of taking a critical attitude toward one's sudden ideas. "Then what in the whole person can be called original?" Goethe once asked.

These three theories are not wholly incompatible, but distinct in that each stresses a different stage in the temporal development of the creative activity. The temporal process of artistic creation is such that scientific analysis can distinguish several stages. Using Eduard von Hartmann's term, we call the first stage the productive mood. Usually it overtakes the artist without his looking for it. At any time and place it can appear. Not as a gladdening guest is it wont to approach; it falls upon the soul heavily and unexpectedly. "Like tears which come to us suddenly, so songs also come." Goethe says of Byron: "He gets his subjects as women get beautiful children. They do not think about it and know not how it is done." Analysis reveals little. It discloses, to be sure, indefinite images of some sort or other, but no connection with the later work. Often these images belong to a region different from that of the finished product, and perhaps the frequent mistakes of artists as to the field in which their strength lies are to be traced back to such vicarious sensory activity. If no melodies come to a musician, but verses take form, or if a painter in this mood does not see colors but hears tones, we can understand that their inner state leads them to regard themselves as different from what they are outwardly and in fact.

Seen as a whole, this preparation for creation is a surge of feelings and passions. Within the soul forces struggle with one another; the work is still in the stage of birth. The creative artist feels, like a person who faces a moral decision, an indecisive vacillation, which can rise to physical pain. Confusion and disorder distinguish the intellectual state in artistic creation from that in instinctive action. The comparison with instinct, formerly so common, seems to me not only useless but even perverse. It is useless because it reduces something difficult to understand to something more so. And it fails to see that instinct operates with absolute certainty, yet also with great uniformity. In the early stage of artistic creation, however, all is uncertain and various. The torment of this mood is intensified by the anxiety as to whether something useful will ever emerge from the confusion. Even the artist who has often been thoroughly shaken by similar disturbances doubts again and again whether anything will take form out of the chaos. He finds comfort in a feeling of anxious confidence which seldom deceives him. Already he hears faint voices from afar, but still cannot fathom the meaning of their words. He does not yet hear the definite melody or fully grasp the scheme of colors and forms. But in slight signs he glimpses a promise. Vistas open out, as rich and broad as dream

worlds. It appears that a dream brings release from this tension, that the soul, on awakening, suddenly confronts everything clearly and must make haste to set it forth. If the release does not come, the frustration is a cruel blow. Otto Ludwig laments, "I am like a woman in labor, her birth pangs failing to appear." And Hugo von Hofmannsthal confesses:

> Awful this art!
> From my body I spin me the thread
> Which is also my way through the air.

The whole vast organic disturbance reminds one of sexual excitement. But we should not regard artistic talents as simply autonomous offshoots of excessive sexual sensitivity, since it involves no compulsion to construct forms. At this stage of our discussion the main point is that a state of ecstasy precedes both artistic creation and sexual procreation. Moreover, the analogy seems correct insofar as the finally successful creative act is followed by a period of inner emptiness and exhaustion. When the need for copulation is urgent, all perceptions take on a special tinge. We observe the swelling and fertilizing processes in nature, we hear the passionate mating songs of birds, and whatever recollections and dreams of the future repose in our souls surge up. After this our psychic state is drastically changed. The ideas which did not allow us a single moment of peace now vanish, and if we trouble ourselves to revive them, they look colorless and indifferent. What previously tormented us to the point of madness is now a shadowy something that sinks remarkably fast below the threshold of consciousness. Since the circumstances in artistic creation are quite similar, we can say that the second phase of the creative process represents a release from what filled the soul overpoweringly. Similarly, masses of snow are loosened in the spring and roar violently down from the mountain heights into the valleys. But the process under consideration here does not occur so suddenly; rather, it breaks up in turn into several stages.

At the start we must reject as incorrect two views which prevail in earlier descriptions. Contrary to the first view, this liberation of oneself does not yet signify communication with others. It is conceivable, and has actually occurred, that when at last the artist has clearly expressed the idea of his work, he shrinks back nervously from the publication of the idea. There is, to be sure, an urge forcing the artist out of loneliness into communication, but this urge

begins later. The need which appears at this point has nothing in common with the longing to influence others. It is rather the haste and anxiety of one from whom something present has threatened to slip away and who now, knowing it to be safe, draws a deep breath. Secondly, this liberation of self is something to be found generally in intellectual projects, and is not confined to artistic creation. Even philosophical thoughts can disturb the sleep of many nights and so exhaust the whole man that he recovers his health only after the thoughts have matured in him and risen to conceptual clarity. The need to unburden oneself is universal. It seems as though we have not finished something within us until we have released it from the custody of consciousness and given it a fixed form. So what distinguishes art is not merely this, but the special kind of clarifying expression. The productive mood unites the creative artist with all who in the higher sense of the word are spiritually active. All immediate creation occurs in an indeterminate and nebulous state. Even analytic scientific knowledge is not the most original or complete form of expression of intellectual power. So in conclusion, only the nature of the fashioned object which emerges from the preparatory stage decides whether the creative activity was artistic or of another kind.

By the traditional term *moment of conception* we mean the instant at which the process attains definite outer form, thus showing itself as a process of artistic construction. It is the moment in which expression is united with indeterminate content, in which the poet's passion is consummated in words and the painter's imagined picture in colors. Inner ideas become expressible, that is, ripe—in Croce's phrase, expressed intuitions (*intuizioni espresse*). This event we call artistic conception. According to the testimony of artists about themselves, the conception cannot be forced, but can be assisted by experimental efforts. Strangely enough, the work undertaken at this time is usually not effective at the points to which attention is directed, but in quite different, unnoticed places it brings out clear forms. The artist's groping and probing enable him, of course, to catch something or other, but in most cases not what he expected. The creative activity occurs at first without any plan— or if you prefer, unconsciously. For the whole has not yet found a form. But this planlessness is by no means useless. If, in philistine disdain of uncertainty, the artist were to discontinue the experiments, in the majority of cases he would retard the course of events, indeed, even make its completion uncertain. The work serves to

provide opportunities for the unification of what has thus far been incoherent. Particular mental creations strive for a definite form. Now there is still need of a new experience to stiffen the relatively free and capricious activity of consciousness into a secure unity. The inflammable material is ready. If now a spark falls on it, in a magical flash the full-fledged drama stands before the mind of the poet, and the pattern of melodies sounds in the ears of the composer; the painter sees his picture, and the sculptor his statue.

Of course, the completeness is merely apparent. Real completeness would be as inconceivable at this point as a creation out of nothing. Actually everything was ready and only the last impulse was added. The external fact with which invention is supposed to begin already presupposes a certain frame of mind as prerequisite for its efficacy. Theodor Storm aptly called this the "pendular impulse" and illustrated it by an inner experience of his own literary career. What the artist chances to see or hear means something only to his particular personality, specially prepared in this way. Weber got a musical motif from the sight of piled up chairs. Max Halbe once recounted the circumstances under which his play *Youth* was conceived. "They were the most trivial circumstances, scarcely anything, and yet they sufficed to make the whole idea of the subsequent play suddenly come alive." The sight of a February sky and the distant, half whining and half yearning sound of a barrel organ evoked the memory of an experience nine years earlier, and now in a flash this became a poetic incident. In general we cannot say when and how far daily experiences become artistically fruitful. In any case there is no simple relation between the date of an experience and the beginning of a work or, indeed, between a course of life and a connected series of works. Obviously, however, an imagination rich in memories is better fitted to make use of the slightest suggestions than is one with little material at its disposal. Obscure developments strive for completion and find it in an occasion otherwise quite indifferent. So the history of mankind is repeated in the individual. The growth of an art and its present state show its indeterminate and incomplete organization. The great artist who now appears and establishes a new period is like the pendular impulse which sets in fruitful motion what is at hand.

But even now the artist cannot yet say with absolute certainty what will come of his work. It depends upon the further course of development—what comes to life within him from other sources and for other ends, and what later impinges upon him from

without. For new supporting ideas are always appearing. To be sure, we shall describe the further course of the creative activity as though it were merely an elaboration. But it is an error—an understandable error, of course—for creative artists to assert that from the start they saw a great work, as a whole, before them exactly as it later turned out. Actually, many roads remain open, leading on from the discovered starting point. Hence it can happen that the original idea changes more or less, and indeed often turns into its opposite. Some fresh experience intrudes in such a way that the old unity bursts and a new one is formed. Or the first plan remains, but later conceptions develop into separate living beings. In this way works of art yield episodes, dual plots, digressions, and above all grow so long. Finally, anarchy can enter and the work as a whole come to no end.

In the regular sequence of stages the conception is followed by the sketch; it is transformed into something external. Often, indeed, it is only in the sketch that the conception develops at all. From this outer aspect many artistic natures draw all the vital energy for the organic being which is coming into existence. The composer, trying to form themes at the piano, is led by the actual sound to new constructions. While the painter is making a sketch, the lines are instructing him. The poet suddenly feels the thoughts struggle free when words confront him on paper. We usually explain the relation to ourselves by saying that the finished composition needs the sketch merely to hold it fast. But many artists, though not all, value the sketch also for its reaction upon the inward vision. This agreement of the creative power and a suggestion coming from the sketch is usually felt as delightful. At such times artistic creation affords the purest and most intense pleasure. The convergence of what is subjectively imagined and what is objectively set forth kindles a feeling of power and a consciousness of accomplishment. The incomparable student of art, Friedrich Hebbel, once expressed the same insight: "An artist can show his enthusiasm for his ideals only by seeking to embody them, using in this attempt all the means at the command of himself and his art. When some enraptured painter looks into the clouds and exclaims, 'What a goddess I see!,' this brings no goddess to his canvas. Indeed, it is not even true that he sees one. He wins the goddess only by painting. In his whole life he would never use a brush if she had already disclosed herself fully to him." (*Werke*, x, 175.) This truth, that the painter wins his goddess only by painting, concerns a fundamental pe-

culiarity of the spiritual life, the dependence of creation on expression. The old school rule, that we think the matter through before speaking or writing, requires what is often simply impossible for persons of a certain kind. In any case speech and writing help to make thought more articulate, and they are often needed to make it possible at all. Try by merely looking to grasp the details of an intricate object. You only half succeed. Without drawing it you do not really see it. So we all learn by teaching and begin to doubt by boldly asserting. So the poet comes to understand a soul by creating one. The temporal order that seems obviously intelligible—knowledge before expression—is by no means always the actual order. The two functions interfuse temporally and can exchange places.

The sketch may end the creative process in the case of artistic works of the smallest scope, for here the sketch can signify something finished, something that neither can nor need be improved and is the definitive fruit of the artist's ability. But with larger works the execution—or better, the inner fulfillment—follows. The entire form now stands before the mind of the creator. Every line which he puts on paper, every musical phrase which he invents, every dramatic scene which he writes down, is a part of the already present whole. The part gets its peculiar character from its relation to this whole. What has just appeared is continually being compared with the goal. Though flighty aestheticians readily brush it aside as incidental, this labor of fulfillment is nonetheless essential as the very process which reveals the greatness of the artist. Talented persons to whom "illuminations" are granted appear not too infrequently. The productive mood—indeed even an occasional brilliant conception—sets in fairly often, especially in youth. But still this is not a work of art. What has thus far hovered in the imagination must be actualized with the scrupulous skill of the craftsman. The biography of every great artist mentions many traits which necessitate such incessant work. Each of these men has learned from his own experience that he must take himself in hand if he is to accomplish anything at all. He should not wait for the moments when he is in the right mood, but produce these moments, regardless of obstacles in the environment and in his subject.

The old belief that artists create through illumination—as though by an act of divine grace they suddenly found the finished work within themselves—is connected with the idea which has found its most striking expression in Lessing's phrase, "Raphael

188

without hands." This unfortunate aesthetic dogma asserts that the real work of art is contained in the inner form, won without any assistance. Such a view (which is still popular today) neglects whatever precedes and follows the moment of illumination, not only disparaging technique but also claiming to nullify every psychological explanation. Yet certainly the creative imagination alone would accomplish little without the assistance of the ordering and guiding intellect. The artist must immediately catch every significant nuance that emerges, and put it in the right place. The notebooks of poets and composers and the sketchbooks of painters prove this. Something unconscious—or better, subconscious—is active in artistic creation; the ideas work as if autonomously and without continuously burdening consciousness. But from time to time the artist must check to see how far they have grown, so that he can seize the moment when they are just ripe. So much having been collected meanwhile in images, words, comparisons, bits of melody, and patterns of form, very sharp judgment is required to discover the good and useful elements, and promptly discard the others, lest they hinder further work. Beyond their mere possession of special endowments, artists need also to make the greatest use of these endowments. Here most of them fail. Their native ability would be adequate, if only it were exercised more earnestly. Thus many an artist who never finishes a thing and is not progressing inwardly will not admit how carelessly he uses his gifts. But if we observe him, we note that he lets the best ideas go to waste, that he cannot hold them together, and that he avoids the exertion of organizing work. Bright ideas alone are not enough. A short melodic passage may be very beautiful, but six measures do not make a work of art. Single aphorisms have luster and value, but even several dozen of them without inner continuity do not form a whole. The thematic material of great artists can be very slight. Their power is rooted in the fact that they oversee the voluntary and strongly emotional action of their characters, thus rising to serious accomplishment through the cooperation of will and intelligence.

The process just described can be observed in all fields of spiritual activity. It needed to be stressed here, merely because artists are often weak and more exposed than other men to the temptation to be satisfied with a free indulgence in fantasy. Indeed, aesthetics has long since convinced them that they are specially favored beings to whom everything must naturally come. Actually their gifts lie partly in the appearance of productive moods and

conceptions, partly in the ease and speed of inner fulfillment. Yet talent exempts no one from work. I have already suggested that the artist must struggle against the resistance of the object. Almost as soon as it appears, the object leads its own life and often proves stronger than its creator. It forces him to go wherever it wishes. A book not only has its own destiny, but has its own personality too. The sequence of chapters in a novel seems almost as independent of the author's choice as the sequence of male and female offspring is unrelated to the father's decision. Through such autonomous individuality maturing works of art occasionally come into conflict with the artist, attain no genuine unity, and remain obscure. Like the process which begins with sexual conception, artistic creation ends with the birth of an independent being. This new being can become so free of its author that it is revised or carried forward by another artist, turned over to artists in other fields (for musical composition, dramatization, etc.), and left for various transformations by observers. To the creative artist himself his work can become quite strange. If one ponders this, he must say: How much courage it takes to finish a great work of art! How much real passion must be present to strive ever anew for the definitive achievement—that achievement which, like the Aristotelian God, signifies the goal of all change or, like the Hegelian Absolute Spirit, represents freedom for the upward struggling reason of the artist!

Finally, we would have to speak of objectification. But its discussion belongs in the theories of the special arts, since its mode of achievement varies with the kind of art. So let us merely note that music occupies an exceptional position. Whereas every literary work is finished when written down—we shall make up our minds about drama later—and the products of the visual arts are also complete when the artist has dismissed them, in his full score the composer gives little more than an indication. He needs the players to bring the real work of art into being. The notes on paper are not related to the music as the letters are to the poetry.

In the character of artistic creation as a whole there are some features which have not yet come out sufficiently in our survey. First of all there is the relation to reality. A rich experience forms the basis for all artistic achievements. By richness of experience we do not mean extent of experience, as indicated perhaps by travel. This external method of acquiring knowledge of men has nothing in common with the way of the artist, who can see variety enough from his quiet nook. Above all, there dwells within him an

enchanted world of forms. His most exciting adventures are simply his works. (In a short essay, *Über Charaktere in Roman und Drama*, Hofmannsthal has Balzac say of a general spiritual malady of the literary author: "There are no experiences other than the experience of one's own being. . . . But so completely and exclusively is work the whole life of the artist that in the entire world he is able to perceive only the counterparts of the states which he ordinarily experiences in the torments and delights of working.") But the artistic experience of life differs also in kind from what is usually called experience of life. The artistic experience is not really an observing, but something much more involuntary—an instinctive seeing and remembering. Observational ability, in the sense of ability to scrutinize attentively and for a purpose, should be more important for the physician or the detective than for the artist. But let us consider the following point. The observation of nature has been developed by primitive man to an astonishing degree, although he has not known how to view his environment artistically in like measure. Man can master nature in the aesthetic sense only when he turns away from it. Artistic insights come not from work at what is given, but from leisure hours. Indeed, when our lives are in danger while climbing mountains, we unconsciously take in and retain all impressions, however insignificant. And when quite overwhelmed by sorrow, we see and note the most trivial minutiae. These occurrences stand closer to the special perceptual ability of the poet than does any intentional observation directed to certain ends. Precisely because the poet sees or hears for no definite purposes, but rather in a mysterious commitment of sense, a true and complete impression remains, which later can be used at will. Taine says somewhere of Shakespeare, "He thought in blocks, and we think in bits." That is, every so-called act of observation alters and breaks up its objects, whereas they enter as wholes into the soul of the aimlessly experiencing artist.

Even the artist's memory is not designed for alertness and accuracy so much as for that living unity of experiences which makes the remembered content part of the personality. Instead of stored up factual items, the self possesses an inner wealth, even the details having warmth and fullness. As soon as the real creative activity begins, which is the transformation of what has been experienced, the completeness of the memory picture proves to be especially valuable. For this wholeness makes any rearrangement and reconstruction possible at will. Now this and now that con-

191

stituent part stands out at first, seeming to be the essential feature. Hence, a relatively small number of such experiences contains an inexhaustibly rich material, in which every detail is related to the others. Just as the first line the draftsman confidently puts down gets meaning and justification only from the invisible system of ideas within the artist, so the first characteristic the author imagines and uses falls into a total picture of inner form. Artistic activity is not combination, composition, calculation. Such processes are needed, but essentially they belong among the scientific modes of procedure. With J. Milsand (*L'Esthétique anglaise*, 1864) we can suppose that a painter, trying to discharge an assigned task, looks for appropriate experiences from his collection of imaginative material, and achieves an excellent result. He draws a tree, intending to give it a pleasing form. After he has drawn the first branch, he balances it with a second, but to introduce variation deliberately gives this a different form from the first. Yet the purely artistic imagination never works in this way. It does not fit pieces together, but is concerned that something completely present become visible in the details. It regards the whole as prior to the parts. It creates everything at once, introducing into the world an organism from which the organs emerge only gradually. The agreement of the parts does not come from judgment and comparison; it is there in advance, making all imperfections of detail pardonable, for they annul one another by virtue of the vital unity enclosing them all. It is more than a metaphor to speak of the birth of a work of art. Or to use a closer analogy, the process is like speaking. When I begin a sentence, the thought as a whole hovers before me, but I know nothing yet of the particular words, which unfold only during the speaking and enlighten me, like the listener, as to the component parts of the thought. Were it not so, were speaking a conscious activity of putting together previously considered individual words, a sentence would scarcely ever be rounded off and finished. This similarity between speaking and artistic creation also shows why a command of language is important for the literary author. In both cases the mind reaches an unexpected goal with such certainty because we are dealing here, as it were, with an effort to understand oneself.

This insight implies still another consequence. When a total idea is deployed into a series of ideas carried by words, it is clear that this series need not coincide with the temporal sequences or spatial elements in the object. The words have no similarity to the

actual elements; the conceptual world developing within us signifies, rather, a transformation of the given. This is also true in the artistic portrayal of moods, events, and characters. The portrayal is a gradual unfolding of a total intuition, a purely inner process, whose several elements and laws of combination are independent of the outer world. In its urge toward clarification, the inflammable energy of the mind is kindled by an object. A creature of fantasy, which has issued from the most intimate enjoyment of self, unfolds under the guise of a reality faithfully reproduced. The intuitive character of this imaginative creation is quite compatible with its almost complete independence of the external world. For, in the first place, this sensuosity is different from that of nature and, secondly, sense-perceptions and the memory images corresponding to them are not only signs of something external, but also symbols of something internal. When a model serves the purposes of genuine art, it is merely the means by which an inner fact achieves expression. This principle holds for poetry no less than for painting. In our aesthetics every creation which is like real objects seems to be a copy. But still we should have learned from music that the artistic process is just as much a translation of something mental into bodily form. The existent object serves to rouse the artist as soon as it encounters what lies ready within him. The object is merely a means, although almost indispensable for all the arts, and extremely important.

2. The Differences Between the Faculties

Those who accept the general doctrine of faculties mean by the term definitely directed dispositions to activity, which are released by proper stimuli and unite into fairly stable combinations. Whether two faculties are immediately joined together or have issued from a common root, they form a unity. There is a natural kinship between (1) certain differences in the wealth and mobility of ideas (as immediately joined) and (2) the associative strength and imaginative power of these ideas (as having issued from a common root). Yet the most general faculty of the artist cannot be placed on a par with his other faculties, but must be indicated at first only negatively. It is not the (logical) will to intelligibility, not the (ethical) will to freedom and equality, not the (aesthetic)

will to good taste, but the will to formation, to the creation of structures determined only by the facts and the creating mind.

The nature of this formative power must be gradually clarified in greater detail. Here we have to oppose a word usage which has persisted through various fluctuations for some centuries. The layman and even the aesthetician are inclined to call the artist a genius. This application of the term involves both an unduly exalted appraisal of the artist and a neglect of his distinctive abilities. Genius is shown in all fields of intellectual activity and everywhere has the same characteristic features. But the forms of genius vary with the fields in which it is revealed.

A genius stands to other persons as one wide awake does to those half asleep. The aspect of freedom and creativity in mere existence courses through him. Here we have life in the Bergsonian sense, "an impulse (*élan*), an initiative, an effort to get matter to produce something which, of itself, it would not produce." More definitely, the genius is distinguished by a towering intellectual power. Whereas the talented person easily accomplishes what the less gifted can do only with great exertion, the genius creates something which others, even the best of them, could never produce. He commands, as it were, an octave more than we possess on our mental keyboards. Ordinary work in science and art goes slowly and surely along a line. But the work of the genius is three dimensional, continually drawing energy from right and left, and radiating out upward and downward. In the genius, so to speak, the capacity of the body to adapt and organize whatever enters it reaches its highest perfection. Really great minds possess a certain omnipresence, in their command of a thoroughly understood area, and in their confident separation of the essential and the unessential. Others lack this. Especially does the genius have originality. There is a mental ability directly concerned with experiences, with the facts of nature and of mind, and there is another ability which draws its inspiration from the cultural assimilation of these facts. So it is in science. Persons of talent for first-hand material win their insights from contact with reality; persons of talent for second-hand material win theirs by dealing with their predecessors and with the state of the problems in the process of investigation. So also in art. One group creates from nature and life; the other group, conditioned by earlier masters, continues to cultivate their styles or adopts an attitude of conscious opposition. The former group can be imagined even in a primitive state, the latter only at a definite

194

stage of culture. Members of the first group also assert old truths, of course, but they assert them spontaneously—without realizing it—as new discoveries. Members of the second group merely repeat them. Decisive criteria of genius are (1) direct contact with reality and (2) the dual gift of unhesitatingly seizing the heart of a thing and of deftly fashioning something great from the dominant impression. The genius flits about like a bird, snatches a crumb from the riches of life, then hurries back into his quiet nest to devour it slowly there.

A further distinction is necessary. So far our remarks have concerned only creative artists. We should also consider so-called reproductive artists. Here also there is a linguistic difficulty. Although we started with the fact that earlier aesthetics put artistic ability on a par with genius, we must now recognize that in common parlance only recreative artists—such as actors and singers, violinists and pianists—are usually called artists. They use a twofold ability, (1) the most delicate sensitivity to the artistic purpose of the work entrusted to them and (2) the technical skill for artistic performance. But creativity or—if the expression is allowed—invention can be wholly lacking without any notice at all of the absence.

No work of art comes merely from taste and virtuosity. The indescribable but indispensable third factor we are inclined to look for is a greatness of personality. And we may note that when a full, many-sided personality tries its hand at art, it can certainly produce something of interest. But artistic value depends less on personality in this sense than on the special personality of the composer, the painter, and the poet—on the formative power peculiar to each. We know that highly individual and important characters remain at a polar extreme from art and, on the other hand, that many distinguished creative artists by no means impress their contemporaries as persons of significant individuality. In the case of musicians and painters this is quite understandable. When the whole person is carried away by one aspect of existence, he cannot spread himself over other aspects. So only the less delightful elements are left over for every day affairs, especially the trivial and petty things, which are banned from art. As a rule writers are the most impressive and pleasing, since the material which they must master coincides with the fullness of life. But there are also many soft and deliquescent natures among them, so generally excitable that all individuality seems to be wiped out. Their love for the world of colors and tones and for off-beat fellows shows great adaptibility. Their art springs

195

from a passive state in which they are deeply moved by life, from a vague longing which at last finds its application and form. This art is like visionary love, which at first is a quite general yearning and only after a fairly long period of covert persistence focuses on one person. Hence such artists can preserve themselves in life only with great difficulty, because they tend to be resigned or to let something else crush them. They aim to understand everything, but to have character is to misunderstand.

Thus the personal aspect of a work of art is related to the particular personality of the artist. This personality dwells in the smallest element of the work as well as the greatest. Swedenborg once said in the midst of a curious doctrine of homogeneity: "Every sudden idea that strikes a person, every emotion—indeed, every smallest part of an emotion—is a picture, an accurate picture of him. A mind can be known from a single thought." That is perfectly true. One can recognize the composer from a single measure, or at least from a melodic phrase. A few lines of a poem are enough to identify the author. A couple of strokes, hastily drawn, reveal the draftsman and his personality. In 1401 a competition was announced for the bronze decorations of the Baptistery doors in Florence. Brunellesco and Ghiberti submitted similar panels. "The situation, the number of figures, the action, indeed the very enframement of the model were all stipulated. And yet, to the minutest details, the contrast between the two works is simply astounding. But this is all explained by the temperamental contrast between the two artists. In Brunellesco a constructive mind, a hard energy, and a fanatical concern for truth were at work. In Ghiberti we see, in addition to a thorough study of anatomy and a realistic outlook, an inclination for beautiful lines and formal superficiality. Hence Brunellesco chose the critical instant. He shows Abraham's sacrificial knife on Isaac's neck, the quivering boy, and the firm grip of the angel to prevent the climax. Ghiberti goes back only a second in time. The knife is still a hand's breadth from the neck, and the angel is nearby but has not yet gone into action. As a consequence, Isaac can still be looking up questioningly, displaying the full beauty of his youthful limbs in calm repose. Here the feelings of the artists spoke the decisive words. For one the dramatic suspense was everything, for the other the beauty of the young body and the opportunity to revel in the harmony of the lines." (Theodor Volbehr, *Bau und Leben der bildenden Kunst,* 1905, pp. 95f.) But also in another sense there is personality in a work of art. This per-

196

sonality, which we scarcely ever encounter yet set before ourselves as an ideal, consists in the perfect reciprocity of its psychic components. When these are all in such agreement that every occurrence expresses the same tendency, we speak of its striking individuality. A good work of art is like this. It shows the perfect coherence of all the several parts, and the subordination of the particular to the universal. Of course, every work of art shows this in its style, which is the artist's style. Thus for ages we have called a work of art a microcosm, and through it have approached the macrocosm, that divine personality which is the inclusive Substance for pantheistic intuition. For there is no contradiction in having pantheistic feelings and also holding fast to the personality of God. If only we avoid regarding the divine Personality as like the human, we must acknowledge that the unity and affinity in the world are unsurpassed, and that therefore the essential feature of personality is contained in the world. The divine nature of the work of art lies in this, that it is as inclusive as the whole world, and yet personal.

There is a further question as to how personal artistic individuality is adjusted to tradition. This general question has special meanings for musicians, spatial artists, and writers. While the musician lives in a world where tradition contends only with individual invention, the painter and the writer also have to deal with reality, yet in different ways. The spatial reality with which the figurative artist deals is already formed, but actions and characters—the materials of the writer—are in flux. They are crystallized only in legend or history. Such traditional forms do not check the inventive faculty of the literary artist at all. His artistry lies in his undertaking valuable—indeed, teleologically valuable—variations. Let us not form any exaggerated ideas of originality. The desperate search for new materials indicates inferior talent which mostly counts on arousing the desire of the public for the sensational. Womanish lament that everything is already trite betrays the weakness of the mourner. Indeed, progress does not consist in finding out something as yet unheard of, but in making the usual vitally significant. The more familiar the material, the greater can the work of art become. Every analysis of sources in the history of literature, every comparison of melodies in the history of music, and every investigation in the history of visual art show in what measure even the greatest artists have lived on the legacy from the past. Artists are less timid in this matter than scholars, who engage indefatigably in priority disputes and plagiarism wrangles. The

attitude of the artists is more objective and calm. In fact, the author of an artistic motif is not the one who was accidentally the first to use it, but the one who knew how to make something of it. The former is like a shipwrecked sailor, driven off his course to the coast of a strange land. The latter is like the enterprising mariner who really discovered the land.

As I said earlier, it is not the happy ideas which occur suddenly, but rather, the capacity to bring things together systematically, to use them, and to build upon them that make the great artist. Now, more clearly than before, we see the reasons for this. Richard Wagner mentions as one of his peculiarities the most delicate feeling, "indicating for me the mediation and inner connection of all moments in the modulations of the most intense moods into one another." He tells how this need for modulation governs him in life and in conversation. (*Briefe an Mathilda Wesendonck,* 4th ed., 1904, p. 189.) It is the need of the genuine systematist, who strives to work not only through division and demarcation, but also through flux and transition. Wagner's method is like Hegel's. Both refused to tolerate discontinuity. Their very natures forced them to establish connections everywhere, which made real causal sequences seem probable. Their method may also be called deductive. Our textbooks, to be sure, say more about the inductive activity of the artist. For the mind of the modern inquirer finds those gifts more congenial which lead through observation of objective reality and collection of facts to artistic achievements. But there is also an ability less dependent on experience. Goethe said to Eckermann that when he wrote *Götz* and *Werther* he knew virtually nothing of the world, but that nevertheless he portrayed it faithfully. To this remark he appended the pregnant statement that the poet is born with his picture of the world. Balzac possessed the same deductive genius as Cuvier. Indeed—what is more—he had an *a priori* world picture, which reality could but supplement and strengthen. With only a slight digression of thought, this shows us clearly where we may find the basis of the distinction between the sentimental and the naïve or—in Otto Ludwig's language (*Gesammelte Schriften,* v, 320)—between the subjective and the objective writer. The subjective writer can express an inner reality only in such a way as to express his own persistent self along with it. All persons created by these writers have an unmistakable family resemblance, features of blood relationship. They are formed by the writers as by gods in their own images. Other artists of the same

group reveal rather their complementary natures. Out of their long-ing they construct a definite type for themselves, offering it again and again with slight variations. On the other hand, the objective writer creates an apparently inexhaustible variety of figures. While the subjective writer of each kind represents other characters, in the last analysis only to know himself, the objective writer compre-hends persons who have grown beyond him and achieved their own individual lives. But the boundary is vague, and no one can say where the created character has been freed from the control of the author's mind to such an extent that we may seriously speak of objective literature. Drops of his own blood ever cling to the sword with which the poet conquers the world.

A further distinction is based on the role of technique in the accomplishments of the various arts. In the past, artistic achieve-ments were generally judged according to the principle of difficulty overcome. The artist was a technically accomplished man (*uomo virtuoso*), someone who could do something, a person of great skill, conquering difficulties with apparent ease. Even today reproductive artists are often measured by this standard. Pianists or violinists who clear hurdles with dash (*con bravura*) win universal acclaim. In respect to creative artists this aspect is less stressed at present, although as a feature to distinguish the artistic from the merely aesthetic it is always effective. We have seen, for example, that poems do not exist only to present metrical and linguistic difficulties and show the possibility of surmounting them. We do not let poets compete with one another as we let musicians (say) in a medley concert. Yet even today the principle is respected in two directions. Improvising painters, who put a horse or a harmony on canvas in a couple of days (like Fromentin or Whistler) and then ask high prices for them, are regarded with astonishment because the short, easy work seems so disproportionate to the price. Secondly, the public follows this principle, the conscious conquest of difficulties—as opposed to everything mechanical and automatic—being ac-cepted as a distinguishing characteristic of art in general. Hence most people prefer handmade to machine-made fabrics, decorations, or embellishments. It means a great deal to them that in handwork the effort expended remains permanently recognizable and a con-scious artistic skill appears, perhaps even a personal feeling. Ma-chine work, on the other hand, has the inferiority of producing many pieces simultaneously. Indeed, a work of art should always be something unique, individual, never to be repeated. But the

work of machines, however accurate and tasteful it may be, always has the disadvantage of uniform multiplicity. As there will be occasion later to speak of this again, I will merely remark now, to supplement the first point, that difficulties and techniques have various degrees of importance in the various arts. The draftsman, painter, sculptor, and architect need laborious apprenticeships to learn all the prerequisites for their artistic creations. Beyond his natural talent even the musician must achieve a great deal for himself through study. For the author, however, artistic technique is not so elaborate and essential that it must be won in definite form and by years of practice. In the recreative arts there is a similar difference. Compare the musician, who must practice his technique incessantly from early youth, and the actor, who gets along with less stress on the mechanical.

But let us go on. The peculiarity of the various artistic abilities has its ultimate source in what is common to all minds. We see most easily in the case of architects that their artistic endowments are nothing utterly strange. For the appreciation of construction needed by the architect is innate in many of us, or at least intelligible to us. (In H. Hettner's *Kunstphilosophische Anfänge*, 1903, I, 327, Hugo Spitzer doubts that this natural constructive faculty is indispensable for the architect, and thinks that pure technique, which can be achieved without special endowment, along with cultivated taste can suffice for artistic ability in this field.) Even the sharpness of sense and the accuracy of memory which draftsman and painter need are implicit in everyone. But not everyone has the peculiarity that whatever enters his mind must come in through his eyes, and that whatever content of consciousness assumes clearer form, automatically becomes line and color. Wölfflin criticizes Zola's definition of a work of art—a piece of nature seen through a temperament—because "it assumes that seeing is self-evident, whereas actually this is precisely the place where artistic power has to assert itself." (*Dürer*, 1st ed., p. 294.) Böcklin is supposed to have said somewhere that whatever resounds in a painter's soul unites with shape and color, and thus attains definite form. Even a poetic event is received by the painter at once as a picture with all the essentials of form and color. In no sense is it later turned into a spatial perception. When a writer and a painter want to express the same idea, it is not a definite picture for the writer, but a tendency to verbal communication. Meanwhile the painter at once gives it spatial form and color as the natural and immediate

way of expressing his state of mind. (We do not need to go into finer distinctions. Max Liebermann asserts that Velasquez saw spatially, Rembrandt in light and shade, Titian in color, and that "heavenly and earthly love" are produced by the colorful idea of letting the body of a nude woman have the most striking effect through contrast with a clothed figure beside it.—*Die Phantasie in der Malerei*, 1916.) So the figurative artist begins to draw as soon as he can use his hands. We must imagine for ourselves a more pronounced sense of form and color, a clearer memory, and a more dexterous hand than we actually possess. Nothing wonderful can be attested which we cannot find incipiently in ourselves. With closed eyes even we see various and sundry outlandish figures. They change with the utmost speed. Their forms and colors can be charming, but they do not linger, and just when we try to reproduce them, they vanish. The man of limited talent is sorely frustrated by the blockage of the road from head to hand. How much he lives through within, and how little of it comes out! It often seems to him as though he need only reach into his soul to bring forth the most glorious pictures. But just as he stretches out his hand, they are gone. They do not attain the stability needed for objectification. In the artist these inner visions reach, as it were, a higher state of consolidation, and can therefore be actualized.

In a similar way let us think of the painter's memory. It makes no great difference that he has special words for forms and colors, which perhaps we lack. This technical knowledge is useful, of course, but not of crucial importance. We have already rejected the false belief that the artist must have an unusually good memory. Rather, his recollections serve him in every case only up to the point of creation. Then, to free his head for new impressions and new accomplishments, he must forget what has preceded. But another characteristic distinguishes the artist's recollection. The memory of the creative person retains what is connected with himself and is useful for his ends. We, on the other hand, preserve whatever happens to be present in the impression. The artist's recollection is not only associative, but also dissociative. We would scrupulously cling to what we have seen, if only we knew how to retain and reproduce it in all its delicate features. But the painter studies nature without using it directly. In the well-known book by Stratz on the beauty of woman's body, Klinger's statue of a bathing woman and his model are compared. The observer sees at once that the bodily hair is omitted, the hair on the head is stylized, and

slight defects are adjusted. But he also notes how much more unified and natural the bold posture has become at the artist's hand. In the original the carriage is tortured and the body almost mutilated, but in the work of art, which sprang from an idea and used the model merely as a helpful device, the body is a graceful unitary whole. Calmness and a certain persistent pursuit of purpose are unmistakable. When a vision arises in the artist's soul, an essential feature is always present, to which everything else is subordinated. Our ideas from recollection and fantasy are relatively unformed. As the visually minded arithmetician has within himself a tablet on which numbers, as it were, spontaneously order and explain themselves, so the painter too has a tablet within himself on which forms and colors unite in the most astonishing combinations, yet in accord with their intrinsic regularity.

In the case of music the situation is more difficult, because there are people without any musical ability. A yawning abyss separates them from those artists who have, so to speak, brought the idea of music with them into the world. By happy accident we have a word here (for which, unfortunately, there is no corresponding word in the other fields of art); we call appreciative auditors as well as composers and performers *musical.* Indeed, we can berate a virtuoso as unmusical in spite of his extraordinary technique, and claim a higher musical ability for ourselves, although perhaps we have never touched an instrument. This faculty is rooted in the mind as a whole. Sharpness of hearing forms only the foundation, for there are composers who hear poorly and are doomed to eventual deafness, who lack absolute pitch and, indeed, are rather insensitive to inadequacies of execution, especially to impurity. This need not astonish us any more than the fact that many of our best painters are nearsighted, and some are even slightly color-blind. We should realize, however, that sensitivity in art differs from sensitivity in life, and that sensory keenness is not quite the same in art as in psychology and medicine. But to return to our subject—it is characteristic of the musically talented person that he instinctively expresses all his inner experiences in tones and musical forms. Especially what arouses his feeling is expressed not in words, but in melodies. Hence he needs music, and would contrive it out of himself if it were not already there. His consciousness is full of musical forms. Day and night a melody lives in him and passes through his mind while he reads or writes. It does not leave him even in sleep; on suddenly awaking he finds it in mid-course. A

picture or a verse can hardly creep into the mind with such intuitive and nonconceptual force, hence so unaffected by all other ideas. Music is the most tenacious and stubborn of all the arts. It tolerates little besides itself. It absorbs the whole energy of the mind. A richly imaginative life, intricately involved with reality, is not favorable to musical endowment, or to put it better, musical creation. For the tone-pictures are in danger of being buried under various and sundry associations. This often happens in the case of those less musical persons whose pleasure is derived solely from the agreeable ideas the sounds arouse in them.

We turn now to the author. Here the danger is especially great that the human personality as a whole will be confused with the particular talent. But this talent consists chiefly in the abundant means of expression, in the extraordinarily developed vocabulary. While the visual artist's recollection feasts on forms and colors, and the musician's consciousness is continually replenished by suddenly emerging and mutually supporting harmonies, the writer's imagination lives in words and linguistic forms. He can, of course, incline more toward the picturesque or more toward the musical without impairing the distinctness of his art. Indeed, there is external evidence for this inclination. Authors who write their own work and read the manuscript find support for their creative activity in the look of the words and the visible rhythm of the sentences. Others, who dictate their work and have it read back to them, are led by the sound and the audible rhythm to the beauty of the words. Of nothing else was Flaubert so proud as of certain declamatory effects in his writings. On one occasion he told the Goncourts that he had nearly finished his novel *Salammbô,* only the last ten pages being still incomplete, for which he already had the conclusions of the full sentences. Is it not very significant that accent, cadence, and rhythm can play such a role? Richard Wagner is a more difficult case; in Nietzsche's words, "His art takes him in two directions, from a world of music into a mysteriously waiting world of drama, and conversely." It would be hard to say which one more strongly influenced the great formative urge of this pioneer dramatist—music and poetry were simply the two chambers of his heart.

In our discussions thus far we have not yet considered all the artistic faculties. With the writer something is added which, indeed, even the representatives of the other arts should not wholly lack. The artist, and especially the author, must be acquainted with

people, for in pictures, tones, and words he has to tell us of their joys and sorrows.

3. The Artist's Understanding of Human Nature

The fact that many artists have an unusually vivid and accurate recollection of earlier periods in their lives is closely related to our previous considerations. For example, read the first twelve pages in Hofmannsthal's biography of Victor Hugo to see that places, persons, and events which figured in the author's childhood grew into constituent parts of his literary works. But the influence of youthful experiences extends further. Whoever recalls his states of mind from the days of his childhood understands children and the undeveloped natures akin to them. This also provides a key to the soul of woman. Many of her unlovely traits were ours as maturing youths, and even her shy upward glance at her husband is familiar to us from our adolescent years. What distinguishes the writer in his knowledge of human nature is his ready and reliable memory of all the possibilities through which he passed in his growth. The average man forgets amazingly fast how he felt under earlier conditions. Yet, as though the many possibilities created by life were paltry and insufficient, the imagination now reaches out far beyond them. The occasional need to be another person is not satisfied by the revival of the past. From the bit of life which the writer apparently lives he does not achieve the desired number and variety of selves. So the imagination fashions new experiences and personalities. We often observe that highly excited persons adopt views which flatly contradict their own convictions. But this attitude springs from the wish to play occasionally, in a spirit of contradiction, a role other than the one imposed by ability and education. The adoption and defense of such alien views form a new self in embryo; hence the views are readily attributed to another person. Friedrich Hebbel reports of himself: "I have often recounted stories about people, though the events never occurred, have often attributed to people expressions which they never used, and so on. But this is prompted neither by malice nor by base pleasure in a lie. It is rather an expression of my literary faculty. When I am speaking of people whom I know, especially when I want others to know

them, the same process goes on in me as when I am portraying characters on paper. Words occur to me which express the inner selves of such persons, and in the most natural way these words at once suggest stories. . . . But it is not my point to commend that eccentricity." (*Tagebücher*, 1885, i, 120.) In this confession the experience I mentioned is brought to consciousness from another direction and further developed.

Once we have become attentive to such associations, similarities appear in surprising abundance. For the person who is not an artist the most familiar ones are connected with his childhood. The poet—who, indeed, remains a child throughout life—preserves for himself in its original scope an inner world that gradually dies out with us. This innermost world of the soul is disclosed in everyone by countless dramatically formed dreams, by the fanciful wishes which occasionally dart through us, by certain automatic actions, by changes of mood, feelings of anxiety, presentiments—in short, by vaguely sensed facts which we usually ignore, and properly so for the purposes of practical life. Science, having enough to do with the facts of clearest consciousness and of most immediate importance for life, has conformed to this attitude of neglect. But the very attempt to understand the mental individuality of children and adolescents forces us to consider these incidents. To them I add daydreaming, the joy of putting oneself imaginatively into all possible situations, the pleasure of feeling oneself the hero of romantic adventures. Even the most prosaic person has some residual trace of this. Who never plays in his mind with character and destiny when waiting for sleep or when a purely mechanical activity allows his ideas to wander at will? Such reveries seldom find a conclusion, but often a continuation. Again and again a boy returns to the thought that he is a ruthless tyrant, or a person dogged by misfortune and pitying himself with all his heart. Once begun, this self-transformation then persists for years, though naturally with modifications introduced by the vicissitudes of life. This formation of fanciful personalities, whose subjective value stands out against a fabricated environment, can breach the consciousness of reality so deeply that actual relationships are doubted, such as those to parents. More children than we suspect cherish in the carefully guarded sanctuaries of their souls the conviction that they really have parents of very high station or great wealth.

The transition to art is not hard to understand. When so many try to escape in passing pictures from themselves and their

surroundings, they are beginning what art gloriously consummates, for that of which man dreams, and speaks not, has fled to art for final refuge. Almost all great tragedies are rooted in the struggle of a higher person with the circumstances which prevent him from fully realizing himself. So these tragedies also depict the author's own fate. No one suffers more acutely than he from the mediocrity and hostility of the environment, from the drab uniformity and sluggish regularity of the given—in short, from the coercion of the near. And the nearest, the inescapable, is his own character. As in the whimsical play of our idle hours we like especially to transform ourselves, the writer's need and joy is to change his own feelings completely. He raises a protest, as it were, against the fate which has chained him for a lifetime to the same pedestrian individual, to himself.

Now we are beginning to understand. The unreal creations of the imagination form the actual starting point for the writer's knowledge of human nature. The pleasure of being a different person can sharpen insight into other minds even more than the remembrance of personality changes which actually have been lived through. So we assert that the original element is the joy in change, in detachment, and not the desire to see into the hearts of other persons. Those who thus far have treated this desire as the obvious starting point have let themselves be misled, partly by confusing this issue with theoretical needs, and partly by the doctrine of imitation, insofar as they based their view on the inner reconstruction of inferred mental processes. But in imaginative natures another personality exists beside the practical one. If this other personality is ignored, the author is subjected to an impossible demand. He must be at once both choleric and phlegmatic; he must be a hero to be able to create a hero! I am inclined to believe, on the contrary, that the weakling is the very person who can have a finer feeling for the heroic manner than the hero himself, to whom it is as natural as the rhythm of his heartbeat, whereas the weakling in his leisure hours has often dreamed of himself as a man of will. It can be shown that artists who succumb to the sinister lure of moral depravity, who wade in filth and breathe pestilential air, can produce the purest and most delicate works. He who depicts love most beautifully is not the most frequent or ardent lover. How strong must the passion be in those who are driven by lovers' griefs to take their own lives, and how few of them are real poets! No, the poet's apparent character and the quality of his outward experiences

are not the essential things. What he can say about people is derived from his youth and the play of fancy. And for this very reason it is futile to try to plot the course of the poetic imagination like the flight of a projectile.

On observing the development of the imaginative activity described above, we note that through the years its products grow more and more concrete. The author owes this to the improved technique he has adopted as a result of poetic experiences (his own and others'), but still more to the influence of life. Growing personal experience penetrates even into this sphere and makes the earlier indefinite ideas gradually approximate real objects. The pale ideals get stronger colors from the environment, and thus come to refer to existent things. In a word, living oneself outward becomes at the same time living oneself into others. What was originally undertaken merely as an imagined change of one's own personality broadens out into an empathy with actual persons. Yet the writer does not stop even here. Subjective plasticity must be combined with the utmost objectivity of judgment, so that an artistic appreciation and a work of art may emerge. Without this added achievement the author would remain a person who revels in changes of character and easily falls under the spell of another person, but can neither criticise nor create.

The demand we are now making can be expressed most briefly as the requirement that the other person remain an object. Not only does the concept of object presuppose the concept of subject, but also the experience of an object rests on an immediate experience of its opposition to the subject. The other self, which is absorbed into my self, must be involved in a certain struggle against the remaining me, so that it can be treated as an object. Submergence in another person must be supplemented and corrected by the preservation of one's own personality. When I remarked earlier that the writer understands by sympathizing and not by scientifically dissecting, my words were supposed to suggest something different from loss of self. And when I said just now that the weakling is the very one who can cultivate the finest feeling for heroic greatness, I had in mind this counterplay of object and subject. Fundamentally, indeed, we have only to comprehend more clearly that ultimate fact which separates the human spirit from everything else in the world; that is, self-consciousness, or the ability to objectify ourselves. Suppose the case hinges on ideas revived from earlier life. Standing there without any immediate

connection with the present state of mind, such groups of recalled ideas form separate units and develop as if spontaneously into imagined persons. The writer scarcely takes the trouble to unify all the groups he acquires in this way. A sound instinct warns him, for every such attempt weakens his individuality and renders him unfruitful. As the mixture of all colors produces white, so the mixture of all personalities inherent in the artist yields a blank surface. Obviously this is also true of the personalities created by the imagination. The whole wealth of figures which springs from the subconscious work of the mind consists only of opposition to the stable, dominant over-self. ("Even the hypothesis of the duplicate self is a generalizing abstraction from numerous observations, each of which may require its own particular explanation." "When I use the terms 'over-consciousness' and 'under-consciousness,' I am not thinking of quasi-geological strata in the brain, but I choose the terminology merely as a readily intelligible metaphor."—My *Das Doppel-Ich*, 2nd ed., 1896, pp. 48, 13.) As the child at play does not enter wholly into his illusion or the actor into his role, the author also keeps his separation from that unitary mental creation which another person signifies. We used to think that hypnotized subjects, changed by suggestion into other persons, or spiritistic mediums and hysterical invalids, who fancy themselves possessed by spirits, must all experience a complete transformation, even if only temporary. Recent investigations have shown that they do not wholly lose consciousness of themselves.

All sympathy which springs from your understanding of another person's mind is like a baptism; you are received into a new life, yet without any need for self-renunciation. Various elements in the writer's creative activity can be explained only by this divorcement. Notice that, as a rule, in the portrayal of the young and innocent a strain of sadness is added, which the actual state of mind would necessarily lack, and which springs partly from sentimental retrospect and partly from our knowledge of the future. When poets declare that they find mysteries in a very simple soul and beauties in a drab existence, this is an echo of their own inner life. At the same time the moral significance of the events is expressed. All true artists have the good fortune to see people as wonderful and not as sordid, vulgar souls, consisting merely of the commonplace. The philistine thinks of his neighbor in this degrading way, and is just as low himself without knowing it. But in art even the understanding of human nature is serene.

For serenity indicates a free play of our powers, such as neither the coercions of life nor the severity of science permit us. And this free play awakens our interest in people of another kind.

Thus far we have been considering a certain experience and its history. That experience is the immediate understanding of mental processes in other persons, usually without our awareness of any inference from bodily manifestations to mental causes. In the writer this understanding has been perfected. Accurate recollection of one's personality in its earlier phases and the need of the imagination to make another individual out of oneself play essential parts in developing the creative poetic understanding of human nature. Dreams and wishes, by means of which we soar beyond reality, in the case of the mature artist draw to themselves so many constituent elements of reality that from whimsical creations they become symbols of potential human beings. And there is a second restrictive condition. However easily the author may change himself, he nevertheless retains his consciousness of himself and can therefore confront the other character as an alien being.

Since we now intend to explain scientifically, from its constituent elements, a particular case of insight into another person, we must look more carefully at the part played by the body, an aspect of the problem thus far excluded from consideration. From a scientific point of view, physical facts are initially presented to the observer, although we do not experience the relationship in that way. If we want to explain this, we must ask ourselves why an accent or a muscular movement arouses in the observer a state of mind like the one that caused the accent or the movement? Moreover, we must keep out of the problem as far as possible whatever has become familiar to us from rudimentary stages and similarities, since only by such artificial abstraction can a limited but clear knowledge be gained. Incidentally, previous psychological investigations of this subject rest almost entirely on such a mode of approach. So does the well-known theory, which was worked out by Lipps, and was even earlier suggested by Sully in the following words, "When a person witnesses the manifestation of a pleasurable feeling in another, he reexperiences in an ideal form some element of his own happiness; that is to say, his perception of another joy is in itself a consciousness of joy."

Let us again recall that theory of the passions which regards them as not only accompanied by sensations of bodily expression, but as consisting precisely in such organic sensations.

I will not inquire into the general situation here. But for what goes on in the artist I believe that I must claim a finer distinction. From various reports of artists about themselves we learn that they are driven involuntarily to mimetic or other expressions of the feelings to be portrayed, that at the thought of their hero's rage they even clench their fists, and so on. The clenching of the fists at the idea of rage signifies primarily just the inherited and usual association of a movement with a mental process. In the case of the writer, however, the gesture also has a peculiar instrumental value; it starts a mental excitement which can be very intense without disturbing the artist's creative activity. This excitement is not identical with the actual passion of rage as lived through. It may remain undecided whether the actual rage evokes the organic sensations or consists of them. But the artistic excitement is a consequence of the movements, has (so to speak) already digested them, and is therefore no longer disturbed by them or the organic sensations connected with them in creative work. The bodily processes leave enough warmth for a vital portrayal, but they have lost the heat in which literary activity and freedom would inevitably wither. Hence, the characteristic emotions of the author arise through reaction to the sensed manifestations. Anyone to whom this seems strange should think of analogous phenomena in neighboring fields. Some actors shed actual tears in moving situations. To take this as a sign of deep inward disturbance would be downright absurd. We have here nothing but a particularly ready functioning of the usual association. Actors are easily moved to tears, as we are wont to say. But this has its advantages, for these tears now react, in turn producing an emotion which does not, to be sure, like genuine grief, rob the actor of his self-control, yet does give him magic power over the audience. When a master of the violin deeply moves our hearts, the same process takes place in all of us. It is the tones, which affect him too. The painter is intoxicated not only by the color which he sees or recalls, but also by the color which he lays on. And the writer's most important possession is his command of language. The more the words come to him, the more his thoughts increase. The words awake pictures which were dormant until then. Only through the words does he conquer the inmost citadel of another soul and fully live through his own inner processes to the end. Thus we may conclude that the artist's relation to nature is less intuition than expression.

But there is a qualification to make. Mental states as in-

tense as we have thus far assumed do not occur in all artists, and even when they do are hardly the rule. Often the process runs its course without the vigorous bodily participation I have described. Let us take for example a remembered or imagined mental configuration which does not become visible and whose subject does not stand before us in bodily form. In this case imagination creates the corresponding picture. The person stands before my mind's eye; I hear his voice and see his movements, adding interpretation and appraisal, perhaps like this, "Yes, that is true joy; there are still happy people." Here the movements and the feelings induced by them need to be present only as the slightest tendencies. Since an intuitive picture of gaiety and not the mere concept of gaiety fills the mind, the actual person with his psycho-physical unity is preserved even in this case. But since organic sensations and passions participate here to a smaller extent, it is possible, first, for considerably more ideas to be attached, and secondly (perhaps just as important), for restraints to occur more easily.

As for the first point, it must be emphasized that in artistic creation abstract ideas are combined with the intuitive content of consciousness. The character that is becoming intuitive in the picture of an angry man need not be literally represented in all its features, but can also be represented figuratively in words and concepts. Many niceties of the individual who is being interpreted are never represented in consciousness by the corresponding words and concepts, but only by shadowy analogies, by vague relations to something similar. Even incongruous symbols appear, melodies and color combinations being mentioned most frequently in the testimony of poets about themselves. The extraordinary ease and mobility of literary imagination would be inconceivable if all this had to be represented literally and sensuously like illustrations in a book.

As my second point I referred to restraints. They allow a self-enclosed unity of consciousness to emerge from a mere disturbance of the soul. To clarify this, consider the opposite mental condition of the intoxicated person. The use of alcohol removes restraints which otherwise exercise a regulative function. The ideas which emerge (here as elsewhere) are not evaluated as usual. It may be like this with the author in the moments of strongest emotion. All corrective, restraining elements of consciousness recede, and the psychic energy converges on just one point. But in the other stages of creative labor, counter-ideas are active, helping

forward the many-sided, indeed inexhaustible work of art, which nevertheless remains unified and resists dismemberment.

These counter-ideas, springing from reflection, also indicate the watchful activity of the self. We have already come to see that the writer does not lose himself wholly in the other being—complete forgetfulness of self is morbid. Rather, he adopts an attitude toward the images, surrounded by countless associations, of someone speaking cheerfully or behaving in an angry manner. Through imitative movements he shares the joy or the anger, but always in connection with judgments referring to objects, such as, "How fortunate, indeed, is such a nature!" The stronger the feelings attending such judgments, the more decisively they prevent a real self-transformation. For these feelings are related to the constant self, and without such relation no desire or aversion exists. Much the same effect is produced by the pauses in mental process, whose importance I mentioned earlier when we were analyzing the aesthetic impression. All sympathetic understanding of something else grows intermittently, since I involuntarily retreat into myself again from time to time. And even during the periods of progress I usually remain conscious of my own bodily condition and environment, that very consciousness preserving me from a dissolution of the subject into the object. Observation of hypnotized subjects in connection with the so-called objectification of types has provided convincing evidence of this consciousness.

Thus far we have assumed that what is to be understood in human nature is a single state of mind. But in understanding a momentary state of serenity or rage we have not yet achieved much. Our principal object continues to be the whole character, of which we have only fragmentary expressions before us. As Dilthey and Lipps have shown, this character is disclosed by single expressions in virtue of their systematic unity. I must know when and at what the other person laughs, and then catch the nuances of his hilarity and its details, to obtain a comprehensive idea of his mood. Here the conscious expressions are worth less than the unconscious. Only in movement, bearing, and accent can the most intimate life of the personality betray itself. In a very striking sentence, Leo Tolstoy describes the meeting of two siblings, separated and estranged for years. "First that mysterious, indescribable, significant exchange of glances took place, in which everything is genuine; then when they began to exchange words, this genuineness had already disappeared." (*Auferstehung*, trans.

A. Hess, p. 473.) The innermost incidents of the soul have something about them that defies translation into words. But aside from man's inability to express every inner nuance at will, he also finds the very attempt repugnant. "The uttered word is shameless; silence is love's chaste bud," sings Heinrich Heine. We bare the whole soul as little as the whole body; one seems as shameless to us as the other. We also feel instinctively that open discussion would suddenly rob the soul's privacies of their value. And finally, the urge to self-preservation forces us to uphold this or that lie of personal life, which a forthright unveiling of ourselves would make incredible.

The totality of unconscious expressions, in which something hidden comes to light, is regarded as the visible aspect of individuality. Mental individuality is explained most easily in terms of the varying combinations of the constituent elements common to all minds, and their strengthening or weakening. By attending to these combinations and their increases and diminutions, the author becomes the steward of the mental store of human nature. For him the variously changing activities of average people and the most exalted deeds of the hero are of equal value. To be sure, natural inclination leads the poet (like the historian) to the hero, and properly so, since elevation to greatness is something purely human, and the existence of the extraordinary is a distinctive feature of spirit which nature—and hence also natural science—lacks. But even the undeveloped or deformed, the unpleasant or ugly character can attract him. This is true not only because in thoroughly exploring even these qualities he transcends his own temperament (*hinausgemutet*)—to use a Goethean expression—but chiefly because the strong excitement attending the knowledge of such natures quickly removes any feelings of dislike which may arise. It is a defamation of man to assert that he always seeks the ideally beautiful and the harmonious. What he wants is not mere pleasure but life, excitement, and struggle. Such a feeling prompted Shakespeare to fashion his immoral and bestial characters. This he could do all the more easily, believing it obvious that the soul is composed of relatively few elements, and knowing how to judge the world from every standpoint.

But the need to understand individuals is not yet met either by the three types mentioned or by appeal to the varying combination, the strengthening and weakening of conscious contents in an individual soul, which can be undeveloped in certain

directions, while average or even outstanding in other respects. Further points of view must still be considered—certainly, in my opinion, those proposed in the main by Bahnsen. The first concerns the content of the individual mind as dependent on stimuli, and breaks down into two subordinate points of view. First, endowment and environment in general act on individuals to different degrees. Great writers distinguish very carefully between passive natures, which offer slight resistance to inherited impulses and environmental influences, and active natures, which can overcome themselves and the world. With this they generally combine a division into fickle and constant characters, the enduring component usually coinciding with the endowment in the first case (passivity) and with the striving for goals in the second case (activity)—a coincidence which is worked out in the literary tradition, but is not logically exhaustive. Shakespeare regards receptive, feminine natures as innately predisposed to steadfastness; their simple minds return again and again to a state of equilibrium and change little in the course of life. Recollections of a boy's mental life doubtless contributed to this view, since that life can be changed only by shedding its feminine qualities. On the other hand, the unstable factor predominates in those men who follow the impressions of the moment without regard for past or future. As the basis of explanation Shakespeare adds the strength of the feelings of reaction, since the more intense the feeling, the shorter its usual duration. For active natures he considers weakness the worst sin. In his series of historical portraits the great men of action are striving to achieve outward success in the real world as their lasting goal. In his later works, from *Hamlet* on, Shakespeare has embodied a higher end, the perfection of one's own soul. Henceforth this constitutes the terminal point and measuring stick for the conduct of the nobler person.

Secondly, particular impressions have one stimulative force for one person, another for another. Think of innate talents. (Cf. psychological material in F. C. Prescott, *The Poetic Mind,* New York, 1922.) Correspondingly, in epic and dramatic poetry the evaluation a person gives to a single experience helps to reveal the peculiar quality of a character. From this the poet acquires two artistic devices; he shows either the same motive, its efficacy changing with different individuals, or the meaning of various motives for a single individual. Thus the way in which individuals respond differently to the same external resistance is highly indic-

ative as to their mutual deviations. On the other hand, a person can be portrayed through the stimulative value which he finds in various kinds of impressions.

If by all these means the content of the individual mind can be definitely ascertained, the operation of the mind can also be clarified. And the performance of mental functions is explained in a twofold way. First, we consider the temporal sequence and attendant circumstances of the processes as significant for personal individuality; in addition we discover how strong these processes are. Since only a fixed sum total of mental energy is ever available, the individual is characterized by the fraction of this energy he expends for this or that function. Indeed, that very sum total, differing as it does with the individual, can be used as an essential index. All the patterns of personality which have been mentioned are most clearly exemplified by the chief characters in Shakespeare's plays. Referring to the forms and relations of the passing mental processes, Goethe remarked that Shakespeare's characters resemble clocks "with crystal faces and cases." In respect to the distribution of mental energy, Shakespeare adopts the principle that the passions attract the greatest portion to themselves. Then he describes his characters by reference to the nature of the passion (ambition, love) and the distribution of the residual energy among the other mental drives.

4. The Mental Constitution of the Artist

After so much has been said about the psychology of artistic creation and also about the artist's understanding of man, there seems to be nothing left to justify the title of this section. And yet the permanent constitution of the artist's mind, especially in respect to moral and social conditions, has by no means been adequately discussed. Indeed, even in this section I still cannot say everything; much must be reserved for the final sections of the book.

In every age we have compared the artist with the average person, always vacillating between two views. The first view, elevated by the Romantics into a universal law, sees in the artistic genius the true human being, or at least a happy, aspiring excep-

tion. This is certainly so, if we judge the product and not the person. Equally justified is the romantic view that the artist is like the child, for the original unity of self and world—a unity recaptured in creative activity—is indeed a characteristic of childhood. But a separation has not yet befallen the child, whereas the creative artist must first reestablish connections. The second view relegates the artist to the vicinity of the mentally ill, treating him therefore even in practice with indulgence and a certain unctuous benevolence as a slightly deranged person. In fact, he can hardly stand the scrutiny of the physician and sociologist, if the ordinary man is to set the standard. The artist's knowledge of his characters —a point we have just discussed—in many ways already involves features which suggest the peculiar illumination of the soul, inwardly experienced and described by seers. ("All my life I have had a peculiar feeling in the company of human beings. Wholly forgetting myself and often my surroundings, I seem to see behind the words and actions of the people about me another self, pulling the wires and making the puppets dance. The words which come from their lips are strangely blended with others which are soundless. The operation of the brain seems to lie before me like the mechanism of a clock, the speech, gesture, and bearing of people in social situations being merely the movements of clock hands on a dial. I feel a curious attraction or aversion, as the case may be, in the presence of those whom I chance to meet. Even more: I cannot go along the street, sit in a railway car, or mingle with the crowd in theatres and other public places without feeling the hopes and the fears, the joys and the sorrows of human beings. It is as though I felt the pulsation of their souls. Sometimes a whole story is unfolded before me like the printed page of a book—with the difference that I hear (by what means?) and see (with other eyes) words, tones, colors, forms, and places of which I have never heard, faces which I have never seen, clothes of a cut and style which I have never glimpsed. A series of pictures glides past me with greater variety and speed than in a panorama or movie. And, in every case which I can investigate, it turns out to be connected with the person or persons in whose presence the vision came."— K. E. Henry Anderson, "Experiences of a Seer," *Occult Review,* I, 2, 1905, 68.)

There are also derangements which spring from splits in the inner life of the mentally ill (called schizophrenia by Bleuler), and emotional convulsions such as the sound mind never knows. If

we look at Hans Prinzhorn's collection of art by the insane, we are astonished at their similarity to the work of Expressionism. (*Bildnerei der Geisteskranken,* Berlin, 1922.) Only gradually we discover the difference between capricious violation of nature and intentional deviation from nature, between morbidly involved symbolism and pregnant depth of value. In some important cases it is quite impossible to draw a boundary with confidence. We are not helped over such facts by the friendly suggestion that as a rule pathological phenomena stand in no causal connection with spiritual greatness and leave broad fields of mental ability intact. Naturally it is mere playful nonsense to brand as noxious Zola's "mystical inclination to infuse life into lifeless matter." But when we read of Zola's abnormalities, his compulsion to count, to close drawers and doors again and again, to step over obstacles only with the right foot, and so on, we can concede to Lombroso that the writer, medically regarded, is a hystero-epileptic. Dreaming and primitive feelings of terror, inner listening and secret dread, restlessness and grave disorders of the nervous system make many, if not all artists appear ill. People have lamented these facts or have even tried to explain them away sophistically to avoid so serious an outcome. Thus it is all the more necessary to understand the interpretation which must appear at this point. Externally regarded, genius and insanity may seem to be brothers. But there is an essential difference, and indeed, a teleological difference: the genius points forward, the mental invalid backward. If we apply the term normal, not to the numerical mean but to the teleologically meaningful, then we can call the genius normal in spite of all his eccentricities and pathological symptoms. For our final concern is not someone's constitution or feeling, but his achievement.

There is a distinction among human beings. In the ethical religions, hence also in Christianity, it is marked by the contrast between the believer and the infidel. Plato speaks of a sensuous and of a spiritual love, of the urge to material things and of the longing for the spiritual. Both ancient and Christian thought judges man in terms of his relation to a higher power and an independent world of the spirit. This contrast continues to be valid even today. It is not necessarily quantitative, with the masses on one side and a small number on the other, but mainly qualitative. Some come into the world to preserve themselves and their kind; others are born for achievement. Members of the first group think

those of the second group are fools; the second think the first trash. We may regard these two attitudes toward life as equally justified, if only we grant their basic diversity. The diversity is a contrariety; there are countless transitional points and mixtures. But do not white and black remain opposed, although they blend into gray? So the procreative person and the person of achievement are contrasted like black and white. They diverge unmistakably in the persistent trends of their lives, in the tasks and goals of their existence.

When we rise to the point of view of the person of achievement, we must understand at the start that he cannot meet the requirement of good general health. At least we shall agree that bodily and mental energy do not vary in simple proportion; one may increase but not the other. It can be objected, of course, that this is just bad luck, that the ideal demands perfect correlation. Strong feelings motivate us to strive to balance the two aspects of life's unity, but on thinking out the idea consistently we find it untenable. I, for one, cannot conceive of the mind of a Kant in the body of a prize fighter. In the human organism, as in every organization, one part increases its function only at the sacrifice of other parts. The excessive cerebral activity necessary for progress impairs other bodily functions, as the growth of horns injures incisors; no hypertrophy is possible without corresponding atrophy. The mind is a parasite of the body. We may interpret consciousness biologically as a gradual deterioration of the living body, as a mortal illness from which pure life is free. And we may surmise that to the earthworm even the dog seems to be a cerebral neurasthenic. Indeed, it must be said explicitly that we should not strive to be unities of body and mind in balanced development. We are concerned only with the higher development of the mind, and this is scarcely compatible with an increase of bodily functions. Everything great arises amid morbid surroundings, and has therefore often enough been pronounced sick itself. For example, take a woman who quite unwittingly has become pregnant. Must she not regard all the signs of her condition, from her first indisposition to her final labor, as symptoms of a severe illness? But only so can a child be born. The spiritual offspring also matures among similar derangements of the normal constitution, disturbances of the temperament and the nervous system, which cease only when the work is finished. Whoever foregoes artistic or scientific creation from love of good health is like a child whose dread of cutting teeth makes him prefer to have no teeth. And whoever calls the

higher spiritual life abnormal because of its parturient phenomena must also call teeth diseased since, of course, teething occurs with attendant pain and fever. And since the person of achievement never ceases to think and to fashion, he also never ceases to suffer. The biographies of our great men speak a plain language. Truly, such a life is "something that no one fully plans, and something far too awful to be mourned." (Lou Andreas-Salomé declares emphatically that "the more easily and successfully the creative attitude comes to fruition, the more ruthlessly it often conflicts with other aspects of the person's bodily and mental condition. In this regard the work of art is actually like the foetus, whose growth leads to derangements and distresses in the rest of the organism, or circulates mother's poison through its veins. Not infrequently the artist awakes from his stupor as from an obsession with a feeling of emancipation to think again as he likes, to give himself free rein in something of personal or general interest."—*Imago*, vii, 4.)

It may sound paradoxical to speak of health as an evil, and yet something can be said for this view. It is certain, at least, that health is good only conditionally, not absolutely. And the position can be made plausible, that pain and sorrow are desirable as necessary accompaniments of spiritual unfolding, and also serve to deepen the soul. The conclusion is obvious. While the procreative person intends to be healthy at any price, the person of achievement aims to restrict bodily health to the indispensable minimum. If any fruitful intellectual work is to be possible, the body must not fail us, but on the other hand, it may claim only as many rights as belong to it when the goal is defined as we have indicated. For the procreative person robust health is an end to which most of the other purposes of his life are subordinated. The surplus of vital energy is not spiritualized, but expended ever again for the sake of bodily functions, hence to lower and not to raise. Spiritual development gets no impetus, for the anxious precautions against any disturbance of happiness prevent mental spontaneity. The occupational diseases of intellectuals—they as well as miners have them—could be avoided if they were willing to take medical advice and drop their creative activity, if they were willing to live torpid lives instead of unfolding lives. But it is not morally commendable in all circumstances to avoid bodily suffering in ourselves and to remove it from others. The usual prescription of moral counsellors —that is, if you put illness, want, and misery out of the world, you are doing well—is unpleasantly naïve.

In a modern novel, which has been called a jeremiad of

degeneration, the leading character claims to suffer from an offensive color combination as other people suffer from a family catastrophe. Such extreme sensitivity has bad consequences in our world of disharmonies, and physicians, as well as the general public, never weary of combatting this nervous weakness. But it is really indispensable for giving our life more refinement. Whoever feels the furnishing of a room as friendly or hostile, whoever can be cured of a passion by a false note in familiar conversation is at least avoiding callous crudeness. A finer susceptibility first enables modern man to pass from the life of subsistence to the life of progress. The sufferings connected with this transition are seldom correctly judged. For some they are pathological symptoms, to counteract which one must be blunted and hardened, as a musical ear can be mistreated so long that at last it is satisfied even with a melody in the worst intonation. For others the soft sighs of sensitive souls are trivial in comparison with the moans of the starving and freezing. But the question is merely whether something can be achieved with such a bodily and mental constitution. The answer, I think, is yes. Many of the facts gathered by Lombroso from the past, and recent observations too, support this answer. The best example is August Strindberg, who was a manly man and yet was a trembling little child throughout his life, who wrote powerfully and yet was possessed by the demons of insanity. On recalling him as he seemed to me, when I came to know him in the circle of Ola Hannson, Laura Marholm, and Stanislaus Przybyszewski, I share the experience of Friedrich Kayssler, who once said that the memory of Strindberg's personal appearance brought to his mind the picture of that little twelve-year-old trumpeter in Strindberg's own *Gustav Adolf*. Mortally wounded, the lad is carried away to a bed by a young standard bearer of fifteen, who cares for him in the hour of death. "Both are children of the Thirty Years' War and have never known parental love. The little standard bearer ventures a shy caress; the still smaller, tougher trumpeter bluntly wards it off."

Now, in trying to state the mental characteristics of the person of achievement, I start with the words of Gottfried Keller: "On the whole, everyone whose awareness and existence transcend the question of livelihood is more or less sad. But, after all, who would want to live without this silent undercurrent of sadness, without which there is no proper joy? Even when the sadness reflects physical suffering, it may be a blessing rather than an

evil, a refuge from petty sins." The same thought has been expressed countless times by the noblest souls. Jesus teaches that we should not avoid pain and trouble, but overcome them by grasping their deeper meaning. Meister Eckhart reminds us that "the swiftest animal to carry you to perfection is suffering." In Goethe's *Iphigenie* we read:

> To afflictions I call for help,
> For they are friends; they give good counsel.

Even a Nietzschean confession sounds the same note. "My humanity," he said in 1888, "consists not in sympathizing with man's condition, but in tolerating my sympathy with him." In a word, the capacity for suffering is a mark of the spiritual man. He lacks the thousand gratifications and compensations of the animal man who "has a good time." The way of the spiritual man leads far, but not to happiness. Utterly devoted to his work, harassed by physical annoyances, robbed of the procreative person's comfortable animal life, dissatisfied with his own achievement, filled with silent melancholy—he lives a life fundamentally different from the ordinary standard, and yet of infinite worth.

We are born first in our mothers' suffering, then in our own. The inner anguish of the nobler person of our age is firmly rooted in the insatiability of his various needs and strivings. His mind is so finely subdivided that he feels any limitation of one talent and one goal as an encroachment upon his rich nature. His knowledge has grown to grievous magnitude. His passions plague him, for they surge up out of obscure depths and are not plagiarized poses like the passions of most people. Richard Wagner called himself an exclamatory man, adding that the exclamation point was the only satisfactory punctuation mark for him as soon as he left the world of sound. What is such a person to do in our prosaic, regulated society? He suffers from a constant awareness of the conflict between the life actually lived and the life he imagines. But inner contradictions and our attitudes toward them are the decisive elements in man. The hostilities which inevitably arise between native ability, education, and environment, between the given world and the world to be won by struggle, between the bestial and the blessed in the artistic nature, can apparently be adjusted by refusing to face them. This is what the ordinary person does. He divides his head into several compartments, stuffs into each a different ability, and secures the comfortable feeling

he likes best of all. Natural impulses and spiritual aspirations never conflict in him, because they never meet. But a person of superior mind looks for his own synthesis. He is not afraid to discard prejudices which are widely accepted and have become dear to himself, although like amputated limbs they still give him pain later on. He seeks inner conflict, since he cannot grow without it. All sufferings of this sort are good, for they carry him forward. Hence it is fundamentally wrong to pity the painfully struggling artist and to classify him with those who are merely ill. "The world's work is done by its invalids."

To treat artists as morally contemptible, because their social activity is often slight, is to support a similar absurdity. All who truly belong to art stand alone. Restless exuberance and inward suffering cut them off from pleasant sociability. I am referring not to the many honorable artisans who work with perspective or counterpoint, but only to those artists who are guided by Eros to the Ideas. The value of their existence lies in their works. The best they can give they bestow, not on neighbor or wife, but on their own age and ages to come. It is generally known that nothing passes over from the region of daily irritation and distraction into the work of art. Moreover, it can be shown that the most important events in the lives of most visual artists and musicians—indeed, even of many authors—have exerted no appreciable influence on their art. Their artistic style remains fixed or changes independently of occurrences which concern human beings themselves most deeply. The self which is expressed in the work and is unfolding toward universal validity is no more the social self than its acceptance is a social acceptance. Artists as such do not come from our ordinary world, so they ask of life only that it leave them alone for their work. Such natures are not useful in the usual sense; under proper conditions a couple of porters can be more useful. But whoever has fixed his gaze on the eternal and felt his soul filled by a world of the spirit can share the activities of the procreative person only in play ($\pi\alpha\iota\delta\iota\tilde{\alpha}\varsigma$ $\chi\acute{\alpha}\rho\iota\nu$), as Socrates said. So is it with the artist. To quote Gottfried Keller again: "Rest attracts life; unrest repels it. God stays as still as a little mouse; so the world moves around him. Applying this now to the artist, he should endure, watch, and let things-as-they-are come to pass rather than pursue them. For he who marches in a splendid procession cannot describe it like someone standing beside the road." The denizen of a superpersonal sphere very easily becomes unable to give proper

attention to daily requirements, the wishes of those about him, or the natural and social conditions of external existence. Excessive devotion to the usual duties would threaten his fertility and destroy the guardian divinity without which he would not be himself. As a rule, artistic and official activity are incompatible.

Goethe has a fine phrase, "the fortified lines of my existence." He means by this the boundary of his particular abilities and powers. To know his vocation is the virtue of the creative person. The ancients taught a connection between moral and intellectual education, expressing the doctrine in the principle that virtue is knowledge. This involves the insight that there is no instinctive morality. In those dim regions where instinct dwells, true morality cannot live, for it always presupposes insight into the distinction between good and bad. Innocence may lie below this insight, but never morality. Yet there is also a morality which consists in recognition of our own endowments, and united with it, our earnest attempt to make of them all that we possibly can. We may call this the conscientiousness of the artist, although the expression is rather philistine with a musty odor about it. To be conscientious here is not naïvely to follow rules of some sort or other, but to work honestly with oneself and out of oneself. The spiritually creative person always has an uneasy conscience when he occupies himself with things which do not belong to his life mission. Temporarily, of course, he forgets the tasks for which he exists, but no sooner has rest provided an occasion than his inner activity begins anew and a bad conscience drives him on to further creation. So a bad conscience is such a blessing, and nothing great would ever come into being without its punishments. Conscience acts quite differently when the immature try to step over the fortified lines of the self. For the miscarriage of this attempt evokes a milder self-condemnation in a different tone. We should fix our standard high, venture the impossible to attain the possible, and strive for the incredible to bring about the credible. The artist who intends to achieve something great should consider himself not ephemeral, but definitive.

So far we have regarded the mental constitution of the artist as though in isolation. We have viewed the person as a being, existing for himself, and his artistic ability as a tendency of life to soar freely. Since, however, the artist never really creates in complete detachment, but remains tied to environment, race, and family, we should now investigate these factors in the total situa-

tion. The environment exerts an influence as involuntarily as the dialect of a child's associates affects his speech. Even though those who are closest to the child speak a perfectly pure German and the child has little contact with people elsewhere, yet his speech is permanently colored. So it is here. In a quite mysterious way the subtlest streams and invisible beams of influence from the outer world affect the inner world of the artist, especially in his youth. But it would be quite impossible to calculate his personality from these data, as we calculate a triangle from two sides and the included angle. For an innate disposition is always a factor of unknown but effective strength. We shall return to inherited ability presently. But before that we should ask about the artist's relation to the artistic environment. In the artistic practice of a certain period one can usually see two opposed movements, between which the young artist has to choose. If he is a real artist and also a child of fortune, he joins the faction to which the future belongs and leads it to victory. Some interpreters view these circumstances as a useful and almost designed setting for the appearance of the genius. According to another view, the artist owes his greatness to the accidental circumstance that he was born in a disturbed and pregnant time. All the same, the fact is that we see figures like Shakespeare and Raphael surrounded by many men of talent, and that no conceivable biography would overlook this circumstance.

The biographies of many writers, painters, and musicians show clearly that at first they followed definite models in order finally to discover new ones of their own. The new is principally a departure from what is customary for the individual, but need not be anything unheard of for those about him. The contrary situation also occurs, an artistic personality adopting from the start a course opposed to the prevailing trend of taste and nevertheless established by suggestion and precedent. What the individual achieves during his life he need not feel to be new, and yet it is for his contemporaries. In neither case should the deviation from the usual be overestimated; after all it is only a relatively slight modification. The average artist, at least, uses his personality and creative power ineffectively when he shifts the contemporary course of his art drastically.

Unquestionably the artist's personality, insofar as it is revealed in the work of art, shows racial features. But no general theory will enable us to discover the extent and laws of this dependence. For a nation is always a blend of many races, and

errors are quite common in tracing back individual characteristics to national or racial peculiarities. (In *Die Musik seit Richard Wagner*, 1913, Walter Niemann writes about the "musical expression of racial feeling, of racial membership, and of landscape" (p. 275), but he qualifies in a crucial case: "Certainly Mahler's music is not German; it is often insufferably sentimental, mawkish, insincere, convulsively willful, coolly calculative, and outwardly theatrical. But this by no means forces us to call it Jewish" (p. 140).)

Yet we can sympathize with Richard Schaukal's comment about Ludwig Uhland, the most German of the German poets. "The power of his apparently simple poetry comes from three genuinely German qualities: piety, cultivation, and musical ear. Piety is trust in God, fidelity, spiritual depth; cultivation is systematic knowledge and a sure power of formative expression; musical ear is musical feeling, balance, and subtlety of consciousness." (*Erlebte Gedanken*, Munich, 1918, p. 151.) So we understand, although perhaps we do not endorse, the remark in Baumgarten's *Aesthetica* that only the sublime is adequate to the German national genius. As for the family, we should be especially careful not to confuse the biological and the nominal family. Serious mistakes are made because the fact is overlooked that women, who usually change their names at marriage, are responsible for half the blood that runs in the veins of artists descended from them. P. J. Möbius declares that artistic talent is inherited from the father and can count as a masculine quality, as a secondary sexual characteristic. But it is by no means uncommon for a distinguished woman to have a son whose genius is clearly derived from her. We cannot decide with certainty whether artistic endowment is transmitted more readily to the first-born or to later offspring. The popular view assigns to the first-born an extra measure of inherited talent. But Mozart was a seventh and Boileau a fifteenth child.

Only the skill of the biographer can make clear in each particular case how the most real and the most spiritual factors, transmitted ability and the fortunes of life, accidents of ancestry and of personal encounter—how all these merge into an artistically unified soul. Theory of art must be content merely to acknowledge the problem. Of course, even we see something. We notice that the same external circumstances affect people differently. Poverty and need break some and brace others. There are gifted people who need the whip lashes of distress as desperately as a top, which

otherwise cannot even stand on its point. But many are like a hoop; driven by a blow, it runs its course briskly and steadily, only to fall down at the end. Some develop continuously, unfolding ever new aspects of their talent and trying themselves out, now here and now there. If they are very versatile, they can sow fertile seed in many fields and reap rich harvests. Again, others stay as they were at first. They steadily pursue the same course, therein fully realizing themselves, but never daring to abandon it. Gifted people of this latter sort succeed more surely and quickly, because the public becomes accustomed to them more easily than to those of wavering talents. We need not amplify the theme that success and renown, immediate recognition and eternal worth quite often diverge. Sad experience shows ever anew that momentary success falls to the lot of those whom no one continues to mention after their death, and that the sun of fame rises only on the gravestones of better men. This must be regretted, for recognition, when it appears immediately and is fairly general and cordial, usually increases productive power. Of course, especially when premature and excessive, successes can seduce an artist into facile superficiality and idleness. But as a rule the recognition the artist encounters is a spur, driving him forward. Moreover, to one who uses it prudently, recognition assures more leisure and rest, more fresh power than competition and the rushing daily drive usually allow the person who is still struggling. Those who struggle fruitlessly through the years finally wilt, accomplishing in the whole span of life hardly one tenth of what they would have been able to do. And this seems to me the most tragic aspect of the often unfair allotment of success; it involves the loss of so much spiritual power, of so much outer achievement. The loss is suffered partly because certain things can be brought into existence only through greater ability, or a leading position, or the participation of a larger group; partly because anyone who is fated always to play second fiddle finally loses the needed freshness and flight of fancy.

Of course there is a way to maintain adequate spiritual tone in spite of all mishaps. By heightening his self-esteem one may transcend the recognition accorded him by his contemporaries. But this protective measure is not too pleasant for others, and in certain forms it becomes ridiculous arrogance. I want merely to explain psychologically why so many, who thus far have done nothing with their lives, disparage the successful so disdainfully. Without such belief in themselves and such outspoken contempt

for their rivals, they could not possibly go on living. The only thing left for them to do rests on this biological defense mechanism. Furthermore, an unshakable self-confidence is actually one of the most important qualities for success. Only the person who believes life is subservient to him, and his age compliant, achieves great results. Whoever does not nourish this belief should step aside. There is an element of truth in the idea that one is bulletproof. It carries the fighter through dangers he would otherwise not survive. For on all the battlefields of social life, many victories have been won only with the most reckless disregard of common sense. Closely allied to this is tenacity. A chief maxim for the ambitious is, do not become discouraged, lest you justify those who have no respect for you and grant you nothing. It takes great courage and energy, of course, to struggle indefatigably for success, day in and day out, year in and year out. But those who can persevere have a good chance to succeed. Suddenly success appears, without our seeing why the slow growth reaches the goal at just this instant.

In addition to these personal qualities external circumstances must be favorable. First of all there is "protection," as we like to say with a foreign word. This is given most surely to those who have the qualities mentioned, and can be confidently assumed by them. In the end, without exception we are all mutually dependent human beings and personal relations can never be ignored. We must be content, if only preference does not become so prejudiced as to make utterly unworthy persons successful. Impersonal justice, as a realized ideal, would sacrifice many fine and valuable features to a mechanical uniformity. We first really feel unfair preference and neglect when some authoritative board makes a biased joint decision, for here we expect complete impartiality. Moreover, certain institutions in our present society have become unfairly central. In any case governmental administration still decisively influences the creative personality, although it is this personality, and not the merely regulative board of administration, that creates values. But for the success of an artistic achievement to depend essentially on the favor of businessmen (theatrical directors, publishers, art dealers, and others) who live on the activity of artists—and live not exactly in destitution—in most cases that is a cruel anomaly.

VI. THE ORIGIN OF ART AND
THE SYSTEM OF THE ARTS

1. The Art of the Child

The beginnings of art are disclosed by the remains of prehistoric times. Moreover, what we are learning even now about children and primitive peoples throws light on those beginnings. First of all, such facts should be investigated and made the basis of inferences as to the origin of art. From the start we should be careful not to regard these three fields of approach as equivalent. Since the child of today lives under very different conditions from those of early man (and even from those of primitive peoples now), it is highly improbable that the present development of the child's art recapitulates the artistic development of mankind. In fact, the simple scrawlings of the child are obviously very different from the stone drawings of primitive peoples, and his humming from primitive music.

We cannot understand the art of the child at all, unless we can reconstruct the twilight state of early years, unless we know the feeling of at-homeness in the individual who is blended with all things, and know boundlessness in space and time, unless we can contrast the fragmentary character of our present life with the rounded wholeness of earlier existence and of artistic being, unless we can melt the distinctions between past, present, and future in the ardent glow of an intense lived experience. In childhood all things are interfused—self and outer world, dreaming and waking, reality and illusion, yesterday and tomorrow, concept and sign, thought and sense. For the more strongly stimulated children, geometrical figures are not only concepts which have become visible, but are also objects of the external world and symbols

of mysterious forces. The adult can scarcely comprehend any longer what fabulous power a pair of significant lines can have. But for the growing child the simple outline which he produces—in contrast with all subhuman animals—means a whole world. Joy in agreement with the model and in precision as such develops only later. At first the child finds an inexhaustible source of charm in the obscure, for his lively imagination is more stimulated and engaged by what is indeterminate and promising than by what is determinate and final. There is something truly artistic in this attitude. Such intimacy with the mysterious excludes all yearning for knowledge, as the aesthetic attitude does also. In using their own inner life to explain whatever charms their senses, children are appropriating what lies beyond the bounds of reality. They breathe warmth and life into everything as measured by their slight experience. They speak in metaphors. They see the little cap as a dear old friend, punish the table on which they have bumped themselves, and pity the stones that must always lie in the same place. They create worlds and people them with figures which are just as alive as real persons and artistic characters. In this realm they take refuge from trammeling reality and the demands imposed on them by adults. The boundaries between the fields of life are erased, or rather they have not yet been laid out. Hence it is not surprising that nearly half of all children possess synaesthesia, certain sounds being accompanied by certain color images.

But this confusion leads also to the very opposite attitude of children. Since being and seeming merge, real and imaginary objects are subjected to the same requirements. Under no circumstances may fairy tales be altered in their details, no matter whether the stories have been made up by the children—a case more infrequent and harder to establish—or have been told to them. The content of the story refers to actual existence, which can be repeated of course, but cannot be changed; the form represents a mode of the child's experience, a mode fixed once and for all. For both reasons the tale must remain as it was. Pictures are regarded just like non-artistic objects. The pre-school child is interested only in what is objective and can be named. Mood, chromatic charm, composition, and delineation are as foreign to his primitive instincts as poetic structure and the niceties of characterization. (William Stern describes how at first the picture's details, brought out by attention to them, are listed in random order. From the start of the child's fifth year, perhaps, relations

are included, but those contained in the picture are eclipsed by the relations which the child freely fabricates and introduces into the picture from his own background. "The child uses a picture primarily to release his own interpretive and inventive activity, not to take away what is given in it."—*Psychologie der frühen Kindheit,* 1914, pp. 137 ff.)

The sprightly playfulness and gentle naïveté, which charm us in stories and pictures for children, are taken for granted and so are matters of indifference to the child. But he longs for action, and indeed for the most adventurous, for new impressions and enlightenments. He is a hungry snatcher of ideas, a restless, cognitive animal. Verily the novel is what meets his need for activity. The art to which the unspoiled child is inclined and applies his slight abilities is a special art. Children need their own mode of bodily and spiritual food; they have their own way of enjoying and creating. What do they know of tragedy? What are they to do with perplexity? It has been observed that children take delight in flowers more than in landscape, that they turn their attention to the parts of a picture and not to the whole, that they enjoy colors indiscriminately, only the novelty of a color and not its quality affecting its value. That reflects their limitations of experience and of consciousness. Moreover, the child's egoism characteristically appears even here. For example, a little girl said, "This angel is the most beautiful, for it has curls like me." Finally, we find everywhere the need for activity, which makes the average child a boisterous, noisy, and unmannerly creature. In short, the art of the child is one of his peculiar forms of life and pleasure.

Within the child's world of lived experience, there are two points where the confusion we noted at the start passes over into a distinction between subject and object. First, there are the faint early forms of sexual feeling which, at least generally, mark off one's own body from its surroundings. And then there are those visual images of hallucinatory clarity, long known to science, of course, but only recently investigated more carefully in their significance for the development of mental life. (E. R. Jänsch, "Über den Aufbau der Wahrnehmungswelt und ihre Struktur im Jugendalter," *Zeitschrift für Psychologie,* vol. 85, pp. 37 ff.; O. Kroh, ibid., pp. 118 ff.) Although these images are as clear in outline and vivid in color as percepts, they are very rarely confused with actual things. On the contrary, like intimations of the secrets of sex, they are often felt to be very personal possessions and con-

cealed with the most apprehensive silence. The image of a fox played quite a role in my life as a child. I do not know now how I first encountered this animal, but I well remember that I lived through the most remarkable adventures with it. At that time I was eagerly digging with a friend in the garden, as we had heard that whoever cut a hole clear through to the other side of the globe would encounter strange regions and people. Whenever I closed my eyes, I saw the fox working ahead at the hole and finally reaching the black people. I kept these visions to myself, recognizing them as unreal, but they gave me the keenest enjoyment. At that same time I was convinced I had several times flown down the stairs of our house, and was so obsessed by the idea that I often tried to repeat the trick, once—the last time—with rather unfortunate results. So I was then in that nebulous state which obscures demarcations, and yet not all my clear images were thus affected. A similar condition may be present not only in many children, but also in seers and mediums who write the messages they relay. These people need a power of discrimination and selection to discover in the whirling scraps of their inner visions and verbal images what is to have or to be a hidden reality. In much the same way the artist must take the mysteriously lived fragments and fit them again into that whole from which they have broken loose.

When children draw spontaneously, they do not copy things at hand—why reproduce what is present?—but they try to put on paper their memory images of objects. Yet these images are not true copies; rather they are abbreviated schemata, which have emerged from the simplifying process of interpretation, and consist of big, structural lines. Children always give a four-legged animal four legs, although quite often they have seen only two. They make a shoe as black as possible, because they know it is black and have forgotten how many bright and even white lights it catches. They seldom strive like artists to make what they see comply with the demands of their feeling and to portray accurately what they live through in imagination. On the contrary, children are the true delineators of ideas. In a few strokes they give the concept of a thing—and for that very reason, not a picture. According to logical tradition, concepts and words express the nature of things, and hence should be understood merely in restriction to constant essential characteristics (obviously because from these essential characteristics the others can be derived on the basis of fixed

relations). In like manner we could say of the auxiliary lines in primitive painting that these are the graphically fixed essential characteristics. Only gradually does the child come to appreciate more and more the values of form and color in our environment and to draw from nature. Also children (in this respect like immature peoples) succeed only slowly in correctly subordinating details to the whole. Children draw houses through whose façades the interiors are visible. They make people taller than rooms. They put an eye, seen from the front, on a head in profile. Such incoherence appears not only in the art of primitive peoples, but also in Egyptian and Greek art. Certain pieces are treated as though in isolation and are not joined to the rest seriously enough.

Children's drawing is investigated more carefully than their other modes of artistic expression. It is not hard to find the reasons for this apparently unfortunate onesidedness of our knowledge. The drawings of children are preferable to their literary efforts, because they can be started and developed without influence; whereas, when we consider the little counting rhymes, songs, and stories they make up, we never know just how much comes from the children themselves. Moreover, picture-making excels humming, singing, and other forms of music-making, in that its products remain and can be reproduced in quantity without alteration. Hence it will be fruitful to trace rather more closely the course of development in which the child comes to make pictures. Incidentally, this problem has nothing at all to do with education through art and for art, although the three are usually confused.

Drawing begins as muscular exercise and playful movement. The child scribbles, that is, makes marks without aiming to represent anything. He mumbles with his hand, as it were, by imitating the manual movements of an adult who is drawing. Similarly in echo speech, the child repeats the sounds he has heard without understanding them—or more precisely, imitates the visible movements of the organs of speech. (Wilhelm Wundt, *Probleme der Völkerpsychologie*, 2nd. ed., 1921, p. 206.) Imitation is not always involved. Crooked lines are aimlessly jumbled together, a consequence of the physiological need to let the manual muscles function. When we adults hold a pencil with the point on paper, simultaneously thinking of other things at will, we are usually surprised after two or three minutes by an apparently spontaneous movement of the pencil. If we give the moving pencil free play, a meandering line appears, which for many persons grows into

automatic writing. Occasionally we can observe the same occurrence with children, but in their case the movement is usually consciously induced and enjoyed. Its visible result attracts the child more than the trivial activity, and the next step is to assign an arbitrary meaning to these accidental figures, whose production has been stopped by manual fatigue. With the magic power of his lush fantasy, our little friend sees in the scribble now a cow, and five minutes later a house—we must credit him with both. But this does not last long, for soon some vague notion precedes the scribbling and scrawling. By now the child wants to express an idea. For this purpose he does not in any sense draw the actual object from which the idea was derived. Even if that object has been drawn for him in advance, he takes from it merely the what and not the how, but shows his special knowledge in linear symbols.

This commitment to exhibit his knowledge and to recount —indeed, count up—with the pencil everything he knows has many significant consequences, especially when combined with a naturally clumsy technique. First, it explains certain oddities of such drawings. I have already mentioned the animals drawn with four legs although in positions where only two are seen. Or the front view of a human face is drawn with a second nose attached in profile, because the child knows a nose sticks out and cannot otherwise portray this protrusion. Ears are disdainfully neglected; arms and legs are put on at will or even shrunk to hands and feet. In general, only a few parts are suggested, and those by the most convenient lines at the moment, as though the little draftsman were trying to say, "I know, something is there." Here we should also note the transparency of opaque objects; we see the outline of the cranium under the hat, the legs through the skirt, the furniture behind the wall of the house. Children lack just that spatial imagination which gives to intelligible objects and recountable events a pictorial form. They lack insight into the peculiar features and limitations of pictorial representation, precisely that which determines its artistic character. So in blissful ignorance of all difficulties, children venture the impossible. Until the ninth year (or the fourteenth according to other estimates) nothing seems to be beyond the reach of their pencils. They are very proud of their work and resent improvements added by others. But as soon as artistic taste begins to appear, the little artist is ashamed of his achievements, usually gives up drawing for years, and after this pause starts anew. But then that is no longer the art of a child.

Two points deserve the special attention of the aesthetician.

First, if it is true that children always draw "out of their heads," we have struck something here like what we found in connection with the artist's knowledge of human nature, that imaginative products and formative impulses are present at the start. Thus the theory of imitation is dealt another staggering blow. There are a few reports, of course, that count in its favor. In the introduction to his *Gespräche mit Goethe*, Eckermann recounts that as a boy he saw a picture of a horse on a package of tobacco and felt an irresistible urge to copy it. "When I had finished, it seemed to me that my picture was a perfect reproduction of the original, and I experienced a joy I had never known before . . . From that time on, the once awakened impulse to sensory reproduction has never left me." But such introspections are rare, and perhaps distorted in recollection. Usually a likeness arouses joy because merely by chance the schematically intended lines approximately agree with the real object or the model. The second result, of more general importance, is based on drawn communications. These afford us a further view of the connection between drawing and writing, figurative art and language. Children's drawings are communications in which the lines serve partly as general concepts or words, partly as written characters. Such drawings show clearly an original relation between these functions, a relation whose significance we cannot estimate until later. A fine example—not devised by children, to be sure, but for children—is the animal picture, gradually constructed through narrative drawing. I give two samples of these innocent and suggestive bits of fun, taken from Walter Crane's *Line and Form* (London, 1904, p. 28).

Thus far we have considered only drawing, but our neglect of color and plastic art is justified by the facts of the case. The children we observe model and use colors very seldom, though children of other times and nations may have been different. At the start there seems to be no longing to work with colors; black and white are enough for the child. The inclination to use watercolors appears only gradually, at first to decorate, then to copy reality, and finally in artistic blending. Yet we can hardly say how far this is the result of education. I rather think small children would prefer clay modelling to drawing, but the practical difficulties involved prevent extensive investigation. We do not even know more generally whether, in the artistic development of man, graphic or plastic art began earlier. Presumably the discrepant findings and conclusions are due to the fact that in one place

Fig. 14.

Fig. 15.

Modern Picture Writing According to Nursery Tradition. The figures are drawn upon the progressive system, the stages of development being indicated by the numbers. Fig. 14. "The Little Man & his House & Estate." The little man builds (1) a little house for himself having (2) one window. He makes (3) a broad serpentine path leading to (4) a fine pond, well stocked with (5) fish. This magnificent property excites the envy of certain poorer neighbours, or, some say, robbers, who take counsel together in (6) two groups of three near the pond. They decide to take separate (7, 8) paths to the pond, but at their approach the fish take fright & (9) jump out of the water. And (10) the little man, hearing the noise, takes flight in great alarm —and so it may be said, "The goose is cooked."

Fig. 15. "Thomas & Charles." (1) T [stands] for Thomas, (2) C [under it] for Charles, the names of two partners, who build a house having (3) two chimneys & (4) two windows. They planted (5) grass before the door. Their house being complete, Charles & Thomas (6) set out on their travels, & after some time at last reach (7) the end of the world, where they think it time to turn back. After many adventures on the road, & at least four distinct falls, they at length regain their fireside, & live happilly ever after in the form we see.

—Walter Crane, *Line and Form* (London, 1904, p. 28)

stones and animal bones were available, in another place plastic materials. (Hermann Klaatsch uses findings about the Aurignacian period of the earlier Stone Age as a basis for his claim that art developed from painting to sculpture in *Die Anfänge von Kunst und Religion in der Urmenschheit,* 1913, p. 10.) Furthermore, it seems certain to me, although in contradiction to widely held theories, that the paltry music of children springs not from excitement, but from the gentler emotions. At least, singing tends to begin when children are sitting in a corner, quietly enjoying themselves, or are calmly moving about; then they warble and hum. But we hear the musical expression of sorrow or joy far more seldom. This is quite understandable, for these emotions need quick and sure communication. Sportive play, which is undeniably connected with art, comes from those calmer moods and that enviable feeling of overflowing youthful energy.

Aesthetic theory has often harked back to childish play to explain the nature of art. The purpose of this regress has been to find the origin of the very puzzling occurrences, attending the creation and enjoyment of works of art, in a universally human faculty and to derive artistic sense from an essential and prevalent quality of human nature. As the most important point of contact, Schiller observed that just as in play the child treats actual things not in terms of logical necessity but in terms of his own needs, the artist works with what is given to him, fashioning it with perfect freedom. Like the child at play, the creative artist stands above things. Hence, the artist should be called the true man, for man plays only when he is a human being in the fullest sense of the term.

But an objection must be raised to this comparison of creation and play. In artistic activity there is a need to communicate, a need of which play shows no trace. Although the creative (and even the recreative) artist turns to other people—at least to an imaginary ideal public—the child playing alone or with companions does not care at all to communicate himself or to make an impression. Everyone at play is content with the activity of the moment, regarding it as a passing diversion, but the artist aims to produce an enduring work. After all there is a considerable difference.

But perhaps play is more like aesthetic enjoyment than like artistic creation. Karl Groos especially has referred to this similarity. We enter spontaneously into all play, he thinks, and we show the same spontaneity in living ourselves into the action of a

drama. In both cases the first step is taken without any compulsion. Even in further stages we remain free, in the sense that we let ourselves be wholly carried away by the magic of the (ordinary or artistic) play, and keep ourselves free from conflicting motives. Above all, we do not think of an ulterior end, as we do in work. At least as a rule, for there are exceptions, our serious actions are determined in such a way by a goal to be reached, that they are felt as merely means to the goal. On the other hand, our delight in art and play is our enjoyment of their aimlessness. When we enter into these two spheres, we reach a "carefree" realm and drop the heavy burdens of serious life.

This view, I believe, must be altered and supplemented a little. That art is carefree I agree, but freedom from care should not be misunderstood as unbridled and wanton indulgence. Play and art free man from the pressures of reality by transporting him into a new realm of law. In no sense does anarchy prevail in play. Even the simplest games of children show the tendency to work out their own rules. In games of movement, for example, one child must be allowed a head start over the others, or a certain place passes as a haven of refuge, or only one foot may be used for hopping, and so on. Books of children's games contain countless such sets of rules. This also applies to adult games. For wrestlers there is a very complex system of permitted and barred holds, whereas naturally in war almost everything is allowed, or at least the moral limits are moved a long way. In card and board games the cards and pieces are arbitrarily assigned certain values, the relations among them being governed by strict rules. The same combination of cards which would have brought me a little money in one game wipes me out in another. If anyone tries to break the inviolable rules, the others say that they cannot play with him!

In addition to the established system of conditions there is usually an opponent. His skill must likewise be taken into account, for he can offer more or less resistance. In this way the game is given a variable element, although we must add at once that its variablity is limited by the rules of play. In short, two factions arise. The interaction of these factions usually does not continue indefinitely, but ends at a previously fixed point. This terminal point is not reached in the shortest way, however, or in whatever way one likes. It is reached rather in accordance with the performance of both opponents and in the way prescribed by the rules of the game.

Now if we view the spatial and linguistic arts in the same

way, the natural prototype to be portrayed may be called the artist's opponent. The writer struggles with the plot on which his work rests; the painter struggles with his model. Like good players, they must know whether or not they are equal to their opponents and how to handle them. The material contains, as variable magnitudes, the helps and hindrances through which the artist finally achieves his end. Like opponents in a game, some material permits brief treatment and other material demands long labor. In any case the meaning of a drama, for example, is not the mere attainment of the goal—in tragedy usually death, in comedy betrothal—but actually the turning points of dramatic fortune which lead to the goal.

Secondly, as for the "rules of the game," they are conveyed to the artist in the formative principles of his chosen kind of art. Every drama is distinguished from every novel by definite rules to which author, reader, and spectator must submit without question. If a composer has decided to write a piece of orchestral music, he is governed throughout by orchestral technique, and correspondingly so, if he is using the human voice. Marble is quite different from bronze or wood in the demands it makes of the sculptor; oil painting and etching have different "rules of play." In a word, the peculiar nature of the medium, in which the artist's vision would seem to be freely realized, actually confines his imagination most strictly. Indeed, the rules for painting with watercolors on paper, for example, are clearly more objective than the rules of chess or lawn tennis, because the painting rules are firmly rooted in the nature of the medium.

In other respects the comparison can be pushed still further. As is well known, to insure good and enjoyable play, it is not enough for the player to be familiar with the rules and keep them in mind; he must also have a feeling for them. There are plenty of intelligent people who never learn to play chess well. So also many an artist never gets beyond the practice of his art as a handicraft, because he cannot move freely, easily, and pleasantly within the confines of its rules. Whoever continues to feel the technical demands as fetters is just not made for life within this realm of regulation.

As a special region with its own laws, play shows us that the child's interaction with things leads him on to make up stories. Many children have an insatiable desire to recount what has (or has not) happened to them and what they expect of the future.

Even when they contrive puppet stories or fairy tales, there is usually a reference to themselves. For this reason rag dolls are so popular with little ones. Older children prefer fairy tales, later on Indian stories and tales modelled on *Robinson Crusoe*, which are easily applicable to their own lives and wishes. The principal charm lies in the suspense (which is not impaired even by listening to the story repeated) and the happy outcome. Strange events occur in rapid succession with color and dash; enchantments and dis-enchantments take place, lower animals and human beings are transformed into one another, kings become beggars and goose-herds princesses, and so on. Thus the fairy tale appeals to the imaginative life of the child more than to ours, for we like similes and metaphors, which the simple fairy tale lacks.

2. The Art of Primitive Peoples and of Prehistoric Times

Can we know in general whether there is a primitive art? When a primitive man finely rounds off and polishes his tool, his purpose may be to make it more useful. When he dances and sings, perhaps he is merely expressing communal feeling. Such mis-givings vanish on further consideration, for the outward similarity of all these achievements to our works of art permits us to apply the concept of art to them. Moreover, in all ages and circumstances art is more than an accumulation of beautiful objects or a perpetu-ation of moments of aesthetic charm. *Art is a form of spiritual and social life,* and as such may as properly be assumed to be present in primitive groups as are religion, science, and law. Our task is merely to get a true picture of the peculiar nature of primitive art. How difficult this task is we learn from a glance at Japanese art, which is racially alien to us, yet highly developed, and has been taken into our culture for decades now. We know and love a delicate and whimsical Japanese quality, which often turns into a technically masterful reproduction of keenly observed reality. But discerning Japanese declare this view to be a gross misunderstand-ing. They themselves see in their art the powerful expression of the Asiatic spirit—more precisely, of Chinese knowledge and Indian faith. It is not precious *objets d'art,* not birds and flowers, not plum

blossoms, but the dragon, defiance of death, and Buddhist self-sacrifice that constitute their general and also their artistic ideals. Personally I have no right to an opinion, but I do believe that the persistence of so basically diverse views about something so open to inspection leaves it very unlikely that our interpretations of primitive art are correct. Nevertheless we must try to describe the material which has been gathered by ethnologists and clarified in part by historical scholars and in part by philosophers.

We shall consider first the manually produced work intended to be a visual object. This figurative art is committed by its purpose to portray the human and animal world, to which the man of lower cultural level feels himself much more closely bound than to the rest of his environment. This is true of hunting and fishing tribes, of Australians, Bushmen, and the inhabitants of the northern polar regions. The artist prefers to direct his artistic activity to his own body. The first and simplest bodily decoration is removable and changeable daubing. Then follows the permanent imprinting of patterns by cicatricial drawing and tattooing, and finally movable adornment and finery of many sorts. None of the three kinds of decoration serves to set off the generic beauty of the nude body; this cosmetic art has nothing to do with beauty. As decoration of one's possessions it springs from the joy in property and in being different. It attracts the other sex and intimidates the enemy, but especially serves as protective ornament in the talisman sense. The *Report of the Cambridge Anthropological Expedition to Torres Strait* (1912, IV, 14) goes so far as to assert that, "of the reasons which led the natives to bodily decoration, only one of six groups was really ornamentation, the others being rooted in social conditions (totem signs, social classes, brotherhood insignia, medicinal and magic signs, etc.)." But as certainly as these undertakings are connected with superstitious ideas, just as unquestionably do aesthetic norms (the need for symmetry, and so on) arise in carrying out the undertakings. For here the dominant concern is by no means the reproduction of human and animal forms, but adornment and pattern. In the embellishment of primitive peoples and more generally in their figurative art, there are certain original ornamental motifs which tribes in all parts of the world have used, although it is impossible to suppose migrations of the motifs. (The close kinship in form and expression between the art of the mentally ill and primitive sculpture is also evidence against the theory of transfer.) Since it seems out of the question that the Turanian shepherds have borrowed ornaments from the Peruvian Indians,

or conversely, we are dealing here with patterns which have arisen everywhere in like manner and yet independently. Such root forms of ornamentation, most clearly seen in weaving, are taken by some investigators as symbols of a universal fire worship, once spread over the whole earth. This hypothesis would accord well with the fact that the original myths and epics also reveal a worship of light and the sun. But only in a very forced way can the particular forms and their concatenations be traced back to reproductions of the sun, of the fire altar, and so forth. And it is still more difficult to derive all or even some of them from practices in fire worship.

Hence we must examine the question more closely. The figures here referred to often give the impression of geometrical figures. There are triangles, circles, rectangles, parallel lines, and angles, the same figure being repeated many times or different figures appearing in alternation. These designs set us a twofold task; we must judge both the individual forms and their serial principle. If this principle shows a certain regularity, perhaps even a marked uniformity, such regularity should be understood as springing from the joy in symmetry and rhythm, in the regular repetition of a unit. Symmetrical designs are often found where we cannot assume that the material has exerted any compulsion or the natural prototype any influence. It follows that originally asymmetric patterns become perfectly symmetric in their development or degeneration. Then may we not suppose that a pleasure in the unification of multiplicity is a cooperating factor in this process? Even the very common zigzag line is the graphic expression of a rhythmic articulation, and if there is a natural joy in it, such serial formations are easily understood. But still the individual forms which appear in the repetition are not thereby made intelligible.

Three theories have been advanced concerning these forms. According to the first, man has an innate sense of geometrical form. From this sense he constructs his ornaments. Just as the child is supposed to draw straight and parallel lines, circles, quadrilaterals, and triangles wholly from his own resources, primitive man is said to be led instinctively to such lines when he decorates his body or draws a furrow in the sand with a stick. It is further asserted that pictures of natural objects, especially of the human form, have grown from these figures. A circle became the face, a cone the trunk. A crossbar with erect hooks at both ends signified the arms in the posture of prayer. Gradually these geometrical signs became more natural and streamlined.

Another theory asserts that a transition in the reverse

direction occurred. What appear now as geometrical forms were originally, according to this theory, copies of real objects. Primitive man wanted to reproduce the solar disk and drew a circle. He tried to copy the python and an undulating line with intermittent black dots resulted. He wished to represent a woman's skirt and contrived the triangle. The geometrical style would therefore be a schematically stiffened late form of the naturalistic style. The inferior technique of the earliest artists and the necessity for frequent repetition would have produced this wealth of forms. In the case of New Guinea we have strict proof that highly stylized question marks and flames in patterns really represent human and crocodile forms. "Heads of birds become trapezoids, semicircles, triangles, and rudimentary spirals. . . . In the transformation of human beings we see clearly at various intermediate stages how the head gradually disappears, the trunk becomes a rhombus, and arms and legs turn into straight lines which meet at angles." (Wörmann, *Geschichte der Kunst*, I, 53.) But there are still two points to consider. It is very remarkable that in different tribes, and even within one and the same tribe, the most diverse natural objects contract into the same pattern. Such a regular conversion or reduction to only a few geometrical forms seems to indicate a natural predisposition for just these forms. And secondly, we should not forget that the transfer to a surface involves a creative achievement for which there is no prior model whatsoever. For nature never shows us triangles and quadrilaterals on a surface—never, at least, in that region of natural phenomena known to primitive man. The meaningful line, drawn in the sand, painted on the body, or engraved in stone, is something intellectual, which leads as much to writing as to pictures. Even the dismemberment or distortion of figures indicates a voluntary mental activity. Grosse has shown that a naturalistic sculpture rests on two characteristics, keenness of observation and sureness of hand, and that hunting peoples must possess these characteristics to survive in the struggle for existence. But still this does not explain how a faithful imitation of what is seen leads so quickly and universally to an apparently geometrical use of lines. Max Verworn believes that the transition was produced by the advent of "theorizing activity in prehistoric times," this activity being represented in the "conception of the soul" and generally in religious ideas which favor an "ideoplastic art." (*Zur Psychologie der primitiven Kunst*, 1908, p. 35.) Yet it is very hard to believe that this process, even if supposed to have run its course, would have produced such a formal effect.

The investigation of this question is made especially inter-
esting by discoveries in Mycenae which force us to conclude that
an earlier style preceded the geometrical style. In the period before
the Doric migrations this national art was practised by the Pelas-
gians (Homer's Achaeans). Their clay vases were decorated princi-
pally with plant tendrils, but also with birds and quadrupeds. In
Conze's words, these vases are characterized by the "decorative use
of plants, which is almost entirely absent in the [Greek] geometrical
style; by a masterly artistic portrayal of animals; by the frequent
appearance of human representation, not schematized as in the
geometrical style; by a prevalence of variously and freely traced
curves in the ornamentation, as contrasted with the uniform and
restrained drawing of the simple, geometrical, animal forms." Yet
these discoveries by no means prove that necessarily and universally
a naturalistic style preceded the geometrical. Böhlau's inquiries
have made it probable that even before the Mycenaean culture an
early European peasant art with mathematically formed ornamental
figures existed at the same place. But whether this refined and rich
Pelasgian style sprang from the peasant art through independent
development, or was derived from Egyptian and Phoenician influ-
ences, coming in by way of Crete, is still a moot question among
specialists. The following conjecture has a certain inherent plausi-
bility. Prior to the rise of the Aegean style, the Pelasgians may have
possessed only a limited number of decorative geometrical figures.
Then came the Phoenicians with their highly developed art and
their figurative representations. They would have wholly subordi-
nated the art of the Pelasgians to their own if the so-called Doric
migrations had not brought about a state of war which destroyed
this stimulus provided by imported Phoenician articles. Then the
native systems of decoration reappeared.

The third and last view of the matter rests on the prevalence
of the minor arts among primitive peoples, especially the arts con-
cerned with useful objects. We are forced to conclude that the
practical purpose of a thing influenced its shape and form of decora-
tion, or—looked at in another way—that this form was an unin-
tentional by-product of the work and in accordance with the law
of inertia was transferred to other fields. Thus the origin would be
neither an imitation of real objects nor a primitive joy in geometri-
cal forms, but would have to be found in technical necessity. This
would support Gottfried Semper's observation that the constitution
of the material requires a certain formation, to which aesthetic
feeling then attaches itself. F. Adama van Sheltema has given a

somewhat different turn to the thought. For him, ornamentation is "a symbolic representation of the active forces in the ornamented object, these forces collectively determining the instrumental value of the useful object and dictating its form." Yet Schmarsow has rightly remarked that this view could, of course, account for the decorative forms of architectural members (the acanthus leaf, for example, which shows the pressure of the architrave), but could hardly be applied to useful objects whose mere form adequately reveals their function. It is surely less a question of portraying than of accentuating the empathized forces and the forms determined by the purpose of the object. For example, Schmarsow regards the nail head as the source of the ornamental circle, since this circle repeats in outline the necessary form of the nail head. "When a technical motif has been taken over, evoking the authenticating feeling of value, the motif is thereby raised into the aesthetic sphere of the ornament." (For these discussions, see Z.f.A., xv–xvi.) The most familiar examples are drawn from wickerwork. But also in the weaving of cloth, in the spiral winding of wire, and in the stratification of masonry, patterns arise which are then transferred to earthen vessels ("laced ceramics"), later to metalwork, and are further developed in certain other variations. To unite two skins, holes must be punched in their margins and threads or thongs drawn through. For primitive man these points and crossed lines may acquire independent value and general applicability. Yet we restrict ourselves to "may," since we do not know of any proof and are aware of many contradictory facts. For example, bowls of earthen vessels, which are supposed to copy older baskets, often do not have any linear decoration. In the present state of our knowledge it is scarcely possible to reach a sure decision. Beyond question, however, we have refuted the theory that geometrical ornament is to be traced back exclusively to the imitation of nature. And it seems to me equally certain that from the beginning a joy in symmetry and rhythm has persisted, playing an important part in the artistic attempts of primitive peoples. Prompted by such joy, man has adorned his products to bring out significant parts more vividly.

The soot drawings which native Australians produce on the bark of trees may be regarded as the most familiar rudimentary stage of our art of painting. These drawings are very lifelike, especially in the portrayal of movement, but are inaccurate in details and without perspective or shading. Objects closest to the spectator are drawn at the bottom. Objects in the background are arranged

in horizontal rows, the height of a row signifying the distance of its objects, without any change in their relative size. For the draftsman tells of things as he knows them, recounting them with his artistic means for transaesthetic ends. At any rate, drawing is connected with theoretical ideas; scientific and artistic beginnings seem to be firmly united here. A pair of examples shows art being used in unusual ways for communication. Karl von den Steinen reports how speech was accompanied by gestures delineating drawings in sand. Mallery describes a conversation between Alaskan Indians in which the right forefinger was used to draw lines in the left hand, serving as a tablet. Other travelers are astonished to find how effectively primitive men express with drawings what they cannot convey intelligibly through speech, and how often their pictures express ideas rather than copy objects. Such visible words develop into ideographic writing and explanatory drawing, into miniatures and book illustrations, even into portraits, which tell us in the language of form and color the age, constitution, endowment, and mood of the persons portrayed. (According to Karl Bühler in *Die geistige Entwicklung des Kindes,* 2nd ed., 1921, p. 259, drawing grows into (1) writing (sentences, words, letters), (2) schematic ornament, (3) the map-like outline, (4) the faithfully reproductive picture. But these things are so different, and in part so certainly traceable to other origins, that this genetic grouping cannot be allowed. At any rate, ornamentation is accompanied by pleasure in one's own movement, which we have already met in the art of the child (p. 232). The joy of movement is obviously most intense where the form of the object changes its direction, and precisely these transitional places are preferred for decorative lines.) Moreover, this train of thought also leads us back to what was previously discussed. The crude decorations with which the primitive man adorns his body are supposed not only to impress observers, but also to serve as his own name. To beautify himself is to distinguish himself. All of heraldry springs from this. An Indian legend about the union of Prajâpati and Wak points to the importance of hieroglyphics to distinguish houses and their occupants from one another. And was not the relief on the gable of a Corinthian temple originally but a paltry house mark to designate the owner? Most plastic ornaments have grown out of useless heraldic figures or plastic epigrams. Finally, we should remember that hieroglyphics and the creation of signs belong together. With many races the first pictures were hieroglyphics and as such also scriptorial signs. According to a Chinese

legend, Ssehoang, who is supposed to have lived about 2700 B.C., invented pictures and writing simultaneously. These facts from prehistoric times, facts which might be supplemented indefinitely, accord with the historical conclusion that the great revivals of the visual arts were always connected with intellectual-literary movements. To the Renaissance not only was science a "liberal art," but also art was a learned study. Leonardo and Alberti were scholars; Dürer saw the essence of his art in rhythm, perspective, and the calculable proportions of bodily parts.

Now we shall examine the poetry of primitive peoples, starting with their epics. These are of small scope, recounting in rapid tempo actions whose content comes from observation and tradition. Preference is given to their adventures and victories, in which force, courage, and cunning are celebrated. Thus in its earliest stage epic poetry is obviously connected not only with history, but also with the knowledge of nature. While drama, dance, and music form a group of rhythmic arts originally connected with religious ritual, narratives clearly belong close to the investigation of history and nature. Primitive man can no more distinguish between the explanation and the glorification of the world than he can distinguish between waking and dreaming or experience and fiction. When he tells a story, he is seeking to gain information and insight as well as to arouse himself and others. From the standpoint of our own culture we can say that this primitive view of nature is fanciful, explaining external events in terms of human desires, and anthropomorphic, regarding inanimate things as living beings and referring both morbid and normal experiences to demons. Both kinds of outlook still persist in the speech and poetry of today, and appreciation for the magic power of the word—an appreciation appearing even in the crudest poetic attempts—actually constitutes the essence of literary art. To the primitive mind names and other words seem to be the essential part of that spiritual reality which is active in persons and things. To possess the word is to possess the fact. The word is like the spirit of a person; whoever has rolled up and pocketed the word controls the person as much as though he had a picture of him. For the possession of a picture involves a mysterious right to possess the object pictured. This marvelous power in words and drawings has made priests and artists masters of the world, even down to the present day.

In addition to narrative poetry, the two principal kinds of poetry are supposed to be lyric and dramatic. Adopting this view

provisionally, let us look for the embryonic forms of the lyric. A genetic account, once popular, sought the germ of lyric poetry in repetition. When a primitive man speaks in excitement, he does just what we also often do today; he repeats his statement, underscoring it, so to speak, and thereby making it both more effective emotionally and more convincing. Similarly, a tribal song is only a monotonous repetition of a trivial phrase. The repetition of the whole thought is now very easily boiled down to the repetition of its initial or final parts, and the repetition may become a revival of the content in another form. Thus parallelism arises, which is then gradually worn down to rhyme and rhythm. Yet such a theory of derivation (drawn especially from developments within European poetry) does violence to other ethnological facts. Of course repetition belongs to rudimentary poetic creativity, because it puts the group into accord and brings order into the performance. But the facts show very clearly that, beside repetition, rhythm and meter appear no less independently as first fruits of spiritual activity. Rhythmic order is no late offspring, but issues from one of the most original capacities of the human spirit. It is perhaps the earliest expression of man's creative power. Wherever humanity develops, this rhythmic power unfolds along with social community, belief in ghosts, and language. The inherent interconnection of rhythm, speech, song, play music, dance, religious ritual, and drama has been very familiar to us from the time of Greek tragedy and the sung poetry of the ancient Germans. This unity is so inscribed on the heart of mankind that it was never wholly lost and in every case was merely retrieved from temporary eclipse by modern figures like Richard Wagner. On the other hand—and this must be stressed in advance—in all ages and races the arts and the mental tendencies mentioned have also existed separately.

According to a widely accepted theory, rhythm and work are very closely related. All restricted forms of work, which are repeated over and over again in regular time, achieve stability through rhythmic control; they become easier and more comfortable. Throughout the world people sing when they are pulling a heavy object along by rhythmic jerks or are swinging their sickles together in the field. When a work routine produces a sound at the end of a single movement or group of movements, an audible rhythm begins. If the rhythmic sound fails to occur naturally, a vocally uttered call serves instead. In work the hands or feet are always active, the hands clapping and striking, the feet stamping

and stepping. Hence the rhythms of striking and stamping appear in primitive music and poetry. The earliest songs are working songs, which serve to lighten the labor and conserve energy. This explanation of rhythm in terms of the economic advantages which it yields is shattered by the hard, incontestable facts. Perhaps it has already occurred to the reader that the cited examples of communal labor do not fit the hunting and nomadic ways of life. Even cattle breeders are scarcely acquainted with such forms of work. And even if they were so engaged, the conservation of power would certainly be an irrelevant advantage, since men of this cultural stratum squander their energies anyway. The rhythmic bases of music and poetry were employed for such ends only after they already existed. Rhythmic movements of groups are socially useful exercises and correctives, chiefly in training for war. Only with movement as a luxury (if we may put it so) does aesthetic freedom begin, and only with rhythmic forms which can be fixed and perpetuated does art start.

Let us consider this point further. Primitive men sing also in their leisure time. Even at the lowest level they can separate rhythmic-musical expression from all other activities and cultivate it independently. So also at this stage it must be possible for them to express feelings in certain patterns of sounds, and for these expressions to please their listeners irrespective of all interest in their work. The case is similar for the dance. The rhythmic movement of large groups is seen far more seldom when primitive people are working than when they are dancing for recreation or exhibition. According to many reports of travelers, these group dances have a quality of exaltation. They seem to consist of orgiastic movements, in which overwhelming feelings are struggling to play themselves out, rousing the dancers to ever greater frenzy. The dances of war and love cannot be derived from the rhythms of work, nor can mimetic dances and those which copy the movements of certain animals, such as the kangaroo. Joy in imitation and representation, the desire to express oneself and make an impression are thus present from the start. With music the situation is necessarily the same. If those aspects mentioned just now were not effective, music, the dance, and the drama would never have freed themselves from their union with various and sundry functions of life and labor. Their development as individual and separate arts they owe to other causes. Obviously, it has often happened in civilized nations— and still does—that a working rhythm is intentionally or unintentionally repeated in an artistic rhythm. Heinrich Seidel's collection of chimes, *Glockenspiel*, contains this little poem:

248

White rose, white rose!	Weisse Rose, weisse Rose!
Dreamily	Träumerisch
You nod your head.	Neigst du das Haupt.
White rose, white rose,	Weisse Rose, weisse Rose,
Presently	Balde
Will your leaves be shed.	Bist du entlaubt.
White rose, white rose!	Weisse Rose, weisse Rose!
Darkly	Dunkel
Threatens the storm.	Drohet der Sturm.
In your heart secretly,	Im Herzen heimlich,
Secretly	Heimlich
Burrows the worm.	Naget der Wurm.

Seidel remarks that he composed it while learning to cut screws, and put the full rhythm of this activity into the verses. Another author, who himself once swung the hammer, reproduces the smith's triple beat as follows:

"Come, Sunday! Come, Sunday!"	„Komm, Sonntag! Komm, Sonntag!"
In the beats of the hammers	Dumpf tönt es im Schlagen
Sound muffled complaints:	Der Hämmer wie Klagen:
"Come, Sunday! Come, Sunday!"	„Komm, Sonntag! Komm, Sonntag!"
"Come, respite! Come, Sunday!"	„Komm, Ruhe! Komm, Sonntag!"
The heart hears it too	So tönt's auch im Herzen
In the throbbing of griefs;	Beim Hämmern der Schmerzen;
"Come, Sunday! Come, Sunday!"	„Komm, Sonntag! Komm, Sonntag!"

Granted that purely mechanical operations can be raised to metrical structures, more significant manual work resists automatic regulation. Moreover, in what we call work (something very different from primitive activity) the worker always sees the goal, whereas artistic rhythm is not subject to any such idea of completion.

A further argument against the economic theory is found in the well attested observations of travelers that when primitive people have come together and crouched down to start their choral song, they are obviously trying to escape from reality and forget their usual life. Once more we encounter the truth we have had to note so often (most recently when considering the art of the child), that art is a deepened mode of existence which emerges when we

249

have turned away from ordinary life. But mark you well: primitive poetry always presupposes unity with fellow tribesmen, a unity both felt and publicly manifested. We understand the singing and dancing horde when we consider the popular origin of rhyming proverbs and gay impromptu ditties, or think of improvised Corsican dirges (*voceri*). First of all, the consciously communal group, which rests there inertly or moves metrically, forms the raw material of rhythm. In connection with the repetition of certain sounds, limited forms develop (verses, strophes). The content comes from narrow, musty tribal interests. To be sure, the essential importance of communal and instinctive feelings has been challenged. Gabriel de Tarde contends that rhythm in the broadest sense was contrived by especially gifted individuals, and was merely copied by others. It has issued, he claims, not from mass uniformity, but from personal genius and the primitive power of imitation. To this we may reply that, although we do not know how it was far back in the beginning of poetry, this assumption most certainly does not fit the primitive peoples of today. In these societies the individual will can never create a mode of practice completely *de novo*. It can merely affect the expressions of such a mode, altering them in particular ways and guiding them according to some plan. Thus the temporal relation must be reversed. A single person breaks away from the communal spirit of the group, aroused on some festive occasion, to sing or speak a few words alone. Yet he is only continuing what the group has begun, and he remains from first to last a member of the social body. The stubborn persistence of this process also in the development of European culture indicates how firmly it is rooted in human nature.

The various stages established in this field seem to be fairly independent of the cultural level of the people. But in the case of primitive drama, which we are about to consider, there is such a connection. Among hunting peoples, the drama is simply animal pantomime accompanied by music without words. In the more settled tribes the action is more varied, although always centered in the habits of the most important animals, as even now with Greek stock farmers it is centered in the ram (*tragos*). The chorus is divided into two groups; the actors interpolate brief speeches; one part of the gathering watches the scenic representation, sitting at first in a full circle, then in a semicircle. Moreover, this development shows that the drama is connected with festivals and religious ceremonies. Ancient Greek drama was associated with the worship

of Dionysus, medieval Christian drama with the Nativity and the Resurrection. Until the time of German improvised comedy, the theater stayed wholly independent of poetry. Even now in its primitive forms the theater is entirely divorced from speech. Its next of kin are social life on one side, and musical rhythm on the other, for without the former it would have no content, without the latter no form. When ethnology speaks of a drama of primitive people, it means a concern of the whole tribe, an occasion on which the most important events of tribal life are enacted or imitated, a fixed rhythm of sound making movements in common both possible and pleasant. And the source of this rhythm can be found neither in the repetition of words nor in the efficient articulation of labor. The rhythm should be acknowledged as an original creation of social man.

Like art in general, at its lower levels music also is only a constituent element of the public life. Even before the arrival of scientific ethnology, it was taken for granted that primitive music is chiefly song, since the human voice is man's most accessible instrument. Moreover, music was supposed to be a powerful socializing agent, performed for the sake of common enjoyment. Original feelings are all strengthened by reaction. As morality was once wholly blended with mores, so was art with communal feeling, and it took a long time to break this union. Finally, the influence of music on primitive man—an influence in part soothing and in part exciting—has been known all along. But we owe further details to the research of the most recent decades. Much has been accomplished, especially in the comparative musicology perfected by Stumpf and Hornbostel. Here our next question concerns the sources from which musical art may have arisen. (Cf. Carl Stumpf, *Die Anfänge der Musik*, 1911, p. 21.) Later on I shall have something to say about the conjecture that music sprang from the courting songs of birds, although it must be rejected. Also untenable are the views that music grew out of an excited manner of speaking or is an elaboration of rhythm, although the last theory is undeniably more probable. The view most recently proposed, that the need to communicate through sound is operative here, does not remove all difficulties either. But it does point to the chief question as to how man came to articulate the naturally continuous tonal line into definite intervals. The unintentional part-music of passages containing octaves, fifths, and fourths may have contributed, along with rhythm,

to this change—but the process is not yet perfectly clear. Perhaps music has various sources.

3. The Origin of Art

Having carefully examined art in the life of the child and the primitive, we shall now look for the sources from which art may have originally sprung. It will not do simply to identify the art of the child and of the primitive with the beginnings of art in general, since these two developments, each with its own forms, are too discrepant. When we survey the vast body of ethnological material, we see that primitive peoples live in very different conditions from those of our children, and hence cannot follow the same course. The child's art especially lacks any relationship to use, possession, and war, to superstitions, religious symbols, and primitive feelings of community, on which the art of the savage thrives. For every alleged correspondence of phylogenesis and ontogenesis we could list to the point of weariness the differences left unnoticed. (Children and primitives have long been compared. Cf. Gottsched, *Kritische Dichtkunst*, 1737, p. 87. Karl Lamprecht and Johannes Kretzschmar are the chief contributors to the revival of such comparisons. Cf. *Bericht des Kongresses für Ästhetik und allgemeine Kunstwissenschaft.*)

Without further information we cannot draw any conclusions from this material as to the earliest phase and significance of artistic activity. Prehistoric men may have used modes of artistic expression for which we can find no analogue in the savage tribes of the present. Even when these tribes are subjected to similar conditions, there is still a considerable difference between the modes of feeling and expression in a fresh, buoyant, youthful race and those in a stagnant, decadent race, cut off from any development. One of the best experts calls the primitives of the present "impoverished remains of earlier generations."

On the main point we are left to conjectures. Naturally it is only in the field of spatial art that we have real proof as to the earliest traces of artistic sense. Excavations in prehistoric caves have revealed that bodily decoration marks the beginning of art. Certain groups were already capable of artistic activity in the gla-

cial period. The production of figures freely modeled in the round preceded drawing and ornamentation. At the lowest cultural level, ivory female statuettes were created by subtraction. This seems to be established both for the hunting age and for the age of progressive economic forms, as M. Hörnes calls it. (*Urgeschichte der bildenden Kunst in Europa*, 2nd ed., 1915.) The first relief came after these idols or instruments of exorcism, then outline drawing, and finally the art of geometric decoration; this course of development presumably being compelled by the difficulty of working certain materials. People like to say that these female forms from the age of the mammoth—forms whose fragments, by the way, show strict symmetry in torso and head—were carved by men experienced in love, but of course the statement has no supporting evidence. The Later Stone Age has also left us sculptured figures of nude women, along with rock drawings of figures without arms or legs, restricted to a few curves, points, and lines. The age of copper, bronze, and gold gives us a richer yield, for here begin naturalistic reproductions of the whole life of the age and hieroglyphic ornaments. Yet the controversy as to the temporal order of actual and geometric forms fluctuates back and forth indecisively. Hörnes (p. 576) gathers up the results of his research as follows: "The first highly specialized art in Europe is that of the Late Paleolithic hunting tribes; the second is that of the agricultural peoples of the Later Stone Age, the Bronze Age, and the Early Iron Age. The naturalism of the one as well as the geometrism of the other thoroughly played itself out in its full onesidedness and as a pioneer movement was deadened and destroyed in fruitless confinement or pushed aside by stronger forces. [I add: to the Earlier Stone Age (the age of hammered stone tools) belong the Late Paleolithic Ages (including the Aurignacian periods). After this (about 4000 B.C.) comes the Later Stone Age (the age of ground stone tools). Perhaps about 3300 B.C. the Bronze Age begins (in Crete: Early Minoan Age 3300–2100 B.C., Middle Minoan Age 2100–1600 B.C., Late Minoan Age 1600–1200 B.C.). Around 1000 B.C. the Iron Age begins.] But these movements were the elements from whose fruitful contact and interpenetration the higher or historical art arose as a result of the domestication of wild naturalistic form by disciplined geometric style. According to the testimony of the oldest preserved artistic remains, at the beginning of the development there was also, of course, a weak, undeveloped geometrism (of technical or some other origin, but not of figurate, naturalistic origin). This geometrism, however, lay in deep obscurity

behind a powerful primal naturalism, and had nothing in common with its accompanying and consequent phenomena, the reduced or schematic execution of pictorial motifs in approximately but not perfectly geometrical form. The second stage is a developed geometrism of technical origin with the natural but infrequent fluctuations of such art, the easy transformation of geometrical motifs into figurative representations, and conversely. The third stage is a secondary naturalism, less often in the realm of late prehistoric art (Crete) than in the realm of historic art (the Orient and ancient Greece)."

The oldest dwelling pits and huts were made round, but surely not from any aesthetic preference for the circular form. Even the lake dwellings on piles arose for reasons of utility, while gigantic stones (menhirs), placed side by side and dedicated to pious memories, glorified the power of man and the great oppositions of burden and bearer. On the other hand, artistic purposes are undeniably indicated by the pots and clay vessels preserved from the European Stone Age, and they are still visible in the products of the more plastic Bronze Age. The liveliest interest is taken in the facial urns which have been found in the prehistoric strata of Troy, in Central Italy, and west of the Vistula River. For the connection of the vessel form with human form, together with its terminology, such as *standing upright, front* and *back sides, neck, belly,* and *foot,* seems to be quite independent evidence for the theory of empathy. But actually our modes of expression have nothing to do with the laws of ceramic construction. And these laws in turn do not make (shall we say) the belly of the vessel like a human belly, but allow it (as a surface for chosen decorations) occasionally to appear even as a head.

As we turn from the facts of prehistoric modeling to consider art as a whole, we note first how much the theory of development has increased our difficulties concerning subject matter. The field of inquiry has been extended infinitely and the comfortable vision of the beautiful, the aesthetic, and the artistic as unified in supreme eternal forms is no longer justified. The comparative-historical point of view takes its place beside that of analysis and law. While the latter "proceeds analytically and starts from civilized man," in Kant's words, the former tries to sketch out in its field a developmental history of the mind. In this connection we must remind ourselves that the artistic and the aesthetic object are not the same. Otherwise how could we speak of primitive and prehis-

toric art? Here we have, in part, exhibitions of bodily strength and agility, in part, creations of useful articles and, in part, magic performances. Gradually these things recede—outwardly, perhaps, as excessively decorated weapons become useless and merely beautiful, inwardly in the development from consciousness of tribe and self to appreciation of the spiritual. But they would not have been discarded, were not the other element also present from the start, perhaps even decisively. We shall return to this point presently. An exhaustive investigation of the whole complex of questions would have two problems to solve. The first one is, from what matrix and in what temporal order have the several arts evolved? Connected with this is the second problem, concerning the inner causes of the very first artistic activity. Claims have been made especially for the following mental characteristics as such causes: the play instinct, imitation, the need for expression and for communication, the sense of order, the impulse to attract others and the opposed impulse to frighten others. For each derivation it is obviously necessary to adopt one of the theories which might be offered to meet the first problem (matrix and temporal order). For example, if in the very beginning music in our sense had existed independently, we should hardly be able to regard imitation as the psychological root of primeval art. Nevertheless, for reasons of coherence in presentation, the order of the problems will be reversed here. Nor is this objectionable, since many of the pertinent considerations have been disposed of in earlier sections.

That holds for the derivation of the beautiful from the useful. This is close to the view that the whole realm of the aesthetic and the artistic has arisen from the beneficial, through a purifying process operating for thousands of years. But this view meets with difficulties. In some cases intrinsic value preceded utility, as when clothing was worn as adornment or war booty before the temperature (which grew colder after the glacial period) made clothing necessary. Moreover, we must distinguish sharply between things and actions useful for the individual and those useful for the tribe. The view defended above would depend more on the latter. Finally, we should distinguish between what prehistoric man himself may have recognized as useful, and what philosophical reflection concludes is biologically beneficial. As these aspects cannot be kept separate, the theory remains a rough generalization or a willful distortion of a thought certainly true in some degree.

Even worse is the statement that art is a by-product of

courtship activities. This Darwinian view creates problems comparable (to use the vernacular) with stringy livers and fatty hearts; first we induce them accidentally, and then we take the trouble to get rid of them. This is the case with the so-called music of animals. The capacity of birds for musical expression is supposed to have been acquired as a means to attract the opposite sex. But it must disconcert these theorists to learn that the warbling of birds is not confined to mating time. Is it music at all? Although it is pleasant in a merely sensuous way to produce and to hear the sound of warbling birds, this tonal confusion lacks both rhythm and structure, the basic elements of all human music. We can trace an unbroken line, running from primitive music to the music of our day. All innovations within this development signify only a continuous advance, partly in the improvement of technique, partly in the construction of instruments, partly in musical memory, and partly in general spiritual constitution. On the contrary, we see no transition whatsoever from the so-called music of animals to the tonal rhythm and structure of primitive peoples. It is supremely anomalous that birds, occupying a relatively low rank in the animal world, have the richest music. Haeckel tells, to be sure, of an Indian variety of anthropoid apes who can sing an octave in perfectly pure and full tones. But what does such an exception prove? We prefer to test ethnologically the alleged connection of sexual and artistic impulses. The enthusiastic and moving statements of earlier science have crumbled. Once we supposed that love poems were the beginning of all poetry, as that still earlier man had wandered from the paradisaical innocence and pure goodness of savages.

Contemporary investigation finds little eroticism in the earliest art. Once we believed that love guided the hand of the first artist when he drew the shadowy outline of his girl on the rock wall. This dream also has vanished. To be sure, the earliest figures in the round yet discovered are female statuettes. Nevertheless, this fact does not clearly imply a sexual origin; perhaps the statuettes are idols which were given female forms for other reasons. Clothing and decoration may have been used in the competition for the favor of women, but by no means only so, and not even in the majority of cases.

It is essential that we relive in our own feeling the primitive man's dull, confused state of mind. He feels the mysterious events of puberty, sexual difference, copulation, and birth to be firmly interwoven with magic forces. Men are afraid to look at the genital

organs of other men and to expose their own, thinking these acts dangerous. Women believe that sunshine and pouring rain will fructify them, if they do not protect themselves by coverings or amulets. On the other hand, the sexual urge is so strong that concealment of the sexual parts and reference to them must draw attention, indeed rouse to action. However, a purely physiological function is never the object of concern, but rather a magical element. Moreover, the time of maturity and the moments of copulation are related to social changes in a way quite different from ours. In a word, when discussing such subjects, we should not inject our own ideas.

Sexual attraction often takes the form of play. The opposed impulse, to shock others, still occurring in the games of our children and even with adults, is a favorite device, which is varied through countless degrees—from humorous surprise to brutal force—and is carried over into art. In games pleasure attends superiority—superiority either over living beings, as in games of love and war, or over inanimate things, as in games of sense and construction. It has been said that in overcoming resistance play and art acquire a biological value. They foster the exercise and perfection of those capacities which assure victory in the struggle for existence. This is correct, but is only a superficial half-truth. The important consequences drawn from it have no justification. They are just as extravagant as the conclusions of another biological explanation of art, which has already been rejected. We can observe in the child that the human being at play is occupied wholly with himself and for himself, whereas artistic creation usually becomes communication. When at play, the child feels the spectator to be a disturbing influence, but when decorating himself or drawing, he wants to make an impression. The goal of play is reached in the momentary activity; art strives for duration, even eternity. Finally, one more point. We should think that a necessary dependence of art on play would make great artists the most ardent lovers of games in their youth. In general this is not the case, although young folks of spirited and roguish temperament naturally have their fling also in lively games. As soon as these children become aware of art, they tend to give it their very earnest attention. It is reported of the young Beethoven that music and ever music was his daily occupation. It is recounted of Mozart: "From the time when he became acquainted with music, he lost all taste for the usual games and diversions of childhood. And if occasionally he was supposed to engage in these pastimes,

they had to be accompanied by music." Moreover, Mozart seems to have also shown vigorous imaginative activity in fields other than music, and indeed had certain inclinations toward systematization. From the start Hebbel's faculty of imagination was poetic and not playful. Of Mörike it is well said that "he did not want to learn music, but engaged in all the games of boyhood all the more extensively, driven on by an incessantly active imagination." Does he not say of himself in *Maler Nolten*, "When the other children were romping about in the yard below, how could I enjoy sitting way up in a dormer window, eating my afternoon snack, and starting a new drawing?" In the case of Mörike, as in the case of Hebbel, we find evidence that fairy tales established a connection between boys' games and the beginning of poetic production. The participation of children in games of imitation and illusion is usually so described that we cannot tell whether a general social need or a first impulse to verbalize inner experience occasioned it. Rather early, perhaps between the tenth and fifteenth years for almost all children, the moment comes when they withdraw from games and enter the realm of art. Only dramatic actors seem to pass through a gradual, steady transition from the play of childhood to the play of the stage. (I once investigated the following biographies of great artists concerning their capacity and desire for play in childhood. Here are the interesting passages—*Joseph Haydn* by C. F. Pohl, 1875, ɪ, 13, 67, 70, 78—*W. A. Mozart* by G. N. von Nissen, 1828, p. 16—*W. A. Mozart* by Otto Jahn, 1856, ɪ, 29—*Ludwig van Beethoven* by J. W. von Wasielewski, 1888, ɪ, 32, 36—*Beethovens Leben* by A. W. Thayer, 1891, ɪ, 117 ff.—Richard Wagner, *Autobiographische Skizze: Gesammelte Schriften*, 2nd ed., 1887, ɪ, 4 ff.—*Hebbel* by E. Kuh, 1877, ɪ, 9, 11, 27—*Eduard Mörikes Leben und Werke* by Karl Fischer, 1901, pp. 5, 6, 8, 24—*Schillers Jugendjahre* by Eduard Boas, ed. W. von Maltzahn, 1856, pp. 53, 57, 59, 66, 71—Iffland, *Meine theatralische Laufbahn: Dramatische Werke*, 1798, ɪ, 4, 7 ff., 21 f., 26 f., 29, 31, 33, 35—*F. L. Schröder* by Berthold Litzmann, 1890, pp. 50, 70, 98—*Leben Michel Angelos* by Herman Grimm, 8th ed., 1898, ɪ, 73 ff.—*Arnold Böcklin* by H. A. Schmid, 1898, p. 7—*Böcklin* by H. Mendelssohn, 1901, p. 20—*Wilhelm Kaulbach* by Hans Müller, 1893, pp. 13 ff. Whoever surveys these accounts—rather arbitrarily selected, I grant, and perhaps not always wholly reliable—will reach the conclusions grouped together in the text.)

Like joy in imitation, the play impulse has the merit (as I have already said) of so interpreting artistic sense as to make it an essential and widely prevalent characteristic. But, although the

play impulse represents something ultimate, its ethnological form is neither the whole nor is it identical with the play instinct, for in the play of primitive people forces are active which the child's play lacks—particularly the forces of magic. Whoever moves in the circles of our occultists, spiritists, and quasi-theosophists, whoever has been present at the grim antics of a Black Mass and the externalization experiments of certain mesmerists, whoever is acquainted with the doctrines of psychometry, which musing minds have evolved for clairvoyance—he will agree with Yrjoe Hirn, that all pantomimic games are mixed with superstitious ideas. We should not "take mere magic of the chase as the model of pure dramatic art," but must familiarize ourselves with the assumption that "the imitation of a thing at any distance can influence the thing, and that in this way a buffalo dance, even carried out in camp, can force the buffalo to come within range of the hunter." The principles of witchcraft are, so to speak, caricatures of insights in natural philosophy. Magical action at a distance caricatures the connection between all objects and events, even the most remote. The belief that the bodily and spiritual constitution of the bearer can be discovered by touching his hair, pieces of his clothing, and so forth, exaggerates the influence which constant contact exerts. The coercive force of copies and charms represents in a cruder way the purely spiritual power which lives in the picture and the word. Our art has developed in a purifying process which consumes these elements in a white heat. But they are not lost. I mention an example from the historical period of plastic art. From Egyptian and Greek representations, and also from literary sources, everyone has come to know the human-headed bird, the siren. According to the popular belief, a divinity or a soul is supposed to exist in animal form, and since in the model this form would be indistinguishable from the ordinary animal, it must be given a human head as a special mark of identification. Hence the artistic type, which is so peculiarly effective and permits so many valuable modifications, has not been created from aesthetic considerations, but is rooted in the religious veneration of departed spirits and in the limitation of figural art, which can only make visible but cannot elucidate. Again, when a small relief alters the carriage of wings and arms, it does this not for aesthetic satisfaction, but because the oval shape of the frame requires it. In the history of a similar basic form, the Nike, and in many architectural changes we can see that actual needs give the impulse to progress.

With this we have again reached the utility which plays a

decisive role in the beginning and progress of art. This utility concerns either volitional or rational activity. Music and war interact; songs and dances both intensify the lust for battle and result from it. Even in an early period we find military insignia coming from horrifying decorations. In pantomimes the tribe trains itself for its martial exploits or celebrates their memory. As for the understanding, its demands are met by pantomime as well as by pictorial representation, both of which strive for clear expression of content. Indeed, they are often clearer than words, especially when persons who speak different languages meet, when strict silence must be preserved, or when the voice fails to carry.

Enough and to spare! The general conclusion is clear. Art draws its nourishment from many sources. Among them are primitive aesthetic forces—chiefly the joy in objects of sensuous and formal attraction—but even these have colorings and combinations that are strange to us. Analytic, rationalistic science does least justice to them. Insofar as such a science constructs the system of the arts on this basis, it suffers the same fate, and only by returning to civilized art does it reach a firmer foundation.

4. The System of the Arts

Our manner thus far of considering art through the history of its development can finally help us to gain a synoptic view of the relations of natural kinship among the several arts. This family tree need not begin with a pair of arts—with a masculine and a feminine art, as Richard Wagner would say—but may have as its root a single art, which by germination or division brings the whole family into life. If we assume that the various arts known to history have been formed by splitting off from an embryonic stage, the question arises as to how this stage is to be conceived and to which of our arts it shows the greatest similarity. Adam Smith's answer was the dance. For the dance, he thought, is found in all savage tribes, and found inseparably united with music and poetry. Just because the dance is inconceivable without these sister arts, it marks the starting point. Now in the dance we actually find united many properties which appear in the earliest art. Love dances indicate eroticism and the influence of superstitious ideas. (Think

of the ancient Mexicans with their phallic demons of fertility.) War dances throw light on the social background of art. Animal dances show man's continuity with his natural environment. Taken all together, dances are spectacles, coming from "the sweet pleasure of activity." The dance, especially the group dance, requires rhythm. Hence both within the dance and out of it, first music and then poetry may have evolved. The mimetic power of the dance may have been transferred to movements that conjured forth plastic forms and outline drawings in enduring material. It has been asserted most emphatically that ornamentation has come from mimicry as a permanent deposit of expressive movements which vanish instantly. It is an intriguing idea, for example, to take the necklace as a perpetual embrace. But to me it seems improbable that primitive man felt constrained to place a high value on such acts of endearment and to retain them permanently. Furthermore, it is supposed that the original linguistic sound was imitative, reproducing actual impressions in the manner of mimic movements. So mimicry enables us to understand all the ramifications. But we have no conclusive proof of this derivation, since prehistory offers no evidence of the assumed dance and ethnology tells us only of separate, complete arts.

Other investigators believe that the principal arts have been separate from the start and have arisen in mutual independence. This conjecture would not imply that one art has never come into existence after another, but only that the later art has never grown out of the earlier. If with P. J. Möbius we assume three primitive arts—mechanics (architecture and engineering) countered by music and the mimetic arts—then both the presence and the absence of contemporaneity among them are conceivable. But it is customary to group several of our arts together either as derived from a common source or without any claim of genetic relation. As an example of the former procedure I cite Spencer's mediating view, that poetry, music, and the dance have one common root, while writing, painting, and sculpture have another. This theory is seductively persuasive, for the essential kinship within each of the two classes inclines us to assume a common origin. And we might find confirmation in this field also for Darwin's principle of all causal enquiry that "things from the same source are of the same kind." But it is still possible to join the two groups, using pantomine as a connecting link. Starting with mimicry, Schmarsow has sketched out definitions of the arts, trying

to do justice to both distinctions and transitions. As I have already remarked, ornamental art, "which is able merely to outline and embroider objects of value, not to represent them," can be taken as a deposit of imitative behavior. But imitative movement is also akin to fixed plastic art, "for they both rest on the palpable unity of the human body." To plastic art as the builder of bodies, architecture is added as the shaper of space. A further stage in the development of man's creative activity is found in painting, which has for its subject-matter the phenomenal connection between bodies and space. Over against the image as the finest fruit of sensuous intuition stands the word (poetry) as a spiritual achievement of a higher rank, for pantomime and mere vocal sound do not long satisfy the urge toward definite expression.

A more ingenious classification has been set up by Hörnes. He groups the arts in three pairs, of which "the first (bodily decoration and the dance) concerns the body, the second (decoration of utensils and free plastic art) represents things in space for the eye, the third (music and poetry) represents things in time for the ear. Within each of the three pairs the two arts concerned show kinship of outer medium and contrariety of inner content. For this reason they are very commonly found together in the real world, where elements are so variously combined. The external kinship lies in material relations: representation (1) on and by means of the human body, (2) on and in inanimate matter, (3) by means of sound. The internal contrariety is this: the first art in each pair is chiefly devoted to abstract aesthetic form, such as rhythm, and so on; the second chiefly to the imitation of concrete nature." (Hörnes, p. 5.) A new point of view governs the attempt of Konrad Lange to erect a system of the arts based on the games of animals and children. The games of movement, construction, and sensation correspond to the dance, music, lyric poetry, architecture, and ornamental art. The games of illusion and imitation correspond, in civilized societies, to the illusionistic arts: acting, drama, epic poetry, plastic art, and painting. This reduction is clever, but it does violence to the facts. Moreover, it seems to me fruitless, as though an anatomist should try to dissect the human body with an amoeba as his model.

Among the problems discussed here one in particular has long received the most universal and serious attention. It concerns the relation of speech and music, or to put it more definitely, the birth of music from the soul of speech. Rousseau defines music as

emotional elevation of speech and Dubos, another spokesman for the same nation (strong in rhetoric and weak in music), asserts, "All art is derived from the spoken or written word." Spencer repeats this thought that "music springs essentially from the cadences of passionately aroused speech . . . song must have evolved through the accentuation and enhancement of characteristics of emotionally excited speech." In our country Jakob Grimm above all took the same road: "For from accented, metrical recitation of words the verse and melody of song arose. From the verse in turn came other forms of poetry; from the melody, through heightened abstraction, all the rest of music." Then Wilhelm Jordan taught that it lies in the nature of speech to assume a pronounced rhythm, hence a musical element, on every enhancement of the inner life and on the ceremonial performance of a prose work. Without the mnemonic aids of rhythm even the rhapsodists would not have been able to retain and transmit their tales. Furthermore, in this connection the thesis that metrical poetry originated in prose has been propounded, which to some philologists of the present seems demonstrated. The Greeks are supposed to have had a melodious prose, no longer familiar to our ears, accustomed as they are to another mode of speech. Out of this prose, it is claimed, developed regular poetry on one hand, and the less passionate rhythmics of the rhetorician on the other.

Both assumptions (music from speech and poetry from prose) have been wholly refuted by the latest research. Note the most convincing reasons against the view of music as elevated speech: (1) many tribes wholly lack the recitative, the supposedly earliest form of music; (2) the music of hunting peoples is often only the rhythmic movement of one tone, and therefore does not arise from any change of pitch or modulation of the speaking voice. Since the first men hardly held conversations in our sense, they could not achieve music from emotional accent, or a heightened (poetic) style from the ordinary conversational style. Adam Smith had the penetration to recognize the actual situation. He saw the primitive character of the nonsense words still persisting in the refrains of ballads, and concluded: "In the succession of ages it could not fail to occur, that in the room of those unmeaning or musical words, if I may call them so, might be substituted words which expressed some sense or meaning, and of which the pronunciation might coincide as exactly with the time and measure of the tune, as that of the musical word had done before. Hence

the origin of Verse or Poetry." (*Works,* 1811, v, 267.) This is true. The earliest songs, like the simplest songs of children, had no words at all, but used meaningless sounds to facilitate tonal articulation, as we do in trilling. Song words and recitatives first appeared at higher cultural levels. So music does not stem from the natural intonation of excited speech. The other side of the problem coincides with the question concerning the boundaries of poetry. If we regard the rhythmical use of language as the distinguishing mark of real poetry and the art of words as the superordinate generic concept, we must remember that poetry is not derived from prose but rather from music. The actual sequence is opposed to the one commonly assumed. We may represent it to ourselves about as it was earlier analyzed systematically: metrical outlines were there from the start; then sounds and words were written in. And observation of children as well as experience with primitive cultures indicates that the musical filling preceded the linguistic. The question, where best to introduce poetry into the system of the arts as the art of rhythmical speech, cannot be answered from the standpoint of a history of their development. For the poetry created by primitive mass-unity is very different from the poetry fashioned by the solitary poet for the solitary reader.

This seems the proper time, on the whole, to consider the affinities and differences of the arts irrespective of origin. We recall the attempts, passed down to us from the ancient world, to order the arts according to the media, the objects, and the modes of representation. A later Aristotelian distinguished two triads of arts. The productive arts (architecture, painting, and plastic art) present finished works; the practical arts (music, poetry, and dancing) involve movement and time. The figural arts do not need performers to present the works again and again, whereas music, the dance, and poetry intended for an audience can not be *performed* without them. Both the figural and the poetic arts are subject to the general formal law of uniformity, called symmetry in the former, rhythm in the latter. Architecture and music are termed subjective, having no model in nature. Plastic art and dancing are termed objective or imitative. Between the two pairs stand painting and poetry as subjective-objective.

Of these very fine and complex distinctions, only the contrasts between the arts of rest and movement and between subjective and imitative arts have remained really important. But the first distinction indicates only the sensory field to which the arts are

applied, or the condition under which their products are perceived. By the term *temporal arts* we very generally refer to the operative medium of the arts, connect them with one of the Kantian forms of intuition, and indicate for which senses they are intended. But, naturally, definition does not concern individual aspects and almost wholly ignores the spiritual forces which function in creative activity. Adherents of the empathy theory can object that the genuinely aesthetic attitude temporalizes everything spatial. Conversely, we can point to the fact that in the temporal art of music we necessarily speak of high and low tones, broad and narrow ranges, up and down, together and apart. As for the distinction between subjectivity and objectivity, it has been modified in two ways. Associational aestheticians distinguish between arts with indefinite and arts with definite associations. To the former group belong architecture, ornamental art, and music; the latter group includes plastic art, painting, mimetic art, and poetry. The distinction makes sense. For architectural and musical forms permit a great many associations while relatively few, for example, can cling to the plastic model of a lion's head or the painted hand of a woman. But at bottom this distinction is only the old division into imitative and non-imitative arts, and merely asserts in psychological disguise that architecture, ornamental art, and music have no definite models in the real world. The other attempt at innovation lays the chief stress on the opposition between the unrestricted, freely creative arts and the applied arts (architecture, handicraft, and decorative art).

Richard Wagner's theory arose from a mixture of the two principal thoughts we have encountered. Accordingly, he finds three kinds of purely humanistic art (mimetic art, music, poetry) and three kinds bound to nature (architecture, plastic art, painting). Movement in time is the most important element, as it expresses the inner man. Since the figural arts produce such movement only by appealing to the imagination, they offer us mere illusion in place of throbbing life. "Only when the urge of the sculptor has passed over into the soul of the mimetic artist, the singer, and the speaker, can this urge be really satisfied." But in another context Wagner distinguishes only two great kinds of art: the feminine, whose susceptibility is wholly exhausted in purely artistic experiences (painting and music), and the masculine, which is so strengthened by absorbing the realities of life that it becomes procreative and can enter formatively into life itself (poetry).

A new idea has won recognition in the Hegelian school.

Max Schasler orders the arts according to their ratio of spiritual content and sensuous appearance. He believes there is a definite gradation in the division of emphasis between content and material —a graduated scale which "starts with architecture (the art working with the weightiest and spatially most extensive material, but with the most meager ideas) and leads up to poetry (the art richest in ideas, although working with the lightest material, articulated sound)." If we take this point of view seriously, then we must be continually grouping together in confusion works which come from arts generally regarded as different. Plastic art is supposed to stand above architecture. Granted. Since, however, many pieces of sculpture are undoubtedly poorer in ideas than the masterpieces of architecture and since the ratio cannot be statistically ascertained, the principle breaks down as soon as it is confronted with the facts. So, although this point of view may be useful for a scale of values within each of the customary arts, it is not useful as a classificatory basis for a system of the arts. But this and other such schemes do suggest the distinction between freedom and constraint. Most arts, we should say, are committed to forms and contents of the real world; architecture and music fashion new forms for themselves. But a contradiction arises at once. Drawing and painting, sculpture and skilled handicrafts are familiar with combinations of forms which do not exist in reality, and these arts can even divert from their natural function the forms and colors drawn from experience. Do they belong therefore among the arts subject to constraint? Is not poetry, so far as it creates meter, rhyme, and euphony, to be counted equally among the arts of unreal forms? The ground grows more and more slippery. Beginning with free architecture, let us then show how in painting and plastic art constituent elements of content enter from outer and also from inner reality, how in poetry the deepening process continues, until finally in music only the life of the soul speaks to us. Let us draw a line, placing architecture (frozen music) at its beginning and music at its end, then fold up the line into a circle. This symbolism enables us to understand two views, which confront each other in hostile opposition, the interpretation of music as an art of pure forms and of architecture as a representation of the precious inner life.

The situation is very complex and unstable. There seems to be no system that meets all demands. We have not found a single incontestable classification, either among the genetically historical or among the others. And we shall indeed face a tough

problem when the mixed forms are to be considered. It is easy to say that we should ignore them. But whoever condemns melodrama should refuse to tolerate the prudential marriage of percussion and string strokes in music. Indeed, he must advocate the abolition of theatrical art as a whole, since dramatic lines only suggest what a host of other arts elaborate. In the last analysis every one of our arts is so blended with other arts in some of its subspecies that classification is difficult. The difficulty is enhanced by the propensity of aestheticians to discover highly intellectual analogies between different fields, and by refined analysis, to reduce apparent similarity to dissimilarity. (Ludwig Eckhardt, *Vorschule der Ästhetik*, 1865, II, 223; Grillparzer, *Gesammelte Werke*, 4th ed., XII, 204; M. Lazarus, *Das Leben der Seele*, 3rd ed., III, 2, pp. 69–246: "Die Vermischung und Zusammenwirkung der Künste"; T. A. Meyer, *Das Stilgesetz der Poesie*, 1901, pp. 120 ff.) In practice our age is also very ready to supplement the means of expression in one art with aids drawn from another. Our practice fits the picture of modernity sketched a hundred and sixty years ago: "A century which turns words on a lathe, which tries (in large and small ways) to sense thoughts and to grasp sensations with the hands, which builds copper engravings, writes woodcuts, and fences to music, is called a philosophical century. Which does this account aim to expose to public scorn—our age or philosophy?" (J. G. Hamann, *Kreuzzüge des Philologen*, 1762, p. 69.)

But only in our own day do we find a revival of serious, thoroughgoing concern to combine several arts for a total effect. Richard Wagner's music as a whole rests on the assumption that poetry, as the road to metaphor, rises from the subsoil of music to scenic visibility, that music is a principal medium of expression, and the drama of purpose. In the motionless and silent work of architecture, plastic and painted products usually are spiritually attached to the meaning of the structure merely as impressive and varied elaborations. But there have also been successful attempts to create buildings merely from pictorial points of view. For most combinations the principle holds that the art with the less definite associations should be given the place of chief importance—hence architecture should have this place among the static arts, music among the dynamic. On the other hand, the previously prevalent view that only the lower kinds of art can survive in combination is scarcely to be taken seriously when we think of the song and the music drama.

We have to consider just two possibilities for the coopera-

tion of arts. Either particular methods and goals pass over to another art from the art to which they belong originally and exclusively, it would seem, or the arts as wholes work together, one of them tending to dominate. But how many arts are there, and what are the peculiarities in terms of which we can define them? When we surveyed the various attempts at classification, we encountered handicraft, decoration, and ornamentation. Should these as separate arts be placed beside the others? I have already said no, and I am postponing a more detailed discussion to a more suitable time. For now that this decision has separated the arts from countless aesthetic skills, and artists from skillful makers of raiment and their ilk, we shall be content with the established arts. So we still have mimetic art, music, poetry, architecture, plastic art, and painting. If we ignore all secondary considerations and order these arts according to the chief traditional points of view, the following schema results:

	Spatial arts (arts of rest and of juxtaposition)	Temporal arts (arts of movement and of succession)
Arts of imitation, of definite associations, of real forms	Sculpture (plastic arts) Painting	Mimic arts Poetry
Free arts of indefinite associations and unreal forms	Architecture	Music
	Figurative arts (Effective means —spatial image)	Poetic arts (Effective means— audible behaviour)

Chart II. Dessoir's System of the Arts

On the last line I name the classificatory principle which we shall prefer on the whole after recognizing that neither a genetically historical method nor a conceptual combination can yield an ulti-

mately valid classification. The system of the arts briefly sketched and defended by J. J. de Urries y Azara in *Zeitschrift für Ästhetik* (xv, 456 ff.) is worked out in greater detail but is harder to take in at a glance (overleaf).

Facial expressions, bodily bearing and movements, tones, words, abstract spatial forms, and figures are languages of art. Its individuality is determined chiefly by these means of expression. In what follows the consequences of all this will be set forth.

Chart III. Urries y Azara's System of the Arts

	Figurative Arts			Poetic Arts				
	Two-dimensional	Three-dimensional		Of Performance			Of Words	
		With Interior Space	With Solid Bodies	Optical	Optical-acoustical	Acoustical		
Objective (Imitative)	PAINTING		PLASTIC ART (SCULPTURE)	Pantomime — MIMIC ARTS	Dram-atic	Drama — MUSIC	Dram-atic / Epic — POETRY	Concrete in Expression
					Musical	Musical		
Subjective (Free)	Graphic Arts / (Surface Decoration)	ARCHITECTURE	(Plastic Decoration) Monumental Arts / Minor Arts (Small or Useful)	Dance		Vocal Music / Absolute Music — MUSIC	Lyric — POETRY	Abstract in Expression
	Spatial Arts		[Visual Arts]	Spatio-temporal Arts		Temporal Arts		

VII. MUSICAL AND MIMIC ART

1. The Resources of Music

I begin with three propositions of earlier philosophers: (1) the general is prior to the particular; (2) language springs from drama; (3) at the moment of its origin music is an act.

Adapted to our purposes, the first thesis means that works of art issue from a general movement of artistic energy and only gradually spread out into details. The second one adds that imagined scenes strive for expression and find it in words. The third reminds us of the connection between music and activities which are in part artistic and in part social. But music and mimic art have not been mutually dependent only at primitive levels; their alliance has lasted to the present day. Music and dance, the pleasures of sound and of movement with others—how could we tear them apart? The forms of classical dramatic music and of the eighteenth-century song show quite clearly the traces of dance rhythm. And, apart from historical facts, most musical people belong to the so-called motor type. The musical conductor is the visible appearance of this native connection. Thus their essential unity allows us to place the two modes of art together. This unity becomes more definite in the view, supported by Rutz and Sievers, that every work of art produced by man in the realm of sound, whether music or speech, is governed by certain acoustic constants which depend on typical differences of tension in the muscular system of the torso. If in fact the proper reproduction of a piece of music is possible only as the reproductive artist adopts a certain attitude toward the tension-type of the author, musical and mimic science certainly belong close together. Then, further on, mimic art passes over into drama and literary art in general. In all these

considerations we should remember that the elements never constitute the source or even the whole of reality. And what we learn to recognize now within the general outlines of music should be regarded as the various media through which music operates, not as a collection of the constituent parts of which music consists without residue.

The first operative medium of music is *rhythm*. But it is not indispensable. Palestrina's music consists mainly of chords. Many Schönberg pieces (e.g. *Opus 19*) are based wholly on harmony without rhythm or melody. But rhythm is still so essential that we must mention it first of all, naturally without repeating what has already been said. In musicology the theory of rhythm tends to form a principal part and to be defined more precisely as the compilation and explanation of all other rules concerning the temporal characteristics of a composition. We do better, although the definition is drastically restrictive, to define rhythm as the relations of duration and accent among the tonal values within a musical unit. This unit and hence those relations are not fixed by the bars. Bach has created a vast wealth of rhythmic forms quite independent of measures. Neither Bach nor any of the other classical composers can be appraised as long as we take these vertical lines of separation to be important. In the familiar theme of the *Kreutzer Sonata* the units and the temporal relations within them are indicated by the lines under the staff:

Or in Beethoven's *Symphony in C Major* the meaning demands the articulation:

So each bar does not indicate the end of one segment and the beginning of another. As a rule it indicates only that the first note beyond has the strongest accent, and that temporal intervals between pairs of adjacent bars have the same length. Hence my

earlier warning against taking the measure too seriously. Metro-
nomic rendition of music is more like an arithmetic problem than
like a truly rhythmical performance. (Perhaps the Flemish masters
of the fifteenth century possessed an "arithmetic style" suitable for
exact division and composition of parts. On these "abstract mod-
elers," cf. Guido Adler, *Der Stil in der Musik,* 1911, pp. 16 ff.)
Mediocre orchestral conductors work like machines, reliably but
without life or freedom. At best they immediately gloss every
change of time by the opposite change, and are anxiously intent
upon reverting from every counter rhythm to the principal rhythm.
But the masters see little value in retaining the same time intervals
and stressing the strong accents unless the logic of the music
happens to demand it. Occasionally the most recent composers
even dispense with bars and yet remain within music—for example,
Alexander Gretschaninov in *Prélude, Opus 61.*

 This is said, to be sure, in the spirit of the present. But
earlier musicologists also saw the deviation from simple, strict ob-
servance of time to rhythmic dissonances as an advance. In the last
movement of his piano concerto, in *Faschingsschwank,* and else-
where, Robert Schumann, who has written so convincingly against
the tyranny of time, has created forms whose apprehension involves
a very pronounced feeling of rhythm. I mean those passages where
the syncopations last so long that the resumption of regular time
has almost the effect of a disturbance. For example, the following:

The expressive power of such off-beat rhythms is felt in a great many ways and by no means merely by persons of excessively refined sensibility. The value of syncopation and hemiolia is already clearly recognized in folk music; for example, that of Negroes and American composers influenced by them. The composite metrical times have also sprung from a developed rhythmical feeling and they begin with a natural necessity. There is a Spanish national dance in five-four time. If anyone feels, when hearing these measures, that one half should be speeded up or the other half slowed down to equalize the time intervals, he does not catch the charm of the asymmetry, which rests on the very fact that two and three meet and persistently alternate, each retaining its individuality. In the case of these asymmetric and off-beat constructions, the accumulation and combination of impressions, through which the memory creates higher and higher unities, occurs with absolute certainty. Every significant scheme of temporal and accentual relations, whether or not they accord with the metrical time, provides the fixed frame for melodic construction. The masters in the manipulation of rhythm, viewed in this way, are close to the creators of melody, since rhythmic change always entails change of melody, but naturally not the mere translation of a three-four into a four-four time, and so on. Also, from the musical performer's point of view, rhythm is seen to be fundamental. But here perhaps extra-musical circumstances are involved. For example, the conductor must remember that he should indicate rhythmic (and other) changes to the orchestra in advance, even beating time when the tempo is slow, and that his own inner emotions are transferred to the auditor through suggestion.

To rhythm we should add *pitch* as a second medium of expression. I do not believe that we extract the middle position in the range of the human voice as a point of reference any more than we call the tempo of a piece fast or slow by reference to our pulse rate. The differences between soprano and bass are too great for the concept of a neutral position to be derived from the total range of the human voice. Moreover, tones such as a^2 and b^2 from a violin or flute do not seem high, but from a soprano they seem rather high, and from a violoncello very high. There is impressive evidence to show that the singer must tighten the higher parts of his vocal organs to form a high tone. The only fact which everyone experiences is the increase of tension with high tones and the decrease with low. Especially in the case of ascending sequences

this may contribute to the qualitative significance of high pitch. But in the main the peculiar quality of the tones determines their division into the two groups. And this quality depends partly on the producing instrument and partly on the influence of the environment. Light, thin, mobile tones seem high; heavy, broad, sluggish tones seem low. Within a range of two octaves, let us say, the same tones can assume either set of characteristics, depending on the well-known general nature of the tonal source and on the relations of the tones to preceding and simultaneous tones.

The most important graduation of pitch is the musical scale. Its regularity is not exact, since the intervals do not remain the same throughout. Nor is the regularity uniform over the whole aesthetic field, since intervals less than a half-tone have a certain aesthetic value although banned in music. But the scale belongs only to art. It demands that the differences within it be sharply and firmly fixed. The continuous alteration of pitch (the singer's *portamento* and the slide on the string) is obviously an exception. The most remarkable feature of the scale is the octave, a unison which lets two tones remain distinct. To this are added the fifth, the third, and the other tones in the familiar orders. Even primitive peoples use minor scales, which are therefore just as natural as major scales, and have become rather difficult and rare only in the development of our musical instruments—as Wallaschek was able to prove against Helmholtz. So probably the two scales first acquired their emotional values in historical times. Even today the folk music of various nations transcends this rigid distinction. While with the Scandinavians the minor keys and the empty fifths predominate, the Slavic phrase is peculiar in the occasional absence of the third, the use of augmented intervals, and the irregular position of the half-tone in the scale. The Spanish *malagueños* and *boleros* often end in the dominant—or really in a key we have lost. Many Spaniards, of course, brand these dances as Moorish. The augmented second and augmented fourth are characteristic of Hungarian music. Liszt's *Third Rhapsody* contains the whole Hungarian (more properly, Indian) minor scale. This may be called an harmonic minor scale with augmented fourth. So there are many keys whose peculiar emotional significance results from their customary association with ideas of a national character. (Cf. Mattheson, *Neu eröffnete Orchester:* "C Major (Ionian) has a rather rude and impudent quality, but will be not unsuited to jubilations and other occasions of unbridled joy. Nevertheless, a clever com-

poser, especially if he chooses the accompanying instruments wisely, can transform it into something charming and appropriate even in tender situations. F Major (transposed Ionian) can express the most beautiful sentiments about the world, whether magnanimity, constancy, love, or whatever else stands high in the list of virtues.") But if, extending the earlier aesthetics of music, we were to assign certain regions of feeling to the usual keys, we should be reading far too much into them. That is clearly shown as soon as a singer, performing without accompaniment, transposes his melody through an interval which does not require change of register. Whoever lacks absolute pitch will usually not perceive any change in the character of the singing. But of course he will in instrumental music. This is because the nature of the instruments enables us to recognize every transposition by a change of tone quality. If a musical piece written in D major is lowered a half-tone, the clearer, open strings are taken almost entirely out of use.

On the whole *tone color,* the next medium of musical expression for our consideration, is more widely effective than one would believe. But in general aesthetics we are less concerned about this than about the concept of tone color itself. Much acute thought has been expended on the trivial question as to why the term color, which designates the essential quality of visual impressions, is not used for pitch, the essential quality of tones, but merely for one of their secondary properties. Some theorists defend this linguistic usage with the observation that drawings are possible without distinctions of color and so likewise are melodies without distinctions of tone color (but never without change of pitch). Not because of its indispensability, they say, should tone color be compared with visual color, for variation of pitch is expressive and constructive in contrast with the more incidental variation of colors in a picture. Finally, it is said that the absence of timbre (as in

the overtoneless tones of the flute) and the absence of color in a drawing are supposed to make the same light and delicate impression. Turning directly to critical remarks—vigorous black-and-white drawings and tenuous pastel paintings disprove at once the cleverly contrived contrast between the strength of the colored and the weakness of the uncolored. But in the main the problem springs from the fundamentally false view that a picture is essentially complete in its outlines and can then either be colored or not. Being two different kinds of figurative art, drawing and painting should never be compared with two features in the medium of a third art. For the painter, however, color is the very principle of expression and form. So the attempt at an explanation is thwarted. Moreover, explanations of this sort seem less important than the more general insight that all such analogies are used for music, but not for the other arts. We call the timbre of a tone its color, but never the color of a picture its timbre. We compare melody with drawing and harmony with coloring, but hardly the reverse. We apply the spatial distinction between high and low to scales, and so on, without any corresponding transfers from music to space and figure. All of which leads us to the conclusion that throughout the history of music its indefiniteness and detachment have invited the introduction of auxiliary metaphors from other fields. This fact is crucial, whereas for the general science of art it is important which metaphorical expressions have seemed most appropriate at a given time.

The artistic use of tone colors is due chiefly to their universal intelligibility. (Let me insert a note on the problem as to the characteristic qualities of musical keys. Richard Hennig not only asserts the existence of an objective set of qualities characteristic of the various keys, but also reports in Z.f.A. (xii, 35–68) that he himself, though utterly devoid of absolute pitch, on the strength of a single chord correctly names the key of a piece of music quite unfamiliar to him, because he confidently recognizes the quality of the tone as that of a certain key.) The singer brightens his voice in gay numbers, darkens it in serious songs. The composer uses instruments with many and especially with high overtones to express lively, radiant, excited states of mind. For the contrary effects he uses harsh, nasal, flat, dull, hard tone colors. Although the expression of inner states is by far the most serious problem, we should also note the imitation of other musical instruments and of natural sounds with the aid of timbre. As for the former kind of imitation, the violinist can produce thin, overtoneless tones, which

277

are commonly indicated in the player's directions as flutelike (*quasi flautato*); at the start of the eleventh Liszt piano rhapsody we find "as if by cymbals" (*quasi cimbalo*). With respect to the reproduction of confused noises and natural sounds we speak of tone painting, but of course mean also all the effects contributed by the other musical media. Although I intend soon to treat this subject in its proper context, let me provisionally stress the fact that we are always dealing with a translation into the foreign language of scales, hence with a kind of description which can lead to recognition of the object. (Herein we can already glimpse an influence of naïve tone painting toward less form, for this use of music turns too sharply from fixed musical forms to reality. Riemann has further criticized tone painting for "leaving mere sound as a temporal process whose function ends when the sound is replaced by new forms."—*Bericht des Kongresses für Ästhetik und allgemeine Kunstwissenschaft.* Contemporary composers prefer to portray the inner effect of an outward event rather than the event itself. For example, in his piano composition, "On Hearing the First Cuckoo in Spring," Frederik Delius does not reproduce the call of the bird, but renders the mood of the listener. That leads directly to program music, which we have to consider later on.) The clattering of the mill, the tramping of horses, the hammering in a forge, storm and wind, the surging of waves, the crowing of a cock—all this is not taken over intact from the real world, but merely imitated approximately in translation. Very often the rhythm is the element transferred, and rhythm can help even when something inaudible is to be represented musically. For the composer may transpose into motion what belongs to another sense department or to the mind, thereby introducing rhythm. In Brahms' *German Requiem* the words "for all flesh is as grass" are sensuously symbolized and the reaping activity of death is tonally portrayed by the metrical imitation of the movement. The Grim Reaper reaches out in the third quarter of the three-quarter time and mows in the first two quarters. The tempo indicated is "slow, marchlike." But music can also clearly represent certain modes of motion through means other than rhythm (such as approaching or receding motion through increase or decrease of volume, since the listener immediately associates the soft with the distant and the loud with the near). Moreover, the spatial symbolism of the scale is so familiar to us that we interpret every tonal rise as an actual ascent, every fall from high to low tones as a spatial descent. It seems almost as though the length of the interval had some relation (very obscure, of course) to our sensa-

tions of balance—indeed, as though it were permissible to portray heaviness and lightness in music. A similar involuntary transfer leads us to interpret a long, sustained note as something stationary. In Liszt's *Christus* the high A flat represents the fixed evening star. Later, when the same subject recurs, the notes $c\sharp^2$ and $f\sharp^3$ are trilled with the obvious purpose of making the star seem to twinkle. And this effect is certainly produced. Incidentally, this is one of the few cases where the trill as such is artistically justified. All too often it is merely a means to virtuosity, and then this rapid inter-weaving of two adjacent tones affects us like a pyrotechnic display.

Now I must invite the reader to enter the maze of harmony problems. But I should not lead him in beyond the point where he can easily find his way about, even though he is still far from musical theory. As the reader knows, a single sound is composed of definite tones, which are usually not distinguished in consciousness, although they can be under certain conditions. A theory of consonance and dissonance has been based on these overtones and beats. The strength of the theory is its support by unquestionable facts, the weakness its failure really to explain what is to be explained. But on the assumption that overtones, differential tones, and beats have the predominant influence, feelings of harmony would be reducible to the original feelings produced by tones. A second theory, on the other hand, is not constructed out of physical relations and simple feelings, but makes the sensory and affective oppositions spring immediately from the assumption of more or less blending. Whenever two or more sounds are produced simultaneously, they combine to form a unity in which they can still be recognized more or less easily. If they wholly fuse, as in the octave, we have perfect consonance; if they strongly resist fusion, they are called dissonant. It seems quite conceivable, then, that the unity of the total experience is pleasant, the disunity unpleasant. A third theory tries to ground the feeling in intellectual processes. The view that, in hearing, the mind unconsciously counts the vibrations, getting pleasure from the simple numerical relations and displeasure from the complex, is one of the best examples of earlier aesthetic rationalism. At present this view appears in the claim that the regular vibratory sequences, which stand in simple ratios, and those composite sounds, whose beats combine to form a simple rhythm, have an inner rhythmic affinity in virtue of which they are experienced as harmonious and satisfying. Finally, let me mention the theory which makes the relation of individual sounds to a unitary whole decisive. If the relation is fixed and, when not

given perceptually, at least always added in thought, the impression of consonance appears.

It will repay us to pause here a moment. From this point of view consonance appears no longer as something immediately accompanying the content of tone sensations but as a chief precondition of the so-called rational faculty. Harmony does not depend on consonance but rather the converse; a consonance is found when tones belong to the same harmony, to the same major or minor chord. The essential nature of musical experience reveals two advantages in this idea. First, it does justice to the fact that there is a feeling of latent harmony. However a melody is rendered —homophonically, polyphonically, or with accompaniment—it has a harmony of sequence. This harmony, or tonality, means that the constituent elements of the melody are all related to one basic tone or chord underlying the whole. Whenever such a melody is taken as a unit, a principal tone or chord is retained in memory. Therefore Rameau has called melody temporally deployed harmony, and primitive peoples who have melodies also use harmonized accompaniments. Hence the doctrine that tones are consonant whenever they belong to the same basic chord reduces consonance to this "feeling of latent harmony," which is inseparable from music. A second advantage lies in the justification of dissonance thus provided. Dissonances are by no means mere meaningless tonal aggregations. They are musical forms which in part serve the incidental purposes of the ugly and in part have an intrinsic value. Each function can easily be described, if we interpret the dissonant tone as not belonging to the harmony but as contradicting it in an intelligible way. In dissonant combinations there is a conflict between the several tones which unite in the harmony and the final tone, thought of as foreign. Otherwise dissonances would be scarcely tolerable, still less necessary. Even when we are concerned not with typical chords, but with the cooperation of several contrapuntally directed parts, the very awareness of the manifold movements of the parts decreases the unpleasantness of the auditory impression. Our conscious attitude toward every significant dissonance is a denial of affinity. Just as truth is connected with the unification of subject and predicate in judgment, pure beauty is connected with the unification of sounds. And as the predicate of a negative judgment is seen to be foreign to the content of the subject, so on hearing a major seventh we refuse to take the second tone as fitting the harmony of the first. Neither affirmation nor consonance means the disappearance of the one in the other; neither negation nor disso-

nance means the destruction of the one by the other. In all four cases the constituent parts are preserved. And in still another respect dissonance is like the corresponding logical form; only those dissonances have value whose predicates (if I may put it so) must indeed be rejected, although not imputed without any reason. If I add the tone *c* to *dfa*, the whole has a value like that of the pregnant negative judgment that "happiness does not insure morality." But if I add *b*, the whole is so senseless that I should be ashamed to write out a counterpart from the field of worthless negations.

The principle, closely allied to our view, that a piece of music should maintain the unity of its keynote, has all the authority of an artistic norm in spite of its restriction to tempered tuning and in spite of many deviations from it. (This principle has been likened to the law that demons and ghosts must leave where they entered.) For the urge to return to the initial harmony causes a movement of attention by which the work of art is comprehended and the particular passage is related to a direction established for the ear. When this rule is not observed, other means are needed to maintain the relation to the keynote. The liquefaction can never go so far that every form vanishes. Whenever actually distinct tone values are confused (when G-sharp is changed to A-flat, for example), the piece of music modulates into a new key, evoking surprise. But this bringing of very distant things together presupposes the most acute musical sense. The use of chord tones from different scales demands a heightened capacity of the listener to preserve the unity of the whole in consciousness. On the other hand, tones close to one another can be brought still closer through chromatics, the melody sinking, as it were, into infinitesimals. But if the pitch were to vary continuously in a perfectly gradual transition, if the chromatic movement, like a line, were to blend all of its tone points together, confusion would result. In every musical age the discrete scale has been indispensable, just as rhythmic activity has also. Only, we should realize that in the progress of music, harmony and rhythm have proved to be very elastic.

2. The Forms of Music

Like harmony and rhythm, the forms of music can also be expanded. Of the many reasons for such changes, we need consider only a few for the purposes of our discussion. Growing instrumental

technique contributes some. This is true of the violin, although it has changed but little in the course of time. The lightness of our bow makes possible the thrown staccato, so unusually suited for transitions from one chief note to another and for the expression of whimsical moods; our sensitive strings make possible the use of flutelike harmonic overtones at will; and so on. In the case of the piano this growth of technique has exerted an even more pro- nounced influence. I shall mention only the invention of the pedal. When it is used, removing the pressure of the dampers, overtones are added, and the tone at once acquires timbre. Hence the use of the pedal brings out the melody most happily, achieves a smoother combination of tones, at times frees all ten fingers for the accom- paniment, permits imitative effects like the collisions of swinging bells or the confused howling of a storm, and gives the piano a polyphony which suggests the orchestra. In the orchestra itself we can recognize most clearly the influence of material appliances on the extension of musical forms. Today the separate effects of tone colors are exploited in a way very different from earlier practice. Contemporary composers work with an unusual range of compo- nent orchestral sounds in mind from the start, and can therefore use repetitions and oppositions in a new way. Without all the aids provided by the modern orchestra, their imagination would be quite futile. They would join the company of those unfortunate souls who sense the chimerical and demand the impossible.

There is another factor. As music has broken away more and more from the forms of the lyric and the dance, musical forms have been increasingly melted down. Whereas in our classical music, modelled on poetry, four-line stanzas with four measures in each line predominate, now sonata and aria forms have crumbled to make way for freer forms, especially those with recurrent themes. Whoever wishes to speak of formless form is free to do so. In any case a form is present, even though it does not correspond to the sharply defined traditional one. Indeed, the rhetoric of today is also criticized for its pragmatic formlessness, although it has merely changed its form, but by no means lost it. The older rhetoric re- quired the speaker to create definite parts and definite transitions between them. Our kind is better suited to a freely unfolding de- livery, provided coherence is preserved. In this sense Combarieu also declares of articulation by means of pronounced rhythm: "I re- gard the rhythm whose parts (measure, motif, theme, stanza, etc.) are brought out in sharp relief as the work of a still undeveloped

artistic consciousness which, being too weak to grasp things in their coherent totality, reduces them to smaller relations, breaks them up into pieces to understand them better, repeats certain parts to remember them more easily—in short, fashions artificial relations for its language." (*Théorie du rhythme*, 1879, p. 3.) To be sure, I would place a higher value on repetition. It is important not only on account of its aesthetic utility, but chiefly because the return of the same theme—in precisely its first form, of course—gives the performer the interesting task of introducing a just perceptible difference through nuances of volume, tempo, and timbre. Moreover, musical repetition is highly expressive. It can suggest how a reflective spirit returns ever again to the same thought, or how proud joy insatiably relishes the object of its pride, or how a deeply disturbed soul incessantly reverts to an obsessive idea. The verbal repetition we seem to be seeking in poetry is more acceptable in combination with music, since it is precisely the musical form which directly mirrors the course of our inner life. But music does more than employ comparison and recollection; it removes the insipidity and poignancy of sheer repetition. For sensitive persons are suffocated by immersion in their own past, and they get pleasure from recollection only with the aid of such artistic forms.

Simple repetition is allied with modulation in the familiar forms of imitation, inversion, and the inexhaustible, indescribable variation. The theory of art is interested in the apportionment of retained and deviant features, perhaps in the fact that rhythm and intervals persist while pitch and harmonic sense are changed. For in music we can observe exactly what remains and what does not, whereas in the other arts we cannot follow the secret of similarity so precisely in detail. Moreover, part and counterpart are revealed much more clearly in the usual opposition of two different melodic characters than in drama. Dramatic and musical polyphony spring with the same necessity from a creative imagination for which one course of movement is not enough. Both temporal arts can bring oppositions into play successively since, of course, what precedes persists in memory. But only music has the twofold advantage of (1) heightening contrast and conflict by bringing the opposed elements together simultaneously and (2) artistically interweaving in modulated passages the constituent elements of its themes in the motliest mixtures. Along with the accompanied or harmonized melody, a musical style has successfully utilized these two advantages still further, insuring to each of several parts its own intrin-

sically interesting existence. This style makes the greatest demands on the receptivity of the listener. Whoever can hear more than a blurred confusion in a fugue can also appreciate the uniqueness of an art able to elaborate so artificial forms. Indeed, the solution of contrapuntal problems all too easily becomes a scientific exercise. The composer, bound to the rules of his science (which restrict and yet aid him, as the rules of chess restrict and yet aid the player of that royal game), is hardly concerned any longer with the demands of the ear. He directs the parts to satisfy the eye and the mind of the reader. Perhaps this is why the canon and the fugue so often seem artificial to us. Fugued movements of recent music (the rondo of the *Symphonie fantastique* or the conclusion of the second act of *Die Meistersinger,* for example), are expressly justified by their contexts. In other places composers may prefer a form which appears in Bach's cantatas, such as *Actus Tragicus*—the simultaneous occurrence of two melodies, mutually independent but not exclusive. The fugue technique is deliberately avoided at the end of *Die Götterdämmerung,* in the introduction to *Die Meistersinger,* and in Liszt's operatic fantasies dealing with Norma and Robert the Devil.

Again and again in our survey we encounter melody. This peculiar musical form is so important because it satisfies all the requirements of aesthetic value, and perfectly unites harmony and rhythm. A keen and trained intellect may learn the refinements of counterpoint, but never contrive a flowing melody to warm the heart and captivate the whole person. There is something wonderful about the immediacy and irresistibility of an original melody. It is not a musical thought, as we are often erroneously told. Aside from its nonconceptual nature, there is the obvious difference that the content of a thought can be expressed in other words when necessary, whereas in music the one certain form is quite indispensable. Rather, a true melody is an incomparable, inexplicable creation. If we observe someone of mediocre musical endowment as he begins to revive and fix a melody he has heard, we notice that at first he has only the melodic curve (so to speak), the rising and falling undulation without the values of the notes. After the second hearing he can hum the melody to himself. But when he attempts to sing it out loud or play it on the piano, he gropes back and forth until he finds the right notes and substitutes them for the wrong ones he has tried. So it seems as though melody were based on an indefinite tonal movement.

When a melody is analyzed into its still viable components,

these smaller parts become fruitful seeds. We call them motifs, meaning by the term not abstractions or mere single measures, but actually present structures in which all of the musical media cooperate. They have in fact developed into an autonomy. The old-fashioned melody can be replaced by the use of motifs in the sense of recurrent themes, almost as the broad application of color is replaced by stippling. The whole composition is transformed from the architectonic to the organic as soon as it develops out of the little cells according to the laws of life. The recurrence of the motifs gives unity; their transformation yields variety; their interweaving serves to express the most intimate events and hidden relations in the stream of consciousness. Hence Wagner's musical dramas may be taken either as dramas enlarged by music or as symphonies whose programs are visually expressed during the performance. In many passages of his writings Wagner has stated that he himself wanted the poetic factor to be the starting point in understanding him, but the more spontaneous expressions in his letters indicate a more important role for the musical factor. And in fact, the mere wording of the music drama without reference to the singing or acting is frequently open to criticism. ("Just think! When I was recently working out the gay pastoral song connected with Isolde's voyage, a bit of melody suddenly struck me, which is far more jubilant still, almost heroically jubilant, and yet withal quite true to the spirit of the people. I was on the point of discarding everything once more, when it finally dawned on me that this melody belonged not to Tristan's shepherd but to the flesh and blood Siegfried. Immediately I looked again at the closing verses of Siegfried with Brünnhilde and recognized that my melody goes with the words

> She is for me eternally,
> Is for me forever,
> Bequeathed to me and my very own,
> One and all . . .

That will seem incredibly bold and exultant. . . . For the Walther songs you do not have the melody, which here of course is the indispensable thing. I wrote the verses to fit the melody in my head—something quite unthinkable to you, I'm sure."—*Richard Wagner an Mathilde Wesendonck*, 4th ed., 1904, pp. 161, 301. In the case of Franz Schreker the musical factor is certainly the starting point. From it a theatrical form seems to emerge, and from this in

turn the literary factor as the linguistic meaning of a dramatically aroused piece of music.)

A word of caution. This often unconscious interplay of the two arts in creative activity has nothing, absolutely nothing in common with the old-fashioned practice of setting words to a given melody, as the seventeenth century did to piano and violin sonatas and even the nineteenth century to Beethoven adagios.

The reverse procedure, the fitting of a singable melody to given words, for a long time determined some of the principal features of the song. Without any deeper consideration of its meaning, every stanza was set to three-membral music, the poet's words being shortened, lengthened, or repeated at the convenience of the composer. No wonder that forty years ago an Englishman called the words of vocal music "support for the tone" and dared to assert of the singers: "Not one of them is trying to express the thoughts contained in the words of the song. The words are used automatically." That is a vicious calumny on the modern song and the kind of execution it requires. (W. R. Gowers, *Lectures on the Diagnosis of Diseases of the Brain*, 1885, pp. 122, 127. It is inconceivable and deplorable that an expert like Wallaschek concurred in this view; cf. *Psychologie und Pathologie der Vorstellung*, 1905, p. 30. For many years I have observed very intimately the preparation for vocal performances, from the first step to the final delivery, and I can testify that this view is a gross misinterpretation. Usually—always in the case of modern songs and music dramas—the accomplished singer begins his study by reciting the words. Shortly before the performance he impresses constantly upon himself the meaning and mood of the poem. During the rendition he remains just as conscious of the meaning of the words—no more nor less—as a reciter or actor. Clarity of enunciation is supremely important for him.)

We should not always think of a song as the strophic song in the old sense, as an originally contrived and invariantly recurrent melody, which scarcely needs accompaniment and fits the words, at least in the first stanza. Today we do not want a fixed and final melody for the sake of which the hearer neglects the words. Rather should the music, by giving the piano equal rank with the voice, sound forth the innermost feelings of the poet, the subtlest secrets of the word. The artistic song, as it has gradually developed, either gives the melody to the instruments, introducing a freely recitative voice, or it uses the art of thematic formation and modulation,

abandoning articulation in terms of verse and stanza, but being most scrupulously faithful to the interconnections in the meaning of the words. This meaning controls the music in the sense that the music never does it violence. Nevertheless, the music is not the completion of the lyric as a subspecies of poetry, for the lyric is complete in itself. But surely both arts gain from the union. The musical imagination gets rich stimulation and definite support; poetry at least profits in the fact that songs with good music spread fast and live long. So, especially in the strophic folksong, the melody sometimes wanders from its original words to others.

It has just been said that poetry can stimulate musical creation and point it in definite directions. This is true not only of singing, where the two arts proceed hand in hand, but also of successive cooperation. In social life we have music precede speech or also follow it. We like to begin important occasions with music. In religious services the speaker is always grateful for preceding music to create the proper mood; then out of the solemn tones comes the definiteness of the address. But also after the spoken word, tones retain their magic power to supplement and enhance what was said. Here we are approaching program music. (Another relation between word and tone lies in the captions and directions for performance. Instructions as to volume mostly concern the group of forces in the composition and the intensity of feelings. The indication of tempo concerns emotional and volitional attitudes in the successive phases of the music. The directives applying only to expression indicate the chief emotion or the dominant mood.) From the title or text before us we have learned what motivated the composition, and now we follow this suggestion as we penetrate into the structure of the work. Naturally the structure is formed entirely in accordance with musical laws, just as the composition of a picture is determined by relations of space, form, and color. Yet here, as there, the object contributes to the fashioning. Indeed, no musical principle is so absolute and inflexible that nothing could influence it. Whoever purposes to extrude everything foreign from music must condemn the sonatas and symphonies which have sprung from a series of dances, must reject the masses and cantatas which are based on mere formulas—in short, must reject the whole wealth of the most wonderful music of the last century. A lived experience (perhaps the departure of a dear brother), the look of a picture (say Kaulbach's *Battle of the Huns* or Steinle's depiction of St. Francis walking over the waves), a poetic impression (drama

and verse), even a unified thought (John 4:14 or Nietzsche's *Zara-thustra*) and the inner meaning of a mood (*Luminous Night*) can become for the composer a stirring message he feels obliged to impart. For he extracts the leading ideas from the endless ambiguity of experiences, in order to work them out in the realm of music. But only when there is something symbolic in the poetry and the musical program, can musical symbolism in the proper sense arise, this symbolism being directed to the representation of something abstract in sensory form and at the same time being full of feeling. (Cf. Hugo Goldschmidt, "Tonsymbolik," Z.f.A., xv, 1–42.)

Now let us return to an example of imitative music, the very common portrayal of a storm. The impartial listener can interpret it correctly, but he can also take it as the angry outburst of a person or as the tumult of war. (The Couperin, Schumann, and Grieg piano pieces, all entitled "Butterfly," show how little of reality passes over into music. Cf. Paul Mies, "Über die Tonmalerei," Z.f.A., vii, 397–450, 578–618.) Just because music intends everything symbolically more than realistically, feels inwardly more than outwardly, stirs indefinitely more than it imparts definitely, metaphysical aesthetics has concluded that music penetrates to the heart of the world. For nature and spirit are indeed one in the Unconditioned. Whenever music re-presents this unity of natural and mental events, it reveals to us the intrinsicality of things. If we stick to the facts and their description, we can hardly say more than that natural and mental occurrences have general tendencies in common. In the musical representation of these tendencies a certain indefiniteness necessarily enters. But no one will take a musical passage like the one about a storm mentioned above as a dance of maidens, an exultation of the soul, or a peaceful country scene. So musical tones do indeed clearly define an area without determining what can happen within the area. This very fact justifies the composer in stating explicitly the circumstance which was his stimulus. The case is like the one investigated in experimental psychology where, under the guidance of a concept, relatively few ideas are associated with impressions, because the preparatory word considerably restricts the region of possible ideas. If a second word is added, the range of choice becomes still smaller. Thus the music program corresponds to the second supplementation or specification. But it can never force the listener to again feel under all circumstances precisely what the artist has previously felt.

One more point. If we assume that recollections of a storm actually emerge into consciousness, somewhat as a poetic descrip-

tion can at times evoke a clear picture of a storm, it is evident that here feelings are aroused in the listener not only by the music itself but also by the concrete image. That is, music actually reaches out beyond its narrowest scope and relies on emotional effects connected with ideas of things. If on listening to the previously mentioned passage from Liszt's *Christus,* I not only hear a long sustained high note, but also have before me the image of the dark nocturnal sky and radiant star, this image can affect me almost as much as the real sky or a picture. So the expressive value of music is enhanced by the ideas of things aroused by the music program. Here, as in the figurative arts, empirical content helps to construct the work and to influence those who enjoy it.

3. The Meaning of Music

The consideration of mixed forms permits still broader vistas. I said earlier that in everything real and in everything artistic there are features we may call musical or at least natural occasions for composition. Yet they are not the whole of the musical work. Rather does the creative artist open up new aspects, never before developed, as he continues in his own way and with the resources of his art. If one compares Dürer's *Apocalypse* (1498) with the biblical text, he discovers that the artist has, so to speak, written a new book; the woodcuts are so full of his own intuitions, even his own thoughts. In the two measures from Liszt's *Battle of the Huns* reproduced above, the rhythm unquestionably marks the Huns as horsemen, whereas Kaulbach's painting represents them as foot soldiers. So the painter has been corrected or at least the content of his picture subjected to further thought. Verses are often born of the spirit of music, this origin by no means signifying an exact agreement with all the laws or requirements of music. The situation is as follows. Some rhythmic sound, expressing a mood, stirs for hours or weeks in the soul of the poet. With a musician, whose imagination works both in rhythm and in pitch, a melody would arise from this and be recorded in musical notes. With the poet the inner movement issues in words, thus winning a thoroughly individual character, self-authenticating in every respect. Of course, we can still detect the common root, rhythm as expressing the feeling of affinity. But even here the arts are separated by a valley which

prevents any imperceptible advance from one peak to the other. No mixed form removes the boundaries between two arts, as each has and retains its own nature.

What is the special meaning of music? Naturally it is not disclosed to anyone who cannot distinguish tones of different pitch, not even to anyone unable to grasp the unity of correctly heard tones or to distinguish different patterns of tonal sequence. In a word, the meaning of music is revealed only to the musical. In the higher sense of the word we call a person musical for whom compositions speak a perfectly familiar language, a second mother tongue as it were. But anyone is called musical in the common sense, if he gets pleasure from rhythmical and harmonious tones as he does from beautiful forms and bright colors. The obvious melody and the simple rigid rhythm that provokes movements are enjoyed with a feeling of bodily comfort, much like a tepid bath. Music which meets these conditions is scarcely to be called pure art. In essence it is still a finer and organized form of noise. A long silence suggests something dead, unnatural. Whoever likes to play with words may call quiet disquieting and disquiet quieting. For in unrest there is life, and this feeling of being engulfed by life has a beneficent, calming effect. The elements of the noise need not be precisely distinguished. Any raging and whirring whole, any incessant roar, makes us certain of being alive and surrounded by life. This pleasure in noise as a sign of life is the ultimate source of our pleasure in music. We have all come to know such pleasure from occasions when we yielded to the soft seductions of light music while wandering enjoyably in a park amidst giggling girls or carrying on casual conversation at a festive board. In such cases music is actually only a pleasant noise. We hear it, but we do not listen to it. We enjoy rhythms and sound effects much as in other situations we enjoy the bustle of the world—except that all is already stylized, composed according to definite laws, and hence even to scarcely conscious reception more agreeable than sound and rhythm in nature. The effect of this music, hardly noticed and surely not *understood*, becomes exceedingly important for man's whole feeling of life. We feel ourselves released and revived by the tones, removed into happy unconcern by the humming and swaying dance melody, roused to youthful rigor by the primitive power of the martial music. As a social art of noise music is a regular succession of air vibrations which pleases us. It permeates our environment at every point, exciting at the same instant and with the same inevitability

all persons present in the same space. Oskar Bie has called this decorative music.

The meaning of music is broadened when we become actively engaged in it. Then its entire mechanical aspect must be a chief consideration. Here an important point of view is the practice of music as a technique of movement. It is a time-consuming drill of digital or laryngeal muscles—a drill now painful, now pleasant. This training of the bodily equipment is certainly as indispensable for the amateur as for the professional, and we should not make a lot of it. Rather we should spare the artist (like the scholar) the offensive praise of diligence—work always speaks for itself. But this labor becomes dangerous in pretending to present something from life when nothing is present. If passionate, insatiable listening to music diverts us from more serious tasks, the practice of music seduces us still further into neglect of more pressing duties, into spiritual emptiness and sloth. The incessant struggle with the insubordinate hand and voice finally takes the whole man captive. No sport, no quest of amusement, no vocation narrows the field of vision so dangerously.

Yet the apparent plenipotence of musical technique still does not adequately explain the attraction we feel for active engagement in music. Behind musical technique there is yet another reason why we so readily sacrifice other interests to musical performances. On these occasions we can live life to the full with greatest freedom and spontaneity. Every flight of fancy we introduce into the composition arouses in us something of the sensuous heroism of earlier man. All our muscles are tense, we raise our heads boldly, and shivers run down our spine, as though we confronted a great crisis, certain of meeting it successfully. A boy was playing his own little composition, which ended right after a fortissimo dissonance. "He postponed the resolution; he withheld it from himself and his listeners. What would it be, this resolution, this delightful release into B major? A joy beyond compare, a satisfaction of infinite sweetness. Peace! Blessedness! Heavenly bliss! . . . Not yet . . . not yet! A moment more of postponement, of delay, of tension, which had to be unbearable to make the gratification the more precious. . . . Still one last, very last taste of this pressing, driving desire, this yearning of the whole being, this utmost, convulsive tension of the will, which yet deferred the fulfillment and resolution, because it knew that the joy is but for an instant." (Thomas Mann, *Buddenbrooks*, 1901, ii, 168 f.; cf. 522 ff.)

In very truth we become kings, lords of the world, when

we vary tonal volumes and play off rhythms and harmonies against one another. We create beings by mere accents and annul them by equivalent slurs. We live through the most wonderful adventures, charging forward, shrinking back in terror, freeing enchanted princesses—who could list all this activity? There is also the consciousness of having gazed into the ultimate depths of the composer's soul. And further, a fusion with the soul of the present accompanist; the exquisite encounter in nuances of execution which cannot be prescribed in advance, when there are the obvious accelerations and retardations, the sharing of the brief breathing rests, and the mutual confirmation at every instant. Whoever has played in an orchestra knows that there he feels as he does in a company of soldiers on a battlefield. Above stands the conductor. His facial expressions and bodily movements clarify the composition as the actor interprets his dramatic lines. Before, beside, and behind the player are his fellow fighters, animated by a single will. Off to one side are the independent allies. Yonder is the foe, now victorious, now beaten, now superior and defiant, now fainthearted and despondent. The bows of the violinists are poised for the down-stroke—is it not as though uhlan lances were flashing in the sun? Is not the primitive social meaning of all art revived?

Even really fine music has such effects when played by competent performers to sensitive listeners. Occasionally, at least, we do not attend properly to the work of art, but allow ourselves to be instinctively aroused by the movement and the tonal beauty, or indulge in purely personal thoughts. In the marching rhythms of military music the motor activity in common forces our feet into the same beat. At times this motor activity becomes even vigorous when we overhear the conversation of the spirits (as it were) among the four parts in a quartet. (On the basis of a statistical investigation, Richard Baerwald asserts that there are "very gifted and sensitive persons who reproduce music purely by movement"—Z.f.A., IX, 339. Cf. Vernon Lee on individual susceptibility to music, Z.f.A., II, 543.) If you listen to a graceful Bach suite, say the one for flutes in B-minor, the rhythmic and tonal pleasures are interwoven with accidental associations, such as visual images of a rococo minuet. To be sure, social and artistic music are fundamentally different in nature and in effect. The former is a pleasant pastime; the latter is something deadly serious. The former is a boon for the very poor and ignorant; the latter is useless for those struggling with the cares of life. The former is emotionally the simplest and most popular of all arts; the latter is the most inscrutable and abstract. And yet,

when we observe composers, performers, and appreciative listeners, we see that social and artistic music remain akin to each other at all stages of their activity. Especially do people for whom art passes immediately into reality and develops into dramatic action make the musical rhythms of *Parsifal*, on principle, just as lively as those of a popular song. Whoever takes this attitude has no need at all to recognize what is going on in the purely musical sense, but lets the mere sounds prod or soothe him. Shakespeare's frequent tributes to music are familiar and so is Nietzsche's report of his reactions to Bizet's *Carmen*. Perhaps Stendhal was saying much the same thing. "Last evening I learned that perfect music affects the heart like the presence of a beloved being, that music apparently imparts the most intense joy possible on earth. Were this true of all men, then nothing in the world would incline them more to love. But last year in Naples I observed that perfect music, like perfect pantomime, leaves me reflecting as to what forms the fleeting object of my reveries, and that it brings me to grand thoughts. In Naples the question concerned the means for arming the Greeks." (*L'Amour*, ch. xvi.) We grant that for anyone enjoying music in this way the music itself must finally vanish. Rigorous and austere art leaves us no freedom to consider political questions. For such friends of music it remains at that first stage—stylized noise. Still, it is not enjoyed merely as postprandial fun or a little treat, but as a sedative or stimulant.

A very familiar fact already indicates where to look for the other significance of music. I refer to the fabulous precocity of musical genius. Children of eight have done the most astonishing things in understanding, performing, and even composing music. A race as utterly uncivilized as the Gypsies achieves remarkable results in music. In the other arts there is scarcely anything comparable, for the understanding of men and the world which the poet and painter need can be won only gradually even by the most gifted. But the meaning of music is quite independent of reality. Because of their apparently supernatural source, sounds early became the medium of a serious symbolism. In fact, sounds are events of a special sort with their own intrinsic value. They are not, like colors and shapes, properties attached to things. Having their own norms, they do not rely on models in nature or the mind. They reveal themselves with all their rules to the predisposed spirit and often reject the advances of the most refined aesthetic taste. In many cases good music is only a system of sounding forms. I do not know what objectively justifiable ideas of reality and what emo-

tional stimulations the listener should get from Bach fugues. Such masterpieces show imagination and inner life, to be sure, but they express no definite mood. Who will venture to infer from them the state of mind in which the composer worked? Their effectiveness depends on the articulation of their divisions and the guidance of their parts by contrapuntal rules. Pleasant social noises, like physiological stimulations, are absorbed, but the art of spirituality and solitude is something to understand, and should be understood. We should know whether key and scale, rhythm and time are retained or changed; we should fix the theme in mind and recognize the variation as such; we should note the distribution of parts, follow the movement, greet the goal. In short, we should be attentive to everything. Then we enjoy tonal combinations in their purity, the return of the melody, the emergence of earlier themes, development, connection, transition, the entrance of different instruments, and a thousand other fascinating things which are hard to comprehend when sitting there comfortably or preoccupied by thoughts of a wholly different nature. Not only the composition but also the listener must meet certain conditions to do full justice to the art.

We have considered the sensuous power and formal independence of music. But it has still a third characteristic, which we recognize in a familiar example. In Beethoven's *Pastoral Symphony* the dance of the rustics is suddenly interrupted and the basses very

softly intone a note in another key. This abrupt change, painful to the ear, destroys the form and cannot be justified by any of the interpretations familiar to us. Yet the passage is one of the most wonderful in the whole symphony. In defense of its exalted beauty we may appeal to the theory that music is expression, the listener understanding and enjoying the process empathically, discovering the inner life as expressed in the sounds, and thus taking them as symbols of a deeper meaning. Certainly the superior composer is first of all a master of rhythm and sound, then an expert in forms, but third, he is someone who finds tones to release his moods. And since we have an innate ability to express emotions in sounds, we can refeel what appears in many (though not all) pieces of music as inner disturbance, even as a general spiritual tendency. But the real problem is still unsolved. It lies in the question whether and how far psychic foundations and activities are conditioned by the peculiar nature of music, how sensuous charm and audible form also acquire metaphorical meaning. Not every excitement aroused by sounds should be taken as subject matter for the theory of art. But we are concerned with emotion which can be shown to have its basis in the object, or concerned with the puzzling fact that in the connection of rhythms and harmonies something internal can achieve an external existence. Since the whole course of the exposition so far has directly and indirectly provided a variety of material for the clarification of the problem, we will now focus our attention only on the central issue.

In musicology a hermeneutic system has been worked out. First appearing in musical periodicals and biographies of musicians, it has grown more and more autonomous, more and more authentic, both artistically and scientifically. It was developed from the seventeenth-century thesis that a piece of music is not a complex of forms, but signifies a combining, strengthening, and balancing of fluctuating emotions. In this connection Hermann Kretzschmar said that the emotions, "the characteristic qualities of sensations, images, and concepts, are embodied in motifs and themes, in tonal patterns generally." So we have the task of reading these "emotions out of the tones and of giving in words a skeleton outline of their development," of animating the skeleton with forms and events from inner experience, from the worlds of poetry, dream, and presentiment. Up to a certain point every piece of music is intelligible to all men. (Therefore, according to Kretzschmar, absolute music is an absurdity, like metrical and rhyming poetry without thought.) And what is understood can be described in words. "Even in the case of instru-

mental compositions without descriptive titles the hermeneutic art will often go beyond the mere determination of the emotions and be in a position to demonstrate (or at least conjecture) the objects of these emotions. Biography and history offer the means for this." (*Jahrbuch der Musikbibliothek Peters,* 1902, pp. 54 ff. Kretzschmar cites Mattheson (1739), who directed composers how to portray anger, courage, and other emotions, and Quantz (1752), who distinguished between principal and secondary emotions. It is not enough, Quantz held, for the performer to attend to the principal emotion. In using even the smallest time element, like a short grace note, he must himself be clear as to the underlying emotion.)

Later we shall consider whether it is really possible to discover the objects or events which ultimately explain the composer's feelings. Now our concern is to adopt some attitude toward the theory of emotions as such. We do best to start with the fact that everyone instinctively describes a piece of music in terms of what he takes to be its meaning by using expressions of popular psychology, calling one theme defiant and another insinuating, for example. But is that more than a preliminary and purely figurative comparison? Obviously, it is chosen because the music stirs the corresponding feelings in the listener, although he cannot assign any objective basis for them. We can say the same thing of the composer, whose directions for performance spring chiefly from the need for an intelligible interpretation. It remains questionable whether the musical work of art actually portrays emotions and whether the appropriateness of the emotions to their respective forms is demonstrable. It is relevant to the first point to note that tonal relations of time, volume, and pitch do indeed permit a stylized representation of the corresponding relations in the realm of emotions, although these inner relations concern the conative rather than the affective aspects, tension and release rather than pleasure and pain. When Schopenhauer made music the expression of the Will, he was right in this sense, that the vitality of a self (which is not identical with the essence of the practical man) is reflected in the climbing, sinking, roving, and interweaving of sounds. Perhaps he also felt that persistent tension in the interplay of temporal and dynamic elements which integrates a piece of music as the Will integrates the world. But he viewed everything too metaphysically, forgetting that after all it is a question of what we can hear.

The larger question is whether the emanation of the cona-

tive and affective content into the various musical forms can be thoroughly understood. The answer is yes, if we give greater importance to the unity just mentioned than is done in the theory of the emotions. Advocates and opponents of the theory still stress lapse of time and variation too much. For example, Arnold Schering very effectively describes the agitated body of sound which grows in accordance with constructive laws inherent in the tones themselves. (*Z.f.A.*, IX, 168–75.) A vast variety of dynamic, rhythmic, melodic, and harmonic forces interact, partly in terms of the simple contrasts (high—low, strong—weak, consonant—dissonant, etc.), partly in terms of the formal contrasts (theme—counter-theme, repetition—variation, tonic—dominant, etc.). But this view of music as repeated separations and reconciliations dissolves the structure. Actually the sounds are also together in a tonal space. All harmonious elements, as such, belong together vertically, as we like to say today. But even the parts of a tonal sequence must still be capable of transformation into a space-like structure to be taken in as a pattern. According to Riemann, this enduring coexistence is based on "the recognizable relations of harmonious kinship among the tones, the metrical arrangement of these tones, and the unity of key or, indeed, the cyclic course of the whole." With reference to the duality of aesthetic experience, he holds that we can distinguish between the active cooperation of tonal movements as living expressions of the will and a passive accumulation of structures in tonal space. But we should not make the mistake of supposing that what goes on in the listener or the composer is the decisive element. After Riemann, in his last period, had demoted actual musical sound to a mediating link between two pieces of tonal imagery, Kurth declared that the sound signifies only the organization of the sensory field, in which "primal formative excitement breaks through to achieve formation." This seems to me an error. I must hold fast to the thesis that music is essentially structured audibility. Sound, temporally (horizontally) as well as spatially (vertically) ordered, is not adequately explained by psychic energies, but bears a spiritual content, which is created and appreciated.

The assumption of such a spiritual content seems thoroughly compatible with the tonal and rhythmic precision of a piece of music and its lack of formal ambiguity. But the assumption seems hardly consistent with the fact, established by the history of music, that the same melodies have been used for very different words and in all cases have been judged expressive and

appropriate. In the light of this fact, what is the standing of our assumption (barely mentioned earlier in passing) that from music we can draw conclusions as to things and events? Certainly the symbolic language of music is extremely ambiguous. But it would be foolish to regret this. The peculiar nature of every art is, indeed, directly connected with its limits or limitations, and if music is indefinite because the same composition can express opposed moods, on the other hand poetry is also restricted by the necessity of reducing to words what is essentially ineffable. But yet what compensating advantages at the same time! The fluidity of its medium enables music to break triumphantly through the barriers with which we like to block off the several parts of the soul from one another, and to reveal the unitary essence of the soul in all its manifestations. In the following examples Lotze has indicated the reason for this plasticity of music. "What can we portray musically? Not the justification of an act, but the immutable consequence of the act, which is the formal symbol of justification; not the resolute, incessant striving of the human spirit for a goal, but the alternation of tension and fatigue, and the persistent return to the same, yet ever mounting aspiration; not well-wishing and hope, but the compliant acquiescence in circumstances which, despite their hostility to the original course of development, have now been absorbed by this development and transfigured." (*Kleine Schriften*, 1891, iii, 213.) Put more generally, tonal sequences do not reconstruct the feelings in all emotional dimensions. They are satisfied to indicate emotional states, such as stability and disturbance, swiftness and slowness, variety and vacuity, to mention a few. In this respect music is exceedingly definite. If we compare Beethoven's *Eroica Symphony* and the program Wagner provided for it, we must admit that the melodies are more articulate than the amorphous elucidation. I can say, of course, that a melody heads straight for its goal or loses itself in space, slowly dies away or is suddenly broken off. I can clothe the melody with serious reflections or lightly touch it with the softest similes. In spite of all this I remain infinitely far from its precise nature. Yet this nature is quite peculiar, not the nature of a visual perception or a concept. Robert Schumann wrote about his piano piece *In der Nacht:* "Later, when I had finished the piece, to my joy I found the story of Hero and Leander in it. . . Whenever I play 'The Night,' I cannot forget the picture—first, as he plunges into the sea—she calls—he answers—he swims joyfully through the waves to the land—then the cantilena where they

embrace—then as he must be off again, but cannot tear himself away—until the night once more envelopes everything in darkness. But tell me whether you, too, feel that this picture fits the music." (*Jugendbriefe,* 21 April 1838.)

In his extremely valuable appendix to Bosanquet's *History of Aesthetics* J. D. Rogers says that without knowledge of Schumann's letter he experienced a different imaginative scene in connection with the same piece of music. To him it seemed as though the moon were struggling with the clouds on a stormy night. Now the moon emerged, now it disappeared; at first a silvery veil lay over it, then impenetrable black clouds enveloped it; still the moon occasionally shone forth, but at last its light went out. A verbal comparison of the two descriptions clearly shows they are compatible. The clouds correspond to the waves, the moon to the swimmer. Just this common element lies in the music.

If scientific language had an emotional counterpart for the term *general concept,* we might say that that is what music expresses. The general concept *commodity* calls up a great variety of particular images, for there are countless kinds of commodity. One image is as appropriate or inappropriate as another. But the real meaning of the concept is unfolded only in a judgment, that is, in a logically precise determination of the content of the concept. So I can attach the motliest pictures to a musical work, but its true meaning lies in the musically precise development of an affective form. On further consideration we see two circumstances which make this proposition more intelligible. In our wonderful language, occasionally the mere modification of a vowel radically alters the meaning of a word. Think of the verbs *regard* (*achten*) and *outlaw* (*ächten*). Far more often in music minute variations of the same principal theme create ramifications which point in opposite directions. And of course, it need not be accidental. Rather, the artist's insight can lead him consciously to stress the common stem of opposed tendencies, struggling apart. When the same motif, with scarcely a nuance of change, portrays the glad start and the sad end of a heroic career, we feel that the proud courage of youth and the resignation of old age spring from the same root. But that is really the nature of the human soul. Who will indicate exactly where passionate love ends or hate begins; where high fidelity lives or dull custom rules; where the power is greater, in doing or permitting; where our feelings are masculine or feminine, objective or personal?

In Brahms' *Deutsches Requiem* the text of a choral fugue begins with the words, "The souls of the righteous are in the hand of God, and no affliction overtakes them." The sheltering hand of God is represented in the composition by a low D of the kettle drums and basses, sustained throughout the whole fugue. That God is the beginning and end of all things, that He can be felt at all times and places, that on this basis all being rests, that war and peace, becoming and passing away do not affect Him—this and far more are musically expressed in such a manner. This example should not only show us once more that an occurrence of musical forms can evoke a spiritual state of feeling, but also permit us to win a further insight. Whether or not those thoughts pass through our minds as we listen is, we may say, a personal matter. But an essential matter is the corresponding rhythm of inner psychical movements, perfectly blended with the musical process. Pictures and concepts which are of such a nature that they must remain foreign to what goes on in the world of sound do not constitute the psychological core of music. The crucial fact is rather that on listening to music our inner tendencies—memories, thoughts, feelings, associations—take on a certain subtle quality which is absent when we enjoy works of the other arts. They are softened and drawn irresistibly into the music. In this way they are first connected with the sensory and formal characteristics of the composition, and only in this way do they capture a fragment of the whole which once filled the composer's soul. It is hard to describe in words this recoloring of psychic activity. But it can always be introspectively observed. Music envelopes us like the rushing, mighty wind of the Holy Ghost on the day of Pentecost, enabling us to speak in strange tongues. So the scope of music in its expression of joy and sorrow extends from bodily excitement to that kingdom which is not of this world, from organized noise to the "art of sounding silence."

4. Mimic and Theatrical Art

The theater is a world to itself. (Until recently even historians of the theater did not thoroughly understand this principle. In his *Forschungen zur deutschen Theatergeschichte des Mittel-*

alters und der Renaissance, 1914, Max Herrmann for the first time sharply separated the history of the theater from the history of dramatic literature.) The power of the stage depends on decoration and costume, feminine beauty and masculine talent—and of course, on the value of the play presented. Whoever rates the theatrical arts as merely performative, comparing playwright, director, and actor with composer, conductor, and musical performer, misunderstands the true state of affairs. The theater is far more independent of dramatic literature than the musical performer is independent of the score entrusted to his artistic skill. On the other hand, the dramatic text does not require performance nearly as much as does the musical score. Without undue overstatement a specialist recently said that the art of acting must function with an exogenous component, for the musician plays music, but the actor plays a piece of dramatic literature and not a stage performance. The specialist added that the bridge supposed to connect two quite different fields is "the pure art of acting." (In fact, the theatrical director designs the bridge.) In any case, the art of the theater merits separate consideration, although there is no place in this book for the essentially reproductive activities.

But should we really divorce dramatic literature and the theater from each other in this way? Ernst von Wildenbruch declares: "Only when the playwright, as one observer among others, sees his own characters passing by him 'under their own power,' has he reached the distance from his work necessary for proper perspective. . . . The playwright's real activity begins with the performance." (Preface, *Die Karolinger,* 2nd ed.) The playwright can certainly be helped by rehearsal and performance, as the beginning composer can be by the actual orchestral sound of his work, or the young author by the strange look of the printed word and the unexpected decrease in length. What the author did not previously notice now palpably confronts him: excessive intervals become painful; changes are too abrupt; sentences which looked fine on paper fall fatally flat while others, strangely enough, become important, and so forth. A dramatic author without a stage is like a sculptor who sticks to his clay model because he lacks marble. The playwright's only task appears to be to fashion floor beams for the stage, to write from the heart of histrionic art.

Be that as it may, then he either remains at the level of the composer who writes to please the virtuoso, or recognizes that the stage is more than a mechanical device for performance. But

301

in general the statements so far made should not go unchallenged. There are dramatic authors whose imaginations function so amply and surely that they anticipate the whole outer implementation, as the born composer learns nothing essentially new from the orchestral performance of his work because all the tone colors were present to his mind's ear during composition. Indeed, we know authors who vigorously oppose the pretentious arrogance of the theater and will not concede that a drama is incomplete until presented. They are almost afraid to embody the soul that floats freely in the words. And well may they be afraid for, as every connoisseur knows, the theater and the playwright are inevitably opposed. Again and again young playwrights venture an assault upon this stronghold of tradition, and each time they have to acknowledge that the theater goes its own way, that directors and actors regard the written play as hardly more than a sketch to be shortened and altered at will, a sketch from which they fashion the finished work of art on their own authority. Nowhere else is the attitude so conservative, the memory so retentive as in the theater. The old way tried-and-true is the benign, beloved spirit of the place. Every innovation and every desire of the playwright encounters blunt, stubborn resistance. But this chronic backwardness of the theater must have its deeper reasons. Mere inertia cannot explain why *Faust* is again and again monstrously miscast or why playwrights who are forced into double dramas by the natural scope of the material and the power of their own imaginations get no following. Indeed, mimic and theatrical art demand their own rights, and hence the dramatic author must fear the theater, even though he loves it.

The relation of dramatic literature to the theater is much like the relation of religious faith to the church. Silent, sublimated piety tends to shrink shyly from the forms of a fixed, communal worship of God. It feels every outward expression as a loss to its inwardness. Even the author whose feeling for life comes out in actions, characters, and dialogues need not therefore be a friend of the theater. But a feature essential to the theater and very properly called theatrical, the showy trimmings and the vulgarity of accurate stage portrayal, repels some just as strongly as it attracts others. The contradiction becomes less sharp when we realize that stage performance and the need for the theater are more than merely artistic. The cultural power of the theater is like that of the church. It draws its nourishment not only from the depths of

literature, just as the church can never minister only to that state of the inner person which we call religious emotion. Even for long periods of time the theater has been connected with public worship, and such worship is not confined to personal commitments of religious faith. As we have already spoken of the primitive forms of the theater, now let us recall the medieval mysteries or ministries (church services) which were composed and directed by the clergy, and reserved for folk performances of the Gospel stories. We should remember also Calderon's one-act religious plays (*autos sacramentales*) and the festival plays of our own time to make clear to ourselves how deep this connection has sunk into the hearts of mankind. The truth is that the theater offers itself along with various other forces for the common interests of life, yet remains something independent. But we no longer notice how remarkable it is that we seek a theater to see dramas performed by actors in a scenic frame. Meanwhile we should consider what we really retain from a stage performance. There are voices, convincing gestures, pictures—something very different from what we feel whirling about in us after reading. And the question already discussed, whether a literary description evokes visual images, broadens out when we introduce the theater. Perhaps we have a picture in mind on reading Hero's description of Leander's daring feat. But when an actress pours out these words in the greatest excitement, then we see nothing; we merely feel her excitement. In the same way the reader of *Penthesilea* may get from the third scene of the first act a fleeting picture of the events there described, but the spectator is given the mood of the speakers. However you view it, the stage cannot be subordinated to literary art.

So we face the task of understanding the distinctive features of the various theatrical arts. Since the age of Greek tragedy, the art of the actor, in theory and in practice, has known the dual conflict of idealism and realism, of mimic speech and mimicry in bodily attitude and action. Idealistic actors usually prefer rhetorical values, while realists neglect the beauty of speech and revel in the expressive power of the body. In this latter group I clearly see the leaders of an independent mimic art. For the whole state of mind, and not merely a single fleeting disturbance, is expressed in the body, as though the soul were truly the idea of the body (*idea corporis*). On the other hand, the inner processes wholly detached from the body, processes the spoken word expresses much as does the mute written word, belong to literary art, but are essentially

303

foreign to histrionic art. Of course, there are two qualifications to be made at once. Only the actor gives to the discourse the metrical pattern so important for the spirit of the role; only he controls all the nuances of pitch and volume, all the modulations of timbre. In almost every role there is opportunity to introduce inarticulate sounds with which, just as in the spoken word, the actor can show his own peculiar art of expressing the inner life. None of this is prescribed in the lines; it is left to the free play of the artist. Thus we may very well talk of mimic speech. (In a first-rate article, "*Über Versmelodie*," Z.f.A., vIII, 247–79, 353–402, Julius Tenner considers the play of vocal timbre, relations of pitch (characteristic vowel tones, sentence melody) and the tonal architectonic of periods.) Furthermore, the moving recital of the text is on a high intellectual level, and is only just below dramatic literature in importance. As personalities good readers are excelled only by actors. Nevertheless, it was too bold of Riccoboni in the eighteenth century to define the histrionic style with special emphasis on the necessity of having only the soul of the spectator active and his attention wholly withdrawn from the outer world. For then how does the reading of a play with assigned roles differ from a genuine stage performance? Where is the undeniable contrast between the mimic actor and a man like Tieck or Werder? In the past, bodily dexterity was even more important than the gift of portraying the inner life. The dance and dance-song were an essential part of stage plays until *A Midsummer Night's Dream*. Fights, battles, and duels pervade tragedies; clownish pranks and skillful tricks to effect sudden change of disguise appear in farces. Even today in the passionate art of the Italians and the effeminate art of the Japanese, the eloquence of the body has been developed so far that the performance becomes almost pantomime, apparently no longer using the author's lines.

Acting is essentially a primitive art. Saddled with the accidental limitations of his own body—handicapped by crooked legs, forced to make a virtue of necessity out of a cracked voice—the actor is like a merchant who always carries his whole stock with him. This primitive way of doing things is tolerable in young people, to whom pretense and make-up, crying out and jumping about are generally more appropriate than to their elders. Even the life of the vagrant road company comedian is endurable in youth, while it means misery for the aging man, ready for order and security. Finally, the actor must have a flexibility, not so easily

achieved by a mature as by a young person. To these reasons for the primitivity of histronic art I add a reason of another sort. Parts of reality are incorporated into the actor's performance almost without change. Eating and drinking, piano playing and letter writing, handshaking and kissing—ordinary operations—can occur on the stage about as they do in real life. There has often been debate, of course, as to whether an actress should let herself receive real kisses and an actor real boxes on the ear. But it is agreed that feigned piano playing or the mad haste of someone apparently writing produces a bad effect. Be that as it may, in principle it is always possible to insert elements from real life without thus violating the work of art, as we do by putting pieces of cloth into a picture or the sounds of nature into music. However, this again indicates a low level of art.

Yet it is still art. Like other artists the actor is trying to express a lived experience and, indeed, to communicate it in the most nearly perfect way. As something deep within him drives the murderer to confess, so it drives the born actor to surrender himself to exhaustive expression in speech, attitude, and action. With a shamelessness, easier before a large than a small audience, he transposes into cadence and gesture the lived experience forcibly assigned to him by the author, gives the words mimic power, and allows the linguistically formed soul to permeate the body. We can communicate the useful, the factual, and the conceptual to one another, but not what dwells in the depths of our souls, and hence we do not understand ourselves. Only the actor can use sound and convincing movement to give this inwardness external form. He commits all his bodily resources to bring out something of artistic significance from the realm of ideas into sensory presence. The histrionic self is simply saturated with surface appearances, in contrast to the lyric self, for which almost everything—outlook, sex, vocation, past, future—can remain indefinite.

Our modern histrionic art will not be reduced to mere pantomime; its tasks are too complex and serious for that. Yet the language of gesture is certainly the proper and distinctive language of the actor. It can be confined to a few stock phrases—stealthy plotters and sentimentalists with upward glances afford the most familiar examples, tenor vocalists the most amusing. But it can also develop into variety and independence. We owe to science all the rules of physiognomic spelling, so to speak, within which the actor is supposed to move freely. But two further principles supplement

the established laws of physiognomy and mimicry in their artistic application. First, it is not necessary to combine vigorous bodily movements and even more drastic changes of facial expression. On the one hand, the effect of a forceful movement is enough to make the spectator add the assumed facial change. On the other hand, a facial convulsion, indeed even the contraction of a single eye or mouth muscle, while the body as a whole is quiet, can create the most vivid impression. That holds true for art, not for reality. The second principle states that the mute language of the body helps to disclose hidden dramatic connections at least as much as do the leitmotifs in the orchestral score of a musical drama. As these motifs can recall certain persons or events in memory, even when they are not mentioned, so can the actor indicate what is occupying his mind—by glancing at the place where a character has left the stage, for example. By these devices the actor extends the action, as it were, beyond the bounds of the stage. He joins the visible event with what is happening off stage. He stirs associations and memories at the right time in the minds of the audience, achieving all this through the magic power of a clipped movement or a facial twitch.

Through voice and movement the actor gives to an event a form which it receives in no other art. Some have claimed that this histrionic ability is rooted in the urge to be different. Tieck speaks of our active desire to mimic, "to lose ourselves in another person by straining our own temperament to the utmost in the effort to portray him" (*Works*, 1828, IV, 100). Nietzsche mentions "the desire to indulge in pretense and duplicity with a clear conscience, the inner longing for a role and a mask, for a semblance," and he suspects this motive most of all in families of humble stock who "have had to cut their coats compliantly to fit their cloth, to adjust repeatedly to new circumstances, again and again to change their manner of life." Hence Nietzsche sees also in the history of the Jews "a contrivance of world history, as it were, for the breeding of actors, a real histrionic hotbed." We have already noted that the desire to be something else is an essential precondition of artistic power. And so we understand that the masquerade of the comedy stage, which the pedestrian mind deems unworthy, does not seem contemptible to the common feeling of mankind. But the childish joy in costume and pretense, the delight in the chance to play king at least for two hours, still does not adequately explain the aspiration and achievement of the actor's genius. Moreover, in

the last analysis many actors always give us only themselves. Eleonora Duse transposed every character from its own temperament into the key of instinctive and intuitive femininity. Such actors are necessarily expressing their essential personalities, and hence we involuntarily react to them as persons. We enjoy savory and vigorous natures, beautiful women endowed with resonant voices, comedians who hold our interest not through any plastic power to fashion a comic character, but simply because they are just funny people.

The actor reaches the highest level of performance when his feeling of himself seeks immersion in another being to preserve itself in strength and vitality. For the one urge need not be hostile to the other. A person of rich and individual inner life is the very one who can long to broaden and strengthen himself through empathy. Although this can be said of artists in general, we must also notice how the actor of original talent expresses the feeling of his own and of the other personality. The born actor instinctively expresses every lived experience in cadence and gesture just as the musician does in tone. The difference is that the musician is dealing with an independent medium, tones and their combinations, while the actor's material is his own personality. The histrionic artist is at once the creative subject and the created object. Thus he approaches the dancer, sculptor, and painter. Perhaps we would do him no injustice, either historically or essentially, in regarding him as the highest point of this line.

Now here we strike a new problem. Should the actor wholly forget himself, identifying himself completely with the character portrayed, or should he stand above his role? Is he such a chameleon that under the necessities of time and place he can love and hate, feel himself now a king and now a vassal, or is all this only outward semblance? There is another aspect of the question. How far can the actor prepare his performance in advance, and how far is he governed by the inspiration of the moment? In this last formulation the question is of general significance. The best practising artists have answered it in this way. Meticulous preparation is indispensable, hard work being not so much a virtue as a necessity; but on the other hand, there should be inner participation during the performance to produce the illusion of impromptu spontaneity and to avoid the cooling effect so easily created by what has been carefully arranged. The encyclopedist Diderot, to be sure, held that the actor should not feel, that no

grief or melancholy should linger with him after the performance. "It is you, sir, who carry away these feelings. The actor is tired and you are sad. He has been tormented to distraction without feeling anything; you have felt without any such torment." But Diderot's paradox needs qualification. The actor should feel on the stage, of course, but he should be able to control even the deepest feeling. (August Klingemann relates of one of his actors in Brunswick that his own nervous system passed over into his role. "So even in theatrical murder scenes I did not dare to have a sharp dagger or knife placed as one of his properties, since once in a passionate ecstasy he had succeeded in substituting the deed itself for the semblance."—*Kunst und Natur*, 1828, III, 326. In a novella Hauff has a performance of *Othello* in which Othello actually suffocates Desdemona.) Anyone who is really weeping can speak only incoherently or not at all. Whoever lets himself be carried away by the moment is unable to portray a whole as a whole. Even dilettantes can feel deeply, but to give artistic form to feeling is the work of the master. Briefly to repeat what was said earlier, inner emotion and participation in the life of another are not so much presupposed as produced by good acting. Mme Talma related how, as Andromache, she actually forgot to weep. But, mark you, she added, "What concerned me was the expression that my voice gave to the sorrows of Andromache, not these sorrows themselves." It is a matter of practical indifference whether or not the actor is wholly permeated by the mind he is portraying. Likewise, the reader does not care whether or not the author felt himself transported and transformed when he wrote—if only he, the reader, is deeply moved as he reads. Distinguished artists remain cold in a fire of passion emanating from them, and never lose the consciousness of being on the stage. (Joseph Kainz is said to have been in this sense a detached actor. On the fiftieth performance of Sudermann's *Johannes*, so the story goes, Kainz vented his resentment at the fifty repetitions demanded of him by inserting after the most important lines of his role a sotto voce "for the fiftieth time." So the beginning of the play must have been supplemented as follows:

Johannes: Whose misery is so great that he wails aloud, his grief forgetting silence (for the fiftieth time)?

Manasse: Rabbi, great Rabbi! If thou art the one whose name is spoken on the streets of Jerusalem, then help me, save me, help me.

Johannes: Arise and speak . . . (for the fiftieth time).
Manasse: I am Manasse . . . Help me, Rabbi, help!
Johannes: Am I lord over life and death, that I can restore thy
father, child, and wife to life? Can I rebuild thy house for thee
out of its own ashes? What art thou asking of me (for the
fiftieth time)?

Imagine the devastating effect of this devilish aside on his fellow
actors and you can appreciate the independence and self-control
of Kainz on the stage.)

Our initial thesis was that the art of the actor is more than
merely mechanical performance. In itself the written drama is as
complete as the poem, and in the stage presentation something
relatively independent is added, as the music of the song adds
something new to the lyric. While many values of dramatic litera-
ture, belonging exclusively to elocution, are revealed only in speech,
yet costume, facial expression, gesture, and stage equipment achieve
a distinctly different elaboration of artistic purposes. Hence the
performances of great actors differ so radically from one another
that we cannot speak of the same Hamlet as played by this man
and by that. The actor has almost as much freedom with the
characters of the play as the author has with reality. In this sense
Gottfried Keller writes to Hettner, "I want the actors to be original
and free, presenting my work again in a new life, in a second
nature, as it were, so that I can see and respect in them another
independent force." Ephraim Frisch speaks of the many possible
interpretations of the King in *Hamlet,* "because, although perfectly
definite, a character possesses a universal humanity, which indeed
comprises all the individuals of this kind in their contingent
variety, although the character cannot, conversely, be created out of
them" (*Von der Kunst des Theaters*). Obviously this introduces
uncertainty and caprice when the actor is required to test his
creative powers on the indifferent characters of worthless plays. Yet
there is nothing so strange about this. Indeed, it is also possible for
meager themes drawn from reality to be turned into excellent
literary works. Furthermore, the recognition of such histrionic in-
dependence disposes of the current view that the actor's talent lies
in his ability to copy people. This is rather the skill of comedians.
They regale, surprise, and offend us through the arts of imitation
and pretense. But great actors have originality. How can this be
identical with the ability to imitate? Such an identification would

309

indeed contradict not only itself but also the very principle of art. In that case mimetic art would form an exception to the other arts, none of which is a merely imitative activity. Moreover, histrionic style demands an inflation of the truth, an invention of movements and tones which mere observation never reveals. (By this I do not mean to defend those actors who, whenever they have to put away a chair, first brandish it to the right and left, then raise it aloft, and finally remove it.) By a turn of his body, a tension of his face, or a slight vibration of his voice, the actor can say the unsaid. Everyone must have felt at times that the ideas he got from reading a play encountered something radically different in the actor's performance. No wonder. The same song can be sung ten times, and every time well; the same dramatic figure can be played in ten different ways, and every time with artistic correctness. Modern plays especially, in which (as it were) the essential point is silently suggested more than expressed, require the actor's complete control of his most effective and distinctive artistic techniques.

Histrionic talent and musical ability are peculiar in similar ways. If acting presupposed a deep appreciation of literature and a broad knowledge of human nature, it would indeed be inconceivable for young people of meager education, with nothing in their heads but their roles, to be able to accomplish something so extraordinary. Naturally I do not mean that knowledge of life, general education, and especially literary insight, would be useless to the actor. But experience proves that they are not absolutely necessary. In this fact, perhaps, lies the hidden reason for the (still not wholly eradicated) social attitude of disrespect for the actor's profession. The horizon of the average actor (and of the ordinary musician) is very small. Hence neither group is of much use in social intercourse. And their value is usually discounted for other reasons also. How can it be otherwise? (An unfamiliar example of a scientist's adjustment to the social evaluation of an actor is to be found in the dedication W. G. Becker prefixed to the second volume of his treatise *Neue Untersuchungen über Lebenskraft*, 1803: "To his trusted friend, Mr. Ochsenheimer, fellow member of the Society of Court Actors in the Electorate of Saxony, with sincere esteem.") The realm of histrionic art with its odd little group of people lies like the enclave of a free republic in the middle of a strictly ordered monarchy. Absence of historical background, of a governmentally required and regulated preparatory education, independence of scientific advance—these still persist, even in our leveling age.

To these generally acknowledged facts of the situation I might append an appropriate theoretical remark. Our actors, it seems to me, need not take into consideration how the works of Shakespeare and Goethe were presented in their times. Hamlet must be so played that he appears incarnate before the eyes of our contemporaries. The author's faithful interpreter is the very person to bring out the essence of a figure in a mode suited to the consciousness of the age. Since man has changed but little, this is not very hard—on which theme Bernard Shaw has said many pertinent things in his notes to *Caesar and Cleopatra.* For the public of our day a twofold task is involved in meeting this demand. First, every actor should give very careful consideration to his fellow actors, always intensely aware that his own role is only one element in a whole. Today we know all too well that the individual is dependent on his environment. And since we are accustomed to connect personality with the surrounding world, we want to see this influence clearly brought out on the stage. Although previously permitted, the detachment of the chief role from the supporting parts is simply intolerable for this age of social thinking. The play as a whole should produce in us a certain spiritual mood, one aspect of this mood perhaps more important than another, but each connected with all the others. The connoisseur has now outgrown the star, who plays solo parts, unconcerned about the supporting crowd of his associates, who knows no dramatic but only explosive roles, who dazzles us for a moment but does not hold our interest long. Distinguished acting pleases through a certain self-restraint and detachment. Secondly, we demand that the actor portray the development of a character in its full breadth. The biological point of view has penetrated even into our personal affairs. We regard not only natural occurrences but also events of social and individual life from the standpoint of the theory of evolution. Hence it runs counter to our modern habits of thought when an actor begins with stiff make-up and fixed characterization, instead of striving for a slow and logical unfolding, with all the turns and nuances inserted by the author. In scattered essays Hermann Bahr has shown this brilliantly and forcefully.

Among the media of theatrical art beside mimicry we have still to consider staging and direction. By staging I mean the use of all inanimate media. By direction I mean the guidance of those who are working together to incorporate the written play in bodily form. Staging includes constructing the theater and finds its chief difficulty in working out practical details. But we should also ask

311

ourselves whether or not a naturalness as deceptive as possible is a desirable goal. A stage man has answered, better genuine people in a false setting than vice versa. Certainly; but can a genuine setting ever be produced? Is not the fourth wall of the room always missing, and does not the dramatic action usually move faster than the clock hand? There is a special stage optics, as it were, which does violence to the optics of physics. As the spectator, however, adjusts himself readily and easily to the special situation, really the director need only exclude whatever would disturb the impression. Schinkel thinks that the ancient theater avoided every common illusion, but from the "symbolic meaning" of the place fostered that "true and ideal illusion" which "a thoroughly modern theater with all its wings and soffits" is unable to convey. According to Richard Wagner, a restored German theater of the future would be concerned not with elaborations, but only with "pregnant suggestions." (Quoted by Thomas Mann, *Rede und Antwort*, 1922, pp. 58 f.) Yet the surroundings of the stage must retain enough corporeality for the still incarnate actor to be able to live there, and not be forced to step into a picture. Still that is not enough. The spectator wants also to enjoy the purely picturesque, with restraint that does not divert attention from the dramatic action, of course, and at the same time without any offense to sensitive eyes. For example, a responsible director of a performance should avoid color clashes in the costume of the cast. In life we cannot prevent situations where a lady with a costume of canary green strolls in beside another lady clad in loud blue, but on the stage our eyes should be spared such distress. Modern directors are too scrupulous about the historical authenticity of costumes, using the correct dress even when it looks funny to us. To repeat our old principle, an impression of naturalness must be produced, but this does not consist in mere imitation of reality. What is plausible though incorrect is preferable to what is unlikely though permissible. The important thing is to express in the forms of space and time the essential feeling of the written play. In every drama there is a living mood, an atmosphere, which must fill even the empty spaces of the stage. Add to this the demand which has spread from England and in our country is advocated most brilliantly by Max Reinhardt, the demand to give the performance the character of a social festival (with obvious exceptions). In English productions of Shakespeare there are tournaments, pantomimes, and transitional music in such profusion that—to me personally, at least—the author

threatens to disappear. In a performance of *Twelfth Night; or, What You Will* I saw how, after the boisterous scene between the gentleman, the clown and Maria, Malvolio, in a long nightgown and holding a light, surveyed the room and slowly climbed the stairs. Then a cock crowed and the curtain fell. Later I shall briefly discuss the theoretical justification or impropriety of such interpolation, established in English practice.

There is also the theoretically important question as to how it is possible to have various spatial magnitudes visible on the same stage. At times, indeed, the stage represents a small room, and at times a vast landscape. Now there is only one actor on the stage, and now we are supposed to see before us the turmoil of a great battle. The peculiar devices of the director consist partly in reducing the stage, partly in using certain backgrounds, partly in filling the space with objects or removing them. When a small stage and small cast are to create the illusion of a great square filled with many people, the stage must be partially closed off and the supernumeraries crowded together. This gives the impression of a large space and crowd. As for the representation of time intervals, from antiquity the so-called law of unstable stage pattern has held, according to which the actors must rather quickly exchange places and change their attitudes. This prescription could lose its point when action and dialogue develop vitally from within outward. For the law seems inviolable only because we suppose that it states an indispensable condition for holding the attention of the spectators. But the eye finds a continually changing stage picture rather unpleasant. Such instability makes a quiet, restful effect impossible and usually prevents an artistic modulation from one situation to the next.

In customarily adding stage directions to his text, the playwright seems to be assisting the actors. These directions are not ordinarily counted as genuine parts of the text. But the matter is not quite so simple. It is generally agreed that stage directions correspond to the signs governing musical performance, and it is not at all certain that these signs are really external to the composition. Of course they are not music. Yet they help not merely the performer but also the reader of the score. Now, if the dramatic author takes the reader into consideration, he can enlarge the stage directions in such a way that they no longer remain mere practical hints for the director and actor, but serve as a commentary for the reader of the play. In Hauptmann's naturalistic *Before Dawn* we

find this: "It is farmer Krause who, as always, was the last guest to leave the inn." Naturally, no actor can show the spectators that "as always" he was the last to leave the inn. Hence this parenthetical remark of the author is only apparently a stage direction. In *The Weavers*, "At a table a commercial traveler is devouring a German beefsteak." Of course the producer can seat a voracious actor at a table, but even the most gifted director could not show the more specific nature of the steak. Between the playwright's idea and what theatrical art can achieve there is a gap, which he wants to fill. We find the same need and the same inadequate means in modern music. Over a theme in the score of Richard Strauss's *Domestic Symphony* are the words, "The aunts: the spit and image of the papa." And over the musical inversion of the same theme, "The uncles: the spit and image of the mama." That is naturally not a notation for the trusty trumpeter, but a playful protest against the limitations of the music. Incidentally, what applies to the rules for directing naturalistic drama may be transferred to the stage directions in the plays of Maeterlinck and D'Annunzio. Both seem to regard these devices, which were originally matters of stage technique, almost as belonging to the text of the play. Hence both impart poetic polish to these rules and directions, indulging in theatrically useless landscape descriptions and histrionically inexpressible character expositions of the persons in the drama. It looks almost as though this preference for epic elucidations will eventually change the drama into a mixed form.

If a unitary work of art is to develop out of a piece of dramatic literature, vitalized by the histrionic aspect of human nature and all the possibilities of effective activity peculiar to the stage, someone blessed with a creative imagination of a special kind must be endowed with full authority. He is called the stage director. His activity often begins with the preliminary reading of a play to the actors to give them a correct idea of the work as a whole. (Tieck spoke of "pre-playing the score on the wings of the voice.") But regularly and necessarily he reads in such a way as to produce a master script. To prepare a good script the director must be able, in reading a drama, to so anticipate in imagination the whole concreteness of the stage production that he can at once make notes for sets, movements, postures, and accents. Of course, the masters of direction differ among themselves in the degree of precision with which they predetermine the stage production in

writing, as much as in the degree of freedom with which they use their self-imposed directives later in rehearsal. Yet the conversion of the dramatic text into a hundred instructions of very different sorts rests on an imaginative power which is neither literary nor histrionic, neither pictorial nor musical, not even all these together, but akin to each and vitalized by a sure feeling for the uniqueness of the theater. This vision determines the unitary character of the whole, breathes a second soul into the book drama, and governs the director's work with the cast. To realize his vision the director must also have great pedagogic talent. He can control the company and its rapport only when he can reveal his purposes in the speech of the actors, only when he can enter empathically into the souls of these strange people as the good teacher enters into the souls of his pupils. Otherwise enthusiasm dies. In general, actors do not want instruction but immediate advancement, although they are accustomed to waste time fabulously. It takes a very special kind of teaching ability to fill the crowd of supernumerary actors with group spirit and artistic ambition. Finally, the director (and still more the orchestral conductor) needs an ever growing store of patience to prepare the same works over and over again with new performers. ("In this reckless diffusion and dissipation of his own powers, this sacrifice for others, we can detect something of that rare idealism which fills the vocation of the stage director."— Weichert in Plotke's *Deutsche Bühne*, Frankfort on the Main, 1919, I, 375. In Stanislavski's Moscow Art Theater the director has discussions with the actors for weeks before rehearsals start. In these talks, so initiates report, leading themes are found for every role, every act, every scene. In this way the wonderful shading, the silent interweaving, the striking effect of pauses, and the Russian "inner music in a minor key" are attained.)

If anyone observes the beginning of a series of rehearsals from the standpoint of the theory of art, he will note with surprise that from the start the acting and the sketching of scenes in very rough outline proceed together. The point of departure is the whole. This whole is flat, of course, without heights and depths, but a large part of the work to be done consists in the gradual shading of proportions. First of all, the text must be cut. (For how seldom is a written play already polished!) Then the accents must be correctly distributed to evoke stresses and relaxations of attention to match the course of the action. Finally and above all, the acting must be worked up into good form. Entrance and exit,

315

grouping, continuation of an incidental thread in the plot—all this the director contrives on his own authority, arranging the many details. Now to make the playwright's words come alive in cadence, posture, and movement requires not only the finest appreciation of both text and stage, but also the gift of explaining to the actor by the aptest expressions what is demanded of him. (Here are a few examples jotted down at rehearsals: "He withdraws his hand quickly, unable to endure the handshake." "She stands still as if transfixed, gulps and struggles for words." "Speak faster—he has already thought it out." "There are periods here—she breaks off, utters one more syllable, and thinks: no, I *will* not say any more." "Among the nobility these things are so obvious that they need not be said in loud tones." "They sit down calmly, not in tension." "Here there must be a low, sinister laugh, for she almost enjoys the new baseness of her husband.")

Anyone who has not experienced it for himself can hardly believe to what extent a speech is colored by gestures which prepare for the sense of the following words, by scattered, inarticulate sounds, by accent, and—a hazardous device, to be sure—by repetition. Still less do we realize how far even the good actor's performance is marked out for him in advance. As a rule he is not independently creative, but acts correctly on the gentlest hint. In rehearsal he also shows the ability, despite almost incessant interruptions, to resume his role immediately with the right emotional expression at his command.

The absence of costume and makeup weakens the effect relatively little. As soon as the spectator is reconciled in principle to the contradiction between what he sees and what he pretends, his imagination can even change a young man into an old one without great effort. (Thaddaus Rittner recounts this incident, with comic exaggeration, from the rehearsal of one of his plays: "The gentleman in the frock coat pointed with his yellow gloves to a demure young man in a blue lounging suit and said, 'His mother is a witch.' And he defended his statement. I swear that I thought it was a joke. But then my blood ran cold, for there were many serious ladies and gentlemen standing around, some even elderly. No one laughed. On the contrary, they were horrified, stunned"— *Das Zimmer des Wartens*, pp. 315 f.) Costume and makeup do give local color (for the provincial town, the seventeenth century, etc.), but no disguises are needed for the universally human. Of course the total effect, to which we are accustomed, results only

from the combination of all the elements and the smooth sequence of the parts in proper order. The director is always in danger of losing good visual judgment and freshness through the many individual rehearsals. Until now he has had only fragments in hand: equipment, direction of the actors, costume sketches by themselves on one hand, scenes (at least acts) by themselves on the other. Now the play as a whole appears, and he is shocked at the contradictions and time lapses. His main task is to observe the performance like someone present for the first time. During all this the actor also has to pass through a process of development. He starts with patient groping. He reads the play and steeps himself in the whole spirit of the role assigned to him, as though subject to a power of suggestion. Here the matter can end, whether because the personality fashioned by the playwright requires only an emotional melting down (like Thekla in *Wallenstein*), or because the power of the actor (often the actress) has reached its limit here. Yet a more or less extensive exercise of re-creative thinking ordinarily follows, in which study of sources, technical exercises, and logical emphasis are combined. In the third stage come the rehearsals with their demand that the actor find his place in a whole, and with their dependence on fellow actors, a dependence which can exert an accelerating as well as a retarding influence. On all these matters the reader will find valuable information, with essential agreement, in the books by Rötscher, Hagemann, Gregori, and Kayssler.

Finally, we have still to inquire into the meaning and purpose of theatrical art. Wilhelm Schlegel has discussed the question from the standpoint of the audience in his lectures on the Greek and Roman theater. He mentions the fact that most people, confined as they are to small areas of activity, regard a dramatic performance as a welcome diversion. Being a miniature picture of life, "an extract from the active and ongoing in human existence," it is not only accessible to the highly cultivated, but so closely united with reality that many naïve listeners are carried away into a confusion of illusion and existence, and conversely, the comparison of life with a stage play seems a proper and profound insight. In cultural conditions where the social and political aspirations of the masses cannot unfold freely, the theater easily becomes the center of life. For us Germans the stage has long been a foundation of our cultural development. It has stood beside the church and the school with equal rights as an educational institution. It has in-

fluenced political life and served as an outlet for the passions aroused by economic questions. Since the advent of the press and the establishment of parliaments, the stage has lost much of this dominating position. Only the oldest among us still speak of the theater as respectfully as we do of these two things. What the cultivated classes now get from the stage is in part aesthetic. There are living ideals of beauty which mean more to most people than the ideals stored away in the sepulchral galleries of the museums. But what they get is also in part purely social. The theater has forever lost its former significance, whether as the center of culture, as an institution for moral education, or as a field of activity for forces which would otherwise lie idle. And yet the theater cannot be wholly understood within the realm of art. So it retains an aspect of sheer sociability. We think of the Greek folk festivals with their theatrical performances; we see the dressy crowd in a French or Italian opera house; we recall those precious rehearsals in the amateur dramatics of our youth. Does the theater exist only as a place for a show and social conversation? It faces the alternatives, to become purely external or to become purely internal. If it chooses the first, dramatic literature will sink to the level of a mere device for producing figurative and mimic effects. We shall be given wonderful stage patterns of great stylistic precision, the theater becoming a veritable exhibition stage, on which life can mount to pictorial perfection. The literary element may make its contribution to this, but a modest one. If the second alternative is chosen, the intellectualization of the theater must follow, with renunciation of all material equipment and histrionic virtuosity. Eventually scenes will no longer be needed and can be replaced by the public reading of the drama, the listener's imagination representing the whole external situation for him far more personally and convincingly than if it were to be actualized. Hence many of our most refined persons, repelled by the crudeness and inadequacy of the stage, disdainfully refuse to attend theatrical performances. Contributors to *Der Sturm* take music, because it has no object, as a model for the theater. Rudolf Blümner wants to so disembody the stage as to leave neither text nor actor, only a rhythmic sequence of gestures and sounds. But, obviously, this would mean the death of the theater.

It may sound strange and yet it is true that out of this very dilemma—apparently ruinous—which really forces stage drama to choose between two forms of death, comes the justification of

theatrical art as an independent art. We have already seen that every art is characterized by a conflict between its media and its goal. Theatrical art also must sacrifice something either from its content or from its expression. Precisely in this lies its charm and its uniqueness.

VIII. THE ART OF WORDS

1. The Intuitional Relevance of Language

In various ways music and mimic art have referred us to poetry. The provision of music for lyric and dramatic texts and the stage presentation of the dramatic have turned our attention to the art of the poet. When we compare this art with the other two, we note at once that it does not depend in the same sense on perceptual immediacy, for it does not act directly on either ear or eye. Rather it uses the intellectually significant word as its peculiar medium. So our first task is to clarify the relation between intuition and language as we find this relation in poetry.

Pure perception is seldom found in life. Usually we see and hear only a pair of focal points and a few surrounding details. Our sense perception is fleeting and fragmentary. What we actually perceive we supplement by memory images and elements added from thought. In the field of memory the helplessness of the merely perceived appears even more sharply. At best, sense perception can grasp a small stationary object as a whole and with tolerable accuracy. But recollection always shows only the parts, and moreover with flutter and flicker, with unrest in the details, as though the picture slipped away between light and shade. An author who was also familiar with painting once depicted the sad fate of sensory memory: "On this day Sali felt neither idle nor unhappy, neither poor nor desperate. Rather he was wholly and incessantly occupied, hour after hour, trying to recapture Vrenchen's face and figure in imagination. But in the course of this excited activity his object vanished almost completely—he thought that at last he had it, but yet did not know exactly how she looked. He had a general

picture of her in his memory, to be sure, but when he tried to describe her, he could not. He saw this picture constantly, as though it stood before him, and he felt its charm. Yet he saw it only as we see something which we have viewed just once, which holds us in its power, and which still we do not know. With great pleasure he recalled accurately the facial features the little girl once had, but not really those he had seen yesterday. Had he known that he would never again see Vrenchen, his powers of recollection would already have been forced to assist him, reconstructing the dear face so clearly that not a single detail would be missing. But now these powers slyly and stubbornly refused him their service, because his eyes sought their rightful pleasure." (*Gottfried Kellers Gesammelte Werke: Die Leute von Seldwyla*, 28th ed., I, 105 f.)

Perhaps we should carry our doubt even further than we have here. But we need not probe all the niceties of the question. For our purposes it is enough to see that even perception is not a reliable and complete consciousness of everything perceptible, and still less is memory. If I scrutinize the pen in my right hand long and attentively, then close my eyes and immediately try to call up its image in my mind, I get a vague picture, vanishing again and again, but still unmistakable. Some light penetrates into this dark region of intuitive, wordless memory as soon as I permit language to enter. I say to myself, "At the point on the right there were a few spots; in the middle the line bent out to the left." By this verbal analysis of what I have previously observed I facilitate the appearance of details in imaginary form. But of course, I am still far from an adequate image of the whole.

Something new has now entered into pure intuition. We tend to treat this cooperation of language from the standpoint of logic as a conceptual factor, unless we ignore it in psychological investigation. But the process has value also for us in the present treatise. Indeed, linguistic cooperation seems to imply that language has a similar function, since it possesses drawing as an aid to accurate seeing and remembering. Those with talent in figurative art clarify their consciousness of a thing or event by drawing it. With every stroke their recollection grows clearer. Persons inclined and sensitive to poetry grasp the determinateness of the real by struggling to utter it. Without verbal symbols they can neither observe sharply nor recall faithfully. The intellectual power of language must reveal the sensory world to them. Now the inter-

connection of all reality—an interconnection unmatched in mere thought—enables the sensory aspect of language in turn to open the world of the intellect. From the sounds of language, even from its letters, our appreciation of the innermost depths draws its nourishment. We all know how largely intellectual activity depends upon sense impressions of our environment. An accustomed sound, the look of definite, fixed objects, in short, the connection of the creative mind with familiar and intelligible sensory stimuli, assist the mind in its work. If the poet finds creativity closely connected with the look and sound of words, this means only the intensification of that broader situation. The stimulative power of the verbal sound or figure is essentially the same as the stimulative power of any sensation or image, and is so much stronger only because the association between word and thought is more firmly established and infinitely more restricted.

So we may say that language performs a dual function: its intellectual aspect stirs and enlightens the sensory world, its sensory aspect the intellectual world. But both functions are present only within limits. Where this limit lies can be seen most simply in the case of the first function, and in large part has already been shown in Fiedler's *Schriften über Kunst* and Mauthner's *Kritik der Sprache*.

The eye gets stimulations from without, which it fashions into shapes and colors; the ear appropriates a new world for itself. These two realms, the visible and the audible, differ in content and laws. Reality does not reveal itself outright to either sense, but each selectively constructs its own reality. It is just so with language. Language is not the continuation of either the visible or the audible world. Rather it is a world in itself which can, of course, be combined with the other two, but can never be merely their linear prolongation. We can raise the perception of a color or sound to the highest intensity without naming these sense qualities. Or to qualify the earlier example properly, the indefiniteness of memory images is not really removed by translating them into words, for the words at once destroy the particularity of those images. Sensations can precede (or follow) words, but never become constituent parts of them. Only the incessant and instantaneous cooperation of the two spheres makes them seem alike. I see a uniformly red surface and say, that is red. There is no recognizable similarity between the visual perception and the linguistic expression, between what is actually sensed and the judgment. Yet they are closely akin to each other. How is this kinship to be understood? Why is it

that the world of words, although independent, even artificial, seems to coincide with sensory existence in a certain area? We can broaden the question to the more general problem concerning the relation between nature and mind as such. But here we must proceed more cautiously. And first of all with the simple consideration, long recognized, that in the consciousness of the speaker words and sentences usually refer to particular, intuited objects or events. In making an assertion we are not ordinarily aware that it can also be applied to other things than the particular thing of which we are explicitly thinking. "So at the start of its development in meaning, a word must always correspond only to an individual concept as its phonetic equivalent—a concept which has arisen through the articulation of some synoptic sense perception or image." (Wilhelm Wundt, *Völkerpsycholoqie*, i, 2, p. 456.) As a rule this individual concept and its corresponding name refer to their object only in that respect which—because of the so-called narrow limits of apperception—has been apprehended most clearly. But the possibility of referring to object or quality or state at all in their sensory constitution is explained currently by the fact that the original linguistic sound is supposed to have been a vocal gesture and so, like other gestures, the utterance of an impression made by the object. An unambiguous relation between sound and meaning thus ends. (Wundt, p. 607).

All of which seems to me to yield this result. At the start, and often even in its later development and use, a word has a quite determinate reference to an individual thing; it reproduces a sense impression or image as do mimic movements. What, metaphysically viewed, is the elevation of nature to mind, has its psychological analogue in the conversion of a sensation into a vocal gesture. As soon as this change has occurred, the efficacy of the sensation ceases. In its place something else has appeared, of which we are also conscious. Not every intuition can be so transformed as to admit of a verbal expression which satisfies the speaker and is intelligible to the person addressed. When we use language for communication, we often note how long we must fix our attention on a sensory or imaginative object before we find a word for it—still by no means the best word. So the view is essentially false that every bit of intuitive content in consciousness attracts the corresponding word through association. For there is no factual evidence to support the associative coupling of two constant ideas.

But let us hasten on to matters more important for us here. First and foremost, language serves as a means of communication. If we ask how it has become the expressive medium of an art, the older poetics gives us two answers. One answer points out that language, in which almost everything can be communicated, gives the richest content to the art which uses it. The other answer reminds us that poetry has its own language—a concrete language, rooted in feeling and intuition, living in images and rhythms. We are told that poetic language is fitted to the imagination and the feelings, that outer and inner events are its very stuff and the reproduction of intuitive immediacy is its highest goal, that the conceptual style, on the other hand, is concerned with opinions and judgments, with clarity and sharp distinctions. There rhythm rules, here logic. This theory, I fear, fails to see how much that is neither intuitive nor emotional demands expression in all the greater works of poetry. Moreover, the theory makes too simple and rough a distinction. In many contexts the poet's style remains that of daily intercourse and scientific exposition. And inversely, when we are speaking for the sake of mutual understanding and agreement, we often use figures and forms which the poet employs for artistic purposes. (Consider the hyperbole so beloved especially by women.) Finally, this theory overlooks something absolutely essential, which we have already considered. The aesthetic function of language is not to express definitely a completed event of the inner life but to prove itself a self-activating power in artistic creation. Heinrich von Kleist may have spoken from his own experience when he said, "The idea comes in speaking."

But here we are not concerned with language merely as a means to heighten consciousness and to foster thought and self-insight. According to the prevailing view, language serves only to transfer the poet's images into the mind of another person. Although, in this view, painting is dependent on color, poetry is not in like manner bound to linguistic sounds, to these mere vehicles or media for conveying the forms of fantasy. Eduard von Hartmann asserts that "the poetic effect, as such, depends only on the meaning of the words, not on the beauty of the language or of its recitation. When this effect is strengthened by the other two elements, we are dealing with the addition of an extra-poetic effect to the poetic, hence with the composite effect of a work of art, involving several arts." (*Die Philosophie des Schönen*, pp. 715 f.) In poetry, he holds, the meaning of words is revealed through intuition. Therefore, the

poet must return to the basic meanings of the words and so com-
bine these words that the images lying hidden in each individual
word will be fulfilled and enhanced. Poetry should achieve the
highest measure of intuitive immediacy. Language is only the
technical device for creating the world of imagination in which
the ideal value of the work of art lives. For this aesthetics the
concrete phenomenal form of poetry is not an illusion of sense
perception but the linguistically established illusion of imagination.
Words are indispensable, to be sure, but in that illusion they be-
come a transmuted element.

This theory has been gradually modified. Theodor A. Meyer
has very definitively advocated the view that language is the
medium of poetry. "For not in sensory images, suggested by
language, but in language itself and in what has been created by
language and is proper only to language do we get the value of
poetry." (*Das Stilgesetz der Poesie*, p. 8.) Poetry, he holds, is un-
suited to the production of intuitions. As a rule, discourse does not
arouse any sensory images. So the very words and thoughts of
language are the medium of poetry. This view makes it possible
to explain poetry according to the principles currently beginning
to prove effective in the other arts. We now come to understand
the uniqueness of each art by starting from its distinctive medium,
which determines its formative activity. As we like to speak of
"tonal art" and recently also of "spatial art," we should say "art
of words" instead of "poetry." For as tonal feeling is aroused by
music and spatial feeling by architecture, so is linguistic feeling
aroused by the art of words. The goal of poetry is enjoyment
through words. (Many moderns even think, *enjoyment of words.*)
And the artistry of a poet (many moderns think his whole outlook)
consists in command of language. Meaning and language belong
here as close together as meaning and sound in music. Language
portrays not only something inward but also itself. If the artist is a
person who forms something, the poetic artist forms words and
forms with words. But of course, words are essentially different
from marble or canvas and color. Words are not dead matter; they
are living creatures, filled with spirit. Hence the art of words is
indeed not quite the same as spatial or tonal art. Language is more
akin to the inner life than anything else, and yet it transcends this
inner life, encountering the stream of consciousness as unyielding
objectivity. So language can immortalize what the heart feels in
its humanity and divinity. The poet's linguistic power is shown in

seizing and holding fast what for others escapes words, and through such conquest, in increasing our possession of the linguistically clarified and spiritualized. To lapse into imagery would destroy this value.

We must return to the question already discussed in Chapter III, how the poet's medium, language, is related to the production of intuitions, and whether the feelings aroused by this language need intervening sensory images. Various cases are possible. We could hold that only imaginary feelings (such as a tenuous joy or a tinge of anger) are connected with the words as such, when the words do not evoke sensory images, and that an actual feeling is induced only by visual, kinetic, or auditory images. Accordingly, then, as we believe we can get along with imaginary feelings or demand real feelings, we shall call the merely verbal constructs adequate or inadequate. But whichever way we decide, this formulation of the question with its simple either-or must mislead us into a premature answer. For poetry surely creates feelings of both sorts. The question is only which one we take to be of principal importance. Let us consider a case of anger indicated by a description of a person's appearance, and let us suppose that one sympathetic reader finds an imaginary anger in himself, another reader a real anger. Here the author probably expects (yet does not necessarily achieve) the appearance of the corresponding visual images, even though he aimed to evoke only nebulous feelings. But there is also an indirect description. It chooses something sensory, using the relation of this sensory element to the emotional state to identify this state. So the author has someone describe his beloved in extravagant terms to make the reader aware of his love. Here the important thing is not the imaginative reproduction of the beauty extolled but the reader's vivid awareness (induced by indirection) of the hero's state of mind, which thus becomes the content of his own fairly strong feeling. (Cf. Meyer, *Stilgesetz*, p. 115.)

This last example shows that there are poetic descriptions which are not intended to evoke images and yet achieve their goal—usually the sympathetic reliving of another person's mental state. In the case of immediate description, to be sure, images quite often appear and bring definite feelings in their train. But this does not make poetry the art of fantasy. Rather is it essentially adapted to our activity of linguistic representation. The feature peculiar to poetry is not this imaginative form but its origin in language. This

is proved by the fact that at least the so-called imaginary feelings and perhaps even the most genuine feelings are attached to the words themselves without any intuitional activity. And we can understand this by recognizing that words have value as substitutes for reality, that when combined with artistic correctness they can represent the facts of a situation. Our inner life has developed in so peculiar a way that words entail the same consequences as experience of a reality to which the words correspond. Indeed, for some people the feelings evoked by words are stronger than the feelings derived from life. So, for example, the brute sensuality in us is excited just as readily by descriptions—even merely by single words—as by the sight of certain things and events. Feelings from the lowest to the highest are joined directly to the words. When Heine has a balsamic plant emit a "cadaverous odor," no one gets an olfactory hallucination, but the expression is artistically effective because the word at once arouses all the inner disturbances that would result from the odor itself or its imaginative reproduction. Thus a description of a person or a region need not evoke any visual images at all and yet can be as impressive as a painting. Metaphors and allegories do not absolutely require an actual comparison, but like harmonic sequences or color harmonies can affect a sensitive spirit. Although perhaps at first the effect of the words was conditional upon the presence of a sensory image, for us this has become almost superfluous. Language has been solidified into a world to which all mental effects are attached just as readily as to the world outside.

In support of this assertion let us first take a very simple example. The word *dog* can call up a visual memory image in me, the word *oboe* an auditory image. But it is also possible for images from other senses to appear. For example, *dog* may cause me to hear barking in imagination, *oboe* to see the instrument before me in my mind's eye. There is no evidence for the necessary reference of a particular word to a certain element of consciousness. See for yourself whether the term *dog* evokes something perfectly fixed and constant in consciousness, such that you can clearly apprehend and declare it. The logical definition of the concept does not coincide with the psychological data. What we can actually observe in ourselves is a very wavering and fluctuating activity. Clear and unclear images for dog are two quite different occurrences, which need not prevent the use of the same word, to be sure, although they are not present in it. There are still a great many possibilities

of representation. To break up the continuous work of the mind, to carve out logically determinate and clearly defined units, to give these units such independence that they now seem to undergird every mental occurrence—all this may be indispensable for scientific purposes, but it does not give us a faithful picture of inner reality. For this reason, when we recognize a word various particular images can arise, but still every word has a content, not confused with any other. The reason for this is partly that the possibilities of representation are limited, after all, and partly that we can spread out the conceptual content in propositional form. Hippolyte Taine, the most important recent philosopher of art, once brought out the second point with extraordinary clarity. "It is no longer natural, if we are painters. Utter the word *tree* in the presence of a modernist. He will know that you are not talking about a dog or a ram or a piece of furniture. He will deposit this term in a separate labeled compartment of his head. That is what we today call observing." Doubtless the sensory experience is not usually repeated in imagination, even when—as so often in the most recent poetry— an expressive word, isolated by dashes or interlinear intervals, is set off for the reader with great emphasis. We receive no sensory content, only verbal. And most certainly the strength of the aesthetic experience is entirely independent of a possibly present image, for this is usually so slight and obscure as to be unable to excite any lively effect.

Only the very beginnings of a word's life are like a glimpse of sunlight. Then the word is still fresh and vigorous, not faded or worn out; its whole meaning is grasped by everyone. From this insight poets have returned to the original meanings of words, to rough dialectical forms and natural metaphors. I once found a reference to a statement by Henry David Thoreau, which can still be called a classic expression of this thought: "Anyone is a poet who . . . can restore words by tracing them back to their original meanings (as in the spring the farmer drives back into the ground the pales raised by the winter frost), in whose use of words we at once sense their origin and derivation, who transplants them to the side of his book along with the earth still clinging to their roots." That is finely said, but it involves an impossible demand. For what average reader has such a feeling for roots? Even the poetic value of ancient expressions does not lie in their power to produce intuitions, for they are just the expressions which usually have very little of this power. Rather do we experience through them an

emotional effect that is purely linguistic. To understand this consider the phonetic significance and traditional force of proper names. Some names sound forth the renown of the bearer like a fanfare (Sarasate), others sound comical (Bemperlein), still others are genteel, indifferent, or hardly noticeable. In *Wahrheit und Dichtung* Goethe rightly remarks of Christian names: "And the urge to dignify his child by a euphonious name is laudable, even though euphony is its only claim to propriety. This connection of an imaginary world with the real world even lends a lovely luster to the whole life of the person." Now I ask you: has that anything at all to do with the visual imagination demanded by the earlier poetics? No. Rather is the resultant feeling attached to the sound, to countless associations and relations, which appear only within the world of speech, far from all reality.

With metaphor the situation is as follows. Metaphor of sound is an "explicitly noted similarity between the feeling-tone of the spoken sound and the feeling connected with the idea signified by the sound." (Wundt, *Völkerpsychologie*, ɪ, 1, p. 326.) Words with depressive or bright vowels, chosen to express sorrow or joy respectively, would be cases of this, but also (as Wundt evidently intends to suggest by an example) groups of words whose rhythm characterizes a movement they describe. In the former case we can speak only of indirect, in the latter case of direct intuitional immediacy. But as a matter of fact, there is hardly a convincing case for regarding real metaphor as a stimulant to imagination. The poet's ensoulment of the bodily world and embodiment of the mental world does not spring from any particularly strong faculty of intuition but from the poverty of our language, which can seldom refer to the mental world except in sensory terms, or to the bodily world save in words drawn from cognitive activity. Essentially metaphor is not a mere embellishment but a basic form of poetry, because deeply rooted in the nature of language. (Hyperbole belongs more strictly to the sensory world. For the intensification and enlargement of ideas is something that we experience very often— almost nightly in dreams and daily in free recollection. Hyperbole can be interpreted as exaggeration or even as deception only if we take the normally intelligent person's scientifically purified view of reality as the whole truth. We do not naturally represent things accurately, but indulge our inclination both to overstatement and to understatement.)

Metaphors can give rise to similes, and they in turn can

shrink to metaphors. But of course, many primitive similes, especially those (like measurements) meeting practical needs, have arisen independently. (Cf. Willy Moog, *"Die homerischen Gleichnisse,"* Z.f.A., VII, 104–28, 266–302, 353–71. In the *Iliad* detailed similes are rather more numerous than simple comparisons; in the *Odyssey* and in later poems the reverse is true. Yet even now there are still similes of Homeric elaboration; e.g. Karl Spitteler, *Prometheus und Epimetheus*, 2nd ed., 1906, p. 71.)

The power of single words to evoke images is in general very weak and never unequivocally determined. The fact that newly coined words arouse images more readily should not lead us to infer that when we hark back to original meanings, dialectical words and metaphors, a heightened intuitive immediacy is the purpose and result, for here no two cases are just alike. Now, what is the situation with sentences? Every sentence forms a unit. Its unrolling in temporal sequence does not preclude its complete unification in consciousness. For the whole scope of what it says is grasped, although the sequence of words may temporarily throw this or that idea more clearly into relief. And the whole affects the parts. As we have seen, these parts are not sharply circumscribed terms of fixed signification, but adapt their factual and evaluative meaning to the context. The poet's art is seen, then, in so confining and setting off the words that we grasp just those aspects which are relevant to the effect sought. As in conceptual thought the essential elements in a concept are not forever fixed but determined by the temporary purpose for which the concept was formed, so the effective elements in the words of the poet are conditioned by the artistically created context. The formative aspect of all art makes us feel those poetic descriptions vital which go together to compose a unity. The artistic truth of a description consists not in its agreement with reality and not in the imaginative reconstruction of all the individual terms in their serial order, but in the pre-conceptual unity of a self-articulating and conditioning representational activity.

The nature of the content makes it usually difficult to determine this unity. Probably the most important consideration is that the poet more than the figurative artist has the chance to portray all the inner reasons and outer causes of an event, its mental consequences and physical effects, and indeed with a delicacy and precision which only language can show. The systematic unity thus arising is not like either the logical or the actual. The syllogistic connection of three propositions can be represented by mere let-

ters; indeed, it can even be ascertained by a sort of calculating machine. The poet is committed to the artistic use of language. In life all significant coexistence and sequence is distorted by chance, or trifles and absurdities enter as connecting links. But the artist fashions a clean-cut coherence of what seems to him essential and immediately conveys the intended mood. Thus the reader gains that exalted feeling of power which the real world usually denies him. This feeling is enhanced by the free play which literary art leaves to the appreciative reader. For he is no passive recipient, but someone who is also actively shaping things, someone who can follow the suggestions of words in his own peculiar way. Eduard von Hartmann has already referred to the fact that the listener's imagination subconsciously draws from his own experience to supplement what he hears, painting the landscape in which the action occurs on the assumption that "the more precise nature of the details left indefinite by the author is not essential for the effect of the action" (p. 717). We must go even further and say from our own experiences, though only somewhat similar to the author's description, that we attach very vivid ideas to what we hear or read. My thinking of similar landscapes or houses or persons (often also pictures or stage scenes) naturally makes it hard to get the author's words accurately, but the translation into imagery becomes easier and stronger. An enumeration of examples and a more exact psychological inquiry into the extent of the similarity would carry us off our course. What usually happens is that a few words, whatever the details mentioned, give us occasion for a spontaneous formative activity based on personal recollection.

Accordingly, the definiteness attainable by linguistic description is always inferior to the precision of a pictorial reproduction. For even the fullest descriptions never enable the recipient to reconstruct exactly the idea the author had. In his 1887 preface (entitled *Le Roman*) to *Pierre et Jean*, Maupassant says Flaubert taught him that the most trivial object contains something unfamiliar and peculiar, distinguishing it from all similar objects; that to catch this nuance the author needs a clairvoyant knowledge of every shade of meaning which the word can acquire from its contexts. "He made me describe a being or an object in a few phrases so as to particularize it clearly. . . . Whatever one wants to say, there is only one noun to express it, only one verb to animate it, and only one adjective to qualify it." As has been shown, this directive must be supplemented and corrected. But in addition—

and fortunately—it conflicts with the ambiguity of even the most precise linguistic statement, so far as this remains artistic. All truly poetic descriptions have that floating, indefinite quality which we feel so strongly as a necessary component of the artistic. What good painting laboriously achieves through blurred outlines and gradual color transitions, poetry possesses intrinsically by virtue of the indefiniteness of words and their combinations. In his mode of portrayal the poet stands between the figurative artist and the musician. The observer must attach definite images to a picture; he can supplement words in several different ways, and tones in a great many. A sculptural work forces the observer into one path, a poetic work leaves him several; a musical work gives wings to the imagination for a flight into the infinite. The painter can portray, the poet express, the composer suggest.

Let us cast a cursory glance at the musical element in language. Word combinations acquire luster when their sound and rhythm are pleasing and the associated feeling-tones blend harmoniously. Purely auditory similarities become an artistic technique in description. The words lure one another forth, as it were:

> And if a word is friendly to the ear,
> Another comes the former to caress.
> —*Faust* ii

And rhythm, the persistent feature of all music, pervades every artistically constructed sentence and every poetic combination of sentences. Through the arrangement of words, which only a poet can discover, the reader or listener is lured into certain accents involving almost a melody. Details may be read in Arno Holzen's *Revolution der Lyrik* and in the aesthetic pronouncements of *Blätter für die Kunst*. Rhythms are unmistakable even in certain treatments of prose, and can be established by an author's stylistic peculiarity as belonging to him. They come out more clearly in metrical (bound) discourse. In its presence almost everyone feels a mood created by the melodious cadence, such as calm equanimity or strong excitement. Quite apart from the ideas that may arise regarding matters of fact, our comprehension is bound up with this emotive power of the rhythm. Hence we should speak rather of binding than of bound discourse, especially when it is heard and not read. The harmonious synoptic view which we owe to the genuine work of art is rooted here in rhythm. With the exception of the prose romance, all the special kinds of poetry get their organic

unity from the rhythmic structure which encompasses the work, not only sentence by sentence but as a whole. In contrast with rhythm, rhyme and refrain are merely ancillary devices in the art of words, but still worthy of attention because they are possible only with words and have important emotional effects. It seems very significant that in the ancient world rhyme was permitted in prose but prohibited in poetry, that since Gorgias consonance at the beginning and end of sentences has been accepted in rhetoric, but only there. Hence the peculiar nature of language is so effective here. From that nature and not from other causes we should derive this formal contrivance of lyric poetry.

Meanwhile we do not intend to get lost in details, but return to the main issue. That words cannot be artistically effective without intuition was the fiction to be refuted. According to the reigning truth, in the listener or reader the author's words occasion images, to which the aesthetic pleasure is attached. The heir-apparent truth of the future counters that the pleasure is attached to the very words and sentences. The earlier doctrine was that there should be nothing in the idea which does not also appear in sensory form, and that every sensory appearance must be wholly fulfilled in the idea. Now we are beginning to see that this general theory can be applied to the art of words only with drastic restrictions and modifications. This art is far too complex in nature and influence to be possibly labeled by just one catch-word. Our train of thought has stressed the following consideration. If art is a form of the spiritual life through which our feeling is liberated and enhanced, the medium of poetry for achieving this goal is language— language with all its peculiarities, from the nature of the single word to the rhythm of the whole. If art consists in idealization rightly understood, this process occurs in poetry not so much through the intentional alteration of reality as through its initial conversion into words. How many of our inner experiences, which seem to us indifferent and ordinary, are actually transfigured as soon as we recount them in common language, still below the level of art! The mere transfer of the occurrent into the spoken already contains the seed of that transformation of the existent which this art of words undertakes to perform. And if this fact is so easily overlooked, the reason is that words are our usual medium of expression. On seeing simple outlines and on hearing musical sequences we feel that here a new world is looming up. But language seems to us essentially like things, whereas actually it represents a quite distinct

mode of grasping reality. And for the poet language is more than a way of retaining inner experiences; it is the means for achieving them. He sees choice of words and invention of themes as belonging together. There has recently been a rather fruitful attempt to discover the first germs of particular poems through stylistic investigation. (Berthold Schulze, *Kleists Penthesilea oder von der lebendigen Form der Dichtung,* 1912; Hans Sperber and Leo Spitzer, *Motiv und Wort,* 1918. Sperber says, for example, "Whenever a word proves to be emotive, we should expect to see the signified idea play a role in the author's story." Meyrink finds emotive terms in the region of suffocation, of blindness, and of the vampire complex. These terms furnish the most potent words for the linguistic artist and the most gripping themes for the raconteur.)

First we asked, without respect to the art of words, how language and sensory reality are related. Language, having arisen from the conversion of sensory objects into vocal gestures, even today is often concerned with the transfer of particular sensations and images into words. For the poet this transfer may even be set up as a rule. But it does not involve the preservation of the sensory objects in the words. And no more can a word, in turn, become an act of intuition. The word can only lure out an image after vanishing from consciousness itself. The question is now whether the function of poetic language is to stimulate mnemonic and fanciful imagery of maximal intuitive power.

Actually and necessarily many images arise in the reader's consciousness, especially when there are comparisons. Motor excitements, particularly in the case of portrayed actions, are more common and emotionally affecting because connected with the sensory aspect of feeling. But various images can occur for a single word, and every sentence suggests different possibilities of imaginative fulfilment. Hence we readily add imaginative content from our own personal experience and probably never attain the image that floated before the artist, a re-creation that is indispensable in figurative art. In general these visual images are far too weak to explain the strength of the aesthetic experience. Exciting passages are the very places where the reader hurries on without leaving himself time for images, and sentences which cannot possibly have any imaginative value produce poetic moods. So the aesthetic effect is not dependent on the sensory images occasionally stirred up by language, but on language itself and the structures peculiar to it. On the one hand, this effect depends on sound and rhythm, which

are important for linguistic feeling, apart from any factual representations that may appear. On the other hand, there is the decisive consideration that to enjoy a poetic description it is enough to know the meanings of the words without the intervention of images. Verbal portrayals represent reality in the sense that their inner effects can be similar to the inner effects of living through what is portrayed. The poet's task is to secure for his description the highest substitute value; *the interval between language and reality always remains amply large.* The poet performs his task partly through the choice of words—metaphor is no stimulus to imagination but something purely linguistic—partly by constructing sentences and fitting them together, through which a unity of pattern must arise.

2. Speech and Drama

Words are like apparitions, which we can only suspect but not grasp. Their mode of being and acting has something uncanny about it. They possess neither the honorable visibility of colors nor the entirely public audibility of sounds. A name does not signify the nature of a thing nearly as accurately as a pictorial copy can, nor does it indicate the underlying feeling like unarticulated tones. While all other arts are cosmopolitan, the art of words remains confined to groups of compatriots, ultimately even to smaller regions of space and time. Language cannot be molded at will like tone. So the artist committed to this material seems to be fenced in and restricted on all sides.

Nevertheless even here strong, free, vital expression is possible. A genuine artist of language—the concept is to be taken seriously—shows his whole spiritual culture through his degree of linguistic culture. For style arises whenever anyone says something, whenever a personality conveys a message. More precisely, every sentence must be pregnant, compact, crammed full, free of vacuities, strictly built or intentionally asymmetric, fortified within by rhythm and meter, by nuances of sounds and inner word-values, and securely inserted between what precedes and what follows. And every sentence must so express personal individuality that no one else could ever again write it. For artistic dominion over this land of illusory freedom, soul and language become wholly unified (like

soul and sound, soul and color, soul and material in other fields).
So the artist lets nothing foreign intrude, but eagerly retains his own
written product. It would be a grave misconception to believe that
artistically correct linguistic usage always leads to imagery and gets
its personal stamp from its particularization of this general feature.
Some of the so-called figures (contrast, irony, crisis, repetition) can
very well have logical relevance; others (like the use of species for
genus, of part for whole) must even remain outside the sensualizing
process.

Thus the usual view is most absurd, for it threatens to
eliminate the broad field of rhetoric. This field has long, and rightly,
been placed beside poetry. Only during the nineteenth century did
the art of words shrink in scope to the size of poetry, thus losing
its true character. In antiquity the two fields remained firmly united
by the fact that the same style governed both writing and speaking.
With us the charm of good prose consists partly in its constant
blend of rhetorical and poetic features. At present rhetoric lies
prostrate, and for this very reason most people feel we should call
it a skill with added aesthetic features, but not a form of the
spiritual life or a true art. Nevertheless I would make room again
for rhetoric in its ancient place of honor. The art of words seems
to me to include three subordinate arts: first, speech and drama,
which have an inner affinity and externally are both connected
with mimic art; second, prose in the familiar forms of the narrative;
third, poetry, which is based on rhythm and expressed in the lyric
as its purest form.

The medium of the public speaker, spoken language, de-
termines his technique. The possible duration of an exalation creates
the units. Intelligibility for the listener forces upon him sentence
structure, choice of words, use of repetitions, limitation of time,
and many other things. While the actor is essentially a mimic in
mien and movement, the speaker—even when reciting poems,
stories, or dramas—should use these aids sparingly. The relation is
much like that of a song singer to an opera singer. The former, if
he is living in his song, can hardly avoid appropriate changes of
facial expression. But he is not allowed to gesture or move about.
For he is not portraying a person, but a poem set to music. The
stage singer, on the other hand, pretends to be another person, and
performs with mask, costume, decoration, and other such accessories
of the usual actor. Hence the singing or speaking male soloist may
reproduce the speech of a girl or a dialogue between a man and a

woman—something unthinkable for an actor. The flesh-and-blood personality of the soloist is entirely hidden by the performance. He is like the musical instrumentalist, and the dramatic reader is like the conductor who plays the score on the piano.

But let us now consider the public speaker as the creator of a form of art. Ancient oratory reached a high point. The special science of art, corresponding to it, consisted in a description of the forms evolved from practice and the rules extracted from these forms. Therefore, that discipline cannot suffice for the modern scientific lecture, the sermon, or the parliamentary speech. Characteristically, ancient rhetoric included beside the simple mode of speech both a spirited and a stately mode—"gently, moderately, grandly (*submisse, temperate, granditer*)," says Cicero. The grand kind of speaking (*grande genus dicendi*) is the highest, the speech prepared word by word and packed with meaning, the speech that borrows from architecture orderly structure, from poetry a wealth of comparative images, and from music sound effects. Antiquity and the Renaissance produced wonderful speeches of this sort. Many of them were written by persons other than the speakers; many were never delivered. When fifteenth century humanism had raised eloquence to a new peak, pompous speech came into vogue. Court festivities, weddings, funerals, as well as royal visits and conclusions of wars, required the art of the court orator. Contemporaries felt that a brilliant rhetorical performance gave the event a peculiar consecration. Something of this spirit is currently reviving in Europe, but generally music is taking over that function. Now it seems to me that if we are at present indifferent to rhetoric, it is because we think of rhetoric as more artificial than artistic. This is the sense of Pascal's words, "True eloquence mocks eloquence." This is why Bismarck disliked to be called an orator. But should not this art also be possible today in freer forms, and thus be a rhetoric to match our altered consciousness? Could not we, who all confess the power of the spoken word, also fashion the theory to fit our practice? Above all, I think, we must get a more vital conception of speech from the facts of conversation and communication. But I decline to derive this conception here, and shall confine myself to a few remarks.

Through the (overt or covert) apostrophe the forthright and uncommitted speech shows its essential nature as involving a discussion between two parties. Yet this feature is so colorless that it can be abandoned without loss. To me it seems more proper for

337

the speaker in the course of his remarks to address a lively appeal to the audience, thus eliciting interpolations. But of greater value generally are the techniques creating an inner bond between speaker and audience. Here I have in mind quotations and examples from daily life or certain vocational groups. Such concrete bits bring the speech back to common and familiar ground. The older rhetoric treated them unfairly as merely ornamental. But the speaker unites his audience with himself most securely by immediately detecting and refuting objections and misgivings presumably or obviously present, or by making concessions to his listeners which do not seriously weaken his line of argument. Even the so-called rhetorical question is a conversational form transferred to public speaking—a platform device which stimulates the listener's independence. At last we penetrate into the heart of rhetoric when we recognize that public speaking and conversation share not only their living plasticity of form but also their rich variety of content. The conflict between what is real and what is necessary for thought, the diversity and relativity of all experience, form their common presupposition. For, when absolutely certain, we can dispense with rhetoric, but when in doubt, we wait eagerly for the spoken word. So the speaker addresses himself first to the understanding, since this is most easily convinced and freed from prejudices by demonstration. Then it is in order to win over the listener's feelings, which slowly follow his understanding. In the first approach all the skills of scientific dialectic are available; in the second the effective techniques of the drama must be used.

At one time hostile nations would leave waste land between their countries to avoid border conflicts. In almost the same sense (or at least as a buffer state) rhetoric lies between science and art. It absorbs the offshoots of scientific methodology, those parts concerned with the convincing presentation of what is already known, not with the discovery of facts and laws. Yet clarity and cogency of demonstration are only one aspect of the matter. Every good scientific lecture is a conversation of the thinker with himself and other thinkers; every good sermon is a struggle of the spirit with itself and other sinners. Dramatic inner life and its expression in dialogue are merely veiled. In defining the soul as a questioning being, a long-forgotten philosopher of the mid-nineteenth century struck the intersection point of three circles. The intellectual-scientific, the historical-social, and the artistic-dramatic life touch one another in the basic problems of question and answer, statement

and counter-statement. Now if we consider further the similarity between speech and drama, the next item to mention is the heightened importance of the plan of the whole. In the pulpit as on the stage it is a mistake to utter decisive thoughts or stirring words at the very start. A classic case of this error is Massillon's funeral oration for Louis XIV, which began, "Only God is great, my brothers." Laboulaye rightly remarked, "The introduction has destroyed the main body." Our earlier remarks about the initial effect of the stage set apply also to the first sentences of a speech. We do not become fully aware of their meaning because our attention is still not properly focussed but distracted or caught by trivialities. Every professional course of instruction in dramatic literature mentions the clever trick of opening a play with "servant scenes," scenes that occupy the eye and involve only minor characters. But after these scenes the action must proceed steadily, retarding moments and refreshing episodes being allowed in speeches precisely where they are also proper in the drama. It is important for rhetoric to recognize that in a certain place a thought may be logically legitimate and yet seem rhetorically inappropriate because it impedes the swing of the speech. To blend the particular fragments, introduced in the preparation, and to achieve the utmost vitality are necessary both in speech and in drama. Play and counterplay, change and contradiction, contest and conquest determine these most flexible forms of the art of words. So rhetoric, like dramatic literature, works essentially on the will, and tendential writing, though much reviled, might be introduced with equal frequency into rhetorical and dramatic works.

In beginning the following discussions please note that we are now dealing with the drama as a species of the art of words. Attention to the stage has a coarsening influence, restricts scope and content (since there is naturally more freedom in publication than in performance), and demands a structure in which the mute theatrical set already reveals the climax. On the other hand, the unfairly disparaged drama for reading has abundant means at hand to preserve its individuality even without the aid of the theater. Important means of this sort are the preference for progressive or contemporary themes. But rhetoric also aims to make everything reported seem to be present and press on incessantly. Both forms require first-person speech without naming the speaker and immediate shifts of speakers, the distribution between two persons being properly regarded as only an accidental circumstance. No other

technique is so effective as animated dialogue in sustaining suspense right up to the denouement. The purely primitive pleasure in observing what is going on is transferred through rhetorical-dramatic conversation into the sphere of verbal art. It is assumed that the feelings expressed in these words belong only to the characters created by the author, and that nothing can be inferred, at least directly, as to his own attitude. With singular clarity Julius Bab has called attention to the "complete veiling of this personal interest by apparently objective, freely moved figures." So we feel like witnesses of a present experience, while the narrator, who is always interfering, never lets us forget that it is just a story. Hence we should recognize the novel (in which the characters, the author, and the things can express themselves) as the broadest form of verbal art, in contrast to a certain narrowness of the drama. But we should also pay tribute to the artistic skill of the playwright, who can assign all his inner life to his speaking characters so that they reveal more about themselves than even they know: their hidden relations to other persons and to the unitary meaning of life, their private odysseys (to themselves and to God). Polyphony and conflict are gifts of the dramatist. Wilhelm von Scholz thus epitomizes the creative activity of the dramatic author: "It is an inner experience in which every idea shows a counter-idea as its shadow, which grows with it and is suddenly animated by its life. It is a dialogue of wills which—contrary to dialogues of opinion—someone other than the conversants is guiding: unexpected self-revelation, chance, passion, and destiny."

Whenever the waves interplay in the soul of the dramatist, the words flow forth at the same time in an unrestrained wealth of forms, for all linguistic aids are mobilized. We wonder at Shakespeare's ability to work with an equally sure touch on our sense of language and our sense of theater. Of course, he often offends our purely aesthetic feeling. If the only concern of drama were beauty, then every single part of the action in itself would have to arouse pure pleasure—apart from the amount of its contribution to the structure of the whole—and the same would hold for the words. But literary drama is wholly exempt from this restriction. Language must contribute far more than mere pleasantness. First of all, it shows the general quality of the work. It is easy and fluent in drawing room comedy, terse and rough in folk drama. Trifling, witty wordplay can fill us at once with the brightness of comedy and in the same way ponderous, severe verse with the tragic sense

of fate. The author uses speech also for characterization. He describes not only through deeds but also through discourse. Of course, not in his own words. He does not say, "My hero is a fresh, vigorous primitive." But he puts into his mouth fresh, vigorous words and figures of speech available only for someone reared in the open. The characters in a drama would lose definiteness and vitality if they all used the same style and the same figures. Even the monologue is not intended to express the author's insights and feelings, but merely those of the characters. The unnaturalness we are so ready to mention in criticism of the monologue applies also to the conclusions of acts and countless other necessities of the drama. What surprises us (as in Schiller's monologues) is probably less the unreality than the polished and logical form. Nevertheless the monologue may stand as an artistic expression of the fact that a single decision of a superior man is coherent with the whole scope of his inner nature. The conceptually evolved complexity signifies the participation of a mature spirit in the moment. The monologue depicts an inner disturbance and carries it on in words. Now, to be sure, we never meet a discrete personality, but someone standing in certain relations. Hence language can use these relations as avenues into the inmost regions of the self. The following fact is fundamental. Most people are changed by meeting another person of a certain character. They regard themselves then with his eyes. What seems natural to them in the society of one person is felt to be not permissible in relation to another. These fluctuations, due to indirect influence, and adoptions of alien points of view are reflected in the modes of speech. Even if the content remains the same, yet the form and complexion of the sentences change. Thus to the individuality, revealing itself in the kind and degree of its unconscious adaptations, the dramatist's art of words gives an expression which says something meaningful to the more discriminating ear. Finally, language becomes symbolic in the sense that something of value is expressed in an essentially inadequate form, but through this very expression wins a peculiar embodiment.

Aesthetics and the comparative history of literature commonly allow to the drama, as such, only a limited number of principal themes and possible forms. Since Gozzi discovered three dozen dominant themes, and Goethe expressed himself conversationally in a similar vein, the existence of some such definite number of basic dramatic ideas seems to have become a dogma of most theorists. Really, the classification of these ideas can be continued with-

out end, both extensively and intensively. The collection of types seems complete, because hollow abstractions have replaced sensitivity to subtle and ambiguous effects. On the other hand, we should not forbid science to strive for such completeness. Only against a definitive determination of a number, never to be exceeded, should we protest in the spirit of the human studies. In like manner it would be absurd to stretch the wealth of dramatic forms on a rigid frame. The Indian theory of art, with its sharp analyticity derived from mathematics and chess, distinguished two principal kinds, one of which has eight subkinds, the other eighteen. But who would still accept this classification? By and large our dramatic theory is content with the opposition of comedy and tragedy. When Schiller says of comedy that it "leads the drama to spiritual freedom," he is well indicating the enhancement of playful creativity, which should have its place. I need not consider once again the nature of tragedy, the radical hostility and kinship of the forces struggling within it, and the artistic intensification of this pregnant situation. There is essential agreement even here, and the controversy begins only when we turn to the many mutually divergent forms.

Consider for an instant the historical changes through which the drama has passed. We know an Indian play whose contemplative and submissive characters lack dramatic toughness, we feel, and yet the tragic and comic are so intermingled in the play that our aversion to fixed boundaries is gratified. More familiar to us is Greek tragedy—in its forms, thoroughly rhetorical; in its essence, a picture of the struggle of the polytheistic tradition against the recognition of a higher world order. According to Gustav Freytag, somewhere in the middle of a Greek tragedy the action should reach a climax, from which it then declines. If the hero's faction is dominant in the first half, the opposition takes the lead in the second. If the opposition prevails at the start, it drives the hero to the climax and then yields to his faction. But Freytag had to concede that the tragedies of Sophocles might be said to begin where we would put the climax of our plays. His theme is usually the restoration of an already disrupted order. Crime and complication come before the beginning. The disclosure of the evil and the revenge constitute the real theme, in which the will of man and the decision of destiny cooperate. Shakespeare works in still another way, using external circumstances to explain a permanent condition, especially a state of mind: a presented handkerchief to explain

jealousy and suspicion, divination and woman's power to explain secret ambition. His way of forming a character (the development of contradictory traits from the sources to achieve the utmost vitality), his sense of individuality, his nonmoral treatment of tragedy —these create a new form. On the other hand, the Spanish national drama, which Lope de Vega equipped single-handed, strikes us as rich, to be sure, in contrivance and resolution of plots, but poor in characterization. An involved plot tempts the author; ready-made character types are to be brought into the most exciting situations and suspense created for the spectators by cleverly contrived complications. Imagination does not provide the intermediate moods. The playbills of these cloak-and-dagger pieces can name the characters as types: gallants, old men, comedians. In Calderon's religious dramas there are allegories involving a great variety of things and relations. What the Spaniards lack (and in part also Schiller, who loses himself so readily in mere episodes) is the gift of simplicity. Racine had it. The secret of his art lay in his ability to reveal variety in the simplest thing by mere gradation, to elucidate logically the struggle of a passion against a law. The people of his time whom he sketched showed a hardness excluding all sentimentality, but seemed less severe in the customary forms of social contact and communication. Their affected courtesy in social intercourse and their polished coldness in the arts were simply attitudes to balance enormous intellectual and practical energy.

In turning finally to the most recent dramatic trends, we must begin with Ibsen's drama of ideas. The heart of this drama lies in the demand that the individual person understand himself so that he can give himself to others. But in many symbols feeling also reappears and it becomes the point of his work that we reach such heights in thought, not through the will. To bring out clearly these principal ideas, relevant to social criticism, Ibsen has pivoted his plots on peripetia and worked out a technique that looks like a return to the three unities, but really amounts to the broad psychological elaboration of the last act of a drama articulated according to the old formula. A final psychological analysis of this sort is then appropriate, if (as for Ibsen) men seem to be products of their environments. Wedekind scorns such patient studies, for his people, emancipated centers of independent force and goaded on by sensuality, demand a different tempo and dynamism. But he is like Ibsen in his nonmoral, psychological attitude. To use an expression of Hofmannsthal's, Wedekind sees mankind as "nothing but a house

where people are incessantly coming and going . . . a fraud wrapped in a thin veil." Hauptmann also has plenty of the psychological, especially in the relation of men to women, yet in his treatment man becomes an organ of divine revelation, particularly in suffering and death. Strindberg's drama penetrates deeper into the metaphysical. ("Will you never weary of questioning?" "No, never; I long for light, you see!") In a remarkable feat of evanescence, his tripartite masterpiece *Nach Damaskus* wipes out the boundaries between the undeniable bodily existence of individual persons, their inner ambiguity, their real and their imagined surroundings, to submerge it all in a great invisible Something. Ibsen's drama certainly abandons every customary form. And yet it is still filled with action which grips the spectator again and again, for the restless play of attraction and repulsion between persons, of intrapersonal fissures and interpersonal fusions, builds up. Our most recent authors utterly reject the familiar distinction between outer and inner reality. They have now become moralists again—a change which Ibsen (connoisseur of the gray life) and his age would have thought a backward step. They no longer sigh with Strindberg, "We feel sorry for people," but beg, call, implore, "People! Be good!" Since man has within himself all the powers needed to fashion new worlds, since he is independent even of the soul allotted to him by fate, the dramatist has to uncover the deepest strata beneath world and soul. One of these expressionist authors, Paul Kornfeld, has made the following confession: "If man is the center of the world, it is not for the sake of his talents but because he is the mirror and shadow of the eternal, because—though earthborn, to be sure—he is yet the steward of God. . . . Instead of trying to investigate and analyze the complexities of the all too temporal we should become aware of what is timeless in us, and hence in a higher sense experience ourselves inwardly, instead of peering at ourselves in a lower sense. . . . Psychology tells no more than anatomy about man's essence." Such conviction produces a drama which no longer uses one idea, but transfers many (Platonic) ideas from the realm of metaphysical matrices to the realm of scenes, a drama concerning the revelation of inner essence, not the organization of outer reality. Every person is a type, the actor portraying him—as Kornfeld would have it— the spokesman of his thought, feeling, or fortune, and endowed with the "melody of a great gesture," which counts for more than perfect naturalness. The language is highly conceptual, clipped, often explosive.

Even this hasty backward glance shows us what heterogeneity blocks the attempt to find adequate laws. Nor has dramaturgy been very successful. We finally get a classification in terms of aesthetic, technical, and material points of view. Of aesthetic importance is the distinction between tragedy and comedy, which we explored thoroughly in considering the primary forms and again just above. The chief technical question concerns the relation between the plot and the characters. Since the two constituent aspects presuppose each other, we classify a play in one group or the other according to which aspect is given major emphasis. In particular cases author and critic are not always agreed. I am inclined to give priority to the plot if it is intelligible and significant. For, without doubt the peculiar effect of a drama springs most infallibly from a strong, unembellished, and undisguised plot. That previously mentioned sense of presence, which during the stage performance rises to actual bodily feeling, is rooted in our view of the act of will as the hidden essence of nature and of man, and in the fusion of this essence with man's overt act. Both metaphysical reality and phenomenal appearance are tension or struggle. We have always seen clearly that in drama a test of strength must be proposed and carried out—in other words, the characters are necessarily governed by a belligerent opposition. It is only in the application of this principle to character drama that many theorists have found difficulty. But why should the test of strength not be carried over also to the soul of man? The really dramatic element is in no sense lost by such a transfer. For Gustav Freytag is quite right: we find the dramatic quality not in the action itself, but in its origin and effect, in the preparation for a deed and in its consequence. The absolute act is impersonal and indifferent, like absolute rest. At the moment of occurrence death has no greater artistic value than an immovable boulder. The task is rather to explain the transition from rest to act or from act to rest. It is less important whether the development is expressed in outer or in inner events, in political actions or in tender emotions. In the second case even the connection (the steadily growing need and its satisfaction) is easier to preserve. Torquato Tasso or the final part of Euripides' *Heracles* are excellent examples. In these plays the action has small scope and importance. The merely contingent has been overcome, the what wholly absorbed in the how. The characters are so absolutely real that their acts are eclipsed by what is running its course in themselves and in their struggle with the great mystery. We do justice to such dramas

only when we approve their intentional opposition to the fresco style of the stage.

Finally, if the kinds of drama depend on the choice of material, we can make as many distinctions as we like. I shall mention only the historical play. Here tragic fate tends to spread out from the ambiguous personality, "wavering in history" to the broadest scope, or like the waves from a stone thrown into the water, to die out finally in imperceptible ripples. Destiny unfolds with dialectical necessity. The theme always concerns the men of action who are commonly believed to decide the power struggles of history. Neither the relative independence of the masses nor the significance of the thinker and the artist is brought out in historical dramas. At least, there has been only one successful attempt thus far to treat the people effectively in the central role of an historical play, and this portrayal quite ignored the silent labor of researchers and figurative artists. If, then, the principal characters of historical dramas are those men of determination whom we know from political history, the question arises as to the treatment by which they themselves and also the causes and effects of their deeds can be made the themes of works of art. It has been held that the author does this by freeing himself from historical truth and substituting the plausible for the actual. It is quite understandable that through this theoretically justified independence in his treatment of the material the author should try to make his play a piece of pure art. Indeed, there are free character portrayals with historical basis, like Schiller's *Don Carlos,* which are extraordinary works of art. Why should not a familiar historical figure also have embodied certain tendencies in a typical and exemplary way? Did not Shakespeare's Caesar surrender his personality to an idea, as even today a priest gives up his name when he becomes a pope? Nevertheless we may say that Shakespeare's series of historical pictures, Schiller's fantasies on events of the past, and Greek legendary dramas are not genuine historical drama. Whenever a play is supposed to appear historical in other respects to our minds, sensitized by training, poetic license should not follow the Aristotelian recommendation of "what could have happened." I stoutly deny the truth of Goethe's statement, so often quoted: "For an author no person is historical, if that author wishes to portray his moral world and for this purpose confers on certain persons from history the honor of borrowing their names for characters of his own creation." (Hempel ed., vol. 29, p. 636.) On the contrary, in such cases our respect for the facts is so great that

we regard every substantial change of the inherited material as an act of illicit caprice. If the dramatist cannot use the essential facts of the historical material, he should leave it alone. Schiller (in *Wallenstein*), Kleist, Grillparzer, Otto Ludwig, and Grabbe have preserved the circumstances of the time with great accuracy, through this very fidelity presenting a development of character with intuitive immediacy. Here strict adherence to reality is indispensable—one more limit to add to the many others which art must set for itself, although it transcends all limits.

3. Story and Poem

It was pointed out earlier that in comparison with narrative literature every drama is handicapped by its restriction to direct discourse. The drama also shows a certain dependence upon poetry. Shakespeare's plays acknowledge it very clearly in shifting from prose to poetic style at pauses and conclusions. The second part of *Faust* ends lyrically. Not without reason do we call such works poems. For wherever the action has run its course, they approach lyrical forms and are wholly consumed in the spirituality of words.

When we turn to the epics of various kinds, considering them again chiefly from linguistic points of view, we must free ourselves from the outmoded doctrine that they are to be recited and listened to. Actually, they are written and read. The linguistic representations thus formed are the objects of our concern. Neither the visual images nor the strong outwardly directed feelings determine the aesthetic value of the style. But among the many pulsations of feeling those are decisive which are aroused only by the words as read, hence by the words as sounding inwardly in a personal way. They may be quite simple words, but even so, they may bring tears to our eyes. The words may refer to an insignificant chapter from the life of an ordinary person, but this fragment is ennobled by the royal right of linguistic mastery. Just as we can say nothing higher of a painter than that he knows how to paint, the real tribute to an author is that he knows how to write. Flaubert, who became almost melancholy because just once, for lack of a better form, he had to place two genitives in immediate

347

succession, would have been scarcely able to contain his contempt for the careless mediocrity paraded today in the best novels. At least the mother tongue should be kept pure—an ideal never achieved by the scholar, committed to technical terms—and every word should rest securely. But the narrative author has still more onerous obligations. His artistic integrity consists in his sincere expression of himself with convincing individuality. He is permitted to speak loud, for in the story persons, events, and surroundings have that stillness and distance which are foreign to the drama. In his language, as in that of every author, the body of words must be at one with the soul hidden within it. Hence joyous events should be communicated in jubilant tones, care and sorrow in dull colors, doubt in surprising turns of expression, certainty in steadily advancing sentences. This means that in a novel about the golden age of Greece, unrest may well be compared with the turbulent sea, but not with the bounding and darting electric storm. This means that, depending on the subject matter, words flow smoothly, pile up against one another, or leak out in drops. For in all these relations the narrative author is far freer than the dramatic and the lyric.

Since the imagination of the narrative author does not work with general concepts, since it does not know the suicide as such, but this individual Werther, since it even hesitates to use allegory (the intuitive representation of an abstract relationship by conceptually adequate sensory forms), this imagination indeed strives for what is easily perceptible. The external similarity of two things suffices for their comparison (although this would not be admissible in science). And usually, to be sure, only a part of the object compared shows the common characteristic. In such cases, one must proceed very cautiously to avoid high-flown tropes in bad taste. But no novella and no novel consists only of images and similes. Authors with the imagination of a painter, like Ruskin and Fromentin, write far more colorfully—with brush in hand, as it were—although they do not poetize. But in our best stories a great deal is objectively and conceptually expressed. We have works of the finest quality which get along with almost no metaphor. The author who writes from the heart of the language loves vital verbs and avoids the useless stylistic upholstery of decorative adjectives. For he speaks just as definitely as a military commander, although differently. (Cf. Jakob Wasserman, *Die Kunst der Erzählung*, 1904.)

The most familiar and important narrative forms of our age are the novella and the novel. Authors who have reflected on their

art tell us that the novella should portray a single but crucial experience, and that the arrangement of the story about this central event prevents the extensive development or radical change of character. Rather its material consists of ready-made people, who reveal their natures in a certain concatenation of circumstances and create the ensuing complications. (Cf. Spiegelhagen's *Beiträgen zur Theorie und Technik des Romans*, 1883, p. 245.) The novel is very different. We classify it as narrative literature, although Friedrich Schlegel tried to mingle song and dialogue with the "portrayal of a great growing and willing spirit." He was mainly concerned with the author's inner self and his commitments, not with the story itself. Novalis said something similar about the form of his *Heinrich von Ofterdingen:* "The simplest possible style, but very bold, romantic, dramatic beginnings, transitions, sequences—now conversation, then discourse, then narration, then reflection, then imagination, etc. A perfect copy of the spirit, where feeling, thought, intuition, imagination, conversation, and music interweave with incessant speed and group themselves in bright, distinct masses." That, of course, carries us over into the laxer form of the fairy tale and down to the fertile soil of wonder. In fact, Novalis says, "The fairy tale is, as it were, the exemplar of poetry; the poetic must always be the fabulous; the poet worships chance." (*Schriften*, III, 165. Since their point of view differs drastically from that expressed here, I have not considered the important articles by Georg von Lukács on the theory of the novel in Z.f.A. XI, 225–71, 390–431.)

Needless to say, every novel that depicts the past or present must meet special conditions. Here we demand respect for the facts. Here we also employ an impersonal, somewhat communal mode of expression, reminding us of the poetry of primitive peoples —a mode such as Walter Scott used. Moreover, in all ages fictional and historical literature have been equally suited to mold the will. No other art or science influences our philosophy of life so involuntarily and so surely, or is so personally united with us. This active, human quality gives to great works of history and fiction their transporting charm. In this sense they are strong through their practical power. Every historian must rest on human and moral standards in evaluating the facts he reports; he must distribute light and shade; he must affect the reader's will, which indeed is also very closely connected with his understanding. Partisan commitment is inevitable. It operates equally in the account of present economic movements and in the picture of conditions in ancient

Greece, where we suppose our judgment is objective. Ranke believed himself strictly factual and wrote a Protestant history of the popes. According to a well-known quip, Mommsen made Caesar the democratic kaiser of Germany (who will never come). Treitschke actually used the love of fatherland as an explanatory device. His moral-national and rhetorical treatment of historical reality always seems to me a brilliant proof that the scientific and evaluative standpoints must coincide if history is to exert its full social influence. And need we point to Schiller to make it clear that the situation is no different in poetry?

The novel is preeminently suited to be a companion in the bustle of life. For it has now evolved into a form which can assimilate any experience at will. Its distinctive characteristic is that so much goes into it, that it is so convenient a vehicle for communicating and appropriating all possible interests. In most cases the form of the novel is chosen arbitrarily and not as required by inner experience. The content shows the author's sagacity and spiritual meaning, to be sure, but seldom his power of organization. Novels are like artificial ponds in which everything has a place: happenings within and battles without, metaphysics and travel adventures. They are information booths for questions of the day and problems of eternity. In a novel false statements about the history of culture and questionable moral judgments provoke criticism just as though they occurred in textbooks on history and ethics. Even the authors who try to deepen the didactic or anecdotal material through psychological insights achieve their goal at times only by analyzing faculties instead of disclosing them through their effects, and especially in autobiographical novels, by offering reflections instead of events and attitudes. All this we grasp and justify at once by recalling the distinction between the work of art and the merely aesthetic object. More questionable is the thesis novel, even those of our honored elementary-school master, Gustav Freytag. Still more vulnerable is the expressly didactic novel, this bastard of science and morality. But in the naturalistic novel the added material has grown beyond all bounds of propriety. Naturalistic authors treat even love by carrying out an assiduous and thorough case study of all forms (as preparation for a later theory). They are scientific in their goal—truth; in their method—accumulation of evidence, analysis of the mind, exclusion of the author's own personality; and finally in their form—precise description with preference for abstract and technical terms. I recall Balzac, the

social teacher, who keeps ever in view the power of gold and the power of the will, and the struggles stemming from them. I recall Zola, the poet in spite of himself, who is diverted only by his temperament from the tedious execution of his didactic purposes. But especially I recall Edmond de Goncourt's confession in the preface to *La fille Elisa* (1878) that "at times it has been impossible not to talk like a physician, like a scholar, like an historian," and his and his brother's declaration thirteen years earlier, at the beginning of *Germinie Lacerteux*, "Today as the novel grows more extensive and important, as it begins to be the great, serious, passionate, vital form of literary study and social enquiry, as it becomes through psychological analysis and research the contemporary moral history, as it assumes the studies and the duties of science, it can demand the liberties and privileges of science." With these words Paris defined a relation between art and science, as Rome had established a relation between art and church dogma. In both cases something beyond the aesthetic was held to be authoritative: in Paris the truth of thought and life, in Rome the truth of salvation.

To what characteristics does the Russian novel owe its success in Europe? Above all to a portrayal of the individual man which does not dissect him psychologically, but grasps him at the core of his being and in his fruitful union with the metaphysical forces of life. And also to a deep faith, allied with a communistic social theory. Dostoevski takes Christianity as a personal decision, which should occur instinctively, and he believes that the Russians have a mission in world history, because they can freely confess and forgive sin. The power of Dostoevski's novels lies in this rudimentary morality. He has spoken out against crudely tendentious literature, of course, but still has set as his goal "to preach the true Christ by the indirect way of art." So also Tolstoy's soul receives the radiant truth of the Gospel and of brotherhood. Without this theme his writing as a whole would seem to him aimless and corrupt. Even our German novelists adopt a similar attitude. Most of them intend to have their art serve educational purposes. They aim to be leaders of youth or father confessors without priestly garb. All the individuality and color of life, all the brilliance and charm of language become merely instrumental. As Schiller said of *Wilhelm Meister:* "The form of the work, as in general the form of every novel, is utterly unpoetic. It lies wholly within the field of the understanding, is subject to all its demands, and shares all its

351

limitations" (Letter to Goethe, 20 October 1797). Perhaps the thought can be expressed more correctly in this way: the novelist is a "half brother of the poet"—again a phrase of Schiller's—because he is inevitably forced to run the risk of having the (indispensable) extra-aesthetic elements overgrow and stifle the others.

In trying now to ascertain the most general distinguishing feature of the poem we find an agreement with what we already know about the efficacy of the story. Poems also are usually enjoyed by first grasping their content. Here theory and fact differ. In his preface to *Hausbuch aus deutschen Dichtern seit Claudius* —a preface important for the technique of the song—Theodor Storm says: "As my purpose in music is to hear and feel, in the visual arts to see and feel, in poetry it is wherever possible to do all three together. I want to be affected by a work of art immediately, as by life, and not only through the mediation of thought. Hence the poem seems to me the most complete, for its effect is first of all purely sensuous, and then from this the spiritual spontaneously emerges, like the fruit from the blossom." As normative aesthetics this is very true; as descriptive aesthetics it is false. Our relation to language is so referential that with an uncommitted attitude to a poem we see its meaning before us as its first counterpart. Only after this do listeners without very acute artistic feeling become aware of the sensuous-musical element. But the melody of the single poem, like an aria, and the endless melody, continued from poem to poem in the great lyric form, have a peculiar nature effective only in language. Here there are harmonies and disharmonies which have arisen from the phonetic possibilities of words; there are shadings dependent on the choice of vowels and consonants, and in particular there are those rhythmical and metrical forms which have become interwoven with speech.

The sound of the word and the affective power of this sound can be understood in two different ways. Some poets are scrupulously concerned that the words which they have skilfully fitted together do not vary in the slightest nuance from their proper meanings in other contexts. *Sea* is not to function like Amphitrite; otherwise the poet would have said Amphitrite. But other poets want to free the word from its ordinary contexts and lift it into a luminous sphere. They would rouse words as they would sleepy children. *Kiss* should not sound like *smack*, but breathe all the delicacy and sincerity in the chaste touch of a maiden's lips. Should lyrical language actually shed all earthy residue? In my opinion,

since works of art have been created in both ways, it is not for us to extol the one and utterly discard the other. (At least let me refer to the investigations of Karl Groos concerning visual and auditory phenomena in the lyrics of Schiller in Z.f.A., IV, 559–71; V, 545–70. The question is how Schiller's art uses these two sensory fields.— They are equally prominent, whereas in Shakespeare's lyrics the visual field is more than twice as important as the auditory.)

We must consider the possibilities. As a sample of tone shadings I offer a few lines from Verlaine's "Autumn Song":

Les sanglots longs	The long moans
Des violons	Of autumn
De l'automne	Violins
Blessent mon coeur	Oppress my heart
D'une langueur	With a dreary
Monotone.	Languor.

The effect of the tone coloring in these verses is all the more striking, as the meaning is sacrificed to it. For even the author probably attached no definite idea to *violons de l'automne*. Apart from their meaning the words have beauty and intrinsic value, of course, as phonetic unities within which chiefly the vowels determine the feeling tone. Their characteristic timbre is effective even in rhyme. But the rhyme is not merely an accidental similarity of sounds; it ennables the ear to separate the verse lines from one another. It supports the meter somewhat as the color can bring out the proportions in a spatial work of art. It operates, so to speak, like a punching machine that stamps a piece of metal at regular time intervals. Since rhyme gives the verses greater stability and draws its own nourishment from the essence of speech, we understand its stubborn persistence. But the absolutely indispensable element in poetry is not rhyme or even verse; it is only rhythm.

Here by *rhythm* I mean that arrangement of words which creates their ambiguous relation from motor feeling and sound. Then we can say that in the simple song of smooth articulation, "the rhythm does not permeate the individual words, does not stream out of and into each single word with a vigorous up and down, but (as though more tenuous and insignificant than this) flows along under the structure." (Friedrich Sieburg, "Die Grade der lyrischen Formung," Z.f.A., XIV, 356–96. In accordance with its content, the lyric of the folk-song type "explains the situation in a

concise narrative introduction and then expresses the feeling. Such a lyric is directly tied to the lived experience and its form. The poem develops the feeling as it arose in reality."—Franz Baumgarten in Z.f.A., VII, 384.) In more artistic poems the words come out more vigorously. ("If the whole rhyme line of a song—or even several such lines—were a higher unity, then in the extreme case the individual words of every line would be grouped in different unities.") But the hymns, the representatives of the great lyric, raise the words to a life of their own precisely because the rhythm works so powerfully in them. "Not content merely to permeate the word groups, the rhythm tears the individual words loose from one another so violently that their seams open." This sentence was written with regard to Hölderlin. But even in our avant-garde contemporary German lyric, we long for a rhythm that cannot be hampered by a previously adopted schema. In opposition to this, other artists call free rhythm a self-contradiction. The poet who feels fettered by the forms, who cannot move with perfect freedom in the strictest meters, is simply not yet a master. The forms are willing, but also holy. In the conviction that it is precisely the poet of greatest power who seeks the coercion of strict forms, the Parnassian school stiffened its requirements. It dropped the movable caesura and used the classical Alexandrine. It encumbered the rhyme with the condition that even the consonant introducing the rhyming syllable must be the same in both words. Two objections to this can be distinguished even within the general theory of art. When a poet starts from any ideas whatever which he takes as the heart of the embryonic song, pregnant images and words will flow in upon him in very different measure, according to the capacity for enlargement in the form floating before him. This compulsion to speak in the waltz time of hexameter or with the verbal restriction of alliteration is necessary and salutary. Nevertheless, its utility has its limits even for a person of the greatest linguistic wealth and skill in metrical manipulation. To be sure, we cannot point to the boundary line, but in principle we must acknowledge its existence. The other doubt springs from the confusion of form and schema, a confusion already often censured. It is fostered by the theory of the Parnassians and their disciples among the poets. Free rhythms provide a counter-proof. Although their advocates dispense with division into stanzas and show contempt for a definite alternation of accented and unaccented syllables and a maximum number of stresses, nevertheless they preserve the utmost rhythmic certainty.

More especially, however, an excessive devotion to the schema threatens to confine poetic practice to traditional directions and to drive poetic theory into misunderstandings. For example, to speak of metrical feet is an error of the old doctrine of forms. The metrical foot is a conceptual aid, used in attempts to build up from the elements, but dispensable in a method which starts with the great given unities and then regresses from them. As a rule, that is, what we actually hear consists of verbal feet. For example, we hear the words *O stille, sanfte, silberhelle Tage* (Oh still, soft, silver-bright day) not at all as iambic, but as trochaic, an anacrusis preceding the first foot. If this natural word sequence is reconstrued as iambic for the sake of the schema, practical and theoretical difficulties arise.

With these suggestions we shall leave the subject. Yet the unanswered question is still urgent: what is the essential nature of the lyric? On the whole we can say that many details remain obscure and must be enjoyed like forbidden fruit. That we are dealing with an insubstantial web of words, in which an inner life develops, that the meanings and sounds of words are more exclusively dominant in the lyric than in the more realistic epic and the more active dramatic work—all this has already been discussed. But there is still something to add. A lyric ego, however indefinite it proves to be, is always concentrated at a single point, and as Helene Herrmann has well remarked, "from this point alone is able to grasp its inner wealth." "The person indulges himself completely in a certain state of mind and lets it radiate in all directions, inner and outer. The strong inner emotion which is fixed in a definite mode of being comes out in the pulsations of rhythmic language. The mental state is self-enclosed." (*Bericht des Kongresses für Ästhetik und allgemeine Kunstwissenschaft*, 1914.) Many kinds of material can be fitted into such circularity. The historical development has preferred a certain few. In the earlier lyrics not only constant forms of expression but also identically recurring ideas of things are prevalent. The tinkling meter and babbling rhyme are so insufferable in the late stages of decadent imitation because this verse has no new content to introduce. Until recently even up-to-date aestheticians regarded it as a betrayal of the true lyric to try to sing of anything but love and nature. Then, indeed, lyric poetry would be the art of those youthful creatures, mature in only one respect, who take the mating time of the sexes as the meaning of the world. More broadly viewed, this kind of poetry was expected

to assist the direct expression of pure, unadulterated feeling. Almost at a stroke the poet was supposed to say that and why he was sad or glad. The stronger the feeling, the better the poem. Finally, it has been claimed that every genuine poem must be singable, as though it were incomplete until supplemented by music.

Of these three directives for earlier poetry, the first has already been discarded, for the poets of today have greatly enlarged the scope of their material and still remain within the bounds of the lyric. Since it has been so in all ages, since poets of freedom who spoke in the language of fettered slaves and poets of life who brought all fields of actual life into their poems have always felt they were true lyricists, pedantic demarcations will prove futile. So far as something is a good work of art and possesses poetic form, we must acknowledge it as a lyric. Every restriction of content would be a sin against the spirit of the theory of art. But we must demand that the aspects of the real world be translated altogether from the contexts of daily life into a timeless spiritual realm in which these aspects ramify into mutual coalescence, each according to its inner laws. This general principle is the very reason why we must reject poems in which the personal element prevails without limit and primitive passion is the vital nerve. There is no art in which elemental feeling can suffice. If the feelings grow so strong as to overstep the formal bounds of the art, they no longer have any place even in a lyric. Great excitements are always foreign to art. They may hold our attention through the individuality of what is confessed in them and released by them. But over and beyond this, we should demand that the flood of feeling be fashioned and formed, even at the risk of cool contempt for such refined products, when contrasted with those elemental poems in which the pressure of primitive passion pushes on. The stammering and wildly gesticulating confessional lyric reminds us of weeping and wailing children. The artistic lyric begins only when this sickly impetuosity is subdued. Of course, this is not to deny the participation of the author. Goethe's statement that every good poem is an occasional piece brings out this personal element in the birth of the poem. But what is true of the lyric here holds also for the other arts. In those products of mood which disdain any too open display of feeling, recollection replaces lived experience, new events are even contrived to provide a better basis for the remembered state of mind, the experienceable form of the occurrence is absorbed by the artistic form. (Cf. Franz Baumgarten, "Die Lyrik Konrad

Ferdinand Meyers," Z.f.A., VII, 372–96: "Meyer betrays his lived experience to the form.") Finally, we have already dealt with the relation of poetry to music. Like the song, the poem as such should produce sounds and by itself give us the whole vague emotional excitement that music can arouse. If music is added, the main fact is still that a work of musical art arises. For music is the most obtrusive art and even in a subordinate position retains its ineradicable independence.

The truth often appears in places where we do not expect it. Who would look in John Stuart Mill's writings for the truth about the lyric? Yet according to this English Utilitarian, the pure lyric reaches the pinnacle of poetry and the narrative author should not be counted as a poet at all. We conclude our consideration with Mill's words, "Lyric poetry, as it was the earliest kind, is also, if the view we are now taking of poetry be correct, more eminently and peculiarly poetry than any other: it is the poetry most natural to a really poetic temperament, and least capable of being successfully imitated by one not so endowed by nature." (*Gesammelte Werke*, ed. Theodor Gomperz, 1874, IX, 197–222.)

IX. SPATIAL AND FIGURATIVE ARTS

1. The Media and Kinds of Spatial Art

When figurative art is mentioned, we think involuntarily of a colored picture in a frame, hanging on a wall, or a statue standing on a socle and visible from all sides. Yet this restriction of the term *figurative art* (*bildende Kunst*) bothers us, for in the last analysis, of course, it is the task of all the arts to form (*bilden*) patterns. And on further reflection we note that even industrial art belongs to figurative art, that illustrations and drawings should be included, that often what is fashioned by the hand for the enjoyment of the eye merely fills decorative surfaces, that there are certainly more reliefs than pieces of full sculpture. Finally, we recognize how many aspects there are to distinguish in almost every such work: the material out of which it is made, the meaning which it expresses (perhaps as a picture), the emotional attitude toward life which radiates from it. (Strzygowski distinguishes materials (paper, wood, etc.), mode of treatment (etching, engraving, etc.), subject (portrait, landscape, etc.), figure (person, animal, etc.), form, and (inner) meaning. Utitz speaks of strata which are co-existent and in a certain sense also similar, e.g. the material (which must be genuine) and the kind of portrayal, i.e. the warmth and individual coloring of the execution. Such strata can be detached from the subject, one after another, until it lies before us as though unveiled. Phenomenology adds that the stratification can be made intuitively evident. To learn what is in a work of art, intuitive insight is enough; conceptual clarification is not necessary.)

Is there a characteristic common to all kinds of figurative art? The art connoisseur Fiedler, the creative artist Hildebrand, and

the art teacher Cornelius find it in a formative activity performed on material objects in their natural state—an activity which springs from visual requirements. They differ, to be sure, in justifying and working out this view.

Konrad Fiedler regards artistic experience as a kind of knowledge and he saves its peculiar cognitive characteristics by liquefying the concept of reality. "The philosophy of art has developed from a concept of reality which is now antiquated." (*Schriften über Kunst*, II, Aphorism 94.) Knowledge is not sharply distinct from a fixed reality. Rather, the rudimentary world-stuff makes the theoretical generation of reality possible in two ways, that of the thinking man and that of the active, artistically creative man. Had Fiedler stopped there, with the assertion that man can fashion a conceptual world and a visual world, we should at least have had a clear conclusion. But his positivism prevents him from any such acknowledgment of creative reason. This positivism identifies the logical import of a concept with the psychological existence of the words thought, and in general regards intellectual activity as a conscious occurrence in the course of nature. Moreover, difficulties appear on every hand. The religious and moral problems which cannot be handled from this point of view are resolved by silence. The fact that artistic activity obviously starts with an already formed reality leads to the insertion of a rather obscure conventional world picture. But, above all, the non-figurative arts retire into the background, although Fiedler saw the proper approach to the art of words. "Language is not an expression of reality but a form of reality."

In the next case the considerations are simpler. (Since they concern particularly the problem of depth, we should note what Simmel has said on this point in Z.f.A., I. The dimension of depth, it seemed to him, undergoes a qualitative change in its translation from the real world to the picture. In the real world, he thought, the third dimension is not accessible to the eye, whereas in the picture it is directly perceived by the eye and wholly withdrawn from the field of touch. In opposition to this Gustav Münsel says in Z.f.A., II, 219: "The visual aspect of the picture is synesthetically supplemented by the tactual, auditory, and olfactory aspects as they are needed to form the idea of a real world. These other sense departments have a certain visual aspect, to which they are reduced in the picture.")

According to Adolph Hildebrand, the function of figurative

art is to portray the material world. (*Das Problem der Form in der bildenden Kunst,* 8th ed., 1910. A highly instructive comparison of Hildebrand's doctrine and Rodin's way of viewing things appears in Rudolf Bosselt, *Probleme plastischer Kunst und des Kunstunterrichts,* 1919.) Only at a certain distance do bodies have a unified appearance. This is true, of course, because a distant figure is also a two-dimensional figure, the relations of depth being inferred from the knowledge of near objects which we have acquired by ocular movements and accommodations. In perception at close range, I would say, we are too vividly aware of the temporal succession in the visual process for the unitary, timeless view of distant objects to occur. The further we remove the spatial from the temporal arts, the more vigorously must we insist on the law of the distant figure. For only there do we have the apparently timeless view in one single instant. Then draftsmen and painters would have an advantage over sculptors, as the former work on plane surfaces and need observe only the nature of distant objects, which are themselves planar. We also contribute to the flat picture the supplemental work we perform in looking at distant objects. The painter can artificially give his two-dimensional figure the very shape which nature imparts to a distant object, so that we seem certainly to be looking at a three-dimensional figure. (For convenience we identify the pictorial (or plastic) way of viewing things and pictorial (or plastic) art, although those distinctions are recognized in the particular arts. Hence we are justified in speaking of a picture's plastic effect or the pictorial construction of a group of plastic figures.) According to this view a picture is an organic whole of space and form. Its function is not to recount an event, but to convey a spatially intuitive necessity of the empirical world.

Hans Cornelius regards the matter somewhat differently. He says that if the figurative artist aims to give the observer an idea to appropriate, he should not repeat a certain way in which the object appears, but rather he must produce characteristic views of the object. "A view of the object which . . . evokes in the observer a definite idea of interconnections among shapes or colors according to law and not arbitrary choice—no matter whether or, if so, how far this idea agrees with the actual state of affairs in the object viewed—is called a characteristic view." (*Elementargesetze der bildenden Kunst,* 3rd ed., 1921; *Kunstpädagogik,* 1920.)

If in all figurative art the idea of the object is transformed in the way just described, if therefore even the plastic figure should

function like a distant figure, then the further statement (which we want to examine) can be made that painting and plastic art are equally committed to making depth intuitive. But the art of painting existed long before foreshortening and perspective were discovered as means of representation. Children and primitives, still unable to simulate depth on a plane surface, are eager to paint and take pleasure in it. The third dimension is added only in the development of the art; indeed, with the same necessity as that with which the muscular movement of the eye follows upon its visual capacity. We can still enjoy pictures which have been kept perfectly flat, and we all distinguish at once between them and the fully formed bodies of plastic art.

Very often there is occasion for the artistic treatment of plane surfaces, whether with or without color. Think of the trademarks on manufactured articles, the devices of printers and publishers, book plates and monograms. Since natural forms come from letters, or conversely, writing and reality perform a little dance together. Even empty spaces on paper are skilfully included in highly abstract patterns. The artist does not aim at pictorial effect and certainly not at corporeality. The whole design remains a flat surface and assumes only as much depth, mostly through shading, as seems necessary to clarify the parts. The communicative power of the line, which we have already encountered, is vastly increased in picture riddles. Heraldry is familiar with the term *speaking arms*, which means that escutcheon pictures, as it were, mark the bearer with a name (for example, a hen on a mountain for the Henneberg family). Although such speaking arms are not pictures, they can have artistic value. True to its origin even at the present time, linear art generally retains its connection with writing. On Japanese prints we find written characters, partly for elucidation, and partly for ornamentation. We also observe that the line of movement, so often seen and practised in calligraphy, on the whole influences the linear rhythm of drawing. The hand has become accustomed to hastily executed forms, put on paper with a brush or scratched into a palm leaf with a stylus. Other laws govern writing. And what is more important, while drawing is ever imposing new duties and winning new charms, penmanship is content with the practical goal of legibility (and does not always achieve even this). And yet handwriting can have an artistic perfection in contrast to which every piece of printed script leaves us indifferent. This is true, not because handwriting follows the trade rules of

calligraphy, but because, though lacking mechanical polish and precision, it satisfies the demands of personal definiteness, utility, and unity. (Cf. Lewis F. Day, *Alphabets Old and New*, 1899.) When artists have words to fit into glass windows or grids or drawings, they are seldom satisfied with the letters of the compositor's case. They alter the forms on each occasion according to the context. In his *Geometrie* Dürer gave directions for the design of two alphabets, and recently there have been potent forces at hand to refine and enrich our type.

From such facts we see at once that there is a many-sided artistic activity which is not at all concerned with the reproduction of the third dimension. When we give theoretical expression to its simplest form, we speak of the abstract art of lines and planes. In content it coincides with ornamentation and decoration. In the development of the art, these govern the beginnings and accompany all later phases with a modest auxiliary status. Formally it is concerned with a play of lines which is not supposed to be *a picture of reality* in any sense. Rather it is satisfied, on the one hand, with the aesthetic pleasantness of outlines and patterns, on the other, with application to pedagogic and practical purposes. (Of the many investigators whose thought moves in the same direction let me mention Oskar Wulff. According to his view, in spatial and decorative art rhythm governs the function of the measuring sense, as it appears objectified in the regular structure of linear systems, planes, and masses. But in figurative art the "reproductive principle" is dominant, with illusion as its goal.) As media we think especially of pen and pencil, stylus and graver, etching plate and wood block.

Lines have their own peculiar language and idioms. Like musical tones they can unite in discrete forms, or like an endless melody they can pass restlessly into one another, so that in principle they need not have any end. Even in such constructions a developed sense of form finds the definite law which a less sensitive eye recognizes only in the clearly discrete. Corresponding to the historical course of music and literature, the free rhythms of delineation have consciously evolved only in the modern period. The theory of these rhythmic forms has yet to be written. Metrical and free linear combinations are governed by the laws of unity, of radiation, and of repetition, while the mechanical balance of large and small, right and left, above and below, is confined to the less mobile structures in which symmetry is sought. In essence radiation and repetition also signify a unification. The former involves

ramification from a center or stem; the latter juxtaposes identical units, and indeed without scruple, since no real things are included as component parts. For real things resist repetition, and all the more resolutely, the more concrete they are. But the chief way to produce unity is to use provisional boundaries. When a pattern is drawn within a simple geometric figure (which, of course, can later be erased), the pattern is assured greater coherence. I might almost compare this compactness with that of a statue, carved out of a marble block.—Straight lines within closed or open patterns usually have constructional value. As verticals they sustain or stand fast; as horizontals they unite or separate. The effectiveness of horizontals is slighter, and so tends to be strengthened by repetition, by thickening, and by explicit involvement in the whole. Full-length horizontal lines evoke the feeling not only of breadth, but also of weight, of rest, indeed of sadness. Curves easily suggest movement, for we have seen countless times that the slowly falling hand or the thrown ball describes a curve.

The decorative filling of plane surfaces can be preserved in its essential nature even when color is added. Whether or not a tapestry is colored, the wall must be a fixed and final background, allowing no pictures in depth on its surface. Carpet design lost in force and individuality when perspective effects were introduced at the beginning of the sixteenth century. I once saw a Gobelin masterpiece of 1682, "Heliodorus Driven from the Temple," which showed four rows of columns four planes in depth. This imitation of an easel picture spoiled everything. In addition to tapestries and carpets, we might mention the lettered and pictorial posters which use color schemes to catch the eye at a distance.

Of course, most useful works of art are three-dimensional. As they share this characteristic with buildings, we prefer at first to familiarize ourselves with the principles peculiar to these functional works, or at least most clearly exemplified by them. So we shall consider respect for the material as a principle which can best be understood here. Two cases are to be distinguished. Emphasis can be placed on the costliness of the material which is worked into abstract spatial forms. That is quite proper if the outward appearance of the material is appreciated at the same time. For everything costly is rare and approaches the uniqueness of an artistic value. A similar respect for the facts (a respect which we demand in historical drama and regard as one of the legitimate effects of naturalism) leads us to preserve even accidental qualities

in the constitution of the material. The freakish play on iridescent vessels and the curious incalculabilities which crop up in the melting and casting operations of a glass works develop into a source of the finest artistic creativity. Furthermore, good industrial art tends to confer a general value upon the nature of the material used. It is true that the preference for cheap imitations is ruinous not only aesthetically but also morally, for it destroys all sense of the genuine, the sincere. And it is deplorable that the doctrine of aesthetic illusion has fostered neglect of material. But, on the other hand, we should not view the constitution of the material narrowly. Wood, for example, always permits the scroll lines of the rococo style. In all ages water vessels, or at least their inner spaces, have been produced by bending wood. A chair holds, props, and stretches round, when it utilizes the elasticity of the wood. (Incidentally, every one of us slaves of the writing table should have his working chair built not by a cabinet maker but by a muscle physiologist to fit the chair as closely as possible to the masses and forms of the body.) Wood is the very material for which Semper has shown convincingly that its deficiencies (relatively short duration, fibrous and hygrometric texture) contribute as much as its virtues to its effective artistic use. (*Der Stil*, II, 254 ff.) That accords well with the general insight that the limitations of the medium condition and promote artistic achievement.

A second distinguishing characteristic of functional art is ordinarily the utility of its products. Clasps, brooches, and bracelets, which are supposed to hold together, fasten, and enclose, get their form from their purpose. The chief problem of clothing lies in the mutual adjustment of usefulness and pleasantness. Yet we should not be too anxious for immediate utility. What lady's hat protects her head without itself requiring protection? But it tops her off and gives her head a magnitude which it usually lacks— and lacks with impairment to the total effect of the figure. In short, the hat crowns the bodily edifice, as it were, like a dome. Even this, from a merely practical point of view, is indeed an extravagant form of protection. Nevertheless, in both cases there is a symbolic utility which is artistically justified. In general, utility does not exclude decoration. In terms of crude utility, caps and flat coverings are excellent. But we know that bodily adornment and costume are intended to heighten an effect. So an element of exaggeration enters into their artistic pattern, which leads to ornamental exuberance and to very daring but also very charming inventions. This

excess should not be censured as inartistic, though so often it mistakenly is. But we should feel misgivings merely in the fact that the work remains completely tied to the use of man and cannot reach that self-sufficiency which Aristotle correctly made the mark of perfection. Now it would be a very naïve evasion to try to establish the independence of works of pure art on the score that they are constructed in useless forms. Unfortunately it has occurred and still does; we marvel at chairs on which no one can sit, glasses from which no one can drink. In this childish manner these things give a false appearance of the highest artistic perfection. But whoever sees in the useful object only a pretext for the unfolding of aesthetic charms errs like his opposite, who believes that bare utility accounts for everything. The truth is that the artistic craftsman has to start from the purposive, and so stylize it that the compulsion of the practical seems to have been transcended. So far as decoration helps in this task, it should not be sternly rejected. A glance at the history of the metal arts shows that the makers of utensils, fittings, grids, wall brackets, well covers, and such, have never tolerated anything unadorned. Or to take an example closer at hand, the cover of a book, which is intended to protect the leaves and hold them together, and ordinarily is visible only on the spine, from the standpoint of utility needs no decoration of the broad surfaces. But in particular cases I would not want to dispense with it. In preparing the interior of the book, certainly good paper, legible type, and dark print are always the chief factors; yet I would call them a beginning rather than a completion of the task. The aim must be to give the image of the printed page a spatial unity, whether in the manner of the old master, printing with dark surface and narrow margin, or in our manner, with brighter surface and broad margin. In any case, paper, format, and letters must harmonize. The same holds for the pleasing variety of captions and initial letters, embellishments and vignettes.

The third and last norm to be mentioned now concerns the sensuous appropriation of nature's primitive forms. We are not concerned with immediately visible similarity (for example, between the carved lion head on the back of a chair and an actual lion head), for theoretically such agreements belong to figurative art. Instead of the obvious relations there is a hidden kinship. In Aristotelian language, not the particular product but the entelechy, the constructive power working in the natural forms, is appropriated by the functional artist. Just as the projections and reces-

sions of a columnar capital catch the regularity of calyces and leaf formations, the construction of a piece of furniture or an implement is guided by the suggestions of nature. Nature shows that regularly convergent lines must have a certain course, that when rotary mobility is required joints are present, that there are only a few ways in which parts can grow out of one another. By comprehending the spirit living in nature, the masters of modern functional art have found new forms for the new problems set them. In their main features, of course, these new forms are always those old ones provided by the performance of work and the guidance of nature. Thus Gottfried Semper traced the four primitive forms of ceramics back to the four chief activities (grasping, scooping, filling up, pouring out) and to four natural prototypes (the gourd, the egg, the cupped hand, the horn with perforated point), "the purest expressions of these four conceptions of the potter's art." (*Der Stil*, 1863, ii, 7.) But there are also forms which have been detached from nature and imbued with their own life.

The chief features of architecture, to which we now turn, do not imitate the formations of nature. Does anyone still believe that Gothic architecture owes its origin to the spruces and beeches of the German forests? Even where architectural elements apparently reproduce plant forms, they have really come from other sources. Most examples which occur to us fall within plastic or purely ornamental decoration. On the contrary, even in architecture the inanimate seems to be transmuted into the animate. The column, which does not bear but lifts its weight, as well as the repetition of this occurrence in the forest of columns, is the favorite example. Against this interpretation of the slender supports, however, is the fact that they are not really constructively constituent parts of the building. Whenever—over and above the architrave—there is actually a weight to be sustained, a pillar is introduced. Moreover, the leaves, so often visible in the capital of a column, appear to hold up the roof—an illusion which might seem to natural feeling as a gross misrepresentation. Only the drum of the shaft can sustain, while the leaves are decorative. But even the drum does not sustain as we do. Use of the same word should not mislead us into personification. Whoever is permeated by such a feeling must combat the rectilinear and rectangular nature of architecture as insufferably oppressive. Baggesen has given very vigorous and witty expression to this feeling—directed, to be sure, against the architectural style of a whole city—in his delineation

of an informal and a formal city. "The latter," he says, "is not only compact and compressed, but cut out and pointed. The complete absence of right angles and four corners in the human form may contribute subconsciously to my revulsion from these straight lines, squares, and cubes. One fears that the inhabitants of such a city must collide with one another every day. . . . Here in Mannheim I freeze, I get stiff, I can't run and jump. I couldn't possibly fall in love here, at least not on the street—something that is possible in any crooked lane. All warmth, all movement, all love is round, or at least oval, and goes in spirals or other curved lines! Only the cold, immobile, worthless, and hateful is straight as a stretched string and angular. If soldiers were formed in rings instead of ranks, they would dance and not attack one another. So the whole of tactics rests on angles . . . his cold, fixed, biting teeth are the only straight thing in man, and nature has arranged even them in a semicircle! Life is round and death is angular." (Ellen Key, *Die Wenigen und die Vielen*, Ger. trans. of 3rd ed., 1905, pp. 269 f.)

Perhaps. But then architecture is precisely an art of death. Since we cannot get rid of what is present, but rather should explain it, we look for another view better fitted to the facts. Schopenhauer finds the meaning of architecture in the sensual exemplification of those Ideas "which constitute the lowest levels of the Will's objectification," chiefly weight, cohesion, rigidity, hardness. But these Ideas have no life like ours. Even apart from the question of their existence or non-existence and from the question as to how far they can serve as guiding concepts in the purpose and work of builders—every glance at a building convinces us that the ruthless hardness of the material confronts the observer with a resistance which no empathy can resolve. Everything architectural shows us a stiff and fixed stability wholly alien to our bodies and souls. The building stays in the same place, while our feet and our thoughts take us quickly from place to place. The building is visibly determined by mathematical laws quite alien to our inner feeling of life. The compact system of the Roman style rests on quadrature; that is, the square (a form utterly foreign to us) is the standard spatial unit. Finally, the dimensions are so large, as a rule, that we cannot feel our way into them empathically. In only one respect do we find that a building is akin to ourselves. In the opposition between depressive weight and upward counter forces, the relation of parts provides (along with extraneous conditions) the form of a familiar feeling. Such a conflict is something that we

know from the experiences of our unitary psycho-physical selves. For the nature of human existence is such that whenever we perform a bodily movement or make a decision, we become aware of counter forces. But the language in which architecture speaks of this is not our language. Stone architecture especially, whenever it is faithful to its material, stands firm and unyielding. It can take on the utmost delicacy, yet preserves the hardness of its material even in the slenderest spurs. Where the Gothic system of buttresses belies the hardness of the stone, only the moral value, which is realized whenever the earthly is overcome, can help to compensate for this violation of the integrity of the material. (John Ruskin, *Die sieben Leuchter,* Ger. trans., 1900, p. 112.) Moreover, in this way architecture is generally drawn into the softness of the pictorial arts. So far as the conflict just mentioned between pressure and counter pressure occurs without the help of other arts, it plays itself out as fixed, rigid rebound, or—put more correctly—it remains in the same place, as the irresolvable opposition of blind natural forces.

Even this should not satisfy us. As a matter of fact, in countless cases we are not at all concerned with such a conflict between force and weight. Our living rooms resemble neither dramatic action nor the opposition of musical parts. We do not want walls and ceilings, windows and doors to remind us of active forces and their counteraction. (We have doors and windows to connect us with the outside world. The floor, walls, and ceiling of a room are there to enclose and protect us. So Edgar Allan Poe in his "Philosophy of Furnishing a Room"—trans. by Baudelaire—objected to the then popular grand mirror. Poe depicts admirably the smooth, colorless, monotonous surface of the mirror in all its offensiveness. Very cleverly he shows that a large mirror as a light-reflecting plane surface—and all the more so a number of such mirrors—removes the forms and boundaries of a room. Moreover, Poe is also a forerunner of modern views in his over-estimation of applied art. "An authority on legal questions can be an ordinary man; an authority on carpets must be a genius. And yet we have seen people discuss carpets with the expression of dreaming cattle.") A room is, as it were, the final, outermost enclosure of the body. It must be disposed about the body as restfully and protectively as clothing. A room furnishing which reflects a lively, vigorous mood or an artistic personality is ill suited to the fluctuating demands of the human spirit on its environment, most ill suited

to the needs of the intellectual worker. "With the exception of those who from youth have been accustomed to such surroundings, splendid rooms and elegant furniture are for people who don't have any ideas and can't have any," Goethe said to Eckermann. (Quoted by Hermann Muthesius, *Kultur und Kunst,* 2nd ed., 1909. Muthesius adds the striking figure that in such rooms one must "plug his tectonic ears with medical cotton" (p. 5). Cf. also Muthesius, *Kunstgewerbe und Architektur,* 1907, p. 122 f., and Fritz Schumacker, *Streifzüge eines Architecten,* 1907, pp. 69 ff.) Naturally, whenever it is feasible, we should preserve a color scheme, cover the walls suitably, enliven the ceiling pleasantly, but all this only so far as is possible without any obtrusiveness or disturbance of the architectural structure. For this structure the persistence and opposition of inorganic forces can hardly stand as a formula of exhaustive explanation. The discovery of completion in suitability is close to the true formula. Indeed it is the true formula, provided we add that the use of space in accordance with reason and function is the guiding thought. Thus the dwelling house should be so adapted to human needs that it also helps to determine the nature of architecture, the art which patterns space. Also, for all large business buildings and stores, the design and lighting of the interior are the decisive factor. It is inexcusable that even now theaters are always constructed with the Italian box-hall as a model, and externally do not adequately show what they are. Gottfried Semper was the first to voice the conviction, "based on the fundamental views of architectural truth," "that so essential a part of the edifice as the rear part of the building, with its auxiliary spaces surrounding the stage, must be expressed and characterized with the utmost independence." Lichtwark has shown how absurdly most museums are built. Since all our love is lavished on the magnificence of the façade, museums become quite unfit to serve as storage places for works of art, and the galleries are degraded to promenades where we find as little rest and composure as on a bustling street. Christian Rang's statement seems to me worthy of note, concerning the extent to which the form of grand Lutheran churches should be altered. He wants unity of the entire space and a central plan with the altar in the middle and a pulpit visible everywhere. I am inclined to think that the usual placement of the organ and choir balcony should also be changed, for it makes a listener uncomfortable to turn his back to the source of the music. In the last three examples, drawn from a wealth of similar ones, tradition hinders

free, realistic planning. That is not the case with department stores, mentioned still earlier. But here the necessity of maximal light threatens to destroy altogether the impression of a closed space. The skeletal style of iron construction makes it possible to reduce the solid parts to a minimum and in the main to show empty places. This prevalence of exciting window decoration is already proving incompatible with artistic architecture. Moreover, being flexible and available for any use at will, iron imposes no coercion of any sort on the architect, and such license endangers the life of every art.

To sum up in a few words, the end in view should first of all determine the interior configuration of space and, by means of this, indirectly control the outer structure. Here we have reached our goal. We understand now that we are concerned with the shaping of space and its influence on the feeling for space. Generally now—following Schmarsow's example—three constituent elements (of course, always mutually involved) are distinguished in the origin of the architectural enclosure: tactual space, kinetic space, and visual space. Of this room for activity, articulated in these three ways, Schmarsow says: "The portion of space which surrounds the person as operating room is the thing first of all desired, not the erection of material masses, which we use for the realization of this space. All static and mechanical preparations, like all construction of walled enclosures, are only means to this end." (*Grundbegriffe der Kunstwissenschaft,* p. 184.) The conceptual configuration of space, created by man for man, can be governed by the horizontal axis. In this case we see and feel space in terms of longitudinal perspective. Or, as in the Gothic style, the vertical dimension can be stressed. Or, finally, in the central building a capsule (as it were) can be formed, which lies around the focal point (the observer, the tomb, the statue) in a circle. All three possibilities can be made more effective by repetitions and articulations. If this occurs individualistically, as in Norman architecture, a different mood arises from that in the Gothic, which excludes all choice and carries through consistently the regularity of the structure.

Nevertheless we should observe that the unified configuration of space which springs from the thought of a purpose needs supplementary aids to insure architecture a secure place among the arts. Nothing is a work of art merely by virtue of a need. In this the building is like the human body; the skeleton, the hidden sus-

tainer of the whole body, needs the flesh to fill it out. We enjoy the rounding of the forms, their harmony and elegance, without discovering at all how this is achieved. Viewed at a distance, the structure of the building never stands out clearly. Its relation to neighboring buildings, its site, and its silhouette interact here. And especially the color, which must be more protected in the damp air of the north than in the sunny south; Bruno Taut does not give sufficient attention to this in his Magdeburg project. For the furniture and interior decoration in oriental countries cool colors are preferred, in occidental countries warm colors. As you know, we have to picture the monumental buildings of ancient Rome entirely covered with paint. Furthermore, even the shaded masses which appear on a building produce fine nuances of tint.

When we reexamine our total impression of a building, taken in at a glance, we are reminded of the law of the distant picture, a law discussed at the start. For the main lines and the colors of the building, which appears to the uninstructed eye as a plane surface, give a pictorial impression. But even in this respect architecture is still an art of unreal forms and hence different from what we call pictorial art. In its essential features architecture is the art of the abstract treatment of space.

2. Sculpture

Mathematics has accustomed us to regard material objects and space as the same. Epistemology also tends to comprise both within the concept of extension. But in art space is a bounded vacuum, only (as it were) a possible place for material objects, whereas the object itself is the filling of a part of space. In architecture the inner space is decisive, and its shape can be ascertained from the outside. In sculpture the controlling element is the outer form of the body, which we always imagine as solid, even though it is really hollow, and whose surface seems to be the broad projection of a body springing at us. In architecture we are concerned with the effect of abstract space, in sculpture with the effect of concrete form. The former art has little in common with organic nature, the latter a great deal. Between the two stands an "art of bodily masses" which we admire in obelisks, architectural monu-

ments, and tombs. This art is related to the forms of inanimate reality, shows their characteristic rigidity and endurance, remains abstract—and yet is the creator of material values, not spatial values. The relief is appropriate to monuments. (In Z.f.A., III, Richard Hamann distinguishes three functions of plastic decoration: to fill and adorn space, to serve as a structural part of an edifice, to ornament a flat surface (relief); he also recognizes three styles: archaic, classical, and baroque.) The low relief has a fixed support in the wall, which also bounds it, and is only a slightly raised decoration of this surface. The high relief is more detached and approaches plastic representation in full depth. The low relief is seeking the effects of painting. A special case appears in the base reliefs of equestrian monuments, to which the man in the street gives a fleeting glance. Unfortunately, the most extensive and also most intimate kind of relief—medals, coins, and plaques—is still adequately appreciated only by specialists and collectors. This minute plastic art is an art of ideas which offers solitary absorbing satisfaction.

But even if monuments and reliefs should grow more numerous than statues, the uniqueness of sculpture would thus become clearer. We can first characterize sculpture in a formal respect by asking how a statue is to be viewed. Some theorists think that the observer's standpoint should be close. As we saw in our discussion of the distant form, when an observer is farther away, he gets the impression of a plane surface, opposed to the intended three-dimensional bodily nature of the statue. The spectator does justice to this bodily nature only by confining himself to so small a circle that, in walking around the statue, he might almost be said to touch its various facets, one after another, with his eyes. Against this view it might be said that of course the constantly coherent visual form of the object is connected with ideas of movement, but that on the other hand, restriction to tactual proximity and preference for circling around the statue threaten to destroy its unity. (Cf. Richard Hohenemser in Z.f.A., VI, 405–19: of the blind person he (who himself is blind) says that even for him the touched bodily forms do not come to express aesthetic value.) The issue concerns determinateness, even detachment. In every measurement he takes, the worker is striving for determinateness, and the artist seeks expressly to achieve detachment with the help of a base. What the frame is to the picture and the stage to the dramatic performance, the base is to the work of sculpture. The base

detaches the statue from its surroundings and quite externally marks it as existing independently. Here a certain height tends to prove effective by forcing the observer to deviate from the normal line of sight. Mimic performances on the floor level of the spectators strike us as inane and inartistic. The actors do not seem to be representatives of another world, but people who belong to us. In the same way it surprises us—or better, it induces an inappropriate feeling of familiarity—to have pictures hung at the height of our eyes. So it is with statues whose feet rest where ours could also be in the next instant. Since detached, self-enclosed unity is held to be so important, the close standpoint of tactual sight and the wandering walk about the statue can hardly be admitted as appropriate.

Included in this reflection there is a further point, which I have only to express more clearly. In 1849 Ruskin showed (in *The Seven Lamps of Architecture*) that the sculptor extracts from the stone not the form of a thing but the effect of this thing, and that he does this, to be sure, because the true form, imbedded in the marble, evokes an experience very different from the natural experience. A statue is not a petrified man; a bust is not a filled-out death mask. Hollows and humps in works of art need not represent realities at all, but are there to distribute light and shade properly. So in exemplary products of ancient sculpture there are the sharpest deviations from the original objects. The impossible "forehead of the gods" is a familiar example. Also the inclination of the best Greek artists to decrease somewhat the stiffness of the bones, to enhance the effect of a movement beyond the extremities in the joints, has been discussed for decades. (Probably first by W. Henke, *Die Menschen des Michelangelo im Vergleich mit der Antike*, 1871, p. 11.) Modern sculptors resort to the most unusual means to avoid the confusion of visible and tangible form. I will not venture to decide whether or not there is a lasting gain in the practice of eliciting from the block a form whose meaning would be justified wherever we might suppose some miracle of creation. But we all approve the protest thereby expressed against identifying the material world of art with that of nature. We hail the technical advantages which enable us to subordinate our knowledge of things to our visual impression and to give the plastic work all the charm of the veiled, the atmospheric, and the mysterious.

In spite of its opposition to knowing, the term *visual impression* means a seeing in which "the eyes of the mind have to

work in constant, vital union with the eyes of the body" (as Goethe wrote in the essay on Purkinje), a seeing which will not dispense with the inner supports. In a book which he chose to call *Expressionism* (1916) Hermann Bahr organized the history of figurative art—quite differently from Wölfflin—according to the kinds of seeing: (1) into ages which trust themselves to the eyes of the mind (like almost all primitive and Oriental art), (2) into ages which let the eyes of the body prevail (like Greek art after the Apollo of Tenea and every art in conformity with the Greek), (3) into ages of struggle (Gothic sculpture and Baroque art) and attempted compromise (Leonardo, Rembrandt, Cézanne). The greatest difference is said to exist between the art of the East, which accepts outer charm in order to unmask it at once as illusion, and impressionism, which aims to surprise nature before it has yet been theorized. This interpretation, as ingenious as it is drastic, doubtless rests on that genuine opposition, concealed under many masks, the opposition of idealism and realism or abstraction and empathy. A great gulf separates the material world of art from that of nature. Even the often misunderstood "characteristic views," which Hans Cornelius expounds, are converted by the artist into creative ideas of an object, a systematic unity of appearances, not memory images of a single appearance. The sculpture of (say) an Archipenko is most highly inferential. He leaves little to sight itself, least of all anything real; for this he relies all the more heavily on the associated movements of our bodies. Visible things are always connected with the outer world, the feeling of movement with the inner. Hence an artistic practice which counts on kinaesthetic cooperation is closer to the inner and thus the spiritual realm than a mode of plastic art entirely open to visual inspection. This raises the question concerning the discrepancy between the color in nature and the absence of color in sculpture. The older aesthetics found the contrast valuable chiefly because it prevented a confusion of reality and image. Vischer has shown in detail that a painted statue resembles an inferior wax figure and that in this way the boundary between sculpture and painting is erased. But other specialists have recalled the multicolored sculpture of the Greeks and have challenged, also on principle, the exclusive dominance of a chalky tone on the surface. The so-called achromatic sculpture, they say, has at least one color which absorbs and reflects light. Moreover, various color effects have always been produced by the ever-present color in marble and its crystalline texture (grain), as well

as by the green film (patina) of bronze and copper. I have never been able to accept this line of argument. For it seems to me that such unavoidable and yet abnormal color harmonies have nothing to do with the problem. We do not call drawing an art of color because the paper is accidentally or intentionally tinted. Should the memory of Greek art, as it may have once existed, influence our present feeling at all? Our best sculptors, even those versed in painting, hesitate to use bright colors, and whenever they produce a polychromatic work, it is received with indifference. The uniqueness of sculpture lies in the artistic transfiguration of organic bodies, when this is confined to pure form, and thus (as Aristotle rightly said) to the divine in man. Whatever is not necessary for the complete realization of this end can be discarded without harm. Thus it is with color. At an early date, to be sure, colored sculpture made a place for itself, but more in the sense of a custom and religious practice than from the inner force of conviction. Probably we should think of the state of mind of Greek artists and spectators as like that of Alpine wood carvers and the purchasers of their figures. Although contributing to the richness and warmth of the work, perhaps with a touch of the Asiatic love of flamboyance, color nevertheless also includes the luster of the polished stone and the hammered gold, material qualities which are incompatible with the use of colors in painting statues. Red and blue, seen against white, are pure, strong colors, almost abstract in nature. We see their effect in Tanagra figurines, which lost their original union with pottery and found their closest connection with sculpture.

A broader problem of sculpture lies in the portrayal of movement. At least, this general problem of the figurative arts is most prominent here, for sculpture requires precisely the active, spontaneous person. The solution is rather generally found in the fact that the individual figure and the group can make us see the progressive unfolding of an event, whereas snapshot photography fixes the assembled parts of a moving body in the same hundredth of a second. Rodin is supposed to have discussed this explanation in great detail. In reference to Rodin's John the Baptist, Paul Gsell makes the essential principle clear in this way: "At first resting on his quite firmly advancing right foot, John seems to shift to a swaying position, the more our glance wanders to his left. We see then how the whole body is inclined in this direction, how his left leg moves forward and his left foot treads imperiously on the ground. At the same time his right shoulder, held up, seems to be

trying to shift the weight of the trunk to its side, so that his trailing left leg can move more easily. The art of the sculptor lies in conveying to the observer all these static considerations. Then their sequence can produce the impression of movement." (*Gespräche des Meisters*, 1913, p. 54.)

We started with the position that a work of sculpture cannot be created for tactual consideration at close range. With such contact its unity becomes almost impossible and the actual form of the body, instead of the artistically altered form, comes to be the object of regard. Since the nude body is aesthetically enjoyed, and aesthetic enjoyment is simply identified with the understanding of artistic tradition, this erroneous doctrine persists. In fact, however, the term *sculptor* (*Bildhauer*) indicates that the artist hews (*hauen*) an *image* (*Bild*) out of the material, and an image implies contact with concrete reality (in opposition to abstract spatial art) but at the same time signifies an effective difference from the forms of existence. Only by observing the masterpieces of this art can we discover how the image-character is achieved. Several techniques we learn from history. One of the most original and effective is to stress the vertical axis as the chief line of sight. The upright position, which we human beings feel is the most natural for us, insures a balance of all bodily members. In certain circumstances, of course, we can keep the mutually opposed elements from falling apart by calling special attention to the horizontal axis. But somehow a discrete figurate bodily unity must come into existence. Hence the Greeks chiseled their statues directly out of roughhewn rectangular blocks, and Michelangelo said (if we may draw from a rather questionable source) that it must be possible to roll a statue down a mountain side without breaking off even a chip. The same centricity and rotundity are present in the sculptured groups, of which the Wrestlers in Florence is a fine example. Groups are the very cases in which we note that the unifying force is revealed, not in manual and optical contact with the parts, one after another, but in genuine visual perception—indeed, essentially only in the complementary idea which takes the various bodies present as members of a bodily whole not present.

Modern sculptors work in a different way from the classical masters. The modern manner is modelling. It enhances the effect of the silhouette and animates the inner delineation by superficial distribution of light. At best, bronzes show how the form can build itself out of the encompassing unity of the effective silhouette together with the variety of the juxtaposed planes, without being

rounded off in the old way. Yet the result, the artistic experience of material bodies, remains the same. Whether the experience comes from the predetermined play of light and shade, from an almost impressionistic modelling ability, or from the repose of the forms themselves, nothing changes in the nature of the goal. So the theory need no longer be bound to the criteria of content, which have heretofore been generally applied to this art, in harmony with the formal uniqueness of Graeco-Roman sculpture. While earlier aesthetics confined the material scope of sculpture to pure beauty, to the purified, typical, general, directly idealized (Vischer, *Ästhetik,* § 603), our science also recognizes the estrangement of the spiritual and the bodily. We have no objection to the portrayal of the ugly, and approve the "discovery" of the working man, along with a wealth of his routine daily activities, for plastic representation in full depth. At only one point, if at all, do the current views differ; that is, as to whether our clothing is a possible subject for sculpture. Those who believe it is should not cite as evidence the successful use of working clothes, for these have a certain timeless and unchangeable aspect so far as they always serve the same purpose and exclude everything superfluous. Aside from these, only trousers, it seems to me, are in some measure susceptible of pleasing artistic treatment. They show the lines of the leg and still retain the necessary independence in their folds and creases, which themselves have good form and also indicate the most frequent movements. All our other items of apparel for men and women conceal the anatomy of the body in their arbitrary measurements. Indeed, still worse, they are quite indifferent to the social and particularly the inward distinctions among people. Nevertheless, it is a very unfortunate remedy for nineteenth and twentieth century sculptors to represent their contemporaries nude. The absurdity of the practice is not mitigated by the fact that the figures imbedded in stone masses often bear no greater resemblance to human bodies than the freakish formations of mountain rock which get name and fame from such similarity. Sentimental prophets of a return to nature reproach our age for its inability to appreciate the beauty of the nude body. They fail to see that clothing is a human creation which distinguishes man from the lower animals and which, for this reason alone, must find a place in art. Furthermore, clothing which clings to the body can show bodily forms, and clothing which hangs in great folds or flutters in the breeze can show bodily movements. The point is simply that our artists should discover those styles of modern dress which express bodily form and movement, on the

one hand, inner nature, on the other hand, without disturbing or confusing the eye.

Greek sculpture does not portray strong spiritual excitement convincingly. To establish the difference between nature and art the immediate efficacy of imitative copies was replaced by the production of ambiguous types. Consider the countenance of Antinoüs in the Albani relief. Which emotion does it express? The interpretations of the most distinguished connoisseurs of art have been collected. "One speaks of innocence, another of lust; one of naïveté, another of coquetry and conscious sham; this one of apathy, that one of wildness. One writer sees gentleness and mildness in his features; another sees something bold, rough, proud, malicious, even cruel. Sweet comfort is found in his face, quiet tranquillity, reverie, rapture, and ecstatic love; then again something earnest, pensive, slightly melancholy, a touch of depression, deep sorrow, blind yearning, sad resignation, something dismal, rigor mortis, a hopelessness, inner dismemberment, loathing of life, real despair, pessimism, renunciation and mortification, dark fanaticism." (Ferdinand Laban, *Der Gemütsausdruck des Antinoüs,* 1891, p. 68.) This diversity of views rests not only on the fact that every art historian reads into the object the basic mood of his own time and the emotional tendency of his own personality—this has already been mentioned and will be again later—but especially on the indeterminacy of the typical face. The task awaiting sculpture of a different sort is to preserve the attractiveness without the indeterminacy in the expression of feeling, the proper limits of an image without the sacrifice of individuality. We see progress in plastic art especially in the way in which it has deviated from reality and the organized body is freed from the bonds of necessity and impermanence. Its indestructible connection with the empirical expressions of the organic world secures sculpture against becoming a mere play of lines.

3. Painting

First of all we should briefly mention a few principles which apply to drawing as well as to painting. In this way we shall see at once what distinguishes painting as superior to the

graphic arts. We must keep in mind that we have three basic constituent elements with which to work: line, brightness, and color. Pictorial unities can grow from each one and from their combination. Lines appear partly as outlines of things, partly along surfaces of light and shade. Gradations of brightness are independent of things and correspond to differences of pitch among musical tones. Colors are often so independent that they illustrate something spiritual. These three visible worlds can remain superficial or become corporeal.

I have already talked about painting as surface decoration. Now, if the artist sketches a picture on the surface, that is, introduces transformed reality, his procedure is the simplest and nearest at hand. It dispenses not only with the dimension of depth, but also with the elaboration of the background. Above, below and between the figures there is empty space or a quite inadequate suggestion of the surrounding reality. Excellent examples from this period are found in Greek vase paintings. On the François Vase (575 B.C.), on a cup by Euphronios (500 B.C.), and on a hydria by Meidias (425 B.C.), the figures alone concern the artist and are brought into a coherent unity without perspective or the filling of the intervening spaces. But technical problems have stimulated the painter just as often as factual ones. The graceful animation of dancing women and the great epics of heroic deeds are just as important as the events and the persons whose names have been appended. (Let me quote a description to show how technical difficulties were overcome. "Three women follow, placed close together, each in a differently decorated shawl. For the sake of simplicity the shawls, which are to be taken as wrapped around the shoulders of each woman, are shown as one shawl, only on the right shoulder of the first and before the left shoulder of the last figure. This does not mean at all that one common garment suffices for the three. It is merely a readily intelligible convention, familiar to the painters of this early period. Only in this way was it possible to represent the figures so close to one another in file. Otherwise the mantle of one woman would have concealed another."—Furtwängler and Reichhold, *Griechische Vasenmalerei,* 1904, p. 4.) Medieval illuminated manuscripts also offer fine examples. The portrayal of depth is omitted or replaced by the elevation of two planes; the composition is somewhat like that of a carpet; air and clouds are hardly ever shown. The neglect of the third dimension and the interpolation of negative values among the positive, of

pauses (as it were) among the tones, produces a very charming incompleteness. In some measure it recalls the peculiar value of sketches, which often seem more artistic than the finished pictures. And it teaches us once again that the ability to leave something out is depreciated only by a perverse scrupulosity. Finally, Oriental painting avoids illusion and strives for an expression of mood instead of a representation of space. Oil colors, which appear mostly as media to copy reality, are rejected and replaced by neutral absence of color.

In many ways the superficial representation of figures with intervening spaces is supposed to indicate lapses of time. Although this task is also involved in plastic art, it becomes really urgent only in the other kinds of figurative art. And here the advantage of music, mimic art, and poetry is apparent at once. In Kantian language, time is the form of the inner sense and of all living reality. Insofar as something psychical or an event of life forms the real content of time, the arts of that temporal group seem to have the more suitable means of expression. To be sure, the parts of a rather large spatial object are taken in by the observer, one after another. But he distinguishes the successive contents of consciousness which correspond to an objective temporal event from those based on a spatial order. Counting as evidence against the agreement between outer and inner lapse of time is the fact that painting can retain only a couple of moments in a perpetually unfolding series. And in its recent forms painting is content to reproduce a single instant. We are freed from this contradiction in part by our own attitude and in part by stylistic media of figurative art. The subjective supplementation does not consist, as might be supposed, in the introduction of visual images which mirror the preceding and following parts of the action, but either in conceptual additions or in motor interpolations.

Now how does the artist meet our demand and our attitude? In ways so various that we must get a broader background to answer the question. Until early in the sixteenth century pictorial chronicles were produced, mostly on horizontal panels, telling a story as continuously and fully as possible. Then, by enclosing the chief episodes of the narrative in one frame, the artist produced visual impossibilities. The same figure was present more than once on the same plane, vigorous movement to the right and left was illustrated by two heads or four hands, and so on. These almost unavoidable defects of a continuing visual account can be tolerated

as stylistic aids only by a very lively and charitable imagination. The transition to conceptual-linguistic communication occurs almost inevitably, since illustrator and painter started with this and used other means of communication (so to speak) in a pinch. A better procedure is to depict the causes and effects along side the act, so that several principal scenes are selected, although the whimsical paradoxes just mentioned are avoided. But this form offers nothing novel. New problems are introduced only when the selection is so narrowed and the action so shortened that a single instant remains, from which all that precedes and all that follows is to be inferred. The simplest case would be to represent a movement all at once, not by several glimpses of its course. Does the painter choose an instant at will and give us faithfully the picture to be seen then, as in a photographic snapshot? If he did, he would often arrest the most awkward and unrecognizable postures. So he selects and, of course (as we have long known), chooses those phases in which the movement is relatively slow. The observer retains the clearest memory of these. For example, if a written scroll or a pack of cards is spread out before his eyes, the word on the card with which the movement stops stamps itself on his mind. As most movements show some natural checking points, the effective moments are thus indicated in advance. Only very slow and very fast movements leave the choice entirely to the figurative artist. The first beginning and the last end are always excluded, because in both cases the event is not shown clearly enough, at least not without light from incidental circumstances.

A further point should be stressed. The so-called fruitful moment must have not only factual reference but also the ability to give the composition artistically correct form. Since even with strong stylistic tension an instant of actual time, however pregnant, usually does not meet both these demands, pictures portraying human figures generally show several instants or, in other words, artistic instantaneity. The fleeting present is caught and held only in modern pictures, whose authors have learned from photography, and in certain products of Japanese art. Our earlier art, on the other hand, extends the instant by uniting temporally various effects of the event to give the appearance of simultaneity. The painter must proceed in this way with all the greater motifs, because the dramatic aspect of an event is revealed as it comes into existence and fades away. And even with materials of less importance, the law of variety usually requires a fictitious temporal order. The artist

enjoys the same freedom in relation to time as he does in relation to space. In Raphael's Transfiguration a high, distant mountain has become a low mound in the foreground. Christ, hovering above, is not seen by anyone, not even by the two Apostles pointing in his direction. The real spatial relations have been wholly changed for the sake of the artistic purpose. Nevertheless—and this seems most remarkable—the painting retains a spatial unity of form and a temporal unity of conception.

There are two possible ways to achieve spatial unity, whether in two dimensions or in three. One way leads through light and shade, the other through the realm of colors. They are not mutually exclusive, for every bright color is a light in contrast with a dark color and a shade in contrast with a still brighter color. The masters of the Venetian school brighten their red with pale pink and darken it with deep carmine. But Holbein's earnest and severe art lays all the emphasis on light and shade as such. Rembrandt unifies space, as he unifies bodies, by the light itself and its gradations, ranging down into deep black, often without any regard for the object portrayed. In general, the old masters toned down the local colors, letting the foreground retreat before the relative dominance of the background and middleground. Especially in Dutch pictures of the seventeenth century we can observe how the dull colors, which belong to the far view as opposed to the near, disappear into distribution of light, and how this leads the glance from the first visual plane to the last, from the border to the center. If we ignore quality of color and examine degree of brightness, many pictures give us the impression of an irregular pattern in which light and dark are opposed. Ordinarily there is a principal light, to which the others are subordinated, and the darkness increases as we move outward. Even if the foundation, on which the painter (like the architect) erects his structure, is bright, shadowy masses usually lie along the borders. (Cf. Thomas Couture, *Méthode et entretiens d'atelier*, I, 231: "To sum up. The foundation is most important. (Complementary colors harmonize [red and green, yellow and blue].) The dominant color should be bright and centered. The somber colors should increase toward the edges. Total: good conditions of harmony.")

The genuine colorist transposes all light values into color values; he seeks to express every opposition through a color contrast. All by itself a color combination can evoke definite spatial feelings. Vivid shades drive the others back. Red seems to pursue

the spectator, while blue draws his glance into the depths of the picture. Color spans gaps and unites those parts which would have no mutual affinity in a drawing. It allows parts which belong together to interpenetrate; it separates what would otherwise blend; it imbeds parts in a background or releases them from a background. In short, the interplay of colors has spatially constructive power. In difficult circumstances it induces the eye, as it were, to draw unconscious inferences from which the intended spatial effect springs like a full-fledged logical conclusion.

But the masters of the palette value color harmony even aside from its contribution to structure and arrangement. In fact, color combinations please us independently of the forms on which they appear and of their possible meanings as to the nature of reality. In stained glass and gorgeous illuminated manuscripts we find festive use of gold and silver, and we see green hair, blue horses, and purple leaves. Botticelli is said to have declared boldly that we do not need to study landscapes, that a color-drenched sponge, thrown at a wall, gives us enough landscape. More authentic is Whistler's remark about a blessed time when the public no longer demands any objects, but is satisfied with color combinations —no more figures or landscapes, only tones. It is said that in his late period Böcklin followed the principle of an arithmetic exercise in three color groups (perhaps green in the foreground, red in the middle, blue in the sky). The two other colors accompanied the chief one on smaller surfaces. For example, in a green meadow there would be red and blue flowers; in a cloudless blue sky, green leaves and red blossoms. The lawfulness of the color formula, a lawfulness shown most effectively in its conscious deviation from the natural prototype, rests on elementary aesthetic processes which have been previously discussed. In the technique of painting, harmony is achieved by using the whole color chart or selecting a triad. But the triad has essentially the same effect as the whole, for we supply the missing colors with a fair degree of clarity. If we exclude black and white, then yellow-red-blue should first be mentioned as the combination consisting of unmixed colors. Quite often we also meet the triad, orange-green-violet. The effect depends largely on how the pigments are handled. Impressionism plays down local color which clings fast to real things like coverings, in favor of the loose, floating, incorporeal (as it were) color expanses which we see in looking at the sky, for example. Pointillism, which (so to speak) forces the eye to mix colors, robs them

of all materiality. The difference between the smooth and the granular application of color leads to correspondingly different results. (Whoever insists that pictures can be enjoyed even with a magnifying glass must put his pigment on thin.) A thick application produces greater luminosity, and the rough surface of the picture does not matter if the observer stands at the right distance, which is greater than the one prescribed by the academic rule that it correspond exactly to the area of the picture. Inspection at close range is also unfortunate for paintings produced by a juxtaposition of the color elements, the mixture of the little dots or rectangles being left to the eye. But what aesthetic or moral precept demands that close inspection yield pleasure?

Of course, the red and blue points which blend in the retina to form violet are unnatural. But every use of the brush, whether with broad strokes or with hooks and tails, is different from nature. To evaluate the separation of colors and the speckled style we merely ask what they accomplish. Much. The luminous atmosphere, which changes colors and forms, decomposes them into radiant particles, and from every side shows a unique aspect, cannot be conjured to the canvas more surely by any other technique. When white points are interpolated between the colored dots or are produced by intervals in the bright priming, we get the most intense luminosity and the liveliest impression of sparkling light. Everything becomes mobile, fluctuating, pulsating, fluttering; the objects and their proper colors almost vanish in the streaming and quivering light. This removal of all boundaries, this evaporation of things into a highest unity, which in turn is only relation and movement, this is like the confession of a philosophical relativism. And the resolution of given objects into their smallest constituent parts was well suited to the age of the microscope and bacteriology. Finally, it gives us great stimulation to realize that by changing his point of view the spectator can make a picture now a chaos, now a cosmos, that he must cooperate with the painter in creative activity, supplementing the scarcely perceptible, clarifying the confused. Nevertheless, this style of painting is no artistic panacea. When we want sharp delineation, as in painting on walls and ceilings, when a human face is to be reproduced with recognizable similarity and detached from its context, when rigid rocks protrude clearly or dusk and night are to be portrayed, Impressionism is inadequate. No less inadequate is Expressionism, which seems to us in its purpose the opposite, yet in its formative activity almost the further development of Impressionism.

If Vincent van Gogh should be called an impressionist, the following confession could be attributed to a school. (The younger generation will have nothing to do with his blustering sentimentality; Picasso calls him a "tender street-Arab.") But to me these words from his *Letters* concern the true feeling of every pictorially minded painter. (Did Vincent really *paint* pictorially? Perhaps agitated lines were his most appropriate form of expression.) "Last Sunday I began something which has haunted me for a long time. It is a view of a flat green meadow studded with haystacks. A cinder path beside a ditch runs obliquely across it. And on the horizon in the middle of the picture, there is the sun. The whole is a mixture of colors and tones, a vibrating of the entire color scale in the air. First, there is a lilac haze in which the red sun stands, half concealed by a bank of dark violet cloud finely bordered with bright red. In the sun there are vermilion reflections. Above that a strip of yellow shades off into green, farther up into a bluish hue, and finally into the palest azure. Here and there lilac and gray clouds reflect the sun. The ground is like a rich carpet of green, gray, and brown, full of shadings and life. The water in the ditch glistens on the loamy soil." (*Briefe,* ed. B. Cassirer, pp. 3–4.) In the fullness of such color inflections we can find the necessary counterpart for the transient fluidity of purely Impressionist pictures, the variety in the unity of the distant scene. And we may point to such men as Matisse who, like some previously mentioned masters, combine dots into colored areas, in which spatial depth is at most an added suggestion. Indeed Cézanne, another pictorial painter, tries to represent depth openly, without destroying the unity of the picture. He seeks to create a fixed space with background boundaries. The differences between van Gogh, Matisse, and Cézanne (who so often are mentioned all in one breath) seem almost more important than what they have in common. Then from Cézanne a frequently discussed development leads to the Cubists. (Cf. Franz Landsberger, *Impressionismus und Expressionismus,* 2nd ed., 1919; Paul Erich Küppers, *Der Kubismus,* 1920; Georg Marzynski, *Die Methode des Expressionismus,* 1920.) Whoever wants to give Cubism a meaning (which, to be sure, still does not imply a justification of its products as having artistic value) will use the following consideration. Space is not what the aestheticians have said, a boundless vacuum; rather it has a plastic power. "The form of everything in nature is based on the cube, the cone, or the cylinder"—so runs an often cited saying by Cézanne. Thus active spatiality radiates out into the forms of things.

To show this is the goal of figurative art, which becomes a new art of space. It makes the spatial dynamics of bodies visible and lets the lawfulness of space in general appear. To this end it may—indeed, it must—destroy our image of nature, for in nature's empirical arbitrariness the Platonic Idea of space is revealed only imperfectly.

There is no need to prove in detail that this new brand of essentialism is just as abstract and pedantic as any of its predecessors. To be sure, it remains within the realm of the aesthetic insofar as it exalts space, not something transempirical, to the status of an Idea, but it takes the work of art out of all working connections. Mere remoteness from nature, as such, does not yet have any value. Certainly the naïvely detailed comparison with the real world should be eliminated, but then we are concerned with the quantity and quality of the spiritual element which lights up in the work of art. And here Expressionism is disappointing. In identifying the spiritual element with inner experience, it robs this spiritual element of its value and uniqueness; in carefully excogitating for this inner experience a structure not in conformity with the standards of the familiar world, it robs this inner experience of its communicability. Only a narrow path leads from the Expressionist artist to the spectator. It consists of certain memory images which are as distorted and deviant from their originals as they have been painted. Indeed, having no logical or aesthetic connection, they are least of all able to form the backbone of a significant structure. A work like Chagall's well-known painting I and the Village proves this with alarming clarity.

From the painters' modes of procedure we turn to their differences of content. In accordance with ancient usage, the meaning of the object portrayed is taken as the basis for classifying the subordinate species of picture painting. I find this arrangement by no means contemptible. Since art is more than a play of forms, the outer material as well as the inner essence striving for expression can provide standards for the individual painting, hence for its placement in an order. The religious picture is really a separate kind, for the nature of its theme influences the form in every respect. The painter who draws his subject from sacred history does not interest us by the novelty of the theme. He has only two possibilities. He works through either technical execution—the taste with which he draws lines, extends surfaces, and applies colors—or the emotion evoked by the recollection of unique events. In the former case we are liable to get a perfunctory treatment of the

highest themes, in the latter case a devout handicraftsmanship. Most sacred pictures, indeed even most altar paintings, are aids to public worship and fulfill their purpose all the better, the less their artistic value holds our attention. Hence devotees of ecclesiastical art reject all innovations and hold fast to the sacred tradition. But everyone knows that in this field masterpieces are possible, original in form and conception, living and yet committed, proud and yet meek.

Religious painting is close to historical painting, which in turn borders on genre and landscape painting in many ways. Historical painting also falls largely outside art. Knowledge of historical details may certainly help a picture, but it is unfortunate when an old-fashioned aesthetician relates in praise of a familiar painting that "the Chief of the General Staff of the Third Army, General von Blumenthal, who at that very time was suffering acutely from a stubborn head cold, stands at the right of the Crown Prince and betrays his unbearable condition by facial expression and posture, as he holds his large white handkerchief in an unmistakable manner, accurately observed and reproduced." Photography is quite adequate to portray such contingencies. The artistic problem is so to arrange figures which essentially belong together that they must be seen together, or at least that the line of sight is inevitably directed from one figure to another. We should note at once that certain groups are present and in certain states of mind; we should also feel where the unifying point lies; finally we should enjoy the lines of the human body, the folds of drapery, architectural frames, and scenic backgrounds. Of course, many objects are too brittle for conversion into artistic form. A battle of the late war cannot be depicted with a brush, for the combatants were either thinking beings or machines, hence without pictorial interest. Battle pictures like those of Ludwig Dettmann show only episodes; essentially they are genre pictures of a special kind. Their value depends on their artistic development. Even genre painting as such should not be rejected wholesale, least of all with the contemptuous term "anecdotal weeds." Certainly the picture most noteworthy in subject matter and richest in detail is not ipso facto also the most valuable. But only high-flown aestheticism condemns the narrative pleasure which has all along been bound up with painting. The main point is still that the artist preserve simplicity. The most significant novelists of the brush, the old Dutch masters, depicted the colorful life of their time with exquisite simplicity, and in so doing scarcely ever told anecdotes.

In conclusion I want to call attention to the special problems connected with portrait painting. Contradictory demands make the artist's work the more difficult. Every subject wants the picture to be both very beautiful and very true to life. The need for visible immortality instills these desires in him. (In his fine book on the art of eastern Asia, Curt Glaser accepts the conclusion established by H. A. Giles in *An Introduction to the History of Chinese Pictorial Art*, Shanghai, 1905, that about 200 B.C. in China portrait painting was already a widely practised art. But there is much evidence "that the relation of the portrait to the personality portrayed was more mystical than clearly perceptible, as the picture was thought to be inhabited by the spirit of the departed. The idea of standing before the abode of this spirit did more than the outward similarity of the picture could have done. Indeed, in China today a simple tablet with a name inscribed (which for ancestor worship is the dwelling place of the soul) is still enough to sustain the imagination.")

In ancient Egypt persons of rank had granite statues of themselves made. In sixteenth century Italy bronze medallion portraits were very popular, in seventeenth century France copperplate engravings. Having for the most part to choose between photographs and oil paintings, we prefer the paintings on account of their greater durability. We can understand the concern to preserve the outward aspect as it really is, but in this way the average portrait of the average person decreases in value through the years. Its agreement with the person portrayed gradually disappears; the apparently rejuvenated head and the old-fashioned clothes look ridiculous. After a life has run its course, the standard for measuring resemblance is no longer available. And yet we say of a portrait whose subject, now long dead, we never knew: that must be a good likeness. In this remark we are referring to our impression of vitality and individuality. With this ideal in mind we blame the subject and the painter whenever they strive for superficial beauty, whenever they prefer the more flattering front view, which avoids all dangerous lines, to the more characteristic profile, whenever they sacrifice reality to an impersonal ideal. The typical features of a face should be elaborated, of course, so as to eliminate what is unessential in form and expression. When there is an opportunity, do not miss the chance to place a person beside a bust and an oil painting of him. You seem to be looking at three different though similar objects, not at three identical ones.

Let us recall Whistler's portrait of Carlyle. As to the likeness we have implicit faith in the artist. The picture stamps itself on our memories much as the person himself would have become unforgettable if we had once sat in his living presence. No question that this man was a great benefactor of mankind, for he thought and suffered. The sign of damnation (*signum reprobationis*) of a soul lost in thought is stamped upon him. The spirituality of this person must be evident even to the most unperceptive. We need not know who he was to be warmed by sympathetic interest. Involuntarily we ask, what has life done to you? With what problems have you fought out the battle that is harder than the contest with the dragon? Against what troubles have you heroically steeled yourself? With what people has destiny linked you? The disheveled hair and unkempt beard, the peculiar enigmatic glance, and the conspicuous white hand do not easily let go of the spectator. Only gradually does he notice how carefully the picture is painted, and with what beautiful economy every device is used. The real is converted into the pictorial with great decisiveness, and yet with the finest measurements. The artist never makes a display of his skill, is never lavish, never wanders from the way of simplicity. The arrangement of things in the room, the posture of the body, the strange bulge of the coat at the breast— so original and yet clearly intelligible—in short, the whole plan of the picture is not based on a trite formula but, as it were, is painted with a new brush. Thus neither likeness nor a classical ideal of beauty is our standard of judgment in viewing this portrait. Rather does its artistic value lie partly in the quiet power which leads us into the depth of inner personal existence, partly in the charming assurance which governs the construction of the picture. The first source of value indicates the peculiar nature of portrait painting. Photography seldom has the magic power of a painter's hand to stir the soul.

4. Graphic Arts

From many sides there comes the complaint that Germans of today have no immediate interest in color, that most of them must force themselves to consider it. Their love, it is said, goes to

graphic art, whose realm extends from the woodcut to the copper-plate engraving, from the arabesque, which plays with realities, to the work rich in figures.

Now, whether or not this is so, in any case it is very clear that painting and drawing are different kinds of figurative art. Only recently has this fact been generally acknowledged. Winckelmann said, "Noble outlines are more important in a painting than color, light, and shade," and Ingres asserted, "I shall put the sign *Drawing School* on my door and I shall make painters." Ingres thereby declared that the outline (perhaps a basis of painting) is the essence of painting, and wholly erased the boundary between painting and drawing. At present the conviction is almost universal that something intended to be in color cannot be represented as adequately by drawing. To throw into very sharp relief the inner lawfulness of colorless figurative art, Max Klinger has even tried to free engraving from its connection with painting and plastic art, and to bring it close to poetry. Undoubtedly we can express thoughts and report facts with the stylus as well as with the throat. But the opposition of media rules out any union of the two arts. It remains a fact of experience, safe from all theoretical assaults, that graphic artists reproduce things for the sake of their visible appearance. The establishment of spatial balance, the transfer to principal forms by means of auxiliary lines, conical groupings—we meet no such requirements in the realm of verbal art. Let us imagine a prose or verse description of three acrobats in formal dress performing a grand finale to their act, and contrast the ornament of whose realistic components we only gradually become aware (*see* p. 177).

Fig. 16.

Nevertheless the view is essentially sound. The transformation of the real, without which art is not art, is achieved in graphic art, and especially in drawing, with peculiar force. Even now the

draftsman is permitted to do what was expected of the painter only in very early stages of painting: he can violate the unity of space, combine two different scenes, and take other such liberties. For the abstract quality of outlines makes them, both in the purpose for which they are used and in their impression on the spectator, a language of signs. In the historical development of graphic art, symbols have been worked out which enable the viewer not only to recall at once the natural objects represented, but also to be drawn with a feeling of assurance into their real interconnection and spiritual import. We easily understand that delineations are best fitted to illustrate written and printed books. The simple linear style is suited to the flatness of the page, the abstractive content to the wholly abstract spatial form of the letters. Menzel and Slevogt, in particular, have shown how the author's purpose can be converted into manual activity and visual pleasure—indeed, can even be independently advanced and supplemented. Another procedure surrounds the text with flowing ornamentation, which only occasionally crystallizes into figures. Dürer decorated the Emperor Maximilian's prayer book in this way. Attempts, very instructive in their frequently dilettantish clumsiness, were made by William Blake, the poet and painter who burdened Swedenborg's spirit with profound aphorisms and expressed his own confession of faith that "all things exist in the human imagination alone," by forcing the highest concepts into human forms and distilling the lowest realities into shadowy symbols. His *Book of Job* (1825) bears the notation, "Invented and engraved by William Blake." The copperplates, engraved by the artist himself, contain not only the drawings but also the text, usually inserted between them, and on many lines embryonic vignettes. Here we see very clearly how far writing, abstract spatial form, and graphic art belong together and where they part.

The analyses provided thus far seem to disagree with the fact that black-and-white methods have often fostered the feeling for nature and the joy of life. The cultural historian of the future will learn the appearance of our streets and rooms, our clothing and forms of transportation, not from our paintings, but from our drawings and especially our photographs. There are probably two reasons for this. First, these works will last almost without change and can be reproduced in any desired number. Secondly, indifferent and ugly sights can be caught and held fast on colorless sheets without any delay. Since pictures of present life usually get a wide

distribution and necessarily deal with unimportant, even repulsive things, graphic art is their natural ally, as perhaps narration is in the art of words. Hence graphic artists enjoy a remarkable popularity. And, above all, they feel self-sufficient.

We must dwell a little on this point. Earlier theories of graphic art value hand drawing as an aid to the painter, who makes preliminary sketches. These theories value engraving, etching, woodcutting, and lithography as techniques for the reproduction of pictures. But the modern science of art grants the products of graphic art the right of all works of art to be self-sufficient and complete in themselves. They deserve this status all the more, since countless copperplate engravings and woodcuts are designed to have the very same effects as colored pictures. Here outlines and accents, surfaces and figures, modelled forms and quasi-chromatic gradations are possible. There is a scale of values from black to white which vies with the realm of the palette. But its use always indicates a declaration of independence from the colors of reality. The imagination of the best copperplate engravers and etchers builds a world of its own. These artists do not move into the woods to draw foliage, or place models beside their easels. Rather they create bent over tables, like architects, musical composers, and authors. They rely heavily on a faculty of imagination for inspiration. When an etcher has to represent the vertical side line of a house, we should expect him to put down a definite line, like an architect. Not at all. He turns the straight line into curves, or leaves gaps in it, or makes two parallel undulations out of it. The fine needle goes its own way. Equally self-confident is the accent of the woodcut engraver, who produces variously shaded planes on a black base, and from the contrast of bright and dark surfaces creates a particular style which makes a spiritually replete observer aware of the lasting and essential aspects of things beneath the strong accent of the picture's superstructure.

The question as to whether the addition of color transfers etching and the engraving of copperplate and wood from the field of graphic art to the field of painting—this can be answered in various ways. As only a few colors are involved, they tend to be used without modelling for pure decoration. To many theorists the conscious departure from reality seems to be reason enough for excluding the color print in every form from the realm of painting. I do not find it helpful to abandon as simple and certain a means of distinction as color, because it is not used realistically. I would rather confine painting to those activities which have sprung from

the soul of color. The graphic artist never colors wholeheartedly. Yet the application of this principle encounters serious difficulties. How, for example, should we classify the delicately tinted panel pictures of the English Pre-Raphaelites, pictures which owe so extraordinarily much to the rhythm of the delineation and to the essentially ornamental nature of the work? The pictorial life, centered in color and the most genuine painting, dies out in the palest linearity or even runs off into decoration of the border. At least, that point of view is still the most useful, although it leaves too much freedom to the insight of the art connoisseur in the particular case.

As graphic art was earlier judged to be the prelude and postlude of painting, photography today is in many ways an auxiliary aid and method of reproduction. In fact, we can doubt whether it should be counted as an art anyhow. Its spread and significance are due, of course, to merits other than artistic value. Being an exact copy of a thing or event on a flat surface, a photograph is scientifically useful as the best available substitute for a reality which is inaccessible for some reason. Photographic reproductions of stones, plants, and animals are just as useful as such reproductions of real estate deeds, geographic maps, and house façades. In almost all cases these are not works of art but documents. Snapshots and motion pictures especially are technical products. So the judgment of photography comes mainly from a standpoint outside art. Provided that the optical defects which inevitably appear on the plate are avoided or corrected by the intelligence of the photographer, representations of the utmost precision arise. The photograph tells all the details. It is as reliable as statistics, as impartial as science. When higher claims were made for portrait photography, an inner resistance to this graphic procedure began. Not only were the usual photographs proved inferior in competition with drawings and paintings; they were defective even in essentials, the persons depicted being scarcely recognizable. The reason for this has always lain, on the one hand, in technical defects and, on the other, in the perverse demands of those who have their pictures taken. The patrons of the studios assume the most unnatural postures, alter (or, as they believe, beautify) their appearance, and place themselves in settings not in the least appropriate. But above all, they insist on looking beautiful in the photograph, as judged by a very general ideal of beauty. Retouching must remove all characteristic features from their faces.

Thus, as soon as photography has approached the sphere of

art, it has appeared as a subordinate process, unworthy of thorough consideration. But years ago experts were remarking that the achievements of that time did not indicate the limits of possibility, that we need not condemn photography as a whole aesthetically in rejecting its average products as inartistic. They were trying to free themselves from the automatic nature of their equipment and out of a useful reproductive process to create an artistically worthy medium of expression. The progressive steps of photography, which led to a peculiar, flat-surface art in black and white, were perhaps much like the following. Earlier prints resembled definitions; they made everything minutely explicit. But in art we want an uncertain residue for our imagination to exploit. So photography developed in a direction involving sacrifice of precision and the production of pictures which progressively educated sight enabled to function like paintings. It became technically possible to reproduce movements, clouds and water, the glance and the smile. The artistic photographers began to make nature studies of extraordinary penetration and scope. For a few shots they observed a landscape or a person for six months. They waited with their cameras until reality came to meet their ideas of it. For, as happiness now and then offers itself to everyone gratuitously, so also does artistic value. But we do not always notice it and let the rare moment pass unused.

The progressive movement has developed a technique with which pictorial effects can be obtained. In treatment of the sensitive film, in arrangement, in length of exposure, and in elaboration of the print the technique is almost as difficult and intricate as the other graphic procedures. Especially the orthochromatic lenses for taking pictures and the offset printing for reproduction make a pictorial photography possible. And yet at the same time this has brought a perversion into life, the seductive trend toward unphotographic photography. Let me explain. Most amateur photographic artists aim to conceal the sources of their products. They ape graphic artists and painters in their techniques and modes of viewing things. So photographic prints appear with only a certain family resemblance to their negatives. But in denying its own distinctive character photography renounces the right to be called a separate art. For, as it has often been said already, every art aims, and properly so, with a peculiar formative method and in a way otherwise nonexistent to transform reality and express an inner life. According as that is or is not possible through photographs, they do or do not belong to art. As a matter of fact, it is possible. There

are photographs which prove to be pure photography without impairment by the qualities of a painting. We see that they were taken from nature, for they do not indicate the techniques of drawing or painting. No retouching has done its evil work. And yet posture, light distribution, and shading achieve a pictorial effect which raises such photographs far above the products of ordinary routine.

X. THE FUNCTIONS OF ART

1. The Intellectual Function

Art belongs to culture. Culture is essentially a whole of spiritual values, from the human point of view a mutual involvement of the great fields of achievement: economy, law, morality, religion, science, and art. Culture is rooted in the fact that the active spirit wins immaterial values from what is given to it. Culture culminates in the subordination of what is to what ought to be. Culture requires of man the will to responsibility, to truth, to form —in a word, the will to spirituality. The groups of values differ from one another, to be sure—in kind, not in rank—but they also run continuously into one another. So art is connected with the whole cognitive and volitional activity of man. In the system of achievements which have been fixed in lasting forms, art is entitled to a definite place. Its particular achievement can be most easily ascertained by investigating its relation to science, society, and morality, the structures most closely akin to it.

In dealing with the relation of art to science, it will be more fruitful, I think, to begin our discussion by avoiding generalities and examining a particular case. As an instructive example I shall consider the attempts of art historians to describe works of spatial and figurative art in scientific fashion, to transfer these works from the realm of artistic appearance into the language of scientific concepts. Explanation and evaluation tend to rest on such descriptions. So here we can probe the very roots of the question as to how far works of art turn out to be accessible to the simplest scientific method. The art historian occasionally faces the very intriguing and difficult task of describing an inaccessible work so as to provide the

most adequate substitute possible. For the most part, to be sure, he has only to clarify and animate the visible appearance by his words, but at times he must even try to produce this appearance. Herman Grimm's directive, to make "all works visible merely by description," shows clearly in its very exaggeration that our problem also concerns the theory of art, and indeed affects it practically. Moreover, do not the daily press reports of art exhibitions always contain descriptions of pictures or busts which the reader has not yet seen or will never be in a position to see? Hence it is quite surprising that no exhaustive enquiries into the limits of such descriptions have ever been made. Yet there are respectable contributions, especially from earlier periods.

On glancing back at German theory of art through the last one hundred and fifty years, we find Goethe's illustrious name above all others. His essay on Mantegna's Triumphal Procession contains a lively description, which puts the essential point well. The description closes with the confession that "even so vast a collection of words could not express the value of the pictures described in this cursory way." Vasari's description is rejected as inadequate. "But we do not mean to criticize him for speaking of pictures which stand before his eyes and will, he believes, be seen by everyone. From his point of view, he did not intend to represent the pictures for those absent, or even for those yet to come if the pictures should be lost. But this is also the method of the ancients, which often brings us to despair. How differently Pausanias would have had to proceed if he had consciously intended to console us by a verbal substitute for the loss of magnificent works of art! The ancients spoke as though all concerned were present, and in such a situation few words are needed. Thanks to the deliberately acquired rhetorical arts of Philostratus, we venture to construct for ourselves clearer concepts of valuable pictures now lost."

This passage stresses the disparity between word and appearance, and makes the important distinction between description as a supplement and description as a substitute. But in Goethe's observations on Diderot's essay on painting, other ideas come to the fore. Diderot wrote, "In a single line I complete what the figurative artist hardly sketches in a week, and it makes him unhappy to know, see, and feel like me without being able to express all this in a way that satisfies him." Goethe commented, "Painting is very different from rhetoric, to be sure, and even if we could assume that the figurative artist sees the objects like the speaker,

still they differ vastly in the impulses which these objects arouse. The speaker hastens from object to object, from one work of art to another, in order to think about them, grasp them, survey them, arrange them and express their qualities. The artist, on the other hand, rests in the object; he unites himself with it in love; he shares with it the best of his mind, of his heart; he brings it forth again." We should note that the perception of the artist and of the speaker are not represented as absolutely identical and the scientific enquirer regarded as opposed to the artist.

Wilhelm Heinse, who could speak so enthusiastically of figurative art and music, often referred to our problem in his *Briefwechsel* (edited by Körte). In one passage (I, 243) we read: "Moreover, every art has its boundaries, which no other art can violate. In their peculiar beauties painting, sculpture, and music mock translation; even poetry, the most high and mighty of all, must remain outside." In another context (I, 332) the most significant statements are the following: "To be painted and to be described are almost as different from each other as to see and to be blind, as the clock hand at four in July and the dawn at the summit of Brocken. Even Winckelmann's descriptions are merely ocular spectacles, and spectacles only for certain eyes. . . . But I do not give you any more from any picture than the idea and its pictorial aspects, as I get them. For I am convinced that everything else you must see with your own eyes." (Cf. further in *Heinses Sämmtliche Werke*, ed. H. Laube, 1837, II, 6–17, 58 ff., 176 ff.; VIII, 170–99, 225–50. A typical passage is the one about the Queen of Hearts in Lichtenberg's *Ideen, Maximen und Einfällen*, ed. G. Jördens, 1827, p. 106.) George Forster, who applied the art of description not only to nature but also to buildings and pictures, goes a little beyond these glib indictments. His descriptions do not always please us, but his principle is worth mentioning. "In my opinion," he says, "we achieve our ultimate purpose better by recounting what we felt and thought in the presence of a work of art—what it did to us and how—than by a detailed description. With a description so oblique, we need very alert attention to activate the imagination as we listen or read further and form a fanciful image which interests the mind. The imagination condescends reluctantly to this forced labor, for it is accustomed to construct spontaneously out of itself and not to copy a strange product. Aesthetic feeling is the generative source of imaginative activity, and this very feeling is imparted when, instead of describ-

ing a work of art dispassionately, we try to convey and propagate the pulsations aroused in us when we looked at it. This propagation of feelings then lets us surmise, not how the work of art was actually formed, but still how rich or poor it had to be to show certain powers. And at the moment of our feeling we may contrive a form to which we ascribe those effects and in which we now feel again the ghosts of those original impressions." I would suppose that this method is even more appropriate to music, as it has been applied by Nietzsche to Bizet's *Carmen*.

Of the Romanticists Wilhelm Schlegel went most deeply into the problem. His skill as a translator fitted him for it. In one place he says: "No other general rule can be given for the so often mistaken art of painting pictures with words than to change the style as much as possible to fit the objects. Often the moment portrayed can emerge vividly from a story. At times an almost mathematical precision is necessary in accounts of places. Usually the tone of the description must play the chief part in acquainting the reader with the state of affairs. Here Diderot is a master. He describes many pictures in musical metaphors, as the Abbot Vogler turns pictures into music." (J. Minor, *F. Schlegels Jugendschriften,* II, 231, no. 177. Further accounts, especially of Brentano, in Alfred Kerr, *Godwi, ein Kapitel deutscher Romantik,* 1896, pp. 19 ff.) On another occasion Wilhelm Schlegel wrote the following:

Waller: . . . Of course, individual words don't turn the trick any more than the magic of painting lies in the separate colors on the palette. Not only do forms result from the combination and composition of words, but also discourse colors them and controls their light and shade.
Luise: Fine! This time I quite agree.
Waller: Indeed, to reach the highest perfection here, speech must also choose the sounds to put together, and arrange the movements in accordance with laws.
Luise: Alas! Then it is formally contrived. I would never have anything to do with meter.

These conversations occurred in 1798 in the Dresden Gallery. ("Die Gemälde," *Athenaeum,* II; see also *Charakteristiken und Kritiken,* 1828, II, 151; cf. II, 199.) It was pretended that descriptions of the pictures would provide substitutes for the absent sister of one of the conversants. Hence an inquiry into the possibility and

kinds of such substitutes could not be avoided. And August Wilhelm Schlegel was predestined for the task as a lover of art, as an artist with words, and as a born appropriator and translator.

Now we shall move on from historical recollections to consider the question for ourselves. If we wish to test the expressive power of words for the purposes of the theory of art, making the test with the method of procedure now usual in this field, there are two ways which seem to be the shortest. (1) We can compare the descriptions which various scholars have given of the same work. (2) We can consider the same man's descriptions of various works to see whether they adequately distinguish between the works. The first comparison shows at once that our catalogues and handbooks of art history contain the most discrepant descriptions of the same picture. As proof I juxtapose two descriptions of the Sistine Madonna, which are conspicuously brief and from distinguished contexts. (1) "Mary floats in full figure on white clouds with a misty golden glory of cherub heads. The nude Child Jesus is enthroned on her right arm. From a position directly in front of him, both Mother and Child regard the spectator with large, earnest eyes. At their feet two saints kneel on the clouds in adoration. The one to their right, Pope Sixtus II, has put his tiara on the ledge in the foreground and gazes up in rapture at the Mother of God. At their left Saint Barbara looks meekly to one side and can be recognized by the tower to her right. In the center foreground two cherubs look out from behind the ledge. A green curtain at the top separates the scene from the earthly world." (2) "The wide eyes of the Sistine Madonna have cast a spell over the world. Her expression is formed by the broad nasal bridge, pushing the eyes far apart, and by the parallel lines of her vision into the distance. Her head is perfectly rounded; her carriage has a grandeur transcending life; her erect position in relation to the two adoring saints is as severe in its principal dimensions as it is fluent in its delineation. The figures are bathed in a silvery light, such as Sebastiano del Piombo had striven to achieve. The most vivid color is pale in this light and without the old, formerly popular luminosity."

In both descriptions important elements are lacking; the theme of the action, for example, is not explained. On the other hand, both contain phrases and adjectives which contribute nothing to our appreciation. We even strike a contradiction: the Dresden catalogue mentions a *golden glory;* Gurlitt's *Kunstgeschichte* speaks

of *silvery light*. But—what is most important—would an uninstructed person certainly and necessarily refer the two descriptions to the same picture? Do they further and deepen our perception?

The next example is Dürer's St. Jerome in his Cell (1514). With this engraving *Der Kunstwart* started its series of valuable and praiseworthy "Pictorial Masterpieces for the German Home." An appended brief description reads as follows: "Can anything look more cheerful than such a cell, its wainscoting polished with wax, all sorts of useful household utensils on the shelves, and a huge gourd hanging from the ceiling? The lion, blinking drowsily as it basks in the sun with the Pomeranian housedog, is not a gruesome element, nor even is the skull. A deep sense of well-being comes over us as over the saint, who has placed his outdoor pattens under the window sill, has hung his big cardinal's hat on the peg, has found the most comfortable of the cushions (on which he banks heavily), and in soft slippers has sat down to his writing at the beautifully fashioned table. We see that no misgivings plague him, that as he writes from his rich experience of God, he fervently enjoys his faith. The sunshine streams through the bull's-eye glass panes over him and everything around him in this neat, orderly home of peace—that dear, gentle, calm, warming sun, bringing joy to everyone and rapture to an old gentleman." These cosy sentences convey the mood of the print very happily. But they were written by a writer and not by a connoisseur of art. We do not learn in this way how to look at a picture. When the author speaks of the animals and in the same breath of the skull, he is moving about in a zigzag course over the engraving instead of following the spatial order. When he mentions shoes and hat, he is speaking in the sense of everyday reality and not in the spirit of the picture. Does he perchance believe what an "art expert" said apropos of our engraving, "To sympathize with these moods one need not possess the so-called appreciation of art, but only have a German heart"?

We turn more readily to the description by Wölfflin, a man who also has a German heart, to be sure, but beyond this has an understanding of art and an unusual ability to teach. I shall quote only parts of his exposition. On the whole it seems to me masterful, although in certain places I have objections, which I shall briefly indicate. "A correct late Gothic room with clustered windows, raftered ceiling, and paneled walls. Around the room runs a bench covered with cushions. [He properly begins with what first strikes

the eye, but then prematurely mentions the bench, a detail which at first escapes notice.] A beautiful table and on it the usual little writing desk. Near the window a second desk. [The second is mentioned because of its likeness to the first, but the reference is unfortunate, since the two desks have no artistic connection.] Then on the wall household utensils of all sorts [here the very striking cardinal's hat should have been singled out] and, hanging from the ceiling, a gourd like those we can see in farmhouses even today. [Now the description jumps from the gourd to the lion, from the very top to the very bottom.] The lion lies peacefully stretched out on the floor." In what follows the total impression of cheer, comfort, and coziness is effectively derived from the particular items in the account of the light and the lines. I shall confine myself to quoting a passage which calls for no comments from me. Wölfflin speaks of the shoes, tossed aside in disorder, as "harmless caprices which do not destroy the stillness of the room. This room should look not dead but alive, filled with that warm, homely life, which dances as light in the circles of the window wall, and functions as line in the knotted markings of the rafters, softly murmuring like the water of a little brook flowing on over the stones. The sharpest contrasts of light lie in the middle. There we find a center of great disturbance, which quiets down more and more as we move outward. Although the light seems to be in sprightly flux, yet as a whole it is fixed and focused, just because a supreme light dominates the scene, falling on St. Jerome and on the table." Note the skillful transition from the animation of objects (the shoes tossed aside in disorder) to the animation of the light and the imperceptible blending of sense qualities and feelings. Such passages show with beautiful clarity the gift of teaching art appreciation. This teaching is essentially the use of language to relate definitely to the visible forms what the picture is struggling to express, so that this message may be understood.

The language of our art scholars becomes less adequate when they try to describe the style of a master, which imparts to all his works (or at least to all his works of a certain creative period) their peculiar aspect. For example, Wölfflin finds that in Giotto's work things always "happen in a vital, convincing way." Giotto, he thinks, is a man of reality, an observer with an eye for "the speaking." Masaccio seems to him clearly to give us being, "corporeality in the full power of natural action." Such expressions come, of course, from sensitive and mature perception, and in

context acquire even a certain significance. But they do not enable anyone to distinguish between artistic personalities. The adjectives which Wölfflin likes to use are just as ineffectual, being essentially unreliable and colorless. Even phrases like "of beautiful line," "of melodious play of lines," "of grandiose earnestness" really say nothing. Only when the listener or reader already has a store of images, can bits of pictures appear, whirling about in confusion. And only when the inquirer turns poet does he recount an experience really connecting inner elements. It is thus when he says that a picture is controlled by "an all-pervasive silence, that we believe we should hear the silence whisper when the breath of evening stirs the leaves on the slender little trees." But the preceding words, "perfect peace, absolutely still lines, noble architecture affording a broad vista into the distance, a mountain sky-line, fading away beautifully at the horizon," could apply just as well to a Schwind fairy-tale picture as to the Perugino Madonna, of which they were written. Finally, a last example. Wölfflin uses the following fourteen expressions to portray the early Renaissance: girlish figures with lovely limbs and colorful costumes, blossoming meadows, fluttering veils, airy halls with broad arches on slender columns, all the fresh power of youth, everything bright and gay, everything natural and various, simple nature with yet a trace of romantic splendor about it. That is certainly beautiful and fitting. But the description could refer to half a dozen other periods and artists. When years ago he began a history of the most recent art with impetuous enthusiasm, an author was censured for borrowing descriptions verbatim from connoisseurs and artists, then transferring them to quite different works from those for which they were originally intended. Yet such plagiarisms are possible only because even the most brilliant linguistic expositions lack the precision which would make them uniquely applicable to one work of art or one artist. Unquestionably that art historian had not attempted absurd transfers.

So far we have been inquiring to what extent a non-artistic description can assist us in looking at a work of figurative art and raise our perception to the level of exact knowledge. From now on we are asking whether words can be an adequate substitute for the picture. To secure a basis for the investigation, I have quite often read aloud or even displayed to other persons descriptions of simple works of art, requesting each of my auditors or readers to draw a schematic sketch in accordance with the description. The details of the procedure, I presume, do not need to be dis-

cussed. Very seldom did anyone fail so completely as to claim that he did not receive a single visual image. But a disproportionately large number (almost forty percent) declared themselves unable to draw a reproduction. Neither artistic representation nor regard for details was required, but a certain ability to copy models had been established in advance. So we may assume that the visual images which emerged momentarily were very indefinite, probably not real sensory images at all. Of the attempted sketches submitted, which naturally consisted mostly of rough outlines, only a few were utterly useless. As a whole they show that a fairly accurate verbal description of the chief features of a work of figurative art—not the minutiae and artistic qualities—can evoke a tolerably adequate image. As an example I offer a description from Grimm's *Michelangelo* (6th ed., 1890, I, 153–54) and the analysis of the experimental results undertaken in the seminar. The picture was the [Manchester] Madonna at the National Gallery in London.

"The composition falls into three parts: in the center the Madonna; on each side of her two youthful figures, angels if you will, close together. The figures at the left are shown only in outline, but those at the right are fully represented and so strikingly beautiful as to belong among the best Michelangelo has produced. Two boys, perhaps fourteen or fifteen years old, stand close together. The boy in front is visible in full-length profile; the one behind him faces us. This boy behind has laid both hands on his companion's shoulder and with him is looking at a parchment sheet, which the boy in front is holding before him with both hands, as though reading from it. He has even bent his head forward somewhat and dropped his eyes to the sheet. Perhaps it is a sheet of music from which they are singing, as the half-opened lips would suggest. The bare arms and the hands holding the sheet are both youthfully thin, but were painted from a study of nature in a manner that cannot be adequately praised or described. It would alone suffice to give this figure supreme value. But we must also note the head, the exquisitely slender form, the light tunic hanging down over the knee in rumpled folds close to the body, then the knee, the leg, and the foot—a portrayal of nature almost too moving. With all our hearts we love this child, and would thrust our hands into fire to keep him pure and innocent. The tunic of the other boy is dark. His shaded eyes reveal a very different character, yet no less lovable. His hair also is different, the locks thicker, darker, and breaking out in curls, while the

locks of the first boy, brushed back more smoothly and fully behind the ear, lie on the neck. We see the Virgin directly in front of us. On her right shoulder is a bright mantle, its corners tied together in a strong knot. This mantle nearly covers her left arm, and below is thrown in broad folds around and over the knee. A white veil lies on her dark hair in such a way that it remains visible all the way round. The Child Jesus is reaching over his mother's lap for the book which she is taking from him in her right hand, the left hand moving forward under the mantle to assist her. It is as though she also had been singing with the boys in the choir, and was about to turn the page of music when the child grasped at the book, which she is gently holding up to her right. John stands at our right beside the Child Jesus, more in the background. An animal skin is thrown about his little body, but scarcely covers it anywhere. The light comes from our left, casting the Holy Virgin's shadow on him a little."

Even this detailed description is occasionally so inaccurate as to contain gross errors. When the author says at the start that the composition falls into three parts, he fails to add that the painter has united these three parts very closely. Hence in many of the sketches, submitted in our experiment, the three groups were separated by spatial intervals. Grimm tells us nothing at all about the construction of the throne and little about the positions of Jesus and John, nor does he even mention that the Madonna is seated. Mistakes in the submitted drawings called our attention to such omissions in the description. These mistakes were pardonable to a certain extent, since they were not excluded by the description. But the results were questionable in the case of a book that dispenses with illustrations. So only within strict limits and without absolute certainty can words convey the sensory content through visual imagery to anyone who is not yet acquainted with the work of art. But the description is of great help to the memory and, when completed by a view of the work of art or of a good reproduction, teaches us to see what is there. For all three purposes the natural order in a description would probably be: first, to depict what strikes the eye; then, when the visible appearance as such is fixed, to describe the meaning and bearings of this material; finally, to show the virtues of the work that stir our feelings and to indicate historical relations, adding a critical appraisal. In his *Michelangelo* Grimm holds himself to this order fairly closely at times (four times in twenty carefully examined cases). But usually the formal,

thematic, and critical aspects are artistically, indeed artfully, blended. And since he regards historical relations and cultural contexts as very important, he often omits the description and often the aesthetic judgment. Yet the order—more generally, the whole structure—of a description in the science of art depends not only on the personality of the describing person, but at least as much on the peculiarity of the object to be described. In the case of drawings whose formal relations are supposed to arouse in the spectator the ideas connected with them, and also in the case of all philosophical painting, a description which adequately expresses the artist's intellectual purposes is quite appropriate. Here the transition to be made from the sensuous to the conceptual seems a natural beginning. Anecdotal and historical paintings of all grades form a second class. A retelling of the story in essentials can do justice to them also. In a somewhat different sense this is true even of pictures which, without special selection but with great devotion to particulars, strive to preserve as far as possible a bit of the outer world. For, much as the spectator takes in successively the collection of carefully executed details, the writer also can, faithfully following these details, describe objectively their meaning and the impression they produce. (This statement, which I could not alter here, has been qualified in my investigations concerning the description of pictures in Z.f.A., viii, 440 ff.) However, such works do not yet contain the whole wealth and the ultimate mystery of art. Aesthetics and the science of art naturally tend to regard as normal and essential what is easy to observe and fit to describe. Indeed, they accept without challenge various and sundry pieces of graphic absurdity or at least technical clumsiness, if only these elements have been introduced into the picture for a good reason and have informational value.

But there are works of art in which formal characteristics are so blended with the subject matter that they must stir up ideas. And at a certain stage of our concern with art we find it necessary to bring such characteristics to consciousness in verbal form through analytic thought. Words are inadequate in reference to colors as soon as we pass beyond the most general statements and do not care to use Ostwald's color numbers. But, as we have seen, we can verbalize the other aspects of execution: the articulation and use of space, the arrangement and direction of principal lines—in short, the constituent parts of the substance of art. Art critics of the first rank reach a very useful approximation in evaluating the

technical knowledge of the figurative artist. To be sure, a danger threatens them and their readers. They often lose the most intimate relation to art because their interest does not remain purely artistic, but all too easily becomes rhetorical. The man of words enjoys a picture only when he has changed it, transposed it into language. In high-sounding and well rounded sentences he fancies that he possesses the work of art itself. Speaking or writing satisfies him more than looking; capturing in concepts is his substitute for really perceiving. "One who thinks is worth a hundred prattlers, but one who sees is worth a thousand thinkers," says Ruskin.

Accordingly, the description never grasps more than the foundations of the formal structure and falls very easily into a region foreign to real art. A feeling for the mysterious aspect of the work of art first arises from poetic language. Our great art historians turn from investigators into poets when they can make an actual transference from the visual appearance into language, when out of the artist's soul they create his work once more in their own medium, language. Differences enough still remain, but it is at least the same state of mind which there gave birth to a work of forms and colors and here creates a corresponding work of words and rhythms. If only it were possible in this way to make the intended object appear! But Karl Justi is quite right in saying of Winckelmann's art descriptions written after 1757: "the new descriptions are not objective like those in natural science, where the author uses an exhaustive terminology in an effort to be adequate to his subject matter. Merely from these descriptions one could hardly form images of the statues. But such a description is a conversion of the impression, received by the mind in a moment of sacred contemplation, into a series of images and concepts, just as the artist gradually converts his creative intuition into plastic reality. And since this moment of creative intuition conditions and determines the whole subsequent effort up to its completion, and also the effect of the finished work on the spectator, this mode of description is certainly possible, although not advisable for fidelity to an original." (*Winckelmann*, 1872, i, 1, pp. 45 ff. But Anselm Feuerbach had already said: "There have been men who regarded this aspect of Winckelmann less favorably. And his inspired descriptions have, of course, occasioned a flock of enthusiastic portrayals, which are often like free musical fantasies on an arbitrarily chosen theme."—*Der Vaticanische Apollo*, 1833, p. 295.)

Naïve people probably suppose that nothing is easier than

describing a fixed visible object. They forget that without selection and judgment the description would never end or be of any use. If I were to describe a microscopic preparation just as I see it with all the specks of dirt, air bubbles, and vague visual forms of parts lying beyond the focal distance, my reproduction would be true to nature, but wholly unscientific. Science and art both alter reality as lived through, and thereby master it. We have seen in a particular case the narrow limits within which a scientific description of an individual work of art is possible. We must now turn to the more general question as to the relation between art and science, trying in this way to understand just how science transforms what is immediately experienced. The process is clear in outline. Thought attacks the contradictory and cloudy character of lived experience, rather arbitrarily reworking this inner content, sifting out everything irrational, introducing intelligible forms and the connections universally indispensable for thinking. Instead of slavishly copying the variety of nature, science violates and falsifies nature. As a rule, science begins with so-called elementary analysis. After the elements have been conceptually analyzed, they can and should be brought into a likewise conceptual order. "Unless things are reduced to ranks and, like armies in camp, assigned to their proper groups, all will necessarily be uncertain," Caesalpino said in a striking figure of speech. (To be exact, of course, all intuitive elements would have to be abstracted from this figure, for the battle lines of science lie outside the empirical world.) The arrangement and connection of simple constituent parts is the end of every pure science. Here the logical, artificial nature of the relations is essential. Hence in many places Schelling's philosophy of nature is unscientific, because it lacks prior analysis, and especially because the affinity of intuitive features is used to erect a hierarchy. Pure science employs logical (hitherto mostly causal) connection, not visible similarity, to produce the stability necessary for thought. "The world contains no gap, leap, chance, or fate." These four exclusions agree "only in debarring from the empirical synthesis whatever could destroy or injure the understanding and the systematic continuum of all phenomena; that is, the unity of the concepts of the understanding." (Kant, *Kritik der reinen Vernunft*, 1st ed., p. 230.)

As to the distinctive way in which all art transforms the given I can be brief, since enough has been said about it in the course of this book. That art, in contrast with science, assimilates

some aspect or other of the empirical world into creations of a new sort, that art confers its own validity on gestures, sounds, words, spatial forms—precisely this has been a principal theme of our account. Here, however, the sensory material is susceptible of other possible developments, and these are not mere means but final outcomes. Their inherent necessity distinguishes them from the capricious play of individual imagination. Kant has shown that the forms of intuition create connections which are not logical but nevertheless coercive. When I say of two straight lines that they can have only one point of intersection, my statement is grounded in the laws of space. The necessity of such a judgment is intuitive, not conceptual. Artistic certainty seems akin to it. The painter's absolutely convincing addition of a certain nose to a certain forehead rests on no law of thought; the constraint to resolve a chord in this way and no other remains within the domain of sense. But here, of course, we may introduce the opposite, while we never obtain two points of intersection for two straight lines. The prescriptive force of that arrangement of lines or resolution of a chord gets its validity from itself and not from evidence of universal conformity.

A second mark of the artistic mode of transformation lies in unification. Natural and historical life are boundless and unorganized. They keep an infinite length of thread turning indifferently on the spindle. Only art groups the facts of experience, thus giving them the harmony that charms us.

> Who measures off the ever even flow,
> Conferring life, so that it rhythmic moves?
>
>
>
> The might of man, as in the bard revealed.
> —*Faust*, "Prelude on the Stage"

This state of affairs implies that the effective work of art produces its effects autonomously. The lived experience and the scientifically transformed object need to be related to other things, but the work of art stands on its own feet. When we need something extraneous to enjoy a piece of music, a play, or a picture, a complication is involved. On the other hand, this unification into a whole does not at all mean the refusal to undertake any analysis. Rather, the unification very often passes through this analysis. For precisely out of analysis the most obvious unity can grow.

The false doctrine is widespread, that science and art are sisters, walking hand in hand toward the same goal—yonder where the eternal laws and ultimate grounds rest. The actual relation may be suggested by a similar comparison, perhaps in this fashion. At times science and art turn their backs on each other and strive for different goals, but at times their embrace is so tight and heartfelt that we must look closely to see to which of the two sisters this hand or that foot belongs. The contrast of science and art has already been considered. (The reader can quickly recall the distinction between the anatomical description and the artistic portrayal of the nude.) This contrast is balanced by the involuntary and almost indissoluble connection of science and art.

Such a connection is present in historiography. Historical tradition is not restricted to incontestable, scientifically sound evidence which provides mere information, but includes heroic legends and epic poetry, since both are connected with great events and have a historic core. Tales of travel show most clearly the influence of poetic invention on the popular view of history, as the Germanic epics reveal the unconscious intrusion of imagination into the blending of mythical with historical persons. The view of many modern historians, that all historical movements are tied to great men, is not only an artistic trait, but also a relic from the days of the heroic legend. Here we often find the idealizing view of one who "gladly makes mention of his forefathers." The contents of autobiographies (for example, *Confessiones, Vita nuova, Wahrheit und Dichtung*) quite properly place them in the middle between historical report and poetic revelation. A chronicle of all possible experiences would possess neither scientific nor artistic value. There is scientific value in the honesty which does not even shrink from accounts of anomalous disorders of life, and in the proof of the essential relations between the self and its material-spiritual environment. Artistic value rests on the selection and arrangement of human destinies and on their transformation into symbolic forms which can finally broaden out from the most subjective onesidedness into universal human significance. I shall merely point to the other connection between science and art. I am thinking of the fully conscious conversion of scientific knowledge into artistic performance. The illustrations of scholarly works and the metrical mnemonic aids of Latin grammar can be counted here just as well as the scientific romances of a Jules Verne or the fables of an Aesop.

Nevertheless, art retains its place beside science as an independent intellectual function of intrinsic worth. In Robert Schumann's *Kinderszenen* there is a little piece entitled "The Poet Speaks." Verily, he speaks thus: "Beginning and end come together; the falling melody sings of sinking into self; the soul soars again despite discordant obstacles; calmed in pure intuition, we return into ourselves."

2. The Social Function

The independence of art seems questionable, I confess, as soon as we focus our attention on its achievement within society. We referred earlier to the artistic activity of children as particular forms of life and pleasure for the youthful spirit. We saw that primitive art is almost inseparably blended with possession and use, attraction and aversion, need of protection and of connection, communication and instruction, superstition and war. Then where is the boundary line between these early forms of art and other social processes? The answer seems obvious. The line runs between what has and what does not have aesthetic aspects. This answer can be given all the more confidently, since, as we have seen, the fact that aesthetic pleasure springs from sensory stimuli and from the forms of symmetry and rhythm is one of the first principles of art. Yet two points should be noticed. First the often discussed distinction between a work of art and a merely aesthetic product. Secondly, the fact that not every admixture of aesthetic characteristics changes objects at will into works of art. William Morris went too far in counting every performance and every product as art if only it be given a touch of the aesthetic. Art is not any combination that we choose to make of the useful or instructive with the aesthetic, but that fixed and peculiar blend whose forms have been evolved in the historical process.

Serious objections can be raised not only against the excessive extension of the concept of art, but also against the practical application of this enlarged concept. The desire, now voiced so vehemently, to change art from a privilege of the few to a possession of everybody, is bound up with the desire for art also to emerge from another seclusion, to be no longer locked up in

museums and libraries, in luxurious theaters and concert halls, but everywhere to be connected with our daily and domestic life. In England the principle of introducing art into everything caused a revolution in decorative style. "Our working people must become artists, our artists working people," said the socialist Morris. Since the lack of personal participation and the uniformity of the product diminish the value of machine labor, even the simplest manual worker should create works of art. Even we artistically inactive people are invited to make our own attempts. A German aesthetician goes so far as to say that "art is really art only when, as artistic cultivation, it guides and controls every manipulation of every scholar, every builder, every shoemaker, farmer, and laborer."

The attempt to give artistic form to whatever man can affect has furthered the applied arts and created a field of activity for lesser talents. The theory of art has learned from this movement that external size and customary appraisal of works of art are not the only criteria, that a decorative moulding can have no less value than a huge picture. But over against these gains are serious losses. In economic life the extension of art has bred a disastrous dilettantism. A wisely restricted dilettantism may prove useful. Goethe thought that it "can be both a cause and an effect of a broadened art, that it can develop artistic talent and raise the level of the handicrafts." *Dilettare* means to love, and signifies bringing joy to our souls through artistic activity. But as soon as the amateur forgets that his well-meant performance reaches only to the beginnings of real art, his activity breeds a disagreeable arrogance. Moreover, dilettantes are inclined to regard art as a little tranquilizer for the home, or even to engage in economic competition of the worst sort with professional artists. There is also a degradation of outlook. If we take value as intrinsic value, of relative infrequency and distinction from other things, then the pervasion of our whole life by art would rob that very art of its value. We have already considered this in becoming acquainted with the concepts of callicracy and panaestheticism. The danger is imminent that the distinction between the important and the unimportant will be lost, and that art as an independent function in social life will come to be thought superfluous. Actually art, like science and religion, is a force which should not rule without limit in the social order, but should strike a balance with the other forces. The social functions are so autonomous today that their absorption into one another would be tantamount to the renunciation of all culture.

Thus art is now trying to appropriate not only all objects but also all subjects. We are striving to bring the joyful blessings of art to all classes of people and all ages of life. We must take some position with regard to this trend. And, indeed, to go to the bottom of the problem we might perhaps ask: Does art unite or separate men; does it adjust or sharpen oppositions; is it democratic or aristocratic; is it a necessity or a luxury; should it be the same for all, or may there be a special kind of art for the masses and a special kind for adolescents? I do not intend to treat these questions with pedantic precision, one after another, but nevertheless will try to bring out the most significant points.

Biologically trained thinkers have declared that artistic creation and enjoyment, stemming from a surplus of vital energy, help to preserve the race. Enjoyment of art, they say, puts us into an harmonious state of mind which is extremely conducive to individual and social longevity. We may go further. The creation of art not only affects human beings but is actually a form of communication and as such is a form of human community. In a work of art the capacity of mental processes for exchange is raised to the most delicate understanding which needs no contact between individuals. In this view communication appears as the heart of art as well as of social life. In his lectures on Richard Wagner, Heinrich von Stein is fond of telling us that art shows what persons can be for one another. Through sympathy with the creative artist the appreciative person is united in a higher unity with him and many others who, save for this, remain strangers to himself. The unitary mood thus produced can acquire external value. This is what Gneisenau meant when he exclaimed to his king that the security of the throne is based on poetry. Some such thought was expressed in Treitschke's declaration that Goethe had no less a share than Bismarck in founding the new German Empire. On all joyful and sad occasions which stir the emotions of many people music, like a cord, binds the gathering together. Religious and patriotic inspiration especially are kindled by music. Figurative art often serves to strengthen patriotic sentiment through remembrance of days dedicated to the honor of the nation's heroes. Menzel's best pictures are like halls of banners; whoever destroys one of these prints tears up a Prussian flag.

Now we may ask how such community reacts on the creative artist and his work. The answer depends on what value we assign to the judgment of the general public. While many see in

the masses a herd to be ruled only with whip in hand, others wonder at the rise of mediocre intellects to an astonishing delicacy of feeling. (Bismarck's description of Parliament is very instructive. "Taken individually, the people are—some of them—quite sane, usually trained in the conventional curriculum of a German university. But beyond their narrow interests they know no more about politics than we did as students; indeed, they know still less. In international politics they are children even individually. But in all other questions, as soon as they convene in a body, they are collectively foolish, severally wise."—*Bismarckbriefe*, ed. H. Kohl, 6th ed., 1897, p. 269.) Simmel has tried to reach a decision through a distinction. In anything that requires understanding, he believes, the group remains behind the individual, whereas in the realm of feeling the reverse can be shown. In the particularly clear case of the theatrical audience it is actually so. This case also shows perfectly what reaction on the artist is immediately possible—the reaction of a psychical resonance chamber. As the architect counts acoustically, so the playwright and actor count psychologically on a group of people to fill the room. The best performances and effects are not possible in an empty house. Although the play that radiates out from the stage is usually reinforced in the audience, yet the feeling of an individual is also often repressed by the different attitude of the group as a whole. And this is by no means true merely externally, but also internally. For example, a personal enthusiasm finally cools if everyone else remains indifferent.

Yet there are authoritative aestheticians who will not recognize any such injury, and in the voice of the people hear the voice of God. They regard an art for only a few as a mere discharge of playful joy, and they tend to equate genuine art with the art of the people. In England and America, where the higher spiritual activities are subordinated to public life more decidedly than they are with us, the art critics have become chiefly critics of society, attacking capitalism as the source of all evil. Yet it is the Russian, Leo Tolstoy, who advocates most vigorously the subordination of art to the demands of the people. I cannot deny myself the inclusion of a few passages from his essay *Uber die Bedeutung der Wissenschaft und Kunst* (On the Meaning of Science and Art). These passages bear within themselves their own refutation, thus making an elaborate commentary unnecessary. Tolstoy says: "The sciences and arts will serve the people only when the young scientists and artists live in the midst of the people and as the people live,

offering to the people the achievements of their scientific and artistic service, without claiming any special rights whatsoever, depending on the will of the people for acceptance or rejection. . . . The production of learned works and novels cannot be regarded, respectively, as science and art, so long as those persons in whose interest we ostensibly carry on these projects do not accept the products with joy. . . . Tell one of our musicians that he should play on the harmonica and teach songs to the peasant women. Tell an author that he should discard his poems and novels, and instead write songs, tales, and legends intelligible to the uneducated masses. The artists will simply declare that anyone who demands such things of them is stark mad." At least, all that we now properly call art would have to appear as a squandering of human labor. And everyone can imagine for himself how much art would still survive on the application of these principles. It has often been said that art degenerates as soon as it is detached from the people. It seems to me, however, that art is ruined more rapidly when it is sacrificed to the people.

In fact, very few artists feel themselves the servants or voices of the people's will. Rodin compared himself with the Roman minstrel girl who replied to the contemptuous laughter of the crowd, "I sing to knights!" It is not the worst artists who simply create as they like without any thought of their neighbors, who go their own way, untouched by popular preferences and wholly devoted to the timeless demands of their art. Primitive peoples already have brotherhoods with artistic mysteries and whole families of artists. A kind of fellowship has been assumed to account for even paleolithic cave painting. (Cartailhac and Breuil, *La Caverne d'Altamira*, 1906, p. 133.) In civilized nations the separation developed rather late. In China professional painters did not appear until the second century B.C., and in Greece the divorcement of artist and artisan occurred at about the time of Pericles. Then in the golden ages the artists formed fellowships, subject only to their own laws and deliberately leading a separate life. If such associations, with their apprenticeships, must be renewed today to replace the bloodless academic system, the result will be a similar detachment. Yet these arrangements are not the crucial matter. The much censured arrogance of artists rests essentially on their indifference to social ethics. Their rarest gifts emerge from solitude and pass into solitude. For even the *joy* in high art is a secret joy; no one can share it with another. In more ordinary excitements it

may increase our pleasure to feel elbows on both sides of us. But in the sacred hours of deepest emotion the individual must be alone with himself. The first word uttered by another introduces a false note. Whoever dreams of the white magic of an art for all mankind is either referring to mediocre works—especially the merely instructive and propagandistic—or he is merging experiences which in fact are infinitely graduated, reaching from the vague understanding of a few externalities to the full comprehension of the work presented. The masses can feel pleasure in the object, and occasionally even an interest in its nonaesthetic parts, just as intensely as the few connoisseurs. But a trained and versatile faculty is needed for the total richness of a masterly work to make its appeal and for the charms of the work to take full effect. The painter Trübner once tried to ascertain why precisely the most mediocre paintings have the largest public. He finally reached the explanation that this public values works in which it sees the academic ability with which it is familiar applied to the portrayal of objects in which it is interested. The Goncourt brothers even set up the maxim: "The beautiful is that to which the public has an involuntary aversion." Very few are admitted into the Freemasons' Society of Perfect Artistic Souls. We outsiders help ourselves by omitting delicacy and depth. But at least we know that there is a high level of achievement, where the artist takes the raw material of the art that meets ordinary standards and in addition draws from this material its supreme potentialities. The disposition (shall we say) to fall into ecstasies before one of Korin's asymmetric floral forms; the capacity to elicit, through feeling, the full life from the most delicate refinement, from the most meager arrangement of lines, from the most subdued ceremony; the power to escape from all earthly vulgarity and asperity—all of this is involved in the enjoyment of such achievements. The justification of high art lies in what it gives to two or three persons. Its kingdom is not of this world.

Sound reason and good order remain the best diet to nourish the masses, for the many, who feel a kinship among themselves, need a good rule and a clear rhythm to guide them in all their affairs. Nor can any objection be made to this. Old Sulzer seems to me right in demanding that painting "support devotion in temples, arouse patriotic sentiment in public buildings, and foster private virtue in residential rooms." But I would not call that "the higher use of painting." Wherever in our scheme we may

place the marvelous works of landscape painting, they are not markers on the broad road of popular education. Public buildings can tell of a nation's might and past. Also, of course, these buildings as purposive structures will be intelligible to everyone. But their implicit acknowledgment of the will to form is disclosed in all its gradations only to those who are especially susceptible. So the distribution of the noblest art—at least, many of its works—is blocked by the inadequacies of the recipients and, on the other hand, by a practical impossibility. Where are we to get enough distinguished actors and musicians to offer the people a really exhaustive performance of plays and compositions? A print of the Mona Lisa for two marks hardly even suggests the charms of the painting. Only literary art is protected by its peculiar medium against loss through cheap reproduction. But generally in art, as everywhere, the good is also costly, hence inaccessible to the poor. It is depressing to consider that wealthy dilettantes pay enough for a little picture to support a family, that the millions spent for artistic purposes could save so many wretched fellows from despair, disgrace, and suicide. But we must remember that art and science would not exist at all if we decided to defer their cultivation until that distant time when all misery had vanished.

Now let us try to get a cursory view of the measures employed at present to spread good art. A few words on each main point should suffice. First there are the efforts in behalf of literature, which is actually the most important art for the general public. Were the notoriously base and dangerous elements in literature ever to be effectively blocked, the result would be invaluable. But it would not mean that the highest poetry would become a common treasure. Public libraries and houses publishing for the millions must stay within a definite range of value. In the field of figurative art, attempts to produce the artists' own color lithographs seem to me to be the most promising experiments. For here we are dealing not with poor imitations, but with the artists' original pictures, which they have drawn in this medium and have supervised up to the moment of running the presses. The number of prints is irrelevant. The work of art remains constant and, indeed, precisely what the artist intended it to be. Yet the prices of these lithographs are too high for the poor—whether old or new poor. But the fact that only living artists can speak to us in this way is rather an advantage than a disadvantage, although the restriction has been severely criticised. Works of art have their most

417

far-reaching effects on the period in which they originate, or perhaps on the immediately following generations. When centuries have intervened, many aspects of the work have grown strange, surrounded by their own atmosphere in which the present does not breathe freely. Earlier works require time-consuming study and laborious explanation; they do not immediately reveal their artistic qualities. Only a people as plastic as the Germans should be expected to feel that Phidias or Raphael is closer to them than their own artists of the most recent decades.

These considerations raise scruples against our undue esteem for museums freely accessible to everyone. Herman Grimm declared that the Berlin Galleries are not even suited to introduce students to the world of figurative art. Whoever observes at all the throng of visitors, pushing ignorantly and aimlessly through the halls and staring with amazement at the hieroglyphics in the pictures, will recognize even more clearly the difference between what is available and what is taken in. To solve this problem groups of visitors have been guided by experts. The result is satisfactory to a certain extent without, however, invalidating the judgment expressed earlier. (According to Fritz Wichert, "Actually there is no better way to make art a lived experience for a fairly large group of people than for them all to look at the original together, aided by a suitable commentary." *Die Kunstmuseen und das deutsche Volk,* 1919, p. 38. The average visitor needs an interpreter of what is to him the foreign language of the painter and sculptor.) In public theaters the explanations in the programs help the audience to understand. But with series of plays, arranged in accordance with some unified plan, even the best public theaters cannot find a place for every distinguished play, since they are directed to take works which meet the preferences of the audience halfway. Of course the other theaters are and always will be business enterprises. The complaints about this are as old as the theater itself. The futility of this lament has been shown very cleverly by a workman in the quip that as long as the theater has stood it has been falling. Theatrical performances were once a public concern of the community, or an intellectual sport, or something arranged by a special group of people. Later noblemen maintained their own theaters, just as they employed orchestras and collected pictures. Finally there was the period of the court theater, the state theater, and the municipal theater, countless commercial theaters flourishing along with them. None of these forms

has been devoted purely to art, nor will this be possible even in the future. For the peculiar economic nature of the theater keeps it very dependent on the simultaneous participation of many people, on wind and weather, on fashion and publicity. Today we are told, of course, that an ideal public will create a stage committed only to high art—that ideal public being the proletariat, "which is equal in need and equal in war," as Rudolf Leonard declares. But who belongs today and tomorrow to the proletariat? And how is it that community of interest capacitates a group for artistic judgment? In the past, at any rate, the proletarian theater was more an amusement hall than an abode of art. Throughout the history of Greek folk drama, portrayed in a masterful way by Hermann Reich, the primitive joy in colorful pictures of contemporary life, in clownish jests and couplets, in the arbitrary exchange of humble and exalted station, proved the chief attraction of this theatrical art, fashioned for peasants and proletarians. At the time of the Roman Empire the mime prevailed, the heroic drama with its three active roles being wholly discarded. In the Middle Ages the people imposed droll interludes on the mystery plays, thus remaining true to their love of buffoonery. Harlequin and Pulcinella, the principal figures of the realistic-comic puppet show, swept triumphantly through the European world. Turkish shadow-plays are also centered in a Punch, loutish but victorious through pert mother wit. The merry-andrew has lived for three thousand years and in countless forms, extending from the circus clown to the comic figure in Molière and Shakespeare. The people have always demanded that the theater give them uncouth jokes and crude portrayals of manners and morals. And what does the educated public expect of the theater? A rendezvous of elevated sociability.

The urge to amusement and pageantry is so strong in human nature that artistic activity in society must usually be governed by it. When Schiller regards the stage as a moral institution and Humboldt justifies the free dissemination of all artistic expressions by reference to the infinite goodness of human nature and its capacity to share itself, they underestimate the superficiality inherent in us all. And since this superficiality tends to lapse into vulgarity, the governmental censorship which Humboldt attacks as unjust is indispensable at all times. We almost wish a broader jurisdiction for such control, if we grant that an unregulated society actually caresses the most tenderly the worst and most conventional art. We are a long, long way from that happy state of affairs

in which the art of greatest worth is called for with the greatest eagerness. Artistic creation and artistic enjoyment show no balanced interaction. Singularly noxious are the middlemen, who aim merely to do business in the purveyance of art, and who make the greatest profit from mediocrity, on the one hand, and specialties, on the other. To stimulate public demand they create new fashions at certain intervals, choosing just the things which will yield them the greatest immediate profit, not the things which can last forever. This whole business should be viewed as an exchange of commodities; only as a cunning and unscrupulous foe does it have any point of contact with genuine artistic activity. But the artist, who disdains the patronage of sly traders, has only three possible modes of economic existence left. He can get money in some way or other and then create independently of the capitalists. Or he can adjust to the demands of fashion. Or he can take up his position outside society, preferring to renounce all the benefits of regulated life rather than to surrender even a particle of what he calls his freedom. Bohemianism can very well be a transitional stage. Young blood mixes readily with the gypsies of art, and for a short time may enjoy the charm of the vagabond life. But age needs "a shelter against the storm and rain of winter." Permanent detachment exacts its price in leaving the isolated artist at last incapable of achievement.

Thus far there has been only passing mention of statute provisions for governmental assistance to art. Let us merely recall briefly some familiar facts. The state does not limit itself to collecting historically significant and beautiful works of art and to preserving memorials of the past—even literary and musical memorials—through the activity of officials and boards. The state also establishes schools to train artists, furthering these schools by prizes, travel stipends, and pensions, and even coming out itself as an entrepreneur and critic of art. To deride this whole activity of the state is cheap and in bad taste. Of course, institutions cannot breed geniuses and steer to the "right paths" those whom, let us say, orders or advertisements have brought. But academies of art and of music teach something teachable, as they were set up to do, technical training along with the neighboring departments of general education. Like all schools, they are planned for the average. Similarly the other administrative measures are practical norms for most artists in the art markets. Here, of course, the chief concern must be to counteract an excessive production and valua-

tion of art. Art is a force whose use should not be controlled by itself or its followers, but rather should be fitted into the dynamics of the political organism. When hotspurs demand that art become the whole of life, they are right in this sense, that art tends to wholeness. But religion and science make the same claims. They are all unjustified, for we do not live in a vacuum. The devout Christian would acknowledge no other law than that of the Gospel, even though it should forbid the oath and service under arms; the scholar would subject all conduct to the norm of absolute truth. This juxtaposition already shows how untenable is the desire to make a part into the whole. Were art to become the only standard in social life, faith and science would have to defend themselves against it—not to mention the men of practical affairs. The enthusiasts who would lift the world off its hinges with artistic culture should take Goethe's words to heart, " 'All or nothing' is ever the slogan of the inflamed masses." Ruskin's desperate attempt to overthrow the present economic order by extending the scope of art was foolhardy reactionism. Finally, there is still a fact to consider carefully. Whenever art has won sole dominance, it has grown delicate and coquettish. When art became the all-consuming interest as the ancient world decayed, not only were the vigor and richness of life impaired, but even art lost the grand style.

The relation of art to the education of the young is threefold. We can educate through art, educate for art, or do both together. This last alternative, which we have already skirted when discussing schools for figurative art and music, needs no investigation. It is obvious that serious occupation with music will bring especially the susceptible child back to music again. In the case of education for art the question is: how far can instruction help to awaken aesthetic sense and artistic feeling, and that chiefly in an indirect way? Obviously the cultivation of the observational powers can bear rich fruit when clearly perceived reality is compared with the representations offered by the figurative arts. All the cultural elements contained in religious, linguistic, and historical instruction further the understanding of sculptural and literary works. But the teacher should also refer directly to the great fact of the artistic life for the very purpose of conveying some notion of man's creative power and glory. How seldom our teachers were aware of it! And how much more seldom they allowed their pupils to ascend into this realm! I feel sadly oppressed when I recall my own school years—the countless hours stupidly wasted;

the education for parrotry, for dishonest manipulation of phrases, for false appearances. Pride, love of honor, the striving for independence, and the creative urge, every attempt to grow upright, to fashion for ourselves a character of refinement and freedom were suppressed by the mean, foul dispositions of petty despots. We learned to keep silent or we grew servile. Under such conditions where would the glory and freedom of art have found any place?

It is certainly rash to generalize, inferring that the present situation is like the past. Any such inference is refuted by the lively interest of many teachers in education through art. Naturally this interest is not directed equally to all the arts. Very seldom do these discussions concern the school theater, although it looks back to an honorable past—we need recall merely the Holland of the humanists and the Paris of the Marquise de Maintenon. If we could take the academic theater seriously, the main issue would, of course, be the weighing of pros and cons. The seductive power of the stage is as great as it is dangerous. Whether now the restricted and supervised operation of the theater enhances this seductive power or, on the contrary, can satisfy the desire, preserve the illusion, produce pleasure and refinement—these questions are in principle unanswerable. The efficacy of musical instruction for general education depends on how this instruction is carried on. If it leads to the enjoyment of music, we want it, of course, for every child who is at all musical. But then it would have to be something different from technical drill. A carefully planned development in appreciation and musical theory would replace excruciating finger exercises, the achievement of individual skill being reserved for the unusually gifted. Vocal instruction in the schools could be similarly arranged. In German instruction the nature of verbal art tends to be considerably eclipsed by other ways of viewing poetry. This is almost inevitable. But for this very reason we should finally renounce two prejudices. (1) We are wrong in regarding the masterpieces of our great writers as the most suitable material to teach. It is outrageously false to say that only the best is good enough for our children; rather, the best is wasted on them. The highest achievements of genius constitute a goal for which we should prepare youth, but not an arena for clumsy attempts. Moreover, the ordinary reading of poems and plays gives the reader a false sense of mastery, a feeling that now he is familiar with the works and need not be concerned with them any more. (2) In the aversion to memorizing literature I see another prejudice. Actually it is the natural method, which leaves the child in direct contact with the

creative artist and can protect the child from the dry summaries and explanations of the literary text. As a rule literature is shown no special favor in the schools. Here both teachers and students are misled into a mode of treatment which is thoughtless, callous, arrogant, and yet also very remote from cool, mature scientific inquiry. If we are to equip the child for the vital enjoyment of an artistic whole, we must give him food instead of a bill of fare. The Herbart-Ziller method turns our legends, these genuine cultural values of the German people, into far-fetched and tedious applications of moral principles and their so-called basic elements. This method converts an encounter with the wonderful into philistine advice, a green meadow of flowers into a dusty road, a glittering treasure of the imagination into worthless scraps of paper.

The information we obtained about the development of the child's painting activities showed us that, when he makes pictures quite independently of any external influence, he is mainly putting down in a schematic, almost conceptual way the characteristics of which he is aware. Only gradually does the picture come to full expression, and when it does, the outer form is what has already taken shape in the imagination. Finally the child tries also to represent space. We know nothing about the development of sensitivity to decorative art, and only a little about the development of sensitivity to chromatic beauty. Instruction in drawing usually begins only when the child has already turned his attention to forms. Then the teacher must try to understand correctly the standpoint which the pupil has already reached, to meet him here, and to lead him further. In the course of instruction good artistic models can be useful, occasionally even the much despised ornaments, despite the partisan praise of natural models. Even here the aim is to develop not individual artistry but the ability to appreciate art and to comprehend it fully. Moreover, drawing offers all the advantages of a graphic method. Whoever can draw to some extent will often use this ability for communication and as an investigational aid. We have previously established the fact that language cannot adequately express the determinateness of sensory objects, especially of visual objects. We have learned how strongly the means of expression can react upon the origin and nature of images. These two premises imply a conclusion, asserting the value of drawing to obtain concrete images. Finally, we should not overlook the contribution which an orderly pursuit of drawing makes to the development of character. The cultivation of neatness as the beginning of a modest beauty is already fostering a feeling for

purity and scrupulosity in general. The pupil is compelled to supervise his manual movements closely. His continual comparison of his work with the model checks his tendency to conceal difficulties and prods him into an earnest effort to overcome them. He learns to labor in subordination to an object, and yet creatively.

We might go still further in the enumeration of details; in principle we should never finish the successive mention of particular contributions. But to base all education on the artistic point of view would be chimerical. These preposterous programs are proposed only by the enthusiasts who believe that an artistic culture could solve all social problems and correct all educational defects. Their cloudy enthusiasm is hardest to bear when it intoxicates itself with phrases, claiming for German culture a special right to everything high and noble. Instead of superabundance we need—and need acutely—more feeling for reality and instinct for the future. It would be unfortunate for our youth to be educated into an exclusively artistic view, the view which Flaubert correctly characterized with the words, "If all the events of life appear to you as artistic material, as elements destined for use in some future work, you are an artist."

3. The Moral Function

In art the urge to aesthetic form is blended with elements and demands which have grown up in other fields. So art is intimately related to moral claims and principles. Our aesthetics easily falls into the same fallacy as some economists of the Ricardo school. These economists invented a human being who is motivated only by economic considerations, who will buy only in the cheapest possible market and sell only in the dearest, and they viewed this artificial construct quite seriously as typical of real persons. Likewise our science constructs an aesthetic man, who is not to be found even among the adherents of the slogan, art for art's sake. Works of art spring from the full powers of their creators and engage all the inner activities of those who enjoy them. They are sketched with the arrogance of the fool and executed with the calm of the sage. They deeply stir the feelings and leave the clarity of the mind undisturbed. They excite and soothe; they stand outside life and within it.

These oppositions, which no mere formula can resolve, create difficulties for art criticism, but also for government and education insofar as they have moral situations to oversee. The chief function of the art critic, of course, is merely to intervene between the producer and the consumer to give information about what is on hand. But since he must make a choice—his name already indicates this—he needs to view his subject matter in terms of the nature and function of art. What really belongs to art should seem important to him. There are several possible ways to support his choice and judge the particular work. The critic can declare and apply his standards. This normative criticism seems to me the most appropriate kind if it does not become too rigid and pedantic. The merely elucidative explanatory method, which is most closely akin to science and is also justified in itself, all too seldom reaches a categorial judgment. At best it ends with a conditional verdict: "This picture gives the strongest impression of natural reality. If that is art, the picture is good." Then there is also the impressionistic criticism caustically satirized in the bon mot: "Concerning myself on the occasion of Goethe's *Faust*." Pretentious fellows, who cannot subordinate themselves to a strange work, take it as an excuse for their own production, which they try to make as superior as possible. They are happiest (subjectively and objectively), when they encounter mediocre accomplishments, and they sponsor only genuinely original, budding talent. Honesty and courage seem to me the basic general prerequisites for criticism. The art critic often has the onerous duty of opposing the general public, and he needs great skill not to alienate them in this way. It is incumbent upon him to censure without giving unnecessary offense. Naturally, he cannot take tender feelings into consideration. Even actors, most vulnerable of artists, who lack the consolation of having their works survive them and who present their own personalities to the public, cannot be spared. Nor should we demand that the critic be able to produce a work of art better than the one he condemns. Who expects the orchestral conductor to vindicate his desired rendition by playing all the instruments himself? Who expects the theatrical director to demonstrate all his directions to the singers and actors in full detail?

Although relations between artists and critics are usually not the most cordial, the hatred for censorship is even more intense and widespread. Not only artists but also critics and aestheticians are on guard against the censorial right of officialdom, because it applies a standard foreign to art. We can correct particular censo-

rial blunders, some of them amusing and some of them sad. But the principles, which survive every change of personnel, are in fact questionable. Administrative authority tends to foster products deferentially which make a hollow mockery of everything moral, and to turn its cutting edge against real artistic achievements. Such authority mistrusts the inexorability of an honest naturalism more than the vulgarity of business speculators. Nevertheless, no one can deny that the state, as the servant of moral values, may claim the right to regulate to a certain extent all activities carried on within it. By the same token the educator, whether father or teacher, has the right within a certain scope to keep morally questionable things away from the child. The objection, that to the pure person all things are pure, is simply inane. What we usually extol as purity of thought is only absence of thought. Alert children will naturally ask for explanations of things which they meet for the first time in pictures or words. After all, we should not anxiously remove from the view of growing children everything that can arouse questions and misgivings. Young people seldom pass immediately from innocent isolation into solid virtue. Rather must we introduce at the right time such artistic experiences as will lift the dogging doubt to a higher level, at once disclosing the difficulties in the noblest form.

The more general problem (which outranks problems concerning the relations of art to the state and to education) is often brushed aside with a languid movement of the hand. We say that art is its own end, that its realm is that of pure intuition and quite separate from the realm of the will, which yields actions and their moral values. Has not Schiller, we say, spoken of the serenity of art? Even Conrad Ferdinand Meyer, elsewhere so severe, sings:

Do not look for what these songs	In diesen Liedern suche du
May in earnest say!	Nach keinem ernsten Ziel!
A little pain or pleasure,	Ein wenig Schmerz, ein wenig Lust
And it was all in play.	Und alles war ein Spiel.

If in secret on a leaf	Und ob verstohlen auf ein Blatt
Even a tearlet lay,	Auch eine Träne fiel,
Dried up is the tear at last,	Getrocknet ist die Träne längst
And it was all in play.	Und alles war ein Spiel.

Very beautiful and fitting; works of art are imaginative forms. But this does not mean that either values or disvalues vanish from the content of the artistic product. Events which everyone brands as immoral are portrayed without any apology, yet this is seen to be justified if demanded by the unity of the whole and absorbed into it. Moreover, when people are creating or enjoying art, they are essentially the same as at other times. Pictures have further effects, insinuating themselves as conscious images or unconscious aftereffects into moods and thoughts. Or is it otherwise? Is it true, as a pessimistic writer has declared, that even the most beautiful dreams and the noblest wishes do not add a single inch to the upward growth of the human spirit? Like Rudek in Ibsen's *When We Dead Awaken,* highly refined artists may feel the contrast between art and blooming life so poignantly that they cannot believe in any reaction of art upon life. Persons of this sort can enjoy a work of art to the full without letting it influence in the slightest their view of life or even their conduct of life. But in general this should not be so. The work of art is something different from reality, of course, and yet it draws its power from the roots of reality. The work of art does not exert an intentional and evident influence upon human conduct, yet it enriches and exalts the whole life of the soul (or the contrary). The ever present frame does not completely isolate its content; the island of art maintains commerce with the mainland of our daily life. To be sure, Beethoven's *Pastoral Symphony* will hardly make a metropolitan man enthusiastic about rural life. But, especially on the lower levels of artistic susceptibility, the influence of art can alter moods and perceptions. The child's creatures of fantasy often have the same effects as his experiences of reality; many of his thoughts and actions we understand only if we see them as stemming from this source. When our young ladies become so easily infatuated with tenors and actors in the role of Karl Moor, they are subject to the aftereffects of artistic experiences. And, merely to touch on something higher, a glimpse of the beauty created by man can leave us in a state of long echoing emotion, mellowing and calming; humor can bring lasting consolation and reconciliation; tragedy can rouse us and raise us to a greater life. Whenever the persuasive power of art is allied with the imperative power of the good, a lasting result can appear. There is a reciprocal relation. Moral demands use the aid of art, and rightly so; art uses those demands as part of its content. In its fullness, freedom, and flexibility art often precedes

moral evolution and proclaims the morality of the future. Excessive artistic concern with magnanimity and piety is not desirable. For the artist, as he leads us into the depths of life, is also moralizing us, arousing our contempt for meanness, our sense of independence, our feeling for the relativity of all things. But we should probably acknowledge the beneficial effects of references to the coming dawn and to the cheerful aspects of the present.

Closely allied to the question as to how far morality and immorality are helpful or harmful as the themes of works of art is the more far reaching question (because it also includes music and architecture) as to how far artistic creation and enjoyment, as processes, acquire ethical significance. First let us examine the state of affairs in the case of creation. Countless experiences have taught us that intellectual keenness, educational breadth, moral purity, industry, artistic taste and respect for art—that all this together is not enough to produce a pair of good verses. We can take this fact as final, although on principle we want agreement among the chief features of human nature. We find it harder to endure the union of artistic talent and moral defects in the same person. It seems to us that the Creator of nature and man does wrong in choosing a morally weak individual to embody real artistic ability. Only by recognizing disharmony, as we saw when discussing tragedy, can we do justice to the facts. Yet this does not dispose of every bad result which might spring from the combination of artistic ability and moral inferiority. Consider for a moment the artist's relation to his model. External nature—rock and flower, water and land—are put at the artist's disposal for reproduction. But how do matters stand, when the painter wants to use the face or body of a living person, when the author wishes to write about actual conditions and people? Probably we should all consent to be painted as beautiful or described as heroic. But everyone objects strenuously to having his bodily and mental weaknesses disclosed, and not every woman is inclined to expose her charms to the public gaze even through artistic media. So we get the familiar litigations over caricatures, novels about actual (and only thinly veiled) people and situations, and the use of models in general. But for real art there is no problem here. A correct writer, even though he is morally unprincipled, will always leave a temporal interval between the events and his treatment of them, to remove the dangers of so-called actuality. And a good work, to whatever field it belongs, always involves a drastic transformation of the

428

model, not a sly, subtle alteration to avoid reprisals and evade the law, but a reconstruction grounded in the very nature of art. Another misgiving also vanishes when genuine artists are concerned. Occupation with seductive models, questionable events, and immoral characters scarcely ever leads to immoral feelings, for the constraint of the work and the pure joy in completion do not let low desires arise. As to the physician an invalid is only a sick man, to the artist persons and things are only objects, but objects embraced with the purest love. This is precisely the power of every higher spiritual culture, that it initiates the activity of the self, which produces works of art out of natural forms, moral modes of conduct out of natural instincts. Such a culture we expect of the artist. We demand of him the most earnest devotion to his work with his gaze fixed steadily on his goal. Slovenly products are downright immoral, even though they look quite harmless. Very properly linguistic usage calls the opposite extreme, a piece of work determined by artistic conviction, honest.

We who enjoy art should cultivate in ourselves a feeling for such honesty. A certain sense of propriety must warn us against careless and insincere work. Even when the gifts are not inherently pleasing, persons of refined sensitivity respect the dedicated zeal and the integrity of the benefactors. But from spotted souls and impure hands they will accept nothing, not even a depiction of Christ. This purification of the aesthetic conscience broadens out into a purification of conscience in general. By learning to separate inner attitude from material, the observer matures into an ethics of attitude; by rooting his personal sense of responsibility so firmly that he can refuse to accommodate himself comfortably to average standards, he strengthens his inner freedom. The marts of the arts offer something for every taste. There is no rule to guide our selection. The right choice is not commended nor the wrong choice condemned. Hence, whoever acts here with good intentions does so with moral independence. It has been said that to appraise an artistic attempt, not generally recognized, we need more than taste, we need character. Yet this statement should not be mistaken as aiming to detach the individual from all relations. For, in truth, the person who enjoys art is from first to last controlled by the lawfulness of the object and by his own innate demand for necessity, a demand connected with a still higher norm. He is not isolated, but governed by the rhythm of the work of art and subject to the demands of objective Spirit. And, finally, there is still another

consideration. Ownership in general may be called robbery, but artistic ownership never is. The bread I eat and the salary I draw are in a certain sense taken away from another person. But my enjoyment of a picture deprives no one else of joy.

Although the inner constitution of the artist may be called moral, yet in a larger sense it may also be termed religious. True art and religion, I have read somewhere, share this essential characteristic, that they grow out of life and destiny, not out of reflection and knowledge. In this respect they certainly belong together. The centers of both fields are far from scientific proofs and conceptual solutions. They show clearly that some irrational things, far from being dangerous fanaticism, can unfold into modes of life with their own laws. Furthermore, they are rooted in an overcoming of the outer world by the inner. Through various symbols, common to both art and religion, but also through diverse forms they reach the conclusion that a spiritual light shines through the translucent world of existence. Finally—a truth we have often discussed—an essential and indispensable state of the artist is love, as unity in separation, as the living process which Hegel calls "being at home with oneself in the other." I should not object to our speaking of all genuine art as Christian art in this sense. On the other hand, the decline of the art, called Christian in the stricter sense, would leave the essence of Christianity untouched. Indeed, in times of heightened religious seriousness every aesthetic form can be found inadequate. (In *Entweder–Oder* (German ed., 1885, I, 147) Sören Kierkegaard says, "Wherefore we have always hesitated to call the life of Christ a tragedy. We feel that here aesthetic impressions fail to exhaust the fact.") Religious ritual, as such, is likewise correlated with artistic practice. We have already learned the most important features of these relations in the case of primitive peoples. Greek sculpture expressed a religious feeling which went hand in hand with an empirical consciousness, a contemplation of nature, and a worship of beauty. In antiquity plastic art was favored, but Christian feeling turned mainly to other forms, such as cathedrals, sacred pictures, mystery plays, and church music. Yet even medieval art was not really enslaved by the church. Biblical stories and forms of worship composed a reality so close and familiar to everyone that naturally the subjects for works of art were chosen from this field.

With these suggestions let us pass on, for something more important awaits our consideration. Here we must seek the awe-

some aid of "first philosophy," since we can no longer dispense with metaphysics. "So then the sorceress has her turn." But we will trouble her only so far as is necessary to round out our understanding of the moral function of art.

Here I venture to regard metaphysics as the search for a weltanschauung (world-view). In this sense of the term, metaphysics is formed by life. Ever again an inner command induces human beings to continue the Danaidean labor, looking for the essence of the world and the purpose of existence. A longing for the imperishable and substantial fills the higher souls. ("Being wise, none of the gods philosophizes or strives to become wise, any more than anyone else philosophizes if he is wise. Nor do the uneducated philosophize or strive to become wise."—Plato, *Symposium*, 203, 204.) A philosopher, in the fullest sense of the word, is a person who, in the midst of bustling life and summer blossoms, raises his head and asks: "Who am I and what should I do? What is the purpose and meaning of everything?" The way of the philosopher is to seek the infinite in the finite, the most remote in the nearest, the secure in the ephemeral. Contemplation from the standpoint of eternity (*sub specie aeterni*) does not involve a point of view occasionally adopted, but a form of life, a continual concern for the highest values, a progressive movement toward the eternal. The metaphysician feels that this attitude is the heart and the justification of his existence. The philosophizing person realizes himself in the whole world—or rather, in the ultimate grounds on which experience as a whole rests. The feeling of the whole, which arises in this way, has been mistaken to mean that a weltanschauung is a collection of scientific generalizations. That feeling and the peculiarity of metaphysics in general are more correctly derived from the method employed here, "to complete the facts (always given to us in the form of continuous developmental series) by passing beyond the empirically provided limits of these developments" (Wundt). Since the absolute cannot be reached by the combination of relatives, it is sought in the extension of this or that relative. For example, the self is always given as something conditioned, as a term of a relation, for which the external world forms the polar term. But in metaphysics the self can be enlarged to something unconditioned, which seems to include the whole world. Conversely, objective nature can also grow so far beyond its empirically given magnitude as to absorb into itself the whole realm of mental states, although for inner experience this realm

forms the indestructible contradiction of the outer world. Materialism universalizes the physical, spiritualism the mental. The multiplicity of such starting points and the ambiguity of these lines of development, only one of which in a given weltanschauung can be carried out into the infinite, prevent us from ever grasping the whole truth in a definitive form which would satisfy everyone. This is so impossible, so incompatible with human nature, that we may say that whoever should solve the riddle of life would thereby be removed from the sphere of life. He would be a sorcerer, not a thinker.

This inconclusiveness of philosophy has been deplored as a defect. But such a charge rests on two presuppositions which are not beyond question. The first is the ideal of an ultimate formula which is to solve all riddles and decide all questions of conduct with certainty. Measured by this goal, even the highest achievements of metaphysics must seem inadequate. But who gives us a right to that ideal? Life does not point to it, but to incessant movement. Above all, the purely spiritual values offer us nothing finished and dead. Religion and metaphysics are said to be the two forms—the personal and the objective—in which the irrationality of lived experience is raised to levels of more refined paradox, demanding ever new resolutions, and precisely in this way are religious and metaphysical vitality preserved. A second presupposition is the belief that weltanschauungen are meaningless, because they fail to transcend the lived experience of individual persons, or at least the typical forms of such experience. In this way the standpoint of social practice is introduced, with which the standpoint of spiritual value has nothing to do. It is quite correct, but also quite irrelevant, that so many million persons are optimists and so many million are pessimists, the two opposed groups being unable to convert each other. In the background, of course, are countless others, living on according to the demands of the moment without any decision at all. Metaphysics is not concerned with ratios and numbers. It possesses neither the universal validity of experience nor the convincing power of a happy hypothesis. Starting out as it does from certain basic facts, proceeding to develop their implications beyond empirical limits, and thus reaching values, metaphysics transcends the boundaries of what we experience, or even in scientific conjecture suppose to be present. Metaphysics is the philosophy of otherworldliness. Hence its true nature appears most clearly in the many kinds of Idealism. Materialism is metaphysical only insofar as it embodies all the defects of metaphysics without its merits.

432

That transcendence of immediate existence which we call Idealism extends the lineage of the spiritual to the Absolute, spirit being raised to a supreme kind of existence and power of action. The spiritual first appears as the psychical part of the individual, as the conscious processes which everyone finds in himself, whereas he infers more or less similar processes in other persons. In addition to the psychical a bodily spatial element is given—not given, of course, in the individual person's original experience, which is still unfamiliar with this distinction, but probably in a theory emerging very early and generally. Beyond the world of ideas is the physical world, on the one hand, and on the other still a third kind of reality—present, to be sure, only for man. He has created a new world for himself, which cannot be altered by the individual, a realm of law situated between the outer world and the self. Hegel has called this realm objective spirit. We can accept the term and use it, irrespective of Hegel's system, in reference to the spirit which is like the spirit living in us and yet has attained the high station and stability of what is objective. A mathematical theorem or a legal principle is obviously nothing physical, but rather a spiritual entity, yet having that peculiar validity which distinguishes it from the play of fantasy and even from the actual world as we are aware of it. I do not want any reader to follow all the crisscrossing of my present stream of ideas, all the fleeting sensations and feelings, the odd associations and sudden, useless notions that play tag in my head. But the genuine thought, which lies before us now in print, means something also to another person, although it cannot be touched by a thousand hands like a penholder. Such a thought leads a very peculiar life. It is nonspatial and attached to no place. But if you believe that it is therefore a mere cobweb of the brain, you will soon be convinced of its power in action. Its existence is confined to particular mental activities, and yet is never exhausted by them. Its objective validity remains unaffected by its more or less suitable representation in the consciousness of the individual person.

Objective spirit, the validity of structures in which the mental transcends itself, is the given fact which Idealism can be regarded as tracing to its metaphysical roots. For Idealism teaches that such spiritual values constitute the true significance of human life and the ground plan of reality. Plato declared that the spiritual meanings which have ideal validity are not only existent but possess being of the purest and most enduring kind. He called them Ideas. Thus, what had gradually arisen in the course of human evolution

he made a precondition; what had been added to the factual basis he made a law which the facts obey; the objective spirit which had grown great in civilization he made a necessary and eternal world order. In Hegel's system Reason is like the dominant subterranean fire from which the earth's surface in all its variety may have issued. For our more timorous age reason is only the heaven arched above the earth, not an origin but an end, not a world force but something both subjective and objective. What dwells in this heaven is sustained by our loyalty and yet remains independent of our wills. It overarches the outer world and the self without supporting them. It arises only through the agency of man in his higher reaches, and yet shyly rejects all overtures of familiarity, those of the masses even more shyly than those of the solitary soul.

Let us try to see what such an idealistic metaphysics can indicate as the ultimate goal of morality and how it can assign to art its part. The ethics concerned is centered in that third realm. From this idealistic point of view, to belong to that realm, to become a child of God seems a higher moral goal than personal pleasure or the general welfare. The realm of values is the homeland of the man of achievement. The individual and society, man and nature do not form the whole of things. In considering his own happiness and the dictates of Christian charity the man of achievement has scarcely touched his real task. Progressive mastery of nature, increasing comfort and enduring peace are at best only prestages for the fulfillment of a higher vocation, to discover and secure a new reality. Rudolf Eucken, who is advocating such an idealism most vigorously in our day, says pointedly, "Ethics, religion, and metaphysics are either witnesses to a new world or they are empty illusions." Other philosophers of the present do not share this view. But even they must acknowledge that Idealism has achieved and is still achieving the most extraordinary results. For it remains a fact that every nobler person, even if he repudiates the goal of Idealism, is taking a road which seems to him prescribed by that very goal, that he is able and willing to advance only as though the destination were there. Beside the social ethics of the here and now stands the ethics of the beyond as a general exaltation of the spiritual life. Even the men at the top have a very deep sympathy with the cares and troubles which we lesser souls endure. But this sympathy is not expressed in the much extolled enterprises of beneficence. It is less concerned with unhappiness itself than with the moral devastation which unhappiness produces.

It is less concerned with changeable than with unchangeable things. Above all, it is concerned with the infinite disparity between aspiration and attainment—a disparity only heightened by our higher development—and with the terrible curse of anxiety, with the helplessness and hopelessness whose existence even in a single case must deaden our joy in the world. Neither optimism nor pessimism has bridged these abysses. They are closed only when the third standpoint is won, the affirmation of life *because* it consists of suffering and need. Whoever lives most deeply for the spirituality dwelling in himself, lives most extensively for others. A perfect life is a life that brings objective spirit to flower. An inner rebirth and entrance into a higher order qualify man for an achievement which justifies his existence.

And what can art contribute to this moral destination of man? Art shows that outer and inner, the earthly and the divine, in their ultimate ground are one. Not only for our human view, but intrinsically, the purposive unity of the work of art points to the pervasive power of spirit. Just as every work of art must pass through the gates of sensory enjoyment to reach the spirit, as the picture must please the eye and the music the ear, the earthy scent of our natural existence is always present. But the life of the senses here rises into a higher stratum, becoming so transfigured as to lose its characteristic resistance to purification. When a person of achievement does not shed his sensuous nature, he converts it into the benign form of art. In this very way art fulfills what Schiller saw as the task of aesthetic education. It reconciles sense and morality. In its emancipation from all baser admixtures the body-soul wins the possibility of union with absolute value. Man's dual nature increases the difficulty of educating himself. Schiller spoke of the opposition between impulse and reason. Paul said that the spirit is willing, but the flesh is weak. From time to time even the most genteel person feels, with Nebuchadnezzar, like crawling on all fours and grazing on the grass of the fields. Between these two sides of our nature, the animal and the divine, no agreement seems conceivable. But here art shows its enormous power in making the impossible possible. It can so spiritualize the sensual and so sensualize the spiritual that the two realms meet. Even when the deeply desired peace does not appear, but a bloody battle breaks out, the strife occurs because the adversaries have met on the same level. In this way what have been two incommensurable things until now are brought into spatial coincidence and so into real

435

connection. Of course, art is unable to wipe out immediately the oppositions between the lower and higher elements of human nature. And such a result would be disastrous, even if possible, for we become moral only through combat. Art is not like beauty and aesthetic charm in sweetening the bitter elements of life. But she encourages us to use all our powers. Be thankful to her for so great an achievement.

The biological needs of the race hold even the man of refinement fast to the earth. And his mission is to ascend into the ideal world. As art gives him her last word, let it be also our last. May your life become a purification, the growth of a higher kind of reality.

INDEX OF PERSONS

INDEX OF SUBJECTS

443

with the figurative artist and musician, 331–2. Overcoming difficulties, developing technique, 199–200, 207. Morality, 428–30

Words: *Experiences*. Intellectual feelings and feelings of content in the first experience, 113–4, 352. Tension, 114–5, 127, 334. Individual factor, 116. Wavering of attention, 115–6. Imaginative activity of the appreciative reader and listener, 330–2. Also 110–148

Words: *Literary works*. Intellectual aspect, 42–3, 324; public appraisal of it, 42. Mass distribution, 417. Ambiguity of the work of art, 41. Inclination to excessive size, 103. Limits of possible empathy, 108. Literature in German instruction, 422–3. Also 62–109

In 1906 Professor Max Dessoir (1867–1947) founded the first journal of aesthetic theory, *Zeitschrift für Ästhetik und allgemeine Kunstwissenschaft,* which he edited until 1937, and continued to publish until 1943. His work at the Universities of Berlin and Frankfort did much to advance the academic status of the subject of this journal.

Stephen Albert Emery is a native of Chicago and earned his Ph.D. at Cornell University (1928). From 1928 to 1963 Professor Emery taught philosophy at the University of North Carolina, Chapel Hill, and from 1964 to 1968 was professor of philosophy at Bishop College, Dallas, Texas. Articles by him have appeared in *Encyclopedia International* and *Encyclopedia of Philosophy.* Together with his brother, William T. Emery, he has also translated into English, Wilhelm Dilthey's *Essence of Philosophy.*

The manuscript was edited by Charles H. Elam. The book was designed by Don Ross. The type face for the text is Caledonia designed by W. A. Dwiggins in 1937; and the display face is Optima designed by Herman Zapf in 1958.

The book is printed on S. D. Warren's Olde Style Antique paper and bound in Columbia Mills' Bayside Linen over binders board. Manufactured in the United States of America.